THE SOCIAL FUNCTION OF ART

Music, lyrical poetry and painting pooled their inspiration in India from the 15th to the 18th centuries. These sought dramatically to reveal and consolidate certain universal attitudes and emotions of man that were appropriate for the season in the procession of Nature. Here is a musical mode depicted by Rajasthani painting viz. Ragini Madhumadhavi or Honey-sweet belonging to the raga Hindola sung in autumn and the rains. The note and the sentiment (rasa) of the melody are embodied in the person of the Nymph (Nayika) incarnating herself in visual image and auditory form to the painter and the musician respectively. The scene in the courtyard is full of the joyous suspense of tryst amidst the gathering of rain clouds, illumined by lightning flash. The lovely, Nymph (the beloved Madhumadhavi) is waiting with her cup of life-giving honey for the Eternal Lover (Hindola). The peacock, which is the bird of the rains, and sometimes addicted to drink in the household, swoops down from the tree to sip the honey from the cup held by her responsive attendant. Even the plantain tree with its flower participates in the excitement. The placidity inside the house where the Lover's cot lies empty, is underlined by the verticals and horizontals and contrasted with the eager expectancy of nature and of the human heart. The skilful treatment, characterised by a plastic organisation of formal elements, the rhythmic interplay of palpitating colours and oval patterns produces a deep sense of poise in a scene of extraordinary animation. In another painting of the same ragini we find the Nayika seeking her Lover in a dark stormy night, while this peacock sips the rain drops.

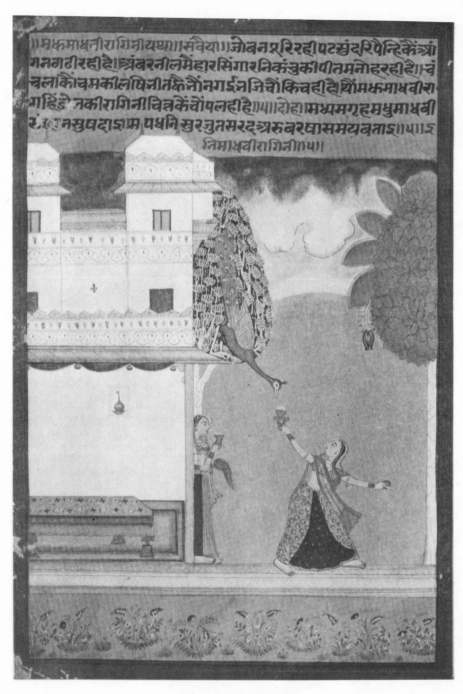

RAGINI MADHU-MADHABI

Prabasi Press, Calcutta.
Courtesy : Ramgopal Vijayavargiya

THE
SOCIAL FUNCTION OF ART

BY

RADHAKAMAL MUKERJEE

PROFESSOR AND HEAD OF THE DEPARTMENT OF ECONOMICS AND SOCIOLOGY
LUCKNOW UNIVERSITY, INDIA; AUTHOR OF: REGIONAL SOCIOLOGY
INTRODUCTION TO SOCIAL PSYCHOLOGY, THE THEORY AND ART OF MYSTICISM
SOCIAL ECOLOGY, ETC.; MEMBRE DE L'INSTITUT INTERNATIONAL DE SOCIOLOGIE
HONORARY MEMBER, AMERICAN SOCIOLOGICAL SOCIETY

UNIVERSITY OF LUCKNOW
INDIA

GREENWOOD PRESS, PUBLISHERS
WESTPORT, CONNECTICUT

Preface

THIS BOOK is the outcome of a series of Special Lectures at the Faculty of Arts in the University of Lucknow. Art is one of those vague, elusive domains of human activity that do not easily admit of precise analysis in the class-room. More can be understood of art by reciting one of Shakespeare's sonnets, listening to the symphonies of Beethoven, kneeling before the icons of Buddha, Christ or the Madonna, or looking at the paintings of Raphæl and Rembrandt. Art can profoundly affect man even without his being conscious of it or of its mechanisms. He is stirred, agitated and moulded unawares by art, by the scale of values that art subtly, constantly and impressively presents to him in all its diverse forms, motifs and techniques. Art is the vehicle of the abiding values that civilization creates and nurtures in different countries and epochs. Man's other institutions and traditions work from without; art transforms from within. Art is the expression and communication of man's deepest instincts and emotions reconciled and integrated with his social experience and cultural heritage. While the framework of laws, governments, and empires decays and disintegrates, the social attitudes and values that the art of a people records, and by which the refinement of its civilization can best be measured, remain vivid and eloquent for all time.

From the viewpoint of the individual, as Freudianism, Expressionism and modern Surrealism have shown us, art epitomises, clarifies and symbolises the deepseated hidden stirrings of the unconscious life and mind. The imagery and symbolism of art are more real, more significant than practical physical existence. Freud and Jung have taught that the unconscious forces of the mind are the same for all peoples, and that similarity of individual temperaments and conditions of repression in social life records itself in similar myths, archetypes, symbols and images in art. This is the scientific foundation of a comparative sociology of art. Man's artistic impulse is also relatively constant through the centuries of social development. It will require rashness to declare that the sculptures of Epstein and Henry Moore show a definite qualitative advance on Negro and Egyptian art, or the landscapes of Turner and Manet on those of the Sung painters. What is characterized today as Expressionist art, that is concerned less with what the eye sees and more with what the human spirit apprehends and dreams, exhibits in fact unexpected affinities. Thus Gothic, Oriental and modern European sculpture presents a remarkable similarity of patterns and styles even though the social backgrounds are so different. All expressionist art, primitive, medieval and modern, indeed takes man, irrespective of his epoch or race, to a universal order with which he finds a kinship in thought and imagination. It is striking that the contemporary art movement in Europe seems to grope boldly after a synthesis of the achievements of expressionism with the formal standards of cubism, both of which dominant tendencies go back to very

ancient Egyptian and Indian art traditions. In the dynamic genius of Picasso, for instance, we meet at once the greatest surrealist and the greatest cubist of the age. In both expressionism and cubism we are face to face with a transcendence, vitality and order of ideal values that appeal to human nature in all epochs, and surpass the cultural context of man's subjective caprice. All great work is characterised by the qualities of universality and transcendence that help man to overstep the narrow limits of human society.

At the same time each true work of art is the revelation of the attitudes and values of a particular culture and social milieu, and adds its characteristic contribution to humanity's heritage of art. The other-worldly art of ancient Egypt records symbols of man's immortality and resurrection by the stress of severe geometrical lines and planes, and the play of sharp and immense shadows on the boundless sands. Chinese art, with its passion for immense spaces, heights and solitudes, envisions man's cosmic moods by its soft tones and swift and subtle brush strokes on the absorbent silk. Indian art, dominated by the conviction of the unity of life or the identity of Being and Becoming (interpreted through the dualism of masculine and feminine principles so favourable for the artistic presentation of Life and Mind), overthrows the barrier between the material and the spiritual, the human and the cosmic, by a dense massing of gods, men and animals in plastic communion and fluent rhythm, or by the richness of its symbols, at once metaphysical and ethical, of silence and activity, manifestation and withdrawal, expressive of the palpitating world process. Indonesian art, assimilating and developing the traditions and motifs of Indian sculpture by the adoption of the methods of painting in a wanton extravagance and vibrant rhythm of figure-groups, expresses these in less symbolical and transcendental and more human idioms. Persian art, vivid, dramatic and decorative, reveals the gorgeousness of human life and the radiant beauty and animation of nature by exquisite line-drawing and perfect harmony of delicate and unearthly hues that intoxicate and carry off the senses into the ethereal realm. Greek art, sense-born and sense-bound, revels in the infinite grace and perfect proportions of the human body, also in the logical symmetry of the temple of the god and the vase of the home. Modern European art celebrates the unending drama, romance and mystery of the individual life through the supremacy of painting over the other arts and the stress of the lyrical and even the privately personal in human moods and of man's dealings with nature in the human setting rather than of Nature herself. Thus do the great arts of the world immortalise the collective visions and values of historical cultures and illustrate the essential oneness of mankind. If the study of art is to win its due place among the "humanities", it has to be aided by the cognate studies of psychology, sociology and history for the unfolding of the dynamic interaction between art and the social and intellectual conditions and movements of the age or culture. Thus the proper study of art is linked up with the methods, materials and enquiries of comparative sociology and culture. Each civilisation, social milieu or epoch evolves its own techniques, motifs and symbols of art, depending so much upon the conditions of science or mechanical invention,

religion or philosophical thought and social structure or class cleavage. The vernacular of art remains the same, the play of forms, masses and volumes, of colours, of light and shadow, but in their ever-new combinations and contrasts that appeal to something in human nature beyond the reach of words and remain inexhaustible in this mystery.

For a proper understanding of the arts of different continents we have to get rid of many prejudices and predilections. This is as necessary for understanding the tensions and aspirations of man in different regions and epochs as for appreciating the motifs, techniques and conventions by which different peoples translate universal, abstract and rhythmical values. What stronger link between races and continents can there be than the full understanding of the generic symbols, motifs and rhythms by which different peoples define and fix emotionally the universal conditions of life and destiny? In what epoch is there a more crying need of art appreciation than in this atomic age when world disunity means the end of world civilisation? The world unity of the future can, no doubt, be based securely less on the economic and political institutions and framework of the United Nations and more on their adequate participation in the pan-human heritage of the fine arts. The purpose of this book will be well served if it contributes towards this realisation of the significance of comparative art.

Every mature work of art expresses not only the values and life-goals of a particular people but also the artist's unique vision. It accordingly differs in its endowment of innate unchangeable value as represented by its abstract formal rhythm and symmetry and its potency of social impact and propulsion in the cultural context. Art is enduring in that it spans the bridge between human contrivance and organic growth, and thus immortalises what is mere invention, an artefact of society. And the most enduring art is that which leads the human spirit, tool and technique to that matrix of organic rhythm and growth where are gathered the seeds of the mighty pulses of creation and destruction, movement and withdrawal of the cosmos itself. In a pregnant passage in the Brahmavaivarta Purana we read:—"Murti (image of art and religion), the wife of Dharma, (the principle underlying order in the cosmos and the human social structure) is form, luminous and charming. Without her the Absolute or the Supreme Spirit (Paramatman), whose abode is the whole universe, would be without support." Art speaks in universal images and symbols; the image or symbol itself is beheld in India as a deity, a muse, a minister of grace, resembling man's figure but different from it, urging him to holiness and goodness and beguiling him with visions of beauty that never were on sea and land. Such is the rôle of true art conceived as the body or image of the Supreme Spirit, ceaselessly and enchantingly playing with the intellect, emotions and aspirations of man and the material forces of nature, and directing these to pure joy (Ananda), the essence of the Absolute. This is sometimes symbolised in medieval Indian art by the figure of the Female Deity, the Transcendental Power (Sakti) or the Celestial Beauty, absorbed in her own charm and luminosity, as she plays ball, touches her breasts, embellishes or sees herself in the mirror in her own hand in complete unconcern for the gods next to her or for her worshippers. Art itself is the Enchantress, but in her way of self-surpassing knowledge is the source

of true joy, serenity and illumination. In the Freudian interpretation, art is also the enchantress; she is the siren who leads the mind away from reality and from the clamant demands of human culture that is conceived as something external and superimposed upon the self. This is true of weak and false art. Freud and his school missed the dynamic social role of true art as the transformer of the tensions and experiences of life into enduring and universal patterns and symbols that become an integral part of man's make-up, and guide him and society. Art fashions sense-data and experiences into symbols, and symbols into life-values and experiences. Man and society can perpetually renew and transcend themselves by the self-transcending meanings, values and purposes that art represents. Art perfected means life, mind and society fulfilled and perfected. But such fulfilment and perfection leave man unsatisfied. That is the constant lure of art ever reaching out into the unknown, ceaselessly enlarging the world and experience of man, and beckoning him to goodness and beauty undreamt-of. Man and society must constantly be directed by art to the source of cosmic order, vitality and movement whence alone their enhancement, enlargement and renewal can come.

This is essential in order that man's feelings and understandings be not deadened nor dulled but be stimulated and refreshed, and that his toil be redeemed from drudgery and his relaxtion from sensual or sexual excitement through the identification of the human with the universal, of the sensory with the spiritual, which is the function of such permanent symbols as art creates. Especially in modern society, where physical, economic, and mental insecurity and the associated tragic sense are so deep and general, art, as in the historical civilizations of the past, is the only balm and anodyne in its refreshing and vigorous revelation of the immortal. It alone provides the social myth, symbol and image that can raise individual life to the highest potential, and serve as sign-posts for the society of tomorrow in which beauty, goodness and truth overcome the fear, sorrow and disillusionment of today.

Acknowledgments are due to the editors of the Sociological Review, Great Britain, the American Sociological Review, Sociology and Social Research, Bhara a-Kaumadi, B. C. Law Volume and other scientific journals and publications to which certain chapters of the book have been recently contributed as articles.

I am grateful to Dr. A. V. Rao of the University of Lucknow for his assistance in revising proofs and to Mr. N. G. Thakar of the Scindia School, Gwalior, for preparing the Index. I am also deeply indebted to the Director of Archæology, Gwalior, the Director-General, Archæological Survey of India, and the Curator, Asutosh Museum of Indian Art, Calcutta University, for the kind permission granted to reproduce illustrations from photographs taken by them. Dr. B. C. Law has laid me under obligation by his kind help in connection with the illustrations and their publication. I am further indebted to Mr. Harinivas Dwivedi for his ungrudging assistance in seeing the illustrations through the press in a difficult time.

Basanta Panchami, 1946,
GWALIOR.

Foreword

SOCIOLOGY AND PSYCHOLOGY are the typical sciences of our time, but until quite recently both have shown an almost complete neglect of one of the most comprehensive spheres of human activity—art. From the earliest dawn of human civilization, the most complete and accurate evidence of man's social and spiritual development is to be found, not in his political institutions, which are often the imposition of a minority, and not in the incomplete and distorted records of historical events, but in the still visible and still vital work of his hands. Art is a living voice from the past, sometimes the only voice, and no history of human evolution can be complete or valid that has not listened to this voice.

It is quite obvious why science should have neglected this evidence. As Professor Mukerjee points out in his Introduction, it was hardly to be expected that the intellectual or rational approach which has hitherto distinguished science should take into account material which required, for its appreciation, not the intellect, but the sensibility. The intellect can classify art into styles and periods, and relate these to other manifestations of social activity; but the significance of art must be determined by other faculties, faculties which science has been content to ignore.

But these are points which Professor Mukerjee himself makes in his book. My purpose in this short Foreword is to draw attention to the remarkable success with which he has developed this new approach to an understanding of human civilization. He has taken into consideration an unusual amount of material, and from his actual point of view, which is midway between the East and the West, he has been able to give equal weight to the evidence from both hemispheres. This gives him a great advantage over most of our Occidental scholars, who have generally been compelled to make some excuse for ignoring the Oriental evidence. This has been a great limitation, for in certain respects the East has shown a deeper feeling for the function of art in society. From our Western point of view it has shown excesses, the sensible reality of art disappearing under a load of transcendental symbolism; but how inadequately individualistic our Western art must sometimes seem to Eastern eyes. In any case, the truth about art, with a full realization of its social significance, is only to be obtained from the kind of universal oversight which Professor Mukerjee possesses. I have been enormously impressed by his eclecticism, by the completeness of his knowledge, and

by the modernity of his outlook. His scope goes all the way from the Upanishads to James Joyce! And the author never loses his way, never leaves the reader confused with a mass of unrelated detail. I think the secret probably lies in Professor Mukerjee's clear realization of the integrative role of art. Art is the projection, from that spiritual depth which Jung has called the collective unconscious, of a series of viable symbols, infinitely transformed, round which, in which, the emotions and aspirations of mankind find an objective unity. We cannot conceive civilization without these rallying-points, and the path that mankind has followed, through thousands of years, can only be traced from one such point to another. Radhakamal Mukerjee guides us with his illuminating intelligence from stage to stage of this immortal journey.

HERBERT READ.

ACKNOWLEDGEMENT

ILLUSTRATIONS OF SCULPTURE:

Figures 1-4, 9, 11-13, 19-21, 26-34 are reproduced through the courtesy of the Archaeological Department of Gwalior. Figures 5-8, 10, 14-18, and 23 are reproduced by permission from photographs taken by the Archaeological Survey of India. Figures 22, 24, 25 and 37-38 are reproduced from photographs of the Asutosh Museum, Calcutta University.

ILLUSTRATIONS OF PAINTING:

Ragini Madhu-madhabi is reproduced through the courtesy of Sj. R. Vijayabargiya and *Krishna and Gopis* from the original belonging to the Archaeological Department, Gwalior. Figures 1-16 are reproduced through the courtesy of the Archaeological Department, Gwalior. Figure 17 is from a photograph by the Asutosh Museum. The illustrations of contemporary Indian sculptures and paintings are from photographs lent by artist friends. I am grateful to all the authorities concerned.

Introduction

CONTEMPORARY SOCIOLOGY has not felt shy in extending its ambit so as to include most aspects of man's life and experience, but so far completely neglected the domain of his artistic activity. A purely intellectual or rational approach to life, a disinclination towards all kinds of value judgment, and above all, a stress of the artist's personal expression and contribution in the regime of individualism are responsible for this. Art work is too often regarded as a matter of divine revelation or spontaneous inspiration of a man of genius defying rational explanation, which, on the contrary, may be detrimental to its true appreciation. All this has stood in the way of serious efforts to examine the sources and processes of artistic activity. Art is neither an isolated nor an accidental achievement. Art forms derive their meaning and value not from single images or isolated groups of sensations, desires and emotions that emerge spontaneously in the artist's mind, but from the comprehensive background of his personality and his ordering or orientation of the values in which he lives and moves. Art is in fact an immediate and vivid expression of personality. Thus a study of the relations between individual and society can ill afford to ignore the creative processes of personality in art work and apprehension. Art as expression, as communication, and as enjoyment is a basic and universal personality-social adjustment. The complex social values, compulsives and repressions of culture as well as the individual's reactions and challenges through the epochs are writ large in art work. Real art is not dilettantism. It is not an adventitious, leisure-time fervour or adventure, separable from society and culture. It is the unmistakable bloom on the ripe fruit, associated with healthy organic growth and maturation of a vital civilisation.

The sociology of art reveals the organic place, functions and meaning of art in society. An adequate treatment of this would no doubt demand a volume of encyclopædic scope covering the entire account of civilisation in its artistic aspects. But it would be worthwhile to examine the fundamental psychological and sociological principles of art work, tradition and development, to survey broadly the forms, motifs and themes of art in historical cultures from the comparative viewpoint in the background of regional and sociological factors and forces. Such study of the humane arts, dealing as it does with the schemes of values among different peoples that make human societies possible and the individual human life worthwhile in different countries and ages, is no doubt much more significant than either the physical or the social sciences in man's understanding and proper orientation of his relations with the environment and with fellowman. Through the epochs of man's history art not only reveals man's

2

intense emotional relations to the world that he sees around him, but also supplies the formal symbol, pattern or design for various activities that bind him to fellowman—work, recreation, religion, government, pageant and warfare. Art establishes and celebrates the balance between man and the rest of the environment, including fellowman, with its profound consequences on the emotions, behaviour and experience of both individuals and societies. On the other hand, the lack of such balance in any existing social situation or culture largely accounts for man's pursuit of a restricted and isolated beauty that does not touch his whole life and the relegation of art to a realm that is of interest to the æsthete alone in the studio.

In no age has there been greater need of comprehension and appreciation of the humane arts than at the present time, characterised by a complete breach between man's practical behaviour and interests and his heritage of enduring values or his phantasy-making and expression. Modern civilisation, largely because of certain peculiarities of industrial and social conditions, has led to the separation of the arts from the major human interests, occupations and goals of life, and pushed art to the drawing-room of the *nouveaux riches*, the salon of parvenus and art-critics and the museum of art historians and collectors. Thus theories of art now hold the field that isolate art and its understanding by removing art work from the scope of common or community life, and judging them from certain criteria derived exclusively from this autonomous realm. The elevation of art to a sphere of its own, indeed, reflects a peculiar social situation in which artistic activity has no organic relationships either with an authentic culture or with the vital adjustment, expression and fulfilment of the individual.

As embodying the rhythm, the unconscious forces and the energies of a society and culture, art is the safety-valve for general adaptation and equilibrium, a deep-seated means of adjustment to and participation in human relations and experiences. Where social conditions do not permit easy adaptation, art serves as a refuge from the tyranny and disorder of the world. But such art from its very nature cannot perform its functions adequately. True or truthful, as contrasted with artful, art is neither an escape from reality nor a mere play with agreeable patterns of sound, shape and colour, but is essentially a revealing interpretation of certain aspects of human life and reality and the contemporary social environment. Art thus is one of the most efficacious means of social control and guidance, enforced as these are by an appeal to sensation, emotion and imagination in sensuous forms, patterns and symbols. Therein lies the true significance of art in society as expounding and justifying or challenging its aims and pressures or those of an established order or regime.

Like religion and myth, custom and code, art no doubt is an effective agency or tool in the hands of society, race or social class to mould the individual's

faiths, opinions and wishes, aiding him in his adjustment and attainment of peace and harmony with the world. While art is more easily acceptable as it carries the entire burden of meaning necessary to satisfy or still the fundamental demands both of the individual and the society and thus embodies a rational integration of individual and collective desires, values and experiences, a particular culture or an epoch of social chaos and maladjustment often gives rise to an æsthetic and a-moral art, accepting the mere production of formal beauty as its chief, if not sole, goal. The latter exhibits a charm, gaiety and lightness of its own, but disregarding as it does the fresh and vital issues of human life, destiny and culture, it cannot become the medium of successful and prolonged commerce in the world of imagination. It is by reference to their art products and experiences that one can understand best the absorptions and aspirations, defects and fulfilments of a folk, society or historical epoch. There are as many art types and styles as there are organised cultures. Many cultures that are dead and gone still live in their art products that are fraught with human meanings and values in which we can all share. In fact art works are the most effective and intimate means of participating in the attitudes, values and experiences of remote civilisations and ages.

In some cultures and in certain epochs, more than others, art has been the vehicle of religious truths and moral ideals, the broadcaster of mass social movements and the stimulus of creative activity in every phase and detail of social life. Art can, indeed, function most efficiently in societies and epochs where it embraces human experience at its highest and fullest in a total and completely integrated whole so that the true, the good and the beautiful can be expressed and appreciated in the same object. Thus can the language of beauty enter into man's work and worship, manners and ceremonies, etiquette and social intercourse, into everything in life, personality and society. On the other hand, the complete segregation of art from the objects of concrete human values and experience, truer in no epoch than in the modern, has impoverished and vulgarised art, life and society.

No doubt it is the confusion of social purposes and the breakup of the community life and values that have not only led to the present artistic chaos and aberrancy, but have also militated against the development of an adequate sociology of art of which the great pioneers of the preceding age were Taine, Spencer, Grosse, Guyau and Wundt. Neither geographical determinism nor racism, nor the genius of the individual holds the major key to the interpretation of art work. Mankind's legacy of art experiences has enormously expanded since Taine, Ruskin and Herbert Spencer. Primitive art with its freedom from technical canons and its directness and grasp of certain fundamental rhythms offers important clues to the understanding of art in its most elementary and hence vital forms. Oriental art, emancipating itself from the camera mind and

concentrated towards the inner reality and its universals rather than the external reality, has also extended both the range and depth of appreciation of art, concerned as it is with eternal and universal meanings and values, experiences of a realm beyond visible nature's. Like Gothic art in medieval Europe, Buddhist and Brahmanical art in Asia became the torch-bearer of social and spiritual universals for millions who at once created and were stimulated and inspired by that communal vision and expression. This give-and-take between the artist and the spectator is also the characteristic of all folk art thriving on a unity of the community spirit and pattern of living as well as on a profound *rapport* with nature. With the Renaissance the spirit of realism, a cold scepticism and a calculated individualism waxed stronger and stronger in Europe. The influence of the individualistic spirit on culture and social development in the West has been treated from many angles. But the relations of individualism to art forms, the appearance of the perspective, portrait painting, romanticism, impressionism and expressionism have not been adequately dealt with. Marxian writers have no doubt stressed the relations between art styles and manners and economic factors and forces. They are quite sound in their analysis of the causes of decadence of modern art that they ascribe to the peculiar economic structure, property system and motives of industrial civilisation that treats art as a form of "conspicuous waste" or as a diversion of the idle hour. But economism, the aggrandisement of the machine, and the regimentation of human values and experience are clearly the greatest enemies of art that are or will be encountered in the socialistic communities.

Man's progress in his mastery of the realm of nature by the methods of science has now out-paced his progress in his social and human relations. Since the dominating spirit of art is represented by the sense of relationship between man and man, both the present scientific method and the effects of the application of science and machine to industry in the direction of fractionalisation of human behaviour and the stress of impersonal, contractual and pecuniary relations have proved inimical to art. So long as industry and commerce and the deliberate contractual relationships that flow from these retain their present importance in the social order, or the scope of standardised production by mechanical means is not curtailed, or, again, the common man thwarted in constructive impulses in the general productive operations, art cannot be integrated with the concrete elements of social life and experience. The causes of the decline of art lie deeply rooted in the deterioration of an over-elaborate mechanical culture and personal disorganization, each being conditioned by the other. Art cannot live without the support of an artistic environment.

A comprehensive treatment of the sociology of art must do justice to the factors of fulfilment and frustration of the personality and to the regional and economic circumstances and social ideologies, sentiments and values—the totality

of cultural behaviour that determine the styles and subject-matter of art. The sociology of art must enter into more intimate relations with the psychology of the unconscious and *gestalt* than with the orthodox atomistic psychology. At each stage of analysis, the thoroughly unified social character of the experience would need emphasis. The interaction between the creative artist and the society or the "spirit" of the age is reciprocal. The mode and pattern of art expression depend as much upon the social organisation, the distribution of wealth and leisure, the social distances between, and taste preferences of, the elites and the masses, as upon the religion and metaphysics of the "times". On the other hand, the genius of an individual artist may so use the materials placed in his hands by his milieu as to solve deep-rooted emotional problems of his society in a novel and completely satisfying manner or give an enduring interpretation of human life and social reality that acts as a solace to man in all times and places. The values that he seeks to embody in his art work transcend not only himself but his immediate environment; his faith that these are eternal values of mankind gives him the rare prerogative to control and recreate his time and circumstances. "The imagination is the great instrument of moral good, and poetry administers to the effect by acting upon the causes," says Shelley who calls poets "the founders of civil society". Imagination in poetry, painting, sculpture or music calls up images of fuller, finer and more perfect human life and relations than the reality. Without the artist's and the mystic's imagination man could not have reconciled himself to the rules of custom, law and morality, and the herd existence. For he irresistibly seeks a better universe that he places in opposition to law and ethics as given for him and realises it in art, placing it beyond ordinary right and wrong. Art teaches and administers not by rules of morality but by symbols—the imaginative transfigurations of human relations, values and experiences. As it rises above moral or social aims belonging to particular times and places through its soaring vision of possibilities of human loyalty, relations and values, it is "more moral than moralities". On the other hand, custom, law and morality can regulate human life and conduct because of the intervention of art that introduces into their working symbols and meanings reaching society beyond existential relations and values. The individual creates beauty and freedom in life and society, fashioning through art, myth and phantasy, a free and perfect world over and above the self-contained world of law and morality. Art history is the record of the constant struggle, with alternating victory and defeat, between the order of values that society cherishes and the order or torment in the heart of the individual, the poet, the mystic and the artist. Thus does every society, every culture approximate through its art to a balance and a unity, however shifting. The sociology of art should accordingly avoid the one-sided interpretations of geographical, economic and cultural determinism and the mystery of the "great

man's" unique artistic creation, but consider the give-and-take between art and its epoch, region, race or ideology, revealing the higher levels of interrelationships and reciprocal adjustments of culture, society and personality.

The austere the religion, the inflexible the code of morality, and the galling the social stratification of an age or race, art, appropriately for the people or epoch, reveals unequivocally the beauty of women, the injustice of the laws, the apathy of the gods or the delight of the senses, deriving its inspiration from the larger laws of life and humanity. Because of the inflexibility of the law of Karma in moral life, and fatalism in spiritual life in the Orient, art lifts the individual to the universal through the vision of the One in the Many, not merely in the compassionate images of Buddha, Bodhisattva and Siva, but also in the technique of assembling myriad animals, men and gods in a palpitating plastic unity in both painting and sculpture Idolatry disappears in the Oriental temples with their vast assemblage of gods and goddesses or with the representation of empty space as the symbol of worship in the *sanctus sanctorum* or with the fashioning of a vast mountain into the image of the god himself. Similarly in the West the denial of the super-sensible in the scheme of knowledge, in religion and in the affairs of men logically culminates in the Mariolatry and praise of Christian piety in the Gothic cathedrals of medieval Europe and the development of abstract and non-figurative art completely liberated from naturalistic requirements in modern Europe. In the art of India where the lives of individuals are regimented and confined in the steel frame of castes, it is painting, which is *par excellence* the mode of artistic expression and record of the fluctuating human emotions and sentiments, that invades and overpowers sculpture and architecture. On the other hand, in the West where individualism is deeply rooted in ethics, religion and social life, it is sculpture and architecture, that can best record and celebrate man's permanent and universal attitudes and values, which exhibit today the greatest vitality and inspiration and ignore painting. All through civilisation the dominant art form seeks to preserve the instinct's free play, society's growth and man's humanity. As a matter of fact, it is natural that the larger the contradictions of life and the greater the mental distress and moral suffering of man, the greater are the heights that art reaches in man's history. Art, nourished thus by the ferment, the conflict and the pain in the heart of the individual, arouses new sensibilities and concords and plays the enduring role of guiding peoples and civilisations to what is most universal and most human in the drama of life. At the height of its mystical exaltation art demands from life and society nothing more and nothing less than the true symbols of life and society that illuminate, transfigure and merge these into Reality, into Truth, Beauty and Goodness. It is the exclusive prerogative of art to create symbols, that bring about the identity between the sensible and the

supersensible, that neither the doctrines of philosophy nor the dogmas of religion, nor again the codes of morality can do.

Great epochs of art are associated at once with the individual reaching some of the highest summits of his faith and being, and the society reaching some of its most perfect, collective visions. Egyptian architecture and sculpture, scooped out of a thousand granite and diorite rocks whose mathematical lights and shadows, planes and volumes, proclaim immortality in the midst of the recurrent floods and the shifting and yet enduring sand-dunes of the Nile; Indian classical sculpture, painting and music, that give a sense of the unity and communion of life that spread from form to form in an all-encompassing and palpitating, yet poised movement; Greek architecture, sculpture and vase-making, that praise the beauty of the sensible world and the harmony of the senses and intelligence that joyously feed on it; Chinese landscape painting, that catches the infinite in a tiny twig, a little bird or a shimmering mist-covered lake or mountain; Indian medieval Rajput painting and musical mode, that aid each other in incorporating all the intoxication of a people in tropical spring and their poignant longing for the beloved in dripping monsoon rains; Western portraiture, that in the inscrutable smile of a Mona Lisa or the introspective glance of Rembrandt's self-portrait dives straight into the unfathomable depths of the human personality;—all these represent both art and society offering to humanity in some favoured and moving epochs sudden exalted visions of the universal conditions of existence. In an age where the structure of social and moral life becomes disjointed, loose and incoherent, art, however, can neither find order out of the chaos of values and disintegration of social bonds, nor possess nor reveal the universal. The mechanical theory of nature, vulgarised by science, the fractionalisation of human behaviour and relations, imposed by industry, and the social disorder and confusion and impoverishment of life of the modern epoch, are reflected in the hesitancy and subjectivism of artists and the Babel of art styles, all claiming to be modern. The isolation and eccentricity of art, indeed, reveal the profound failure of modern society to orient into a well-ordered imaginative union man's traditions and essential values of life with the insights of science and the social consequences of the mechanical-industrial system. An artistic renewal or renaissance is as imperative for post-war world reconstruction as it would be an expression of the reordering of values, of the relations between the social classes, and perhaps of the machine system and technology that have been some of the chief enemies of art and creative activity in this age.

The essence of the sociological method is to envisage every phase of cultural history, including art development, as a continuous process with its ups and downs, the seed of artistic renaissance taking roots and growing in the inhospitable soil of decadence of a previous age, and its entire ideological configuration. Thus in the midst of chaos, distraction and tyranny, modern sculpture in the

West with a deeper human faith and sensibility and finer intuition of the forms and significance of the objective world, is already obscurely and spasmodically preparing to build up the new order. The sociology of art, accordingly, forms, like its cognate branch of enquiry, the sociology of knowledge, a significant division of sociology that is helpful in understanding those creative levels and forms of personality adaptation and socio-cultural behaviour that affect masses of men in their generations overstepping the limits of time and space. In dealing with the elusive realities of the world of art that constitute the driving force and intensity of a society or culture it reveals the latter's inner motivations and goals more clearly and directly than religion or philosophy does. The defeats and frustrations of culture and the individual's reaction to them that take the form of either personal disorganisation and delusion or a challenge on behalf of the ultimate values placed by the individual above the culture and the circumstances of the "times", can be shown better by the sociology of art than by philosophy or ethics.

The history of art, indeed, reveals a striking similarity of art forms among different peoples associated with the fulfilment or bafflement of life-goals, with the proper orientation of values or their confusion. On the other hand, misfits and failures in the realm of art, characteristic of an era of cultural crisis and perversion of values, affect the continuity of society and culture even as great art achievements make for the permanence of certain cultures as well as the immortality of individual minds and attitudes. Humanity remains narrow-minded and uncivilised if the symbols and rhythms, values and life-goals revealed in art works by different and distant peoples and ages do not enter into its experience. The continuity of world civilisation can be assured only through a wide and full participation by different peoples in the rich legacy of generic human symbols, rhythms and values expressed in their forms of architecture, sculpture, painting and music.

Man, the creature of the force of gravitation, with his body kept constantly in symmetry and equilibrium by effort, and with his mind attaining equilibrium by constantly sending out its tentacles beyond his physical boundaries of time and space, everywhere understands and takes delight in absolute rhythms, proportions, harmonies and values. Both art and mathematics express these in the idiom of mathematical symbols that represent the common language of all peoples and ages. There is a close relation between art and mathematics, both the universal tongue of mankind, and gravitation that regulates all motion and equilibrium in space. Gravitation indirectly controls the circulation of blood within the human body and the rhythm of its heart-beats, postures, steps and movements, just as it directly controls the ebb and flow of the tides, the phases of the moon, and the procession of day and night and seasons in the environing universe. It is thus the source of man's sense of rhythm and poise which he

comes to measure whether in his arts—architecture, sculpture, painting, music and dance—or in the order of phenomena of the universe in geometrical patterns without which neither his intellect nor his heart can find security or fulfilment. There is geometry in the human body and in nature before the arts are created, supplying the basis of canons of art. Mathematics that records most abstractly the most comprehensive rhythms and proportions is the outcome of man's reasoning. But mathematical proportions and values expressed in the arts profoundly satisfy both his reason and emotions. For he suffers an impoverishment of life within the bounds of time and space, and searches for the infinite and absolute in the fine arts that reveal these through universal and perfect geometrical measures, proportions and values. Man's reshaping of the relatively intractable but enduring materials of nature and his natural subservience to the all-pervasive immutable forces of gravitation and cohesion are themselves opportunities in architecture not only to construct what is enduring for the defence, worship and habitation of the people, but also to express in geometry his permanent social values and experience, what different peoples hope, strive for and achieve. He records on a broad scale in his architectural styles in various regions, his contrasted modes of achieving harmony with the universe and with society, whether the Egyptian pyramid or the Hindu and Greek temple, the Roman colosseum or the Gothic Cathedral. These all define and illustrate in geometrical symbols generic, metaphysical and social principles and purposes that rationally enclose peoples of different cultures and ages.

As we proceed from architecture to sculpture and painting, the subjection of art and technique to the materials and forces of nature and the permanent utilitarian needs of man and society diminishes, and thus the universal and the infinite can be expressed now with even greater diversity in man's life and destiny, even in the eternal or fleeting desires and feelings of the human heart. Egyptian, Hindu, Chinese and medieval French sculpture and relief sometimes express abstract, eternal and universal principles that govern the vicissitudes of man and society, sometimes share with painting itself the revelation of the fugitive moods and feelings of man, yet in a strict and ordered setting so that what is vague and transient becomes defined and enduring. Egyptian sculpture is characterised by its sombreness, majesty and monumentality recorded by its sharp rhythmical contrasts of shapes, volumes and planes. But the remoteness and imperiousness of the Egyptian statues that are grand achievements make communion impossible. These are products of Egyptian imperialism, theocracy and metaphysics. The Oriental and the European Gothic tradition dominated by the metaphysical convictions of the immanence of the deity and religious illumination of life has, on the other hand, made sculpture rich and engaging and at the same time abstract and reposeful. Indian, Javanese and Cambodian sculpture combine profound serenity and majesty of religious imaging with

3

warmly human, vibrant modelling, carried sometimes to a gorgeous, frenzied enrichment but confined consummately within the rigours of abstract harmony. As in India, so in Java and Cambodia, the single heavily massive and squared figures of Buddha, Bodhisattva, Vishnu and Siva spread harmony and tranquility all round, and the effect is often reinforced by the ecstasic multiplication of the images that are carved in relief on walls, niches and pillars of the caves and temples. And yet, for each image large or small, serenity, understanding and benignity enter into each separate gesture, attitude and expression of face by a most melodious and graceful modelling. Hardly in any sculpture outside India and Indonesia there is such complete harmony between pure plastic experience and human purpose discernible in the revelation equally of the silence and alone- ness of the soul, its supramundane wrath and grim struggle against the forces of evil as well as its shining all-pervasive tenderness as of the raptures of the body in voluptuous dancing temptresses and soft-limbed pious maidens. The mundane drama of human lives, joys and sorrows and the supramundane drama of the trials and flights of the human soul equally find expression here in a mystic- human art at its highest. Chinese sculpture could fashion the brooding gentle Buddhas of the Indian cave temples but freed itself from the luxurious elegance and rich decorativeness of the Indian tradition that in the tropical jungles of Champa became more mellifluent and elaborate and even assumed a flamboyant character, without, however, encroaching upon the dignity and austerity of Buddha and Siva in their sacred niches and chambers. In both China and Cam- bodia the strong Indian metaphysical tradition of the impersonal and negative aspects of Reality could not overpower emotional fervour, and we have gentle, all-comprehending, smiling, yet other-worldly Buddhas and Bodhisattvas, no- where to be met within their cradle lands in India. Something of this humanness and reasonableness is captured in religious sculpture in the Gothic Cathedrals of France where, however, unlike the Orient, the dignity and elevated expression of serenity have been sacrificed to a tender lyricism and dreamy elegance. All this is in marked contrast with the naturalism, the anatomical accuracy of delineation or physical loveliness and the appeal to the sentimental in Greek sculpture of the Periclean age, that has so far monopolised the admiration and exaltation of the world. Indeed, both in architecture and sculpture we find the divergent forms and styles embodying most vitally the entire social feelings, aspirations and notions of an age or people.

Painting is *par excellence* the medium of expression of unique moods and sentiments, frustrations and fulfilments of the individual. And yet it is the spirit of a people and an environment that determines the dominant trend in painting, whether it becomes saturated with the sense and geometrical pattern of architec- ture or of sculpture or of music. At Ajanta and Ellora in India, in the cave- shrines of China, in Byzantium or in pre-Renaissance Italy, painting is almost

entirely held in the grips of architecture. Painting has sometimes a sculptural, sometimes a symphonic aspect, approximating in turn to architectonic and musical rhythm for revealing the structure of natural objects and forms through the organisation of planes and volumes, as in the works of Michael Angelo, Tintoretto, Rubens and Cezanne, or the structure of the soul through blendings, half-tints and passages of lights and shades and colours as in Chinese and Japanese pictures. This blending of the perception and methods of a sister art is not true of painting alone. Even architecture leaves aside its natural juxtaposition of lines, volumes and proportions, whose abstraction, exactness and invincibility symbolise certain enduring social principles and beliefs cementing and disciplining vast multitudes. It sometimes assumes the character of a melody and harmony whose elusiveness it catches in the soaring flight of minarets and spires and the animated ensemble of vaults in the Mussalman mosques and Gothic Cathedrals or in the agitated crowded facades of the Indian, Javanese and Cambodian temples and Gopurams. Thus do the different arts oscillate between their respective and appropriate fields and functions; no art can be said to be autonomous and exclusive in its own sphere. Sculpture working on stone, that is more intractable than wood and less than the original rock, proves a most flexible medium for the record of the entire gamut of notions and attitudes that stand between immutable realities and transient passions. It is akin to painting in its illustrative virtues and yet unlike painting is not picture or story. It is akin to architecture in its massiveness and monumentality and yet unlike architecture achieves the enduring in the individual and the unique, and not in the collective and the general form, feeling and value. Sculpture utilises the full effects of the delineation of elementary organic forms and values, elemental social conceptions, myths and beliefs and the multiform feelings and desires of the individual, blending in one mode of expression the functions of architecture, painting, music and dance. Painting has its source of inspiration in the senses, desires and feelings of the individual, but its resources are equally if not more variegated than those of sculpture. Drawing enables the painter to reach the skeleton of organic forms for the expression of eternal realities and rhythms and thus emulate the methods of architecture and sculpture. Colour enables him not only to present the qualitative aspects of nature and of the human scene as a spectacle but also to suggest like the notes of music the overtones of existence, of the beyond-natural and the beyond-human. The highest expressions of this art enable the human mind at once to delve deep into the strata of the landscape, the structure of vegetation and living body and the matrix of matter and life, and to reach out through the chromatic waves into the ineffable mysteries and tensions of the cosmic heart where music loves to dwell. With regard to the structure, contours and rhythms of the solid reality of the earth the approach of painting is less direct than that of architecture and sculpture, but nevertheless

profound in its suggestiveness. But with regard to the revelation of the infinite
heart of Nature and Man through its multiple and complex relations of tones,
forms and contours, its approach is more direct than that of music.

In two ways the noblest painting becomes symphonic, and melodious, and
awakens in the human soul the soft murmurs and echoes, throbs and crises of the
cosmic. The trend of Chinese and Japanese and, in some measure, of medieval
Indian Rajput painting has been to place the agitated human individual within
a vast panorama of nature in which the ripples of a mist-covered river, the utter
desolation of a snow-covered meadow, the transclucence of early dawn and the
cruel monotony of a rainy night completely silence the stirrings of his heart.
The trend of classical Indian painting as represented by the frescoes at Ajanta,
Ellora, Bagh and Sigiriya, has been to relate the passions and desires, joys and
sorrows of the individual to a scheme of cosmic existence whence joy and serenity
spread, like the vast concentric ensemble of waves of colour in the ancient paint-
ings, to all forms and appearances of life. Alike in the works of Michael Angelo,
Tintoretto, Rembrandt and Van Gogh we find also man's small and transient
desires and feelings finding their true worth in the infinite passion, agitation and
movement of God in Heaven, of the Man of Sorrows or of Humanity in the
modern context. In each case the musical sense of painting which is essentially
an art for the record of individual moods and sentiments catches the individual
in its soaring wings and lifts him up to the inexpressible, the cosmic and the
beyond. Symphonic painting alone can really create the super-individual that
no other art can for the reason that the linkages to the universal that are tangi-
ble, yet invisible for music which is the most abstract of the arts, obtain defini-
tion and precision in painting.

One art thus interpenetrates with other arts, thereby making the super-
sensible and the universal more accessible to the human soul. The victory of a
particular medium of expression lies in the indeterminate point where the
material, art and theme are in complete accord for the expression of those abs-
tract, mathematical proportions and concrete human values in which the
agitated heart of the artist, whether architect, sculptor, painter or musician, and
the conscience of his particular people or age find perfect order and coherence.
It is only a rare genius dwelling in the mysterious centre of the cosmos and the
throbbing heart of humanity that can fix precisely that meeting point, extending
the field of understanding and expression of one art by approximating to the
perception methods and symbols of the other arts.

On the whole, the glory of architecture and in less measure of sculpture
largely rests on collective traditions, (those of the craft, caste, guild or brother-
hood) as these arts pre-eminently record and celebrate the social myths, beliefs
and needs of the people or age. The more rigorous and inflexible the framework
of society and collective living under the logic of metaphysical or social fictions,

myths and customs or regimentation under despotism, priestcraft or rigid caste system, the more do these social characteristics impose themselves upon the monumentality and immobility of both architecture and sculpture. The development of individual consciousness, subjectivism, romanticism, idealism and mysticism, is translated directly into the subordination of architecture and sculpture to the pictorial, the decorative and the melodious sense. Thus does the change of accent of society from order and continuity to freedom and progress usher in the region of painting and music, and introduce sinuous, sensitive and suggestive modelling and melodious play of light over form, of flat tone over space, into architecture and sculpture. The mystical attitude, that is the core of the personality consciousness, effects the transition from architecture to music and dance. The glory of painting and music pre-eminently rests on the genius of individuals as these arts reveal the complex and subtle nuances of the individual mood and the mystical sentiment set against the background of collective metaphysics, dogma and value. As we proceed from architecture through sculpture to painting, music and dance, the individual releases himself at once from social myths and values and art styles and traditions of his environment to dive deep into the inexpressible mysteries o his own soul for the creation of new universal rhythms and patterns that have an appeal to humanity much beyond their social context.

The individual lives eternally in art; while the spirit and conscience, the serenity and tempo of a whole people or epoch his art expresses and consolidates are much more subtle and pervasive agencies of control, and more significant and permanent aids to collective living and achievement than such other social products as industry, law or government with which modern social sciences are now preoccupied. Art is thus not only the enduring glory of the individual, and the imperishable record of culture, but it is also its principal impulsion. Art inspires, exhorts and educates. Law, custom and economic power can rule society only so far as man's imagination and artistic consciousness import into them human meanings, aspirations and values. Without the aid of art these remain formal, inefficacious means of physical coercion. Art is the great binder, the ubiquitous seal of community life and action. Art easily and effectively adapts the human mind to its social milieu, and is therefore one of the conditions of social progress. Many cultures have become extinct because these could not evolve a great art; others survive through the ages largely because they nurture a great living art. The social and biological value of art rests on the symbols or ideal transfigurations of human relations, the social view of man's life and destiny that art gives. Art makes human life freer, richer and more strenuous through its promise of transformation of both society and the self. All what humanity dreams, strives and suffers for stands behind art, giving man peace, peace with self, with the society and with the universe. Society is what it is, not because of

law, morals and tradition that cannot heal nor console, nor because of religion that cannot inspire nor invigorate, but because of art. Art reveals not only the perfectibility of man, but also the enduring essence of society that transcends the barriers of class, race or epoch. Art speaks in a tongue that over-reaches and silences the discordant notes of economics and politics. It is the authentic language of human community and continuity that refuses to accept any barriers of complete communication between man and man, between culture and culture, over-riding distances of space and time.

Other cultural acquisitions outlive their usefulness and power, and die or block man's progress. Art alone is eternal and indestructible amidst the chronic tumult of history. It alone ever renews itself in the aching and agitated heart of man through the centuries, and quietly, steadfastly and confidently directs his social and spiritual destiny, irrespective of the changing vicissitudes of economics and politics. Art is an inexhaustible, ever expansive treasury of beauty, strength and joy for mankind as it is the ultimate measure of the quality of its progress.

Contents

CHAPTER I

ART AND CIVILISATION

The Power of Art

Art is at once a social product and an established means of social control. Art forms are largely socially conditioned and determined, while these are the most effective modes of regulation of the lives of individuals and societies. Both the present psychological and psycho-analytic approaches to art have, however, hardly done justice to the social factors that enter into the unconscious mechanism of artistic creation or into phantasy-making and the formulation of archetypes in art that represent significant personality builders and social binders in all epochs and cultures. A comparative study of types and archetypes in myth, religion and art is of invaluable importance in understanding the psychological roots and processes of reconciliation and synthesis of the unconscious urges and instincts and the social impulses and pressures that underlie all artistic activity or enjoyment. Thus the social psychology of art, bringing to light the various dynamisms such as myth-making, sublimation and symbolisation that bring about the fusion of the unconscious and the conscious in art, helps us in understanding man's emotional misfits and adjustments in a given social and economic milieu or those generic art forms that represent mankind's expressions of, as well as escapes and compensations for, living in society. Such universal expressions of types and symbols are reached in art through an effective social disguise that relieves man's heart-ache without letting him know what the ache is, and through a profound detachment that invests them with a clarity and lucidity that the mind's screen of meanings, labels and stereotypes ordinarily hides from itself. It is these which explain the enduring attraction and power of the world's great art forms that feed and stimulate both the minds and hearts of vast masses of men through the centuries.

But art forms and experiences cannot be judged in their true import without entering into the domain of the mystical life which gives the real clue to the essence of beauty and all significant art forms. Metaphysics, religion and art have all equally found their goals in a reconciliation of certain primary opposites in a higher and a more comprehensive unity and order. Art comprehends and expresses the recurrent alteration of the opposite principles of Being and Becoming, of silence and activity in metaphysics and religion as rhythm or harmony that is the essence of the sense of beauty. The profound *rapport* of the artist with the object of construction simulates the activity of the soul or Being in finding its absolute rest and joy in identification with the manifested world

or Becoming. It is this which brings forth the inner harmonies and rhythms of the fine arts—the cadences of words, the patterns of colour and the significant forms of painting and sculpture that give us delight, though we cannot explain it. This aspect of analysis would bring art study in closer intimacy with the thought-forms and structures and the formless, inexhaustible stirrings of a country or an epoch.

The Universal Appeal of Art

The treatment of art motifs and forms in their social back-ground and from the angle of sociology is even more significant and imperative. Great art expresses the universal social symbols and archetypes that have been connected with the summits of intellectual and emotional experience of various peoples in the history of civilisation. Art is a mode of apprehension and communication. It speaks in 'the tongue of men and of angels', the vernacular of images, symbols and fantasies, revealing the soul of a culture and social milieu in a more significant manner than what religion, science and philosophy can do. For it is his impassioned appreciation that enables the artist more than the seer or the saint to penetrate into the true nature of his object of adoration, and give it finality and permanence. How rarely, however, does the history of civilisation, not excluding even Wells' synoptic *Outline of History* and Toynbee's *Study of History*, comprise a survey of the art forms and ideals of the human race! It is the materialistic outlook of earlier sociology under the inspiration of Herbert Spencer that is largely responsible for the neglect of the significance of the arts in the history of social development. Modern sociology should now vindicate the importance of the fertile field,—the study of art forms as the unchecked efflorescence and clarified utterance of culture, as its principle measure, directive force as well as means of control.

The contours of culture in different epochs and races and the march of human civilisation cannot, indeed, be understood without reference to the meaning of the principal archetypal images and symbols such as Osiris and Isis, Siva and Sakti, Asura and Titan, Buddha and Christ, the Virgin and the hermaphrodite, Madonna and Venus, Angel and Man-animal, Dragon and Garuda, or, again, the Swastika and the Cross and all the rest that myth and religion have cherished and art has constructed and beautified among different peoples through the centuries. Since the dissociation of art from religion and the rise of naturalism and intellectualism in the 15th and 16th centuries, Europe has largely lost the community feeling and the unity of the human spirit with the visible world that modern science and metaphysics have not succeeded in recovering for her. She has since largely disregarded the archetypes and symbols that in the Orient are at once metaphysical, ethical and artistic, feeding both the imagination of the common people and intellect of the elect. A lapse of the cultural legacy of effective symbols and archetypal images to which the larger

community values easily attached themselves, an exaggerated subjectivism and distinction between popular and aristocratic art have gone together in Europe, leading art to sterile paths. Modern Expressionism in the West had its many precursors in the East, and it is necessary for the progress of art to compare and contrast their respective art motifs and methods. It is thus that we can delve into the techniques, conventions and forms by which different peoples seek to express universal and eternal values in art, and evolve a new plastic pan-human language for the translation of universal, abstract and rhythmical values or order and unity in keeping with the needs of the present generation.

Men are basically similar in all regions and races in their bodily construction and instinctive equipment, in their emotional weaknesses and intellectual conflicts. They have the primarily similar emotional problems of youth and love, activity and renunciation, frustration and enjoyment, sin and purity, triumph and death. In spite of the differences of idiom and syntax the tongue of true art has ultimately similar implications and meanings for human life and destiny everywhere. And, in fact, man cannot be true to his common human heritage if Buddha and Siva, Sakti and Angel, Pieta and Resurrection, Virgin and Saint, Venus ond Cupid remain the unshareable possessions of particular peoples. On the other hand, the universality of appeal and the perfection of beauty of such images and symbols depend upon the extent to which these are, not allegorical, nor have meanings only in a social context that require an intellectual explanation. All masterpieces of art are pregnant with a direct and immediate signification that is always there, eternal and universal.

No one in the modern age needs to be a Buddhist, a Hindu or a pessimist in his outlook on life to recognise the beauty of the icons of Buddha and Siva, embodying a profound stillness of the human spirit that has conquered all struggles and passions. No one needs to be a Pagan to enjoy the beauty of the statues of Venus and Aphrodite, Apollo and Hermes, envisioning in marble the ideal of balance, and of the joyousness of the life of the senses. For a Buddhist, a Hindu or a Greek the images, of course, meant much more than to moderns, but the essential beauty of the particular sensuous forms remains. That rests, in the first place, on the profound, eternally valuable moods and attitudes of human life and culture that these images embody, and, secondly, on the abstract formal rhythms and symmetries, the play of light and shadow, relief and solidity, that bring to an emotional focus those moods and attitudes to be appreciated intensely and vividly by all human beings irrespective of their social predilections and individual idiosyncracies.

Art as the Expression of Fear and Power

It is necessary at this stage to indicate briefly the relation between art and religion. In the primitive community art and religion combine their resources

in guiding man's easy and effective adaptation mainly to the hostile forces of his animate or inanimate environment. Art, like primitive man's ritual and observance, expresses his desire for power, ascendency over nature and constant fear and anxiety that dominate the psychological situation. Before he goes to war, hunting expedition or ceremonial dance, primitive man decorates himself with various kinds of necklaces, belts and other ornaments artistically fabricated out of skin, tusk and bone that impressively protect him from evil, or contribute towards an easy capture of the dreaded animals by casting a spell on them; while the imitation of animal voices and movements and the mask and costume used in religious rites engender *rapport* with the totem animal or god of which it is a vivid representation. The belief that man gains power over a person or an object by his power over its representation is the major inspiration of the primitive artist or artist-magician. Among primitive peoples artistic adventures gain much from magic that sets its seal of social approval upon the images of various spirits, ancestors and gods that are much more 'real' than any conceived by civilised man. For the masks, fetishes and idols give deep satisfaction to the primitive man's powerful instincts of self-assertion and fear as to his impulses of construction and embody community emotions and attitudes with more than usual intensity and order. Neither masks, fetishes and idols nor rites and ceremonies are merely religious or magical. These form integral imaginative products in which certain norms of communal action or social values are revealed in the most impressive manner for the primitive peoples. Thus these become effective binders of tribes and folks, concrete symbols of tribal union as well as safety valves of the savage individual's dominant impulses of fear and power that are worked off and achieve poise by being canalised into legitimate, practical social channels prepared in advance. Such fetishes and idols in primitive sculpture are very much alive in the sense that they participate in the life of the community, are spoken to, have food set before them, and are consulted for advice. "In the Marquesas, as in some other parts of Polynesia, a song of creation is sung which introduces the 'newly created image' into all that already exists. The same is true of the mask of the Congo Negroes which are ritually born into the tribal life."[1] No wonder that ancestors, demons and gods share in the dominant passions of the primitive peoples, especially those emotions that arise or are invoked on critical occasions in their lives. "The religious statues of the Melanesians and the idols of the West African Negroes," observes Hirn, "undoubtedly owe something of their wild and fantastic likeness to an attempt to awaken as intense an impression as possible of the divine powers which·they are intended to represent." Images of primitive art are living spirits, vehicles of intense and concentrated power and action, that alone can establish a *rapport* with the emotional savage masses.

1 Warner : *Comparative Psychology of Mental Development*, p. 410.

Evolution of Primitive Art

In a higher stage of evolution as among the Peublo Indians, formal·conventions and patterns come to restrain the vigour and vehemence of the representation of images. In certain primitive figures of ghosts and gods of wood and stone abstract and cubistic forms are met with, that are truly remarkable. Relying on the geometrical effect of light and shade and simplification of features, these show great force and concentration of emotions that are not in the raw but are intellectualised and organised. Savage art is on the whole expressionistic, and rich with formal values that cannot be achieved without a certain degree of intellectual maturity and detachment. At the same time it expresses only a limited range of human emotions and attitudes, especially fear, sex and assertion, that are also discernible in the formulæ and gestures of worship and ritual. It is not without significance that the occasions of birth, death, initiation, sacrifice or war, which move the savage's whole emotional being most profoundly, are celebrated rituals or dramatised enactments, regulating his affective life and laying down norms of behaviour through an impressive array of idols, masks, decorations, totemic carvings or paintings and mimetic activities. Particularly widespread in the savage world are the initiation ceremonies, that are artistic dramatic performances of the maturation of sex and normal sex conduct made impressive by song and dance. Similarly mortuary observances are universal, intended through ritualised lamentation and song, through decoration of the corpse and dramatised performance to work out the grief and bewilderment of the kinship group at times of death.[1] It is also noteworthy that the animation and power of idols and fetishes and the exuberance of songs, dramatised dances and magical observances are greater, the more compelling the instincts and interests and the deeper the fears, apprehensions and perplexities of the savage. Due to the vehemence of the desires and emotions of the primitive peoples, whose fears and desires are reflected in the various magical entities and dynamic powers that constitute their conception of reality, their songs, rituals and dances interpolate with the tribal routine of life, abolishing the barriers between everyday existence and the reality. The hunting dance among the Veddas of Ceylon carried on in the natural arena in the forest dramatises and merges into the ordinary hunting operations, mingled with fear and suspense but with the assurance derived from the protection of the Yaka spirit and recapitulation of the successful performance. "It is characteristic of the primitive peoples," observes Roth, "that there is no æsthetic sphere *per se*, that art is closely united with the social, political and religious life of the tribe." This is the chief reason why tribal song, ritual dance and sculpture show the excesses and conflicts of the savages interpolating as they do with everyday reality. On the other hand, where savage life is tranquil and well-ordered as among the Pueblos of New

1 Malinowski: Magic, Science and Religion, in Needham: *Science, Religion and Reality.*

6 THE SOCIAL FUNCTION OF ART

Mexico, art is also sedate and composed fitting harmoniously with their pattern of culture. Ruth Benedict has described that among the Zuni group of New Mexico the Dinoysian element is systematically eschewed.[1] An individualistic disruptive experience of the artist-magician common among most savage communities is discounted. In fact it is enjoined to avoid vision as an extraordinary experience through fasting, torture or drugs. Drinking of peyot is also forbidden. "The dance of the Zunis, like their ritual poetry, is a monotonous compulsion of natural forces by reiteration. The tireless pounding of their feet draws together the mist in the sky and heaps it into the piled rain clouds. It forces out the rain upon the earth. The Zunis are bent not at all upon an ecstatic experience but upon so thorough-going an identification with nature that the forces of nature will swing to their purposes. There is nothing wild among those dances." Like the dances of other North American Indians these do not culminate in wild movement, cataleptic seizure or frenzy. Thus every primitive tribe has the art it deserves, moulded by its mental attitudes, dispositions and emotions.

With social development the savage's emotional attitude towards the universe is profoundly transformed. No longer is his imaginative world inhabited solely by hostile influences, dangerous powers and bewildering spirits that confusedly mingle together. Art, like religion, discovers protective birds and animals, guardian spirits and totems; an entire complex of mimetic dances and cries, rituals and ceremonies comes to express and regulate unconscious desires and attitudes. As emotional tensions are overcome or the natural vent of impulses comes under regulation, the expression of sex in phallic images and of power and assertion in idols of ghosts and spirits, in masks and totem poles, is shorn of its crudeness and violence. Gradually the idea of self develops in primitive society. The souls of the dead are believed to inhabit statues of ancestors, the modelling of which has reached high development in North-west America, Africa, Melanesia and New Guinea. Man's double or *mana*, the soul substance is also considered by many primitive peoples to infuse with power fetishes or figures of gods and demons. This metaphysical notion invests primitive sculpture with a supernatural import, as statues come to be regarded as the habitat of the *mana* with magical or supernatural results. Similarly totemism that establishes the primitive man's emotional *rapport* with animals whose qualities of strength, agility and cunning he fears and admires underlies the vigour of his animal statues, masks, paintings and tattooings, and the widespread and remarkable use of animal motifs throughout the savage world.

Primitive art is full of decorative, geometrical designs and patterns that cannot be understood without reference to symbolic meanings. Boas, indeed, considers that among many primitive tribes decorative art for its own sake hardly exists, the decorated object representing prayers and other ideas relating to the

[1] See *Patterns of Culture*, p. 72.

supernatural or war-like deeds. "Among primitive people," he observes, "the æsthetic motive is combined with the symbolic, while in modern life the æsthetic motive is either quite independent or associated with utilitarian ideas."[1] Though the decorative tendency is predominant in primitive art, it is by no means true, however, that realistic or imitative qualities are not shown. Like European palæolithic art, the art of the Bushmen of South Africa and the Eskimos of Siberia, for instance, has reached an astonishingly high level in the representation of naturalistic forms. As in primitive religion, so in primitive art the distinction that the mature mind makes between truth and imagery or symbol, between reality and myth or metaphor does not exist. A primitive idol, fetish or mask is not a symbol or image; it is the self-sufficient, intelligible reality, embedded in the whole complex of tribal life. It is deeply satisfying both in its sensuous beauty due to its formal qualities, and in its truth due to the adequate explanation it offers of observed phenomena of nature and human life through the unbroken transition from the realm of imagination to the realm of everyday reality.

Art as the Expression of Perfection, Human and Superhuman

It is the nature and content of the mental processes in immature or developed mind within its cultural envelope that determine both the style and function of art. The relation between self and not-self, the type of psychological association and the notion of the soul are far different in primitive culture from those in modern society; and this endows primitive art works with far different significance than what only their plastic qualities signify to us. As the distinction between the self and the environment is clarified, art begins to fashion forms after man's own image. Such images are still gods and ghosts, ancestors and totem animals but they become less wild and formidable and more friendly, law-abiding and beneficent. Ancestor worship and the hero cult facilitate the transition to representation of purely human forms, while the images of beast-headed divinities in Egyptian, Indian or Greek art may have their origins in totemism. As social development proceeds further man gains intellectual clarity and spiritual courage. Thus art becomes an expression of man's perfect dignity and glory, whether in Buddhist art in India or the Christian art of medieval Europe.

All through social evolution it is from magic, animism or religion that art derives its intensity of expression. But the attitudes and values that art expresses range from fear, anxiety and power in primitive art to dignity, serenity and perfection in Greek, Oriental and Christian Art. As art expresses and consolidates the sense of human perfection, it serves as a beacon light to culture. Religion may produce the gods and angels, but these can only satisfy and stimulate human nature and direct man's destiny as they are reproduced in

1 Boas: *The Mind of Primitive Man*, p. 243.

works of art. Thus the alliance between art and religion that we see emerging hand in hand in the dawn of civilisation is gradually consolidated on an idealistic or metaphysical plane.

At the same time the development of the mind also brings about a separation of the functions of art and religion. As the human mind matures, gods and spirits no longer enliven by their presence wars and chases, rituals and ceremonies. Man can dissociate his environment and routine of life from the objects and images of artistic construction and religious experience. Art also ceases to function as propitiation or worship.

Relations between Art, Magic and Ritual

Ritual among different peoples and civilisations represents different degrees of blending of art and myth, magic or religion, employing various gestures, motifs and symbols. Due to this blending and the social significance of the entire behaviour complex, it has been suggested by Durkheim that religion had its origin in ritual and by Jane Harrison that art arose from ritual. The truth is that in early stages of social evolution the patterns of behaviour are woven out of the subtly combined threads of magic, religion and art, and it is difficult to separate a particular strand from the total experience. In the ritual when the primitive community represents or dramatises the expected hunt or war expedition, the movement of their food or guardian animals or the resurrection of vegetation in spring, the elaboration or repetition of the actions, gestures or spoken words is in keeping with the strong emotions aroused on each occasion. The whole people participate in the dance or magical ritual by clapping, rhythmic swaying or acting as chorus. As a matter of fact, magical ritual embraces only those activities and interests that arouse intense emotions through their mysterious or perilous nature. The mass or community character of the ritual is also strikingly evinced by the fact that on such occasions of dealing with the mysterious and hazardous experiences, the routine of activities of the tribe is suspended and the entire community forgathers and participates. It is the rhythm which furnishes the orienting and organising principle of the tribe in earnest action and emotion; and this spreads from ritual dance, song and poetry to the decorations of earthen and wooden utensils and textiles, to representational sculptures and to the signs and symbols of individual and group worship and social intercourse. Such is the hold of rhythm in the interplay of man's intense emotions and performances; its meaning is entirely lost sight of, if it be regarded as a mere physiological reaction or mechanical expedient.

All people have their signs, emblems and symbols, designed for economy of action and expression of emotions and meanings, and these become saturated with emotions as these are ordered according to repetitive or alternating bodily movements and gestures closely connected with rhythmical, physiological

processes. It is the cumulative force of the rhythm that makes all gestures and movements effective in regulating the forces of nature according to human purposes. Just as dancing feet compel rainfall, rhythmical movements and gestures of the hands are powerful to bring supernatural forces in the aid of the devotee or worshipper. This can be best illustrated by the fact that a symbol understood as a graphic figuration, as it is most commonly, is the fixation of a ritual gesture or movement or series of movements that has to be made to trace it. The use of signs of recognition in the initiatory rights of the primitive peoples, the preparation of talismanic figures, the tracing of *yantra* in Hindu worship and the *mudras* or grips in Oriental worship and dance represent movements and attitudes forming what psychologists call "motor sets". There are not only visual but also auditory symbols. Rene Guenon has suggested that their respective predominance is characteristic of two kinds of rites which relate in the beginning to the traditions of sedentary peoples in the case of visual symbols, and to those of nomadic peoples in the case of auditory ones. Auditory symbols include the *mantra* as contrasted with the *yantra* in Hindu tradition, and it is significant that the *yantra* is effaced as soon as the rite is ended, indicating that the *yantra* is identical with the ritual gesture that is also made explicit by the repetition of the *mantra* in the actual construction of the *yantra* or the execution of the rite. It will thus appear that a rite is made up of a body of symbols comprising not only objects or figures but also the bodily movements and gestures effected and the appropriate words pronounced so that their meaning is derived from the entire series of movements oriented according to certain fundamental rhythms, and is not inherent in them. It is thus that the notion of gesture brings magic, religion and art into true unity and this has a deep significance in the metaphysical domain.[1] Rituals, symbols and gestures are means by which man enters into communication with the higher states of being, whether totem, ancestral spirit, *mana* or deity. For centuries the Tantric system of worship, that was adopted by different religions in India including Buddhism and Jainism, required the preparation of diagrams on a board or canvas with mystic formulæ and painted forms of the deities and their worship with offerings. Throughout the world the disregard of tradition has tended to sunder the rites from symbols which are, however, two aspects of a single reality. With the growth of the rationalistic spirit the motifs and symbols in the ritual come to be interpreted rationally as means of expression of new conceptions and attitudes. As the traditional ritual is thus explained away, sometimes only the element of art in the dance, play, music or dramatic enactment remains as the *raison d'etre* of the ritual. In Buddhism, Islam or Protestant forms of Christianity, the rational attitude has led to the disdain of ritual as a superstition and the expulsion of art

1 Rene Guenon: 'Rites and Symbols' in *Journal of the Indian Society of Oriental Art*, vol. IX, 1941.

from a large sector of life. More than 'religion', it is 'art' in the song, poetry, the socially valid myth or symbol and behaviour of the ritual that reveals clearly the basic attitudes of different cultures.

Relations between Religion and Art

In man's mature mind, just as food and worship, activities and rituals, images and realities no longer intermingle, artistic and religious apprehension also comes to be differentiated in its function in contemplation. Both thrive on contemplation, but æsthetic contemplation does not linger over truths as truths *per se* which religion cherishes. Art clothes truths in garbs of concrete imagery, attitude and feeling that all aid one another and form a unity of experience, vivid and intense. Myths, legends, fairy tales and historical narratives of primitive peoples that often combine fact and fiction, art and science, hold together clans and tribes and effect their easy adjustment to nature and the milieu. Religious myths, in particular, persist because of their integration of human emotions and attitudes with magical and supernatural beliefs. On the other hand, with the evolution of man's religion, art concerns itself with idols and paintings and with myths and legends dramatising the lives of gods and goddesses, and frees itself from magical motives and purposes. Art in an advanced stage of social development subserves the spiritual needs of the people through allying itself with idolatry, the construction of temples and family altars and the development of religious epic and drama. It is thus the history of art alines itself with man's intellectual progress. But even in mature civilisation though art aids religion through the composition of hymns and prayers, narratives and legends, through the sculptural representation of the deity in the form of the human hero or idealised man and woman, and through the development of temple architecture, ceremonial and festival, magic still reigns supreme in folk cults and rituals, mimetic plays or vegetation ceremonies that are however, not permitted within the temple premises but treated as outside the pale of orthodox observance. Art and religion develop together. Art fashions the deity cult in which gods represent not the mysterious forces and events of the world but the aspirations and travails of the human soul. Thus art, like religion, explores the entire meaning of life, the heights and depths of man's experience. It fashions appropriate symbols and makes these emotionally potent, through songs of praise and thanksgiving to the deity who protects him from the forces of evil and misfortune, often represented at Titans, and dramatises worship as the elaboration of the inner struggles of personality and of man's delicate nuances of approach to the deity. Even in the stage of mystical contemplation, which is largely dissociated from the context of myth and tradition as well as from the ritual of traditional worship, art still plays its rôle in revealing the Beyond and the Absolute through poetic imagery and allegory that deeply stir the religious emotions. In

the Orient worship is rendered in music and dance, mimetic offering and petition, festival and procession and in an elaborate set of liturgic gestures and movements, not to speak of the appeal of beautiful images and paintings of the deity, all of which intensify and consolidate the religious emotions and attitudes.

The concentration of art around the lives and performances of Buddha, Siva, and Krishna has in fact reached an extraordinary degree of complexity in India. In Indian households and temples worship largely consists in the participation of the dramatised and creative representation of the entire daily routine of the deity's life, including ritualised awakening in the morning, ablution, offering of food and preparation for sleep. Such artistic enactment elicits an entire gamut of religious emotions and attitudes and feeds the imagination of crowds of worshippers from morning till night. Emotional mysticism, in which religious truths are operative in union with a specific and visual form of the deity and associated attitude and feeling of the devotee, has this common feature to art, and hence it is closely allied to, and is the fount of artistic constructions. Thus the profound metaphysical concepts of the primary opposites, Being and Becoming, Purusha and Prakriti, Unity and Duality that religion feeds on in India are translated in the vernacular of Indian art in the images of the divine couples, Siva-Sakti, Lakshmi-Narayana or Radha-Krishna in which are found both a religious and an æsthetic quality. God's infinite grace and compassion, the power of divinity against sin and evil, or again, the majesty of Death that is yet overcome by the immortality of the human spirit similarly found expression in myriad images in Indian art. There was in fact hardly any intimation of the immortal and the universal that could not be translated into plastic form in Buddhist and Brahmanical art, since the conviction was strong that a person reveres in the image the subject that is represented there, and that the super-sensible world is the real world, crying for expression and utterance.

Classical Greece did not develop any sense of the supersensible in connection with religion, but brought down the gods into the affairs of the world, and shaped them in man's image. The sense of guilt and abasement, the humiliation and despair of the soul in the presence of the infinite, the hope and triumph in God's love and grace—all these which go to the making of the major religions of the world did not have any significance for the ancient Greek. Thus Greek art and religion could more easily blend with each other in their mundane interests, both dealing with sensuous forms and rituals in which were embodied the grand classical ideas of harmony and proportion in all activities and phenomena.

Christianity and Art

Christianity passed through various schisms and controversies in respect of the artistic representation and worship of images and idols. It is interesting to

note that the principle of image worship laid down by the Council of Nicæa is almost identical with the Hindu formulation of the need of images : "For by so much frequently as they are seen in artistic representation, by so much more readily are men lifted up to the memory of their prototypes and to a longing after them." "For giving aid to the worshipper, the Universal is given artistic representation in forms or images," runs the parallel Hindu statement. The Hindu art treatise, Vishnudharmottara, is more emphatic : "Worship and contemplation of the Supreme Being are possible for the human being, only when he is endowed with form, because human beings are limited and finite." In different parts of the Christian world, Syria, Northern Europe and Southern Europe, different religious sentiments, ethnic traditions and climatic factors determined the degrees of fusion between ritualistic and introspective worship in the Christian Church, and this in its turn governed the tendencies towards abstraction and conventionalisation or realistic and dramatic representations of Christ, the Virgin and the apostles and of the scenes of the Passion in the East and the West. What may be called Christian art covers about twenty centuries. The Christian metaphysical doctrine of the Trinity as represented by God the Father, God the Son and God the Holy Ghost found in the Christian world its artistic rendering in the holy images and paintings in churches, and in Catholic countries the elaborate church rituals and processions distinctly favoured æsthetic appeals and values.

In the 12th and 13th centuries there was such a flood of idealism in France and other European countries that it produced some of the world's most magnificent monuments of art. Gothic sculpture resembles Oriental sculpture, and it is worth remembering that the spirit of Gothic art was a type of emotional mysticism closely akin to that of the Orient. Mariolatry was the underlying inspiration of the Gothic period of European art, and as this spread the peoples of Europe found the same kinship between the deepest human and spiritual affections that is the mainspring of Oriental inspiration in religion and the fine arts. This was also the era of the rise of poesy and of the culmination of chivalry with its apotheosis of women in Europe. While the Gothic cathedrals reproduced in their lofty, delicate spires, strung together in graceful proportions, the soaring spiritual vision of the age, the icons of Christ and Madonna, angels and apostles in the interior showed a most remarkable combination of transcendental mystery and human sensitiveness hardly met with again in Christian Europe. Christ here is full of the milk of human pity and tenderness, and is not the omnipotent Saviour seated upon His glorious throne, while the Divine Mother also is always youthful and slender, radiant and smiling with love, and slightly bends as she holds the child in her left arm or on her left knee. Similarly, the angels and patron saints have always young, bright and beatific faces. For their counterpart one has to go to Bengal, Tibet or

perhaps to China where we have the more human types of Buddha and Bodhisattva with the same youthful, bright and yet inward-turned faces as those of the Gothic figures, the same gentle swaying of slender bodies (as in Yun Kang caves) accentuated by the sweeping and innumerable folds of the monk's robes that have a curious similarity with the soft plaits of the woollen fabrics of Europe, aiding towards Botticellian elusiveness and ethereality.

Another parallelism in the development of art and culture is worthy of mention. The cult of Mary and Jesus, and the reverence for women that characterised the spirit of medieval Europe found its expression not only in Gothic architecture and sculpture, but also in the noble poetry and song of minstrels and troubadours, uttering the deepest feelings of the people in the long-neglected mother-tongue. Three centuries later in Northern India the cult of the Divine Child Krishna and his mother Jasoda was similarly the focus of awakening of the national spirit manifest in the development of Rajput and Pahari schools of painting, and the rise of folk songs and hymns (dohas) in Hindi and Prakrit, such as those of Vidyapati, Mirabai and Surdas (15th Century) and of Hindi poetry with the composition of the *Prema Sagara* that reached the Krishna legends from the Sanskrit Bhagvata Purana to the common people. The abolition of the distinction between human and spiritual desires and sentiments was in each case both the momentum and measure of the spiritualisation of human interests and experiences, and linked art and vernacular literature indissolubly with religion. Like Gothic art, Rajput art expressed the collective vision of the people and distilled and communicated the moods and sentiments of a whole epoch that were then finding also an ardent utterance in epic poetry, songs and sonnets. In Europe within a few decades the widespread youthful, religious idealism of the 13th century degenerated into sentimentalism, and the tide of intellectualism and naturalism, waxing with the spirit of the Renaissance, was soon to extinguish the medieval religious spirit. With this the channels of art expression were completely changed. In India, Rajput and Pahari art embodied a profound and delicate assimilation of transcendental and human values, that was the essential legacy of ancient Indian culture. It was thus the last reaction or protest of the spirit of India, nurtured in the inaccessible deserts of Rajputana and mountain fastnesses of the Punjab and U.P. independent Indian States, against the iconoclasm of Mohammedan rule, and the sophisticated and exotic character of Mughal art and culture. As the Western world was turning more and more to realism and anecdotal and photographic representation, we had in India, in the 17th and 18th centuries, a pictorial art that continued the traditions of fine, sensitive drawing and magic pattern of colours of Ajanta and Bagh, and at the same time was, perhaps, the last collective vision of an age that found the divine in the human and the human in the divine.

Islam and Art

A world religion that was inimical to æsthetic values was Islam. Such op-
position to art as early expressed itself in Muhammad's injunction, forbidding
the use of all pictorial representations in the religion founded by him, is to be
attributed to several factors. The Arabs were a simple, nomadic people, given
to war and deficient in higher education and culture; they found in several
countries they conquered magnificent monuments of art that they could adopt
in the absence of a national art of their own. They, in fact, often made use of
Christian Churches for their own worship, converted Hindu temples into mosques
and freely employed architects from foreign countries for building their mosques.
The limitless expanse of the desert and the steppe which they traversed restlessly,
and where there was nothing to arrest attention, bred an abstract frame of
mind. Their logical conception of the absolute unity and omnipotence of God
was incompatible with His representation in material objects; and, besides, the
fear that the people might relapse into fetish worship and polytheism was but
natural. The Islamic prohibition of paintings and especially of plastic repre-
sentations of natural form led, however, to the development of geometrical and
decorative art, hardly paralleled anywhere in the world; while the architecture
of the Muhammedan peoples, richly enriched by borrowings from Egypt, Byzan-
tium and India, had an unprecedented growth, characterised by the contrasts of
reariness and regidity with variegated, fantastic decoration that seem to echo
the incompatibilities of their intellectual nature. The austerity of the Arab
dispensation was, however, profoundly modified in the Islamic world by the my-
stical religion and poetry of Sufism that grew in the Persian soil out of the fusion
of Indian and Neo-Platonic metaphysics. Sufism asserted the immanence of the
Deity in the world and human life, and restored the sense of intimate personal
communion with the Perfect one. The search for beauty came to be identified
in the Sufi creed with the revelation of the Divine perfection, and this became
the stimulus of an incredibly meticulous, elaborate and serene art and craftsman-
ship for which recognition was sought not from the world but from God himself.
Thus the upper classes, and in some measure the common people, were prepared
by both Sufi poetry and metaphysics to find in art work the door to perfect
love and comprehension, and the artistic life was elevated and deepened with
new fervour and poetic imagination. The artist Khwandanur actually
declared that God was the Eternal Painter and the world was His artistic
creation:

> "The Eternal Painter when he made the Sun
> "Adorned an album with the sky for leaves
> "Therein He painted without brush or paint
> "The shining faces of each beauteous form."

Again:

"God's writing and his draughtsmanship amaze
The wise man by their magic loveliness •
The eye rejoices at the curving line
Although the mind may fail to grasp the sense
God's form and meaning both create delight
And shed illumination on man's eye"[1]

Many Persian portraits and other paintings are characterised by a combination of serenity and intensity, tranquillity and lyricism that are derived from the super-sensible realm. Al-Ghazzali, like Plato, has indeed stressed the akinness of the perception of beauty or harmony with transcendental insight. "The heart of man bas been so constituted by the almighty that, like a flint, it contains a hidden fire which is evoked by music and harmony and renders man beside himself with ecstasy. These harmonies are echoes of that higher world of beauty which we call the realm of spirits; they remind man of his kinship to that world and produce human emotions so deep and strange that he is powerless to explain it." As it has happened in the history of so many religions, the development of emotional mysticism in Persian Islam, with corresponding devotional literature, was an inspiration to art, and met the challenge of religious taboo by remarkable humanistic paintings that satisfied and aroused the religious and artistic aspirations of the Muhammedans not merely in Persia but also elsewhere.

Buddhist Art and Culture

In India art first served religion in presenting in plastic forms the prototypes of the Mother Goddess, Siva, the Bull and phallic symbols associated with popular cults in the Indus valley in and about 2000-3000 B.C. Later on images were made of Yakshas and Yakshinis, Nagas and Nagis, snakes as well as spirits of trees and waters that were found in Bharhut, Muttra, Besnagar, Parkham, Patna and other places. The teachings of Buddha definitely discouraged the making of his image for worship, and we have a reference in the Milinda Panha (about 1st century A.D.) to the general opinion forbidding the construction of images. It was probably in Mathura that the earliest image of Buddha was modelled, seated cross-legged under the Bodhi tree true to the Indian Yogi type.[2] From the sculptures of Bharhut depicting scenes connected with the life of Buddha about 200 B.C. to the eighteenth century, Buddhist art covers about 2000 years and ranges in several natural art regions. Buddha is represented in later traditions (Divyabadana) as meeting king Udayana's wishes to have an

1 See Arnold *Painting in Islam*, p. 35; also Pope: *Introduction to Persian Art*, pp. 229-233.

2 For a discussion of the claims of the art schools of Mathura and Gandhara in first fashioning the Buddha Image, see Mookerjee: *Notes on Early Indian Art*, pp. 24-31.

image of himself drawn on canvas. Hiuen Tsang in fact found an image of sandal-wood (at Kausambi which was Udayana's capital city) rather than a painting that was "borne through the air" to Khotan where it became the archetype of innumerable later representations. At Lung-Men there is a statue called Udayana. Early Indian art, due to the prohibition of the making of the image of Buddha, used a variety of symbols such as the wisdom-tree, the wheel, feet, trisula and lotus, all derived from the Vedic myth and religion. On the one hand, Indian and hence Oriental art was profoundly enriched with abstract symbols and motifs due to the earlier iconoclastic attitude of Buddhism. Many of these were no doubt Vedic and Indian, but some were taken over by Indian art from the Near East. Secondly, though the imaging of the Buddha himself was prohibited, no such prohibition applied to the representation of the animals in which forms Buddha showed his courage, pity and self-sacrifice in his previous births. Thus Indian art early developed an ardent love of naturalism, and animal figures were depicted with great sympathy and tenderness.

On the other hand, as Buddhism became the religion of the masses, Indian art achieved a fusion of anthropomorphic and abstract elements satisfying the requirements of both intellectual comprehension and emotional fervour. Even before the sacred feet (paduka), symbolising Buddha in the sculptures of Amaravati, we find a group of remarkably graceful feminine prostrate figures fully expressive of the profound devotion of the multitude to the Great Teacher. Hellenistic influences encouraged anthropomorphism in the Buddhist art of Gandhara and Kapisa where the Buddha's image was carved as a model of Apollo and an Indian teacher or Prince combined, seated not in the cross-legged Indian Yogic posture but in European fashion, but soon this was spiritualised in the Indian religious climate largely due to the influence of the Mathura school of sculpture. Here the treatment is characterised by a fine tracery of the monk's robe, rounded lines of the body and a profoundly meditative face, the ensemble showing remarkable harmony, serenity and vigour.

Buddhism and Brahmanism, indeed, early settled the iconoclastic controversy by the recognition that the image is not significant in worship, but the super-sensible Being or subject incarnated in it. "The image merely as such is of no value, all depends on what he does who looks at it; what is expected of him is an act of contemplation such that when he sees before him the characteristic lineaments, it is for him as though the whole person of the Buddha were present; he journeys in the spirit to the transcendent gathering on Vulture Peak"[1] Coomaraswamy adds: "Aesthetic and religious experience are here indivisible; rising to the level of experience intended, 'his heart is broadened with a mighty understanding'." Besides, if the Being or divinity is immanent in all things in

[1] Saddharma Pundarika, [ch. XV, quoted in Coomaraswamy: *Elements of Buddhist Iconography*, p. 7.

nature, art becomes an ideal vehicle of representation of the unity of all life. The rugged mountain face in Ajanta in the Deccan or in Ch'ien-Fo-tung, famous for the Caves of the Thousand Buddhas, in the Chinese oasis and in distant Yun-kang in Shansi or, again, the vast temple walls in Borobodur in Java could not have been transformed by the presence of a thousand living forms including Buddhas, Bodhisattavas, angels, apsaras and adorers, but for the intense religious feeling of the oneness of all life and sentience through a multiplicity of forms, births and manifestations. The stones burst forth into exuberant life and dynamic energy in cave and temple from the lowest tier to the ceiling that literally became thickly inlaid and compact with forms of life, wholly concentrated upon the worship of Buddha, the primordial essence of all manifestation. "The stones themselves are elevated to the rank of Buddha," wrote a Chinese poet. It was the Buddhist synoptic view of the universe, satisfying both intellect and imagination, that no doubt cemented the partnership between religion and art, art definitely allying itself with religion in translating the eternal and universal ideas in religion, and at the same time revealing in its autonomous sphere of the field of vision ever-new rhythms and symmetries from the world of nature.

The March of Buddhist Art

Not merely was Buddhism associated with wide-spread and noble artistic construction in India, but as it travelled with the Indian monks and preachers along the ancient silk route by way of the Central Asiatic oases or the sea-route by the Archipelago and Indo-China to China, it brought about an æsthetic revolution by mingling with Taoism and introducing into the religious and æsthetic life of the Chinese the major archetypes, symbols and motifs of India. The spread of Buddhism to Central Asia, China, Burma, the East Indies, Siam and Cambodia completely transformed the indigenous art traditions, symbols and motifs of the various peoples, just as Christianity almost contemporaneously (3rd and 4th centuries) refashioned Mediterranean culture and art. The expansion of Mahayana Buddhist art was possible in the East because of the transformation of the earthly or historical into the transcendental Buddha or Being and the interpretation of iconography from the metaphysical and hence universal standpoint. Buddha is no mere individual teacher or Sakya Simha in Buddhist metaphysics and art. He is the primordial metaphysical principle of the universe, Being, "Who has entered into the Suchness" and has never left his eternal seat of meditation on the Vulture Peak at Rajgriha. The Saddharma Pundarika (The Lotus of the Good Law) gave this metaphysical interpretation of the eternal character of the Buddha, of the Buddhahood in every creature that awaits realisation, and Indian art entered its golden age. No wonder this important Mahayana text, which was "a grand religious poem

in itself," greatly stimulated Buddhist art. As Anesaki observes: "The apparition of the heavenly shrine, the hosts of the sanctified adoring Buddha, the stories of miracles wrought by saints in the name of salvation,—these and other topics were painted ceaselessly in a variety of scenes and compositions".[1] The doctrine that Buddha was a god above the gods, an eternal, infinite Being spread from India to China and Japan, everywhere imbuing the people with an aspiration for universal communion, practised in conduct and expressed in art. On its way to China through the ancient silk trade-route, Buddhism was, indeed, largely transformed. Besides the metaphysical principle of Buddhahood (the essence of all Buddhas) there were stressed the cults of Maitreya and Amitabha, the easier tenets of the Paradise or Pure Land to reach which was easier for the faithful or believers in God's grace than through the difficult way of the Aryas. Thus the fresco-painter began to paint the Tusita and Sukavati heavens, stimulating the faith and giving hope and assurance to the faithful. There was, of course, the human form of the Buddha or Sakyamuni and the various episodes in his career, such as his encounter with poverty, with disease and with death, his farewell to his sleeping wife and his renunciation, were ardently depicted in both painting and sculpture. But the heavens of Maitreya and Amitabha far eclipsed in glory Gridhakuta or the Vulture Peak, beloved and sanctified by the historical Gautama. The Paradise of the metaphysical Buddha was more resplendent than the site of Gautama's meditation. In religion and art Maitreya and Amitabha far outshone Gautama. Furthermore, in the early development of Chinese Buddhist art the peace and happiness of the Pure Land were more discernible than any threats of suffering in hell that were so much emphasised in the later centuries. The march of Buddhist art from India to China, Korea and Japan, impelled across thousands of miles by a burning faith that produced altogether new lasting creations of art, can now be but dimly traced in the cave carvings in Bamiyan and Habak on the borders of Afghanistan, in the sand-buried cities of Balkh, Kashgar, Yarkand and Khotan, in the grottoes of Kucha, Qizil and Turfan, the remarkable remains in the caves of Tun-huang and in the colossal sculptures at the Yun-kang caves in Shansi. Much in the same manner Christian art concerned itself not with the scenes of the ministry and sufferings of Jesus, but rather with the eternal birth of the son of God, the majesty of the Divine Mother and the perfection of Christ in glory. As in Buddhism and Brahmanism, so also in Christianity, art can best aid religion if it be not chilled by the formal motifs and conventions of iconography, and this is possible only when philosophy or metaphysics changes the content of iconography, anthropomorphic or otherwise, making it less earthly and historical and more ethereal and transcendental. Metaphysics does not brook the historicity of Gautama and Jesus, and thus

1 *Buddhist Art*, p. 16.

paves the way to art envisioning Buddha and Christ in images that overstep the horizons of time and space, and yet live and love eternally in the Paradise of human hearts. For Buddha is also the beloved teacher and conqueror and victor in the fight, "the peerless Master of our caravan," "the king who ruleth all the world," the very embodiment of *Dharma*. Thus the profound love and adoration of the person of the Master supplied the inspiration and vitality of Buddhist art. Well has Chavannes remarked that the distinction of Buddhist art lies in giving a "moral value to the human figure." Similarly in Christian art, Christ is the Good Shepherd that giveth his life for the sheep and the Man of Sorrows, and lives eternally in the life of love and sacrifice of mankind.

Another interesting parallelism in the history of the development of Buddhism and Christianity is that the Greco-Roman art largely supplied the first iconographic types in both early Buddhism and Christianity. Apollo became Buddha in the Gandhara School of art as well Christ in the Mediterranean. But in the Orient the influence of Mathura early developed an expression of profound contemplative abstraction combined with graciousness and delicacy that travelled from India to Turkestan, Central Asia and China, and soon superseded the Hellenistic, Iranian or Persian models. It was only in the 13th century that Europe could achieve similar spiritual expressiveness in the early Gothic sculpture at Chartres and Rheims. It took ten centuries or more for Christian Europe to rise to the spiritual exaltation that could give the supernatural idealised 'Gothic' human type that is so sharply contrasted with the Greek type. Great epochs of religious enthusiasm were epochs of magnificent artistic achievement, whether in the East or the West. Both religion and art feed mankind's recurrent hunger for the infinite and the immortal.

Distinction between Religious and Art work

The more perfectly the metaphysical symbols and allegories of the ritual are fused with the sensuous forms in which the great truths these express are incarnated, the more beautiful do these forms become. Between the pure allegory and symbol of religion and the complete fusion of abstract concepts and percepts, several degrees of fusion exist, differentiating art works from gods and goddesses of worship. The distinction between religious and æsthetic contemplation lies in the apprehension of abstract formal rhythms and symmetries in the field of vision. Art invests the sensuous forms, derived from the real world of concrete human experience, with abstract, formal values; it is these it essentially relies upon for its emotional appeal. A great work of art always combines a profound message from the depths of the artist's soul with an intense emotional interest for all men, derived by it from the visual play of light and shade, forms, colours and planes. What is universal and eternal is enclosed by art in concrete sensuous forms and phenomena, eliciting characteristic attitudes and emotional

experiences and values that are deliberately sought in the image, ritual and observance. It is the image and ritual that, through dramatisations and allegories, sensitise the worshipper and arouse in him a gamut of emotions attaching him to the religious pursuit. The worshipper becomes the artist in ritual.

The Autonomy of Art

On the other hand, early Egyptian art, developed before the articulation and organisation of religion in the Nile Valley, the courtly and cruel art of Assyria, the sculpture of China that had a fresh exuberant phase after the retreat of Buddhism, Persian painting, Moghul painting in India and, above all, the art of the Renaissance in Europe are familiar instances in history of artistic development unaided by religious enthusiasm. In Europe it was since the Renaissance that the theme of painting has increasingly centered in allegory, portraiture, landscape and still-life. Whenever mankind, through contemplation, through love and passion, through war or any other engrossing sentiment and drama of action and movement, atrocious or sublime, finds an order or symmetry in the unexplored world of forms, colours and movements, the artist's soul creates a new world of rhythm and beauty. Every epoch, religious, puritan, military, secular or political, sets its own problem and work for its artist. It is rarely that he is thrown back on his own individual resources and purposes.

Gradually with the secularisation of life, art becomes an autonomous quest, developing its own traditions and standards, and turns to the lesser themes of personal moods and emotions and the sensible world; while religion also frees itself from the emotional props of images or art objects in which the religious emotions were formerly objectified and distilled as well as rituals, symbolisms and allegories, but turns boldly into metaphysical realisation—the flight of the Alone to the Alone. It is in this cold, intellectual phase of religion, which represents in fact the summit of spiritual realisation, that there may come about a severance between art and religion. Yet both Buddhist and Brahmanical art has tried to embody great metaphysical concepts and truths of self-realisation in plastic forms and symbols comprising a unique gallery, that has caught the mystery of the supersensible and unexpressed and represents some of the most profound artistic constructions of the world. Secondly, the Brahmanical and Buddhist conception of the universal brotherhood of all being and the continuity of life in man and nature served as an enduring inspiration to artistic effort that sought through the centuries to express the full participation of all beings and things in the cosmic life. It was the expansion of the mental vista and the broadening of sympathy, embracing within their scope plants and animals, men, beings of heaven and of the nether world, and the spirits inhabiting nature that nourished the stem of myth and religion and the flowers of art in the Orient.

Interdependence of Artistic and Religious Experience

Man's æsthetic and religious impulse and attitude come out of the same stem of self-expression and reconciliation of the discords of the world and the tensions of the self in a rhythm, unity and order. Myth and religion create the archetypal symbols and images that bring poise or repose to the self. Art embellishes and makes these vivid, aiding the self in the process of myth-making, symbolisation, rationalisation and sublimation and in yet profounder integrations of the personality, and engendering a sense of ineffable joy, rhythm and beauty in the inner life. Myths, symbols and imagery that religion provides for art are constantly refashioned by the latter; in this renewal and re-interpretation these become surcharged with emotions and meaning attitudes, vivid and powerful foci for fresh effort in religious and æsthetic contemplation. It is then that the concrete and the abstract, the mundane and the transcendental values easily slip into each other, which is, indeed, the summit of æsthetic and religious experience. The human becomes transmuted into the divine, and life is envisioned as the sport of the gods in the Paradise of man's heart. Art is great to the extent it expresses the impersonal and the universal in concrete patterns, and the spiritual climate in which the human and the divine meanings and values interpolate is most favourable for its development. Æsthetic experience is characterised by the same sense of competence and insight that are the *sine qua non* of religious experience. Like religious intuition æsthetic intuition obtains these from its unique vision of the wholeness of the universe. But it adds to these, and lingers over a vivid sense of rhythm or harmony that brings about utter identity between the universal and the concrete, the transcendental and the human through the replacement of the *idea* by the *feeling* of identity. From the sense of harmony emerge the patterns of colour and plastic and melodious rhythms that represent the so-called formal values of art, and that are rooted in man's deepest realisations in propitious moments of spiritual or æsthetic ecstasy. Art thus affirms the religious faith that makes the dumb speak and the lame to ascend mountains. It is the sole reliable testimony to the vision and power of true religion, as it brushes aside the cobwebs of dogma and the rust of tradition that obscure the direct vision of religious ecstasy. Art breaks as many religious idols as it creates, renovates and embellishes. As religion languishes or dies, idols insensibly change into stiff forms, or these may obtain a fresh lease of life through the æsthetic fervour taking the place of the religious sentiment, and become new symbols of the life and imagination of the people.

It is not necessary that the symbolic dialect of art remains the same. The iconoclasm of Islam, the austerity of Puritanism and the rationalism of the modern scientific epoch have chilled spiritual passions and discouraged plastic expression, but the search for beauty has at the same time created noble architecture, over-elaborate decorative art, delicate craftsmanship and grand poetry

and music. But, on the whole, in the history of human culture the outburst of enthusiasm of a people or an epoch that has reduced the chaos of the universe into order, and given to the world its imperishable legacy of art motifs and symbols has so far shown itself in the visible forms of religion. The principal reason is that man's sense of order in the universe, of unity of self or Being with the world or Becoming, is a mystical sense that is the core of both art and religion, and is anterior to and surpasses visible forms of art and codes of morality, and constantly creates fresh, visible and expressive idols and poems out of the infinite world of forms and movements that stir man's desires. Both art and religion have helped each other, religion at its highest enormously enriching the intellectual content of art, and evoking at the same time unexpressed rhythms and symmetries in the field of vision.

Art Form and the Spirit of Society

The same absolute and universal values to which religion and art give perfect expression are imperfectly articulated and consolidated in the social and economic order. Each distinctive social system, ethos or culture nourishes its characteristic art form. Authoritarianism and individualism, organization and freedom as social principles leave their impress upon art forms. Myths of nature and of the origin of man and the tribe, epics and legends of gods, heroes and ancestors and lyrical poems revealing personal moods and passions mark the successive characteristic phases of the development of poetry, accompanying the change of the social structure from collectivism and organisation to individualism and freedom. The change in social organisation and ethos of a people is writ large in all the fine arts; while the forms in each are congruent with one another and with the spirit of she people or age. Where the social structure is immobile, unyielding and adamantine as a mountain, giving little scope to the creative strivings of the individual, both architecture and sculpture become severe and conceived geometrically. Architecture becomes monumental in a mathematical setting, and sculpture becomes massive and ponderous dominated by the spirit of architecture in its solid unity with the ground *i.e.* the wall and the figure. Geometry is man's translation of abstract, absolute, limitless values and ideas, the spirit of the timeless and changeless society and universe. Geometrical art flourishes wherever the individual achieves a poise between self and society, between his freedoms and the compulsives and repressions of the social order. It is intuitive, abstract and transcendental. It is the highest kind of art, since like mathematics it can delve most deeply and abstractly into the elements of form and number that embody themselves in the harmonies of the universe, interpreting these like the latter in exact ratios and formulæ that are universally valid, acceptable and attractive. Geometrical patterns indeed, comprise the means of revealing or imposing the most universally obtaining

rhythms that can be conceived by man. Geometric art is contrasted with an art of subjective moods and desires, with impressionism and lyricism that free themselves from the bounds of the mathematical and the exact, and become slack, diffuse and palpitating, as illustrated in realistic, imitative or romantic painting and sculpture and in its extreme phase in the weakness and volatility of the Western Impressionists.

Geometricisation is best expressed in the history of art in the solidly built, bare and systematic Egyptian, Doric and Roman temple or Muhammadan mosque, which exhibit a maximum of mathematical relations and embody in all their strictly exact parts the rigid uniformity of faith and observance and the inviolability of law and discipline holding together the family, the tribe and the community that punish deviation with expulsion and ostracism from the group. For mankind in its earlier stages of culture the rigid compulsory adherence of individuals to myth, religion, custom and taboo is reflected in the geometrical patterns of the Altamira paintings, Negro sculptures and massive symmetrical primitive temples with their simplest lines and rugged profiles, symbolising the unity and cohesion of the social group. Similarly, nothing in the history of sculpture is more impressive than the severe colossal Egyptian statues characterised by the interplay of geometrical forms, masses and planes. These illustrate the same mathematical principles that underlie the logical arrangements of the gigantic collonnades and temple porches and the grandiose monotony of the pyramids and avenues of the colossi. The Egyptian pyramids, collonnades and hydraulic works as well as the portentous cubical sculptures, indeed, equally illustrate the power of the collectivity in the custombound, hierarchical society of the Nile valley. And yet who does not recognise the play of the radiant human spirit in those attractive paintings in the Egyptian tombs where we breathe in those implacable and sinister surroundings the fresh air from the rivers where the birds warble, the lotuses open their petals and the oarsmen sing, and from the fields where the cultivator, shepherd and craftsman pursue their callings with delight? In India sculpture has transformed hills and mountains into temples, and in Java and Cambodia raised sanctuaries as massive as mountains, overwhelming in their size, but simple, logical and hierarchical in the regular frame fixed by nature, social code and law. The long stretches of the temple corridors, the symmetrical arrangement of the entrances, quadrangles and staircases, the construction of halls supported by a thousand pillars, the remarkable simplification and elongation of the single massive and primitively squared figures, maintaining a living context with the ground,—all illustrate the geometrical pattern associated with the immobility of Indian caste and custom, social coercion and regimentation of the individual.

In all communities and epochs of civilisation where authority and tradition hold their sway, architecture becomes the central and most dominant of the arts,

subordinating to itself sculpture and all other art forms. The categorical Buddhist Chaityas and early Hindu temples exhibit a unity of style and centralisation of feelings and ideas as pitiless as the hierarchical principle in functions and aptitudes that ruled the Indian caste organization. And yet religions of love and knowledge like Buddhism, Sivaism and Saktism have nourished the revolutionary spirit of the individual, and a profound social idealism, and modified the architectonic conception of sculpture giving expression to the newly aroused humanism. Thus images became rounded with a sensitive modelling, and their countenances, poses and gestures as well as jewellery, with their pointed angularities and undulating planes, albeit as parts of speedily gliding compositional curves, freely expressed the poetry of human passions and sentiments that compensated for every abstraction. The lyrical, romantic or mystical spirit of the individual overcame the spirit of architecture, the reduction to plane and stereometry, and not merely the powerful contrasts of light and darkness and resonance in depth of the caverns of hills were utilised to express the degree of vehemence or stillness of the gods and goddesses, reflecting distinctive inner situations or altitudes; but the rough or soft surfaces, the smooth or sharp angles and curved outlines, the relations of garments and jewellery to the body and bold deformations of the figures, all tended to the psychological and reflective rendering of the moods and emotions. Even rock walls were organised in the manner of a painting with all its psychological suggestiveness. Whenever a warm current of romantic or mystical idealism and revolt made its influence felt on the immobile social order and rigid discipline and instruction, overcoming the prevailing Indian fatalism and sadness or the Chinese positivism, the images of Oriental art, whether Hindu or Buddhist, were sinuously modelled into the subtle, the elegant and the documentary, and the pictorial spirit rescued sculpture from the atmosphere of congealed cubes, squares and cylinders of stone.

The universal oscillations of the social order, and of religion and metaphysics between the two poles of the human spirit, order and progress, discipline and freedom, leave an indelible impress upon forms of art with their alternate stressing of mass and cohesion or the geometrical principle revealing abstract, supersensible and plastic values, and infinite modulation of surfaces and volumes or the principle of fineness, radiation and ornamentation, subserving the amiable and refined luxuriousness of human beauty, mood and sentiments. Often in the history of art the reconciliation is not possible between social values and their æsthetic expression, between social and religious systems and art forms. Gupta sculpture in Northern India and the Pala-Sena sculpture in Bengal and Bihar are, for instance, efflorescent in poise and repose, characteristics of spacious epochs in Indian culture when there was little conflict between the inner and outer life of the individual, and his life-goals could be most

subtly, sensitively and profoundly expressed in plastic terms. But in the classical sculpture of the Deccan such dignified yet sensuous poise was not discernible, and we find statues marked less by absorption and spiritual bliss or by the charm of humanity, and more by the fury of revolt or the grim calm of the pent-up, dark, unconscious forces of life and mind. The contrasts between the elegance and suavity of Sarnath and Dacca sculptures and the dynamic energy and unrest of the rock-cut sculptures of the Deccan is extraordinarily vivid. Thus do different stages of social development and the culture of the individual with their integrations and conflicts, expressions and repressions, result in characteristic differences in the plastic treatment. The march of the human spirit from subservience and conformity to the progressive phases of romanticism, idealism and mysticism declares itselft in the gradual domination of the lyrical, the pictorial and the decorative sense, and the subordination of both architecture and sculpture to the perception and patterns of painting and music. On the other hand, man's subjectivism and egoism may prove great enemies of art in so far as these may prevent the articulation of impersonal and universal attitudes in art forms that lead towards extreme realism, or towards the eccentric and the fantastic. The development of European fine arts is characterised on the whole by the interplay of the dynamic energy of the individual, and by the stress of lyrical and dramatic attitudes and situations. The revelation of personal moods and values rather than of universal and impersonal abstract values explains the greater development of painting and the relegation of sculpture to the rôle of imitation of nature in Europe associated with the glorification of the individual.

Man's fleeting and fragmentary expressions of the visual world, in so far as these are of interest in the context of his sharply defined subjective moods and desires, have constituted the dominant art motifs in Europe. Exaggerated or concealed realism and identity with reproduction of nature have been the language of art forms and community attitudes. It is only recently that the Cezanne-Picasso movement has given to Europe some new universal or abstract vision of beauty. But just as the soul-killing, mechanical standardisation of all human relations and the profound insecurity and inner disequilibrium of the individual in the economic system have left little scope for the individual to delve into the absolute values and into the timeless nature of existence, modern geometrical art in Europe has quickly lapsed into an empty, frigid and mechanical idealism, showing none of that viable combination of the abstract rhythmical qualities of design with psychological humanistic elements that characterises real art. In the fluid, hectic machine-driven urban-industrial culture there is even a deliberate stress in art form of motion and speed. It is not repose, silence or withdrawal that are sought by art, as throughout its world history, but movement, stir or creation. Thus Marinetti declares in his Manifesto of the Future:

"An automobile in full speed is more beautiful than the Victory of Samothrace or the Venus de Milo". Contemporary European culture is, however, many-sided. Strong tendencies in art are manifest in which the art form seeks to free itself from subjective moods and sentiments, on the one hand, and interpretations of visible nature, on the other, but expresses abstract formal values and rhythmical patterns completely liberated from human and even naturalistic requirements. On the other hand, the older traditions of naturalism, lyricism and documentation are firmly rooted, and art that has a large sentimental and intellectual appeal commands wider popular support. The medley of art forms in the West is itself an echo of the unstability and confusion of social values and ethos of the people. But art forms themselves can become social binders and personality-builders. This is possible only when the intense personal consciousness of the artist rises to a mysticism that derives patterns of beauty from his own intuition, liberating these from dependence on visible nature, and at the same time endows these abstract values and symbols with human meaning and purpose. A profound humanism and social idealism can alone lead the various schools of abstractio-nists to their true destiny. Each civilisation, each social system, the feeling and ideology of particular epochs, speaks in its distinctive variety of art form that always exhibits an alternation and tension between the geometric or the abstract and the organic or the psychological.

Variety of Art Forms and Ideals

Apart from differences in sensibility and experience, we find social prejudi-ces, habits and beliefs that belong wholly to non-æsthetic spheres, preventing a full enjoyment of beauty or access to all the many individualised values and significances that a great work of art of a distant people or age possesses. Many prejudices and conventions of behaviour have to be overcome before we can apprehend and appreciate, far less borrow from, the artistic constructions and experiences of other peoples and cultures. How much is mankind's creative imagination and capacity impoverished because of its ignorance of the plastic vernaculars by which the various peoples of the earth express the eternal and the universal in their moods and emotions! The same regional and comparative treatment that is applied to the classification and study of social and cultural types and institutions would give us the alphabet, grammar and essential voca-bulary of the arts of India, China, Egypt, Greece, Christian and modern Europe that have recorded the ideals of different races and the visions of different epochs. The postponement of comparative art studies in both analytical and developmental aspects hardly benefits modern, humanistic civilisation.

In modern urbanised culture the lapse of myth, religion and faith, the econo-mic and moral insecurity of the individual and the chaos in the social and econo-mic world have been largely responsible for the prevalent æsthetic eccentricity

and anarchy in almost all countries. It is a matter of deep concern for the development of the fine arts whether the present economic structure, marked by a wide cleavage between the classes and de-natured urban industrial milieu with its hectic, unsteady life and emotional irritability and abnormality of men and women, can give us a true, serene collective vision in art, or merely aristocratic, abstract or esoteric "isms" for certain coteries—a passive reflection of social disorder, broken relationship and personal idiosyncrasy. On the other hand, neither the exclusive ideal of the kings or priests or of a caste or class whether the aristocracy, the bourgeoise or the proletariat, nor regimentation by the state or collectivity can stimulate sincere and spontaneous art work. These problems are essentially sociological and are by no means confined to the more advanced industrial countries. Their solution touches the soil and roots of modern civilisation, and for this we should look as much to the deep-lying causes of the isolation and loss of creative impulse of the artist and commercialisation of art in modern industrial societies as to the art forms, ideals and experiences of various peoples and epochs in world history.

A true understanding and appreciation of the art forms of different peoples would help in cementing the unity of mankind in a new world order and in enlarging the developing human consciousness. In the post-war world reconstruction a reciprocal understanding, borrowing and assimilation of the generic motifs, symbols and patterns of beauty created by different peoples and cultures are as important as their economic or political co-operation. For it must be realised that world reconstruction needs as much an artistic as an economic or a political basis. It is art that discovers fresh values, harmonises relations and impels new communions. Thus the artistic experience and heritage of the entire humanity must be pooled and mobilised both to forge fresh emotional bonds between people and people and to lay the artistic foundations of the new world order. Economics and politics can today supply the brick and the mortar, and science and philosophy, the engineering skill and technique, but it is the perfect collective vision that art sees and communicates which alone can instill the faith, impelling and exalting the arduous toil of humanity for building up the new edifice of society.

Art and Social Chaos and Crisis

In the history of civilisation it is often the poignant crises of man's life brought about by war, carnage, sensualism and moral chaos that have elicited the world's supreme artistic expressions. The chosen symbols and motifs of early Buddhist art rose from the Brahmanical sacrificial floors, stained thick by the blood of a thousand animals when the armies of Chandra Gupta Maurya were traversing the entire continent of India and bringing about her first unification through a sea of blood. In the midst of the bloody struggles and invasions of China in the 5th century A. D. there was seen a similar efflorescence of Chinese

art in the Wei productions that anticipated in their suavity and confidence the Buddhistic peace. Mahayana absolute idealism and the golden age of Indian art which sprang from it, were contemporaneous from the 4th to the 7th century with the empire-building of the Guptas of Patliputra, Ajodhya, Ujjain, and Karnasuvarna and the struggles of the Vardhanas of Thaneswar and Kanauj, the Maukharis of Magadha and the Maitrekas of Valabhi. The expansion of Indian art in South-east Asia was also associated with the influx of Indian colonists and invaders displaced from their mother country by the continuous inroads of the Sakas and Huns and the civil convulsions they brought about; while in China the spread of Indian philosophy and the translation of Mahayana idealism into indigenous art forms and motifs, following the great pilgrimages of Hiuen Tsang and I'Ching to the Holy land of the Ganges, took place amidst the civil wars and campaigns of conquest of the empire-builder T'ai-Tung. The confusion, blood and sorrow of the dark days of the fall of the T'ang dynasty also were sources of added strength to the important schools of Chinese painting that sought refuge in the understanding and presentation of Nature. Similarly, the efflorescence of Sung art in the 12th and 13th centuries was connected with the disorder and despair accompanying the dismemberment of the Sung empire in the hands of the Chin and Mongol invaders throwing all sensitive souls to emotional nature poetry and painting. The art, religion and metaphysics of Gupta India that not only created one of mankind's privileged hours of culture in the 7th century but also contributed permanent elements to the spiritual consciousness of the continent, were nurtured amidst a scene of storm and stress of internal political struggles in the Ganges and invasion of the iconoclastic barbarians in the north-west and west. The artistic renaissance in Bengal and Bihar under the Pala and Sena Empire that profoundly influenced the art development of Nepal, Tibet, Burma, Ceylon and Java covered four centuries (from 700 to 1100 A. D.) of political turmoil and continuous change of the boundaries of kingdoms, reaching its full glory when Indian and Mongolian hordes were pouring into Eastern India. The middle ages in Japan covering the 11th and 12th centuries that were full of the great feudal wars between different clans, characterised by violence, injustice and cruelty, also saw the rise of Amidist art with its marvellous supernatural visions of sweetness, tenderness and wonder rivalling the paradises of Fra Angelico. The artistic glory of Hellas was similarly associated with the horror of civil convulsions and the fury of the Peloponnesian War. The Italian Renaissance art was nurtured amidst the chronic civil tumults, internecine quarrels and debauches of the Italian cities. When the Germanic invasions were devastating Europe the people sought solace and peace in the gentle and joyous Gothic statues that dispensed benediction in the magnificent cathedrals of the early Middle Ages. Often have the epochs of blood and iron been the epochs of art and religion. The modern world is experiencing horror and sorrow, moral and

material disillusionment and suffering on a scale unparalleled in human history. The fate of *Homo sapiens* is sealed by total wars and their dangers which now encompass all the continents. The fate of the universe, also according to modern science, is doomed through the continuous annihilation of energy in empty space that condemns the sun to everlasting darkness and cold and the earth to a sterile, lifeless existence. As humanity faces death and void in both physical and social or moral planes, it is natural that a new art will be born accepting the challenge of death by its mystical vision of the unity of mankind that will triumph over the present blood-bath of the nations, and of the All-Good and the All-Beautiful who is beyond the finite universe of time and space and lives and loves eternally through his own cosmic rhythms of creation and destruction, happiness and death. As this vision spreads from the æsthetic to the social, political and moral realms, universal humanity will be reborn, the earth will enjoy an eternal spring, and sorrow and despair will be conquered by art. The function of art is to ceaselessly renew and replenish mankind's sinking heart under the grips of death.

CHAPTER II

THE SOCIOLOGICAL APPROACH TO ART

Art as Philosophy and as Social Science

There are few great philosophers from Aristotle downwards who have not developed some theories of Art. The philosophical approach to art is traditional. It is largely idealistic as in Kant, Hegel, Fichte, Schelling and Schopenhauer. With the advent of the historical method in the study of culture, historicism found its early exponents in the field of art, notably Vico, Herder and Taine. But the historical and comparative methods have since been largely confined to the fields of law, economics and religion. An outstanding exception is Ernst Grosse who examined the evolution of art in relation to stages of economic development and associated the naturalistic art style with the phase of hunting and conventionalisation with the agricultural phase. Although the treatment was too schematic, his emphasis of the economic and psychological bases of the development of art styles makes Grosse a path-founder in art history. Contemporary philosophers have also dwelt upon æsthetic value and experience and the place art occupies in the scheme of knowledge. One may only refer to a few names like those of Bosanquet, Samuel Alexander, Bergson, Croce, Santayana and Dewey.

A fruitful, but neglected approach to art is the sociological. The sociology of art brings under its purview the social relations of the forms and motifs of art. Artistic activity is dominated by the sense of norms and values, and these are largely of social origin. On the other hand, art as individual creative expression clarifies and in some measure reshapes and determines social values. As one manifestation of human aspiration and experience, art is woven into the scheme of values and general pattern of collective living and culture of the people. Art also remoulds the prevailing thought processes, values and ideals of society. The sociology of art is, accordingly, an objective study of art work as (a) an expression of the man's personal striving and fulfilment in the ideal plane and his unique sense of values that orient, articulate or explain the social values of an epoch or culture; (b) a vehicle of communication of prevailing social values moulding the values and destiny of the individual; and (c) a record and celebration of a culture or age, an unerring clue to the life and aims of a civilisation as judged by the larger conscience of humanity. It is less directly concerned, however, with dates, titles, names and biographies or with the sensuous values of works of art as individual, independent objects, which it would leave to art history. It confines itself to the social conditions of origin

and operation of art work, to the background of regional, economic and social factors and forces that determine the forms of art and largely condition its motifs and themes, and also to its meaning in a given culture with all its aspirations, frustrations and fulfilments. Thus it links up its enquiries with both art history and the investigations now being pursued by several social sciences, especially geography, economics, social anthropology and comparative religion.

Among the precursors of the sociology of æsthetics are Taine, Herbert Spencer, Guyau, Semper, Grosse and Wündt. Elie Faure, Strzygowski and Coomaraswamy, among the art historians, have followed the comparative methods in the study of art and have delienated successfully the reciprocal influences of art styles and mannerisms among different peoples and epochs. Comparative art, unlike comparative religion is, however, now in its infancy. Its further development rests entirely on the application of the sociological method in interpreting the art of the primitive, less advanced and civilised peoples, and understanding the continuity of art tradition, values and experiences. Cultural anthropology, as in the hands of Hirn, Haddon, Boas, Scheltema and Ruth Bunzel, and experimental and social psychology now furnish valuable materials and methods for the comparative sociology of art as an indispensable aid to the interpretation of human history and civilisation. From the comparative history of art and culture we can understand the recurrent forms and motifs of art through the epochs among different peoples and the manner in which environmental and economic conditions, religion and social ideal and stage of development of tools and technical methods determine artistic activity. From the study of primitive and folk-art, myth and ritual we can learn more of the first stirrings of the creative activity of imagination and the relation between art and the social process than from the æsthetic elaborations in great periods of culture. Finally, the psychology of the unconscious and the *gestalt* shows us the mental mechanisms of artistic creation and apprehension as social psychology clarifies the personal and the social factors which bring the work of art into existence as well as its consequences to life, personality and society.

An invaluable but hitherto neglected social science is thus represented by fine art, dealing as it does with the entire background and conditions of artistic activity and of the archetypes, symbols and myths of art that reveal social values and meanings more clearly and immediately than any other cultural product in the life of a people. Between art and society there is a reciprocity which has no end. The unity, the rhythm and the concord which the artist achieves is his art work evokes from society aspirations to achieve these in concrete human relations. The radiation of human love and sympathy eternally renews the vital flame of the artist's vision. The social inspiration of art can hardly be neglected as a formative factor in art tradition and

development, on the one hand; on the other, society can never afford to disregard art as a technique of social control and guidance. Art is a subtle, attractive and powerful tool in the hands of society for shaping and regulating human relations and life-goals. Government, education, religion or recreation—all the organised group activities that seek to discipline individuals into certain approved and established norms of conduct are fashioned in the artistic mould without which rule and authority would have been intolerable, and instruction, control and regulation of the common man baffling, if not futile, social tasks. Thus is art the ally of the forces of order and progress in society reaching out to the individual in most accessible forms society's cherished aims and objectives that gain in colour, grace and dignity. But art transcends man's social interests and aims like wealth, power, leisure, knowledge, stability and happiness. It in fact records in the most certain and unequivocal manner the destiny of the individual and of society through its glimpses into the universal values, into the basal and universal forms of the mind itself and into the more-than-human order and unity of the universe that religion can apprehend but only art can make accessible to the common man. Not before we clearly recognise the function of art as a significant mode of apprehension of man, society and the world process, parallel with science and philosophy, that we can estimate its organic place and rôle in the history of civilisation.

Reason and Instinct in Art

Various fundamental instincts and desires are at the basis of artistic creation. One or other of these has been stressed by different thinkers. Thus Nietzsche, emphasising the desire for self-assertion as the root of art, describes art as "intoxication, the feeling of enhanced power, the inner compulsion to make things a mirror of one's own fullness and perfection." Havelock Ellis argues that it is the deep urgency of the impulse to possess which stirs the creative artist. He creates because that is the best way, or the only way, of gratifying his passionate desire to possess. Two men desire to possess a woman; the one seizes her, and the other writes a "Vita Nuova" about her; they have both gratified the instinct of possession, the second, it may be, most satisfyingly and most lastingly. In the above school of thought art represents the wholeness and perfection of man's rationality in its comprehension and domination of the universe. Modern psychologists now tell us that man's fundamental instincts and not reason are at the root of creative work and that these instincts hardly work in isolation, but are found blended with one another in an intimate way in artistic construction. Some instincts are in the foreground, others are in the background of consciousness. Some are directly, others are indirectly implicated in art. Instincts such as sex, gregariousness, self-assertion and possession are involved indirectly. But the instincts of play

and constructiveness represent the core of artistic expression and valuation, and are expressed directly by art.

Art and the Integration of the Unconscious

That central core of play and constructiveness is enriched from all levels of the psyche. From the unconscious there surge up in the child's mind the ambivalent desires of love and destruction. As the child develops in his sexuality these vary in intensity and are directed towards objects both internal and external. Thus the young would draw on the floor, manipulate, model and destroy plastic clay, hum tunes and dance. They would take part in various activities of production and manipulation of the environment which would be regarded as biologically useless activities for animals. The dual opposites of love and hate, sensual craving and aggression that flood the phantasies of the young express themselves in art work whether of creation or destruction, of mutilation or reparation. Phantasies of these elaborate themselves in the unconscious part of the young mind, and are externalised not merely in art but also in social life. As the unconscious urges and wish-phantasies are brought to consciousness, these blend with many other impulses and inhibitions.

Art represents a complete fusion and synthesis of the conscious and unconscious desires of man and especially a reconciliation of man's life and death impulses of love and destruction. Out of the constructive work in art arises a wholeness in man's internal life as well as in external relations, which is the very essence of his success in adaptation. Man's sense of beauty and wholeness which is manifest in his æsthetic and mystic apprehension is ultimately rooted in his imperative need of reconciling the ambivalent, contending forces of love and hate that possess him in the depths of his being. The need of this emotional orientation is connected with the peculiar features of development of human sexuality and affective life. Man's sadistic or destructive impulses and phantasies in his love-life are characteristically accompanied by the compensatory phantasies of 'restitution' or 'reparation', as these are called by Melanie Klein and John Rickman respectively. These psycho-analysts stress a possible genetic connection between the pain due to destructive impulses and the paramount need to create lasting goodness and wholeness from what had been in phantasy injured and rendered bad. As the preservation and enhancement of the objects of attachment is the great concern of the libido, restitution or reparation should be considered as libidinal manifestation in spite of the fact that it owes its origin to the presence of destructive impulses. The urge to reparation is, according to Rickman, owing to the strange nature of human development, probably an integral part of creative activity; the horror of the 'ugly' and the wish to change it is that *vis a tergo* which thrusts us into constructive work in art, in science and even in

the humble tasks of our daily round[1]. Man can unburden himself of his load of anxiety and guilt, his agony that overwhelms him when he finds his loved ones threatened by his own destructive impulses fused with his libido, as he fulfils the compensatory urge to reparation. This principle of reparation which arises from the depths of man's being underlies all human strivings after truth, goodness and beauty. This is the chief reason why in romantic love, artistic expression and mystical experience we find manifestations of exaltation and abasement, tenderness and cruelty so strangely blended. Art working through the principle of reparation re-establishes the integrity, fullness and wholeness of man's life and makes it triumph over mutilátion and death which he associates with ugliness. The term 'ugly' is applied to objects in art work that represent an imperfect integration of these discordant impulses, objects that have not been lifted, so to speak, from their customary associations in man's inner life and external relations, from mutilation and death. The distinction between pornography and art lies in this that in the latter the nude is bodily taken out of its usual context and environment, and forms part of an expressive whole in which even the lure and passion of the flesh are retained and yet perfectly blend with other qualities, interests and values, endowing them with altogether new meanings. It is thus that art can break through conventional pre-possession and transfigure what is discordant, repulsive or frightful. It is art alone which can fuse the incompatible and antagonistic impulses into a unity in which every impulse is retained without loss of its emotional content, the devices of art being such that those impulses which excite disgust or horror in the conscious mind seem necessary and even reasonable. Man would not have, to be sure, imaged his mind and externalised his discordant urges within him in art work but for the fact that his self is divided within itself and that his artistic expression of himself is the only way towards an integration and synthesis of impulses for securing his peace of mind. Thus we can comprehend artistic apprehension and expression better in terms of the integration or harmonious blending of the various primordial unconscious urges than as manifestations of the single tendencies. In all great forms of art we have, indeed, a co-ordination of man's discordant impulses and their reconciliation in an ordered single response. It is this reconciliation or integration which not only supplies an effective and enduring relief from emotional stresses and strains and thereby gives the artist sanity, insight and joy, but also the overmastering energy to immediate expressive activities.

1 Melanie Klein, Infantile Anxiety-Situations Reflected in a work of Art and in the Creative Impulse, *The International Journal of Psycho-analysis*, Vol. X, 436, Part 3. See also John Rickman: Nature of Ugliness and the Creative Impulse, the same *Journal*, Vol. XXI, 294, described by the writer as a marginal note to the former paper.

The Social Implications of Psychic Integration

Integration involves the complex system of processes described in psycho-analytic literature as symbolisation, phantasy-making and sublimation. Art shows many feelings and emotions expressed in disguised form as phantasies. This disguise is often subtle, elaborate and refined, but sometimes the repressed tendencies, though these reappear in their symbolic transformations, can clearly be discerned in their coarseness uninhibited by social influences and the traditions of art. Thus the painting of the nude, which is sexual sublimation, becomes pornography; or there is a more hidden yet coarse rendering of the sexual motif, as in some Sur-realist pictures. The difference between a neurotic, an unsuccessful artist and a consummate master consists in the degree of achievement of inhibition and control of anxiety through the subjective creative processes. The neurotic segregates himself from society, and in his inner life suffers from psychic segregation. There are the repressed instincts and desires which stand out in open rebellion against a feeble will. On the other hand, there are the neuroses of fear and anxiety, reminders of the power of the society or collectivity. The neurotic accepts neither the society nor his own personality, and his immediate expressions, the dreams and delusions give us the picture of a will unable to control his instincts and desires that yet cannot run out their rebellious course. The artist overcomes the psychical conflict through an effort which may be described as æsthetic contemplation. This effort sets his creative expression both above society and ego. The phantasy which is the result of the artist's deliberate play and constructiveness lifts the constructed object out of the boundaries of his own ego and of society. Thus what he creates out of mastering his inner stresses and strains is far removed from them and becomes objective and universal. Therein lies the disinterestedness of all æsthetic experience. The artist refashions his wishes and emotions through fusion with his reason, judgment and experience; the constructed object is characterised by impersonality, breadth and distance. The creations of art exhibit both passionate intensity and dispassionate insight, concreteness as well as universality.

Now the major cause of the psychic stresses and strains of both the neurotic and the artist is the rigidity of social codes and conventions which compel the individual to check the impulses by too drastic repression. Artists at the height of their achievement resolve the psychical conflicts in their ideological experiences in such manner as to offer many distracted individuals effective guidance in the choice of social values and personal adjustment and organisation. The ideological experiences, because these are above the plane of day to day achievement, acquire an unusual, impersonal and abstract character which endows them with a rich significance for myriads of people exhibiting a variety of moods, temperaments and personality problems.

The Social Function of Phantasy

The social reference of the artists' phantasy and ideological experience is obvious although there may be some who work in isolation and do not seek either the approval or disapproval of society. Even they wait for the judgment of a future generation or at least sub-consciously desire immediate social recognition. The normal man craves for human sympathy and understanding. Personality problems arise in the social background, and their solution can become effective only in the real social situation or in the ideological transformation of social life and relations in phantasy and myth-making and art work.

The artist's intolerable anxiety-neurosis which leads him to creative activity is socially determined, while the resolution of his self-created neurosis in the form of the constructed object is, in form and content, socially inspired, and in so far as it can win the approbation and understanding of society also gives him profound satisfaction. The hope of sympathetic audience, real or imaginary, keeps alive the artist's creative activity by satisfying his desires for social communication and approbation. But the mental adjustment of a neurotic and of an artist differs in degree, and not in kind, and it is not to be expected that all art will have a social reference. The mental activity governed by the artist's sub-conscious desires and phantasies which are in conflict with other tendencies in his own self or with the prevalent social pressure, may develop images, rhythms and automatic pictures which may have no meaning for anybody and have no social aspects like the delusions and hallucinations of a paranoiac. As a matter of fact, in contemporary art eccentric and arbitrary creations which do not serve as social symbols nor arouse the sympathy or understanding of fellow-beings, except a small coterie of critics and dealers are becoming more pronounced than ever before. But in art history as a whole while social influences engender psychic conflicts in the individuals calling for sublimation and integration, the symbolical transformations of the former in æsthetic contemplation themselves become the foci of constructive social changes in the life of the people. Thus art has been through the ages an indispensable and powerful agency of social suggestion, control and guidance.

The Origin and Meaning of Art in Society

Art is an end-product of the creative activity of imagination that springs from the give-and-take between the individual and the society, and involves at every stage personal social adjustments. It is a universal social reality that is at once an expression of the summit of the individual's creative will and aspiration and of the vitality and achievement of a whole tradition or civilisation. Art is an integrated total experience brought about by the fusion of the individual's feelings and strivings with social values, judgment and experience. It is through art that the solitary or rebellious individual restores himself to the

community, or socialises himself, and society becomes a constant presence in the fluctuating life of the feelings and emotions of the individual. In art the individual accepts the social norm as his own wish, and society accepts the individual's feeling and expression as its own legitimate dream or aspiration. All this can be clarified only by an analysis of

1. the social and the ideological background of the artist;
2. the individual artist's original or novel achievement and the art tradition;
3. the form, motif and theme of art in relation to the precise social historical setting; and
4. the acceptance or unpopularity of the art object.

These separate fields of enquiry comprise the subject-matter of the sociology of art.

(1) Each artist is largely socially conditioned. His social contacts and cultural relationships govern his achievement at each stage of his career. Both the subject-matter and form of art are derived by the artist from selection out of the raw materials of myth and metaphysics as well as the contemporary social environment and the symbols and patterns in which the art is found. Primitive art was closely associated with the economic toil, magic, religion and war, and entirely subserved the social ends of primitive communities. Their dances of sowing, harvesting and war, their magical rites and ceremonies or their funeral observances were all provoked by their most intense needs and experiences. Rhythm and decoration here served the all-important function of introducing social values in such integral tribal experiences in the manner that was most attractive and impressive. The appeal to the senses and to the sensuous imagination aroused emotional thrill, wonder, admiration or awe according to the situations, and tided the primitive group over psychological strains and crises. Dance and chorus, pageant and drama arose in the history of civilisation out of rituals and observances that dominated the interests of a tribe, a community or a whole culture. For long periods in the history of culture, in Egypt, in India, in Greece and in Christian Europe, sculpture and architecture served a religion that captured the imagination of a people and expressed certain universal moods, aspirations and values. The evolution of art is thus the evolution of mankind's social values and aspirations, as these are objectified and visualised in works of art. In ancient Hellas as contrasted with medieval or modern Europe religion caused less inhibitions and repressions and more fulfilments, and Greek art was relatively less fettered in expressing the generic biological values of human life, while it hardly responded to the supersensible world, true to the Hellenic temperament and intellectual climate. In ancient and medieval India there was also less repression of sex, and consequently

we find Indian art portraying the universal physical or biological motivations and values, unlike the art of the Christian European world which witnessed a rigorous repression of fundamental urges and interests. While European art either became largely compensatory for the inhibited urges, or showed more of a revolt than moralised repression and sublimation, Indian art not only dealt frankly and sanely with the unconscious tendencies of human nature, but also revealed a transcendent and metaphysical sublimation. Thus the revelation of universal values by art, in the higher ranges of culture, may be direct and structural or indirect and compensatory, according to the strength of the mechanisms of expression and repression in society. The artist's own attitude towards expression or sublimation is in short determined by the compulsives of his age and cultural environment.

But the artist also refashions and interprets moral codes and social values, and leads the protest against the rigours and repressions that religions, moral and social codes, impose upon the masses of mankind. All true art work is characterised by tranquillity, the outcome of complete integration of the dominant instincts and emotions of the individual and his geographical and historical milieu. The individual artist in order to find this poise sometimes has to protest against the turbulence and emotional excesses of his age as in the work of Phidias and Michael Angelo, or against the religiosity and passivity of the surrounding crowd as in the frescoes of Ajanta and the bas reliefs at Borobodur and Angkor Vat. Neither the serenity of the statues of Phidias nor the moral grandeur of the style of Michael Angelo can be understood without pondering over the civil disorder and confusion in Hellas and in Athens in particular or the crassness, vulgarity and depravity of morals in the Italian cities. Similarly the graceful langour and sinuous heaviness of the feminine figures and the lush bounty of the earth at Ajanta, the voluptuousness of the flower-garlanded, female devotees at Borobodur and of the dancing apsaras at Angkor that appear endlessly on every wall can only be appreciated in the background of the asceticism and abjuration of all desires and emotions of Buddhism and Sivaism. At Ajanta, Amaravati and Borobodur art could also without any hesitation extol the beauty of women and the delights of the senses, because in Buddhist theology the Bodhisattva is the ruler and king among men, the lord of the riches and pleasures of the world that however do not enmesh him for he seeks the highest wisdom. On the other hand, in the Cathedrals of Renaissance Italy the seductive figures of the angels and Madonnas in the frescoes were entirely incompatible with the Biblical tradition and spirit of Christianity. The master-artist in Indian and Colonial art was not fettered by tradition and theology in expressing the deeper human emotions and experiences that transcend creed and ritual. The persistent revolt of the human spirit against the commonplace emotions and values of the age is also powerfully expressed in the art of Rembrandt where we find at once the frugality and

homely virtues of the wealthy Dutch burghers and the cry of the poor, diseased and oppressed of the slums and ghettos of Amsterdam.

Great works of art show in this manner an almost divine sense of proportion of values, a feeling for the universal and impersonal that make these cherished treasures for all epochs and countries. A people or civilisation, great or undistinguished, leaves behind in its art not its most persistent and its most real desires, interests and passions, but as these may be reordered and reoriented in the larger and more profound conscience and intelligence of humanity. It is in this sense that a people, epoch or civilisation is immortalised in its art. On the other hand, art exhibits at the same time the secret protest that the dominant passions, interests and attitudes of the age or people arouse in its most sensitive souls. In the history of the literary arts the artist has indeed been, on the whole, an innovator and a revolutionary. In the plastic arts, however, the departure from socially established patterns has been more limited. But as new faiths and values of life have established themselves, and sponsored new ways of living for a people, art has played its rôle as their imaginative defender and propagandist.

Art is not only based on the religious and moral foundations of the epoch or the community, but also on its economic structure. The nature of the economy, agricultural-communal and mechanical-capitalistic, the distribution of surplus wealth and leisure, and the relations of the social classes to each other largely define both the form and emotional contents of art. The influence of the economic factors is, again, indirect rather than direct; since the art form and emphasis are almost as frequently as otherwise compensations for, rather than expressions of, the prevalent economic milieu. Finally, group organisation and attitudes, taboos and religious scruples and other elements of the culture-complex govern tastes and nourish or discourage particular art form and styles. At the same time the taste, the art-form and the style that are socially created and approved become associated with the cultural manifestation of a particular nation or race and become powerful factors in social control.

The Eternal and Universal Values in Art

It is thus that social, cultural and religious change and economic relations of the classes of a country or period are reflected in literature and painting, sculpture and architecture. At the same time the artist reaches out to universal attitudes and values which may have no reference to the social and economic movements of his environment. A form of art characterised by a high degree of disinterestedness of experience and dissociation from the real and the material is usually described as 'Expressionist'. In India and China the ancient emphasis in religion and ethics on meditation, abstraction and absorption with the mood created by nature provides the background of an art in which

the tendency towards symbolism and the spiritual interpretation of something general or universal are the leading notes. Symbols, archetypes and conventionalisations of technique have aided Oriental art in developing its expressionist features. In the West the Christian art of the Middle Ages and the art movement of the twentieth century have been equally expressionist, the former under the influence of religion, and the latter under the emotional stress of personal disorganisation, caused by insecurity associated with the recent phase of capitalistic-industrial structure and the unsettlement and unemployment after the last Great War. Expressionism in Oriental art has had a smooth and consistent development through the centuries due to art expressing the universal by way of a metaphysical or æsthetic theory. The Oriental artist even though hedged in by highly conventionalised symbols, motifs and techniques, has depended upon his capacity for meditation to invoke and express the universal in his art forms. His inner realisation is aided by the long history of myth, allegory and symbolism, on the one hand, and the ever-recurring, timeless and spaceless archetypes of Oriental art such as the figures of Buddha, Bodhisattva, Siva or Sakti or typical landscapes that all express the great spirit of the eternal and the universal. Symbolism or allegory implies the personification of abstract ideas and hence for their artistic expression the employment of intellectual means has not become a drag on expressionist art forms because of the profound and sincere conviction of the universal qualities of idea, mood and attitude that rest on contemplation underlying all art-work. Thus the Oriental artist in spite of his legacy of myths, symbols, allegories and conventionalisations of art motifs and techniques has not been impeded in his scope for expression of the deeper traits of humanity that belong to all epochs and all countries.

Expressionist Art Forms in the East and the West

The modern expressionist artist in Europe and America, however, is largely left to his own intellectual and emotional resources for the expression of universal moods. His science, metaphysics and religion are of little aid to him in offering him symbols, allegories or techniques which may serve as vehicles of expression of inner realisation or synthesis. Thus the development of expressionist art in the West is uncertain and chequered. Yet the expressionism of the modern Western artist is of tremendous social significance as representing a phase in art-history that has weaned itself from the tradition of the last three centuries of the artist offering his complete homage to his subjective moods and attitudes and naturalistic-realistic interpretation of the world.

It will thus appear that the major formative movements of thought, emotion or action in the East and in the West, such as Buddhism, Hindu revivalism, the Renaissance, the Romantic revival and machine-technology are associated with

characteristic expressions in art-forms and motifs that can only be understood and interpreted in the contexts of those movements. Mankind will be immensely richer, intellectually and emotionally, if there can be a borrowing, interpenetration and synthesis of universal social symbols and expressions in art that have been associated with the various peaks of intellectual and emotive life in the history of civilisation. With a deeper æsthetic apprehension and more practical syncretism mankind can deepen its æsthetic consciousness, and open out new vistas of creative activity through the reciprocal influence and assimilation of the generic motifs, symbols and patterns of beauty in Indian, Chinese, Japanese, Christian and modern European art, and of their divergent techniques and procedures. It is the task of comparative sociology of art to show the significance of art-forms of different cultures and epochs in respect of their expression of universal social attitudes and norms, and thus enable mankind to mutually correct and enlarge its æsthetic perception and seek synoptically the entire gamut of æsthetic intuitions and experiences of the great masters in the world-history of art.

Art and Individual Temperament

(2) Psychologists in Germany have shown by experimental methods that in the case of artists, as of children, perception and imagination (or memory imagery) are not sharply differentiated as among normal individuals and adults. Many artists have experiences intermediate between imagination and sensation, and these intermediate forms are experienced as something external. It is this intensive eidetic or visual imagery which underlies most art work.[1] Some psychologists, again, emphasise the psychopathic aspects of artists. They believe that the psychopathic constitution tends towards artistic achievement because the intense and powerful activity with which it is accompanied results in experiences which others do not have; it causes maladjustment to the environment and hence suffering and pain, and leads on to dream and phantasy which stimulate art-work. Apart from the common mental characteristic there are differences of temperament of artists. Modern psychological investigations show that there are fundamental differences in man's temperament and character, rooted in his physiology, that find expression in art styles. These have been studied by Jung, Krestchmer and others who distinguish several basic types of temperament. Krestchmer classifies individuals according to cycloid (hypomanic and depressive) and schizoid (hyperæsthetic and anæsthetic) temperaments, and even goes on to analyse the psychological components of modern expressionism in art, all of which he describes as typically 'schizothymic'. The social milieu or ideology of the time may encourage one type of artistic temperament and discourage or repress another type, but since different art-styles have a basis in the corresponding

1 See Max Dessoir: Æsthetics and the Philosophy of Art in Schaub: *Philosophy Today*.

physiological and endocrinological features of the individual these would persist from epoch to epoch and country to country, and if we study the world history of art there will be found in fact more marked resemblance between the same recurrent psychological types of artists in different epochs than there may exist between different types in the same epoch. The contrasted styles of art springing from fundamental differences of the artist's nature and moods may be broadly designated as 'realism' and 'expressionism'. Imitation of nature, stress of immediate experience of the sensible world and of the quality of man's subjective moods and tensions are the universal features of realistic art through the ages. Withdrawal from nature and the sensible world, extremely formal representation and stress of the quality of man's universal moods and sentiments are the features of expressionism. Elements of realism and expressionism intermingle in all epochs; yet such differentiation of art-styles according to psychological categories is valuable in understanding the art-motivations, ideologies and 'spiritual climate' of particular epochs and peoples and the unique contributions of individual artists whose temperaments leave an indelible stamp on their art-works in spite of the predilections and repressions of the community or epoch. It is the talented artist's individual character and distinct way of thought and vision which add something peculiar to his epoch and country that cannot be expressed at the time and in that manner by any other individual. This is a common feature of æsthetic and religious experience. For every mystic the revelation of the same but inexhaustible Divine love, goodness and holiness is unique, and even peculiar in different phases of his own spiritual development. Similarly, every artist's realisation and expression of the same order, unity and rhythm is ever-fresh and unique, thus contributing something of his own to the artistic legacy of the past.

The Symbolical Intention of Motifs and Techniques

(3) The style, symbol, motif and content of the art-object, regarded even independently of the artist, are social products, a culmination of a long series of creative inventions, techniques and achievements, and essentially serve the social purpose of the medium of expression or communication appropriate for particular subjects. A master-artist, whether a painter or a sculptor, incorporates the art-tradition into the personal vision and expression in such manner as to develop a new tradition himself for the future generation of artists. It is in art-work that society encounters the first stirrings of revolt and the first intimation of a better order. A soulless adherence to the old style and familiar theme makes art eclectic, academic and stereotyped although it delights a large section of the spectators that prefer to shun the unfamiliar. Even amongst them familiarity breeds antagonism. On the other hand, a wide and sudden departure from the art-tradition without reference to the social setting leads

to eccentricity. Both are unfavourable to the vital continuity of artistic experience.

Artistic achievement depends as much upon new technical procedure as upon personal vision, both co-operating to produce fresh expressions and rhythms, aided by the progress of the arts, on the one hand, and new currents of humanitarianism and social idealism in the country, on the other. In India, the stylized treatment of image-making, which later on acquired rigidity due to the prescriptions of the Silpa Sastras, was not incompatible with individual freedom and experimentation, especially in epochs of humanism and of the prevalence of Bhakti-cults with their stronger appeals to human moods. Moreover the figuring of the minor deities, vehicles, gandharvas, vegetal and cloud motifs etc., in the same framework or the treatment of numerous myths and legends, Buddhist and Hindu, permitted naturalistic experiments in Indian art. In Greece the Xoanœn form was retained longer for cult statues than for other kinds due to the strong religious art-tradition. Similarly the early Renaissance painters used a formalised outline for the features of the Madonna, while making naturalistic experiments in the background.[1] In the sculptured figures of Christ, Madonna and the saints in Gothic art there was a happy blend of stylized and free treatment while naturalism was displayed in great lavishness in the representation of plants, flowers, animals and gargoyles.

Nowhere, therefore, does the sway of hieratic art-traditions that gather accumulated emotions or the injunction of priestly groups completely overcome the endeavour to discover new standards and forms of beauty. In the Orient technical procedures, however, have a symbolical significance not met with in the West. Thus in Chinese art allegory or personification of abstract ideas finds little place, but symbolism is more deeply inherent in the structural or in the technical means employed : "the brush strokes of Chinese painting are equivalent to or completely allied with the brush strokes of "calligraphy". The point of departure becomes calligraphy which through a subtle combination of idea and form in the individual ideogram carries an ever-present symbolic intention. The sweep of the pure, simple Chinese ink-line, sometimes deliberately left in suspense or blurred in haze in wash over a distance, the treatment of the foliage by brush-drawing over a mass of ink, the phantom-like aspect of the mountains or water-surfaces which are merely shadowy outlines, the whole arrangement of dark masses in which the aerial impression and sense of surface are suggested in wash have all a symbolical significance in Chinese painting that has been unique in the world in presenting the psychological aspects of the landscape, at once elusive and searching.[2] In Japanese Buddhist art colours are related to the

1 Max Radin : Article on Tradition, *Encyclopaedia of the Social Sciences.*
2 Danton, *The Chinese People,* p. 187 ; Grousset: *Civilisations of the East, China,* pp. 300-304, 324-327.

different stages of contemplative ecstasy rising from the black through the blue, the yellow and the red to white, the pure and radiant source. Also colours are associated with east, west, north and south, with the seasons, musical notes, wood, fire, metal, earth, water, emotions, the senses and flavours. Such traditions are probably of Indian origin. For in the Vishnudharmottara we find a definite prescription of the use of colours in painting according to religious symbolism. Colour symbolism in Indian art underlies not only the painting of statues which according to their satvika (truth), rajasika (activity) and tamasik (ignorance) aspects had to be painted white, red and dark, but was respectively selected for rasachitras or pictures of the emotions. Thus love was painted in syama hue, anger in red, pity in gray fear in black and the supernatural in yellow colour.[1] With regard to statues of the gods, an image seated in the meditative posture of a yogi is sattvika, an image seated on a vehicle (vahana) decked with ornaments and holding weapons or showing gestures of assurance and benediction is a rajasika image; while an image in wrath and excitement in the pose of fighting and destroying the demons (asuras) is tamasika. Such is the classification given in the Sukraniti. That the use of colour symbolism is derived from a metaphysical vision is indicated in the Bharata Natya Sastra: "All is futile, the recital of mantras, the counting of beads, austerities and devotion unless one has gained the knowledge of colours, the true significance of lettering, the hue and the virtue of figures".

Physical Laws underlying Formal Composition in Art

The artist's departure from the prevalent technique, style or motif and his success or failure can best be understood by an enquiry into his place within or alongside certain social groups or schools of art. Style, technique or motif have to be judged entirely from the point of view of its success or failure in social communication. This is the so-called 'expression' of the art process, as distinct from the 'significance' of the subject-matter. No doubt the subject-matter with reference, for example, to the religious, economic and political doctrines it holds up or the moral issues it raises influences acceptance or rejection of an art-object by society or by particular classes of sets. But such social judgment is of no relevance with regard to the style or form of literary expression, painting or sculpture. The formal elements in music and poetry have their own psychological laws of universal validity governing the process of suggestion and transmission. These are now being deduced in the psychological laboratories. In painting and sculpture certain fundamental principles also have universal validity. Experimental studies in the laboratory room have yielded many interesting principles, underlying man's æsthetic pleasure in the balance of a composition and its relation to the function of his body. Thus causal laws in

1 See: Kramrisch: *Vishnudharmottara*, p. 19.

respect of man's agreeableness or sense of beauty in artistic work are being deduced with their corollaries of æsthetical prescriptions which can be learnt and exercised in a school of art.[1] The combination of blue and red is agreeable, that of blue and green disagreeable. 'The golden section of a line' is the most agreeable of all divisions. A good balance in filling the space is imperative in all drawing and painting. The balance in design is maintained by a proper adjustment of weights around a centre of the composition. All great paintings show some kind of marvellous approximation to a circle, an ellipse, a square, a cube, a pyramid, a hexagon or any other symmetrical geometrical figure that deeply satisfies the human mind. In the same painting different parts may suggest different geometric shapes and the intricate web of figures with their stress of curves, diagonals, verticals and horizontals form a fine architectonic ensemble that even when deprived of the subject-interest retains in its abstract form a profound agreeableness.

Broadly speaking, artistic organisation in painting represents either equipoise or movement according to the subject-matter, purpose and personality of the artist. The horizontal line implies the conquest of life by the force of gravitation, the rest of sleep or death; the vertical expresses the firm assurance of the conquest of nature or the hostile forces of environment by life. Thus stability or poise is expressed by the stress of vertical and horizontal lines and quadrilaterals. Straight lines, whether vertical or horizontal, stand for poise and restfulness. All life, growth and movement, whether vegetative, animal or human, on the other hand, reveal themselves not in straight lines but in swaying action or movement, by the stress of curvilinear forms and sharp lines, diagonals and triangles. Curves, concave and convex lines in alteration, express life's pulsating rhythms and movements. The angles stand in between. The triangle shows the movement in abstraction. The diagonal represents the direction of the movement. Stability and repose rest on the disposition of lines and rectilinear forms in the pattern of composition; tension and action are revealed by the grouping of curves and curvilinear forms that indicate change as well as the eventual completion or return of movement in the direction in which it is set. All lines and curves, rectilinear or curvilinear forms symbolise distinct moods and experiences rooted in man's physical and organic adjustments as a bipedal creature constantly seeking balance, symmetry and power against the force of gravitation. Who can forget the tranquillity and silence in Giotto's 'Obsequies of St. Francis', Leonardo da Vinci's 'Last Supper', Perugino's 'Crucifixion', Poussin's 'Shepherds in Arcady' or Deineka's 'Defence of Petrograd' in all of which the quadrilateral outline of the composition is combined with the horizontals and verticals at right angles to one another? In striking contrast with the static artistic organisation

1 For a discussion of these see Münsterberg: *Psychology and Life*, pp. 152-162; also Woodworth: *Experimental Psychology*, chapter on Æsthetics.

of these masterpieces that produce a mood of repose, even if these be dissociated from their subject-interest (as in the case of Perugino's Crucifixion where the subject-matter is dramatic and poignant), is the animated rhythm of Giovanni da Bologna's 'Rape of the Sabines', Tintoretto's 'Bacchus and Ariadne,' Rubens' 'Rape of the Daughters of Leucippus' and El Greco's 'The Cleansing of the Temple', 'Descent of the Holy Ghost' and 'The Opening of the Fifth Seal'. In these cases the tension, agitation or confusion are skilfully achieved by the break in circular, elliptical or spiral forms and sharp triangles pregnant with violent motions often in contrary directions. A perfect and complete movement is a circle thus expressing equipoise as illustrated in the basic compositional pattern of Botticelli's 'Madonna of the Magnificat', Renoir's 'Seated Woman' or Kuznetsov's 'Cotton Picking'. On the other hand, the spiral represents movement that is carried on indefinitely towards the vista beyond as in Titian's 'Bacchus and Ariadne' and Greco's 'Assumption of the Virgin'. Intersecting diagonal lines and acute angles produce animation and excitement just as strong verticals or horizontals parallel to one another produce perfect quiet and ease. A symmetrical balance in the composition is also often resorted to for the expression of violent emotions and movements as in several of the paintings of Tintoretto and Rubens. In Rubens and Greco, the contrasts of concentrated emotional intensity in the realms of the flesh and of the spirit are chiefly in spacing and colours, the compositional pattern in each case being characterised by the dominant motifs of swift lines, sharp triangles, long diagonals and incomplete and swirling curvilinear figures organised in space with agitated rhythms.

It is noteworthy that in painting in the Orient where life is restrained, serene and slow the structural basis of the composition is characterised largely by horizontality and verticality and not by the disposition of curvilinear forms that build themselves into exciting patterns of movement revealing change, violence and tension in the masterpieces of the West where art like life is swift, stream-lined and clamorous. The social values and attitudes of Oriental, Egyptian and modern European culture govern the dominant forms of construction in art for the record of stability or change, restfulness or exitement. An analysis of the composition of the masterpieces of Indian painting exhibits the dominance of motifs of horizontals, verticals and global forms recording moods of restfulness, devotion and minimum tension. A remarkable effect of serenity and pregnant silence has been produced, for instance, by the blend of horizontality and verticality in the well-known Rajput painting of 'Siva and Parvati' of the School of Kangra, now in Boston and reproduced in Ganguly's Masterpieces. In the smooth extension of the spacious tiger skin, in Parvati's reclining pose and in the shore line of the mountain lake, we have the stress of repose, associated with Siva's confiding the secret of immortality to Parvati, while the latter falls asleep

exhausted as the exposition continues for twelve years. The verticality of Siva's own posture and of that of his emblem, the trident, aspiring straight up at right angles to the seat brings into relief the grim tranquillity and austerity of the whole scene, whence all animation has been excluded by Siva's injunction. A strikingly different motif utilised for the expression of cosmic quiet is the arrangement of three concentric cycles in the religious fresco, Rasamandala of Jaipur in Rajputana. In the centre, which is the object of concentration for the worshipper, dance the divine pair, Krishna and Radha, to whom are dedicated the specific gestures and attitudes of each of the infinite number of damsels, symbolising human souls yearning for the infinite. These 'sixteen thousand' Gopis are all interlinked and oriented within the gradually expanding circumferences of the moving circles that owe their rhythm and unison to the central dancing figures. The moonlight Rasa-dance of Krishna and Radha symbolises rest in movement. In Indian metaphysics and art, movement in rest is illustrated by the dance of Siva, of which we have a glorious painting by the School of Kangra in the Tagore collection. The formal pattern here is composed by three sweeping curves bearing with them the bowing and swaying gestures and movements of gods, goddesses, saints, gandharvas and kinnaras that all converge from different directions in the dancing pose of Siva at the centre. The stiff verticality of the pose of the Goddess, seated on her lotus throne with its sharp edges, and of all her female attendants that yet form parts of the curvilinear movement, reveals the immobility of the Primordial Spirit of Nature that she represents as the co-partner of Siva in the world-process. There is no real intercommunication between the votaries of Siva and of his consort even though the central figure of the dancing Siva lends a cohesion to the two sections of the painting that stand for two divergent metaphysical entities—the contrasted elements in the scheme of the universe. Like Greco's painting of 'The Pentecost', which it strikingly resembles in the structure of composition, this Indian painting has achieved a remarkable success in the handling of both formal principles and metaphysical notions with unparalleled profundity, vitality and variety. Smooth, sweeping curves and diagonals represent the dominant motifs in the heroic scene of 'Krishna's Quelling of the Serpent Kaliya'. The trepidation of the wives of the Serpent, and of the parents and gopis, due to different causes, is reflected in the curves of Krishna's dance and the writhing body of the vanquished Serpent, of the shore-line of the lagoon and the landscape and of the agitated crowd on the bank. The motifs of curvilinear forms, diagonals and sharp angles in the expression of tension and movement are also superbly illustrated in 'Vishnu riding on Garuda', 'Kali', 'Krishna crying for the Moon', 'Hori-Lila', 'Gai-Charan Lila', and the 'Expectant Beloved' among the Rajput master-pieces.

It should be stressed, however, that due to the smooth tenor of Indian life, in spite of animation there is no tumult, and thus the excited movement of the motifs in composition is often checked by the interplay of some verticals, horizontals or rectangles that serve as foils. Yet in both European and Indian art, the structural basis of the composition is similar, while the spacing and colouring in each case, giving weight to one part of the picture or another, reinforce the balance of the composition, producing the effect of greater stability or restlessness through the smoothness or the abruptness of transitions from colour to colour and from light to dark respectively.

Such effects are of course rooted in man's basic biological and spatial adjustments with which are associated specific dispositions, feelings and moods moulded and reinforced by social experience or habitual complexes. In Gestalt psychology there are the well-known laws of simplicity, closure, pregnance, balance and proportional grouping in perception. Along with symmetry and closure Wertheimer mentions also the principle of the "good curve." Forms that are incomplete, distorted or unusual or that have weights and attractions on each side, that are ill-distributed, acute angles that speed down an incline, lines that suddenly stop or are attacked by other lines produce a strong tendency towards closure and homogeneity of direction and parts, because of the disagreeableness of their incompleteness and the consequent jeopardy to the organisation of thought-structure. Hence such abortive forms express tension and violence. On the other hand, "closed areas are more stable," observes Koffka. Complete squares and circles and other global forms, right angles and parallel straight lines that constitute a compositional pattern arouse a sense of restfulness, poise and formality. This is apparently because there is a natural tendency or "inner necessity" (Wertheimer) towards wholeness, continuity and symmetry in perceptual form and thought-structure, bound up with balance, equilibrium and minimum tension. Such condition of equilibrium holds good also of other continuous physical systems, drops of water, soap bubbles, crystals or electric networks that all gravitate towards good or pregnant figures. In human perception and motor activity an incomplete or imperfect figure means unbalanced brain tension, while a good Gestalt means equilibrium, and therefore the brain response to what is presented gravitates towards completeness, regularity and perfection of figure.[1]

This pervasive tendency asserts itself in the social consciousness, determining fairly uniform group reactions to similar compositional patterns in art. Such principles of perception and thought are no doubt strengthened by social experience since art deals with sets of common symbols of structuration. These

1 Cf. Ellis: *A Source-book of Gestalt Psychology*, section from Wertheimer, pp. 71-79. Woodworth: *Contemporary Schools of Psychology*, p. 117; and Eysenck: The Experimental Study of the 'Good Gestalt', *Psychological Review*, 1942, pp. 344-364.

underlie the structural basis of composition whether in painting, sculpture or architecture, aiding the observer to come in harmony with the purpose of the artist. It is only thus we can explain the correspondence of forms of design in thousands of paintings belonging to different peoples and epochs. It is astonishing that famous works separated by ages exhibit similar and even identical forms of construction. This exemplifies in the history of art the universal validity of the principles that underlie the "whole properties" of a composition such as symmetry, equilibrium and closure, arousing similar meanings and sentiments and in fact satisfying certain deep-seated generic tendencies in human nature.

In contemporary abstract and non-figurative art, freed from the limitations of given forms of natural objects, we now notice a profound sense of spatial relationship and contrasted values that carry painting to unfamiliar revelations of proportion and rhythm. The artist in his development of formal values is here guided solely by the archetypal forms that exist in his creative imagination to which he has to conform most rigorously. The slightest deviation from these would be a serious artistic blunder. In a sense, therefore, abstract art is more restricted within its own field than representational art. The archetypal images of both rhythmic forms and colours, that are unfamiliar and yet profoundly satisfying, are in non-figurative art produced without reference to any naturalistic requirements. In fact the artist of the abstract school uses shapes and colours and combinations of tones like the notes of music in completely liberated forms so as to evoke and consolidate distinctive moods.[1] It is largely due to the development of abstract art, freely using lines and tones according to the principles derived by creative intuition that are yet as rigid and absolute as any holding in the realm of figurative or representational art, that man's sense of scale and organisation and of intensity of colours has been profoundly enriched in the modern epoch. In no age, indeed, has there been greater significance attached to the appreciation and utilization of the formal and basic elements in art to the maximum advantage. It is now also considered even possible that we might have a few mathematical equations that may be sufficient to account for most if not all of the properties that are æsthetically delightful. Aesthetic canons are thus formulated having universal validity and a natural basis in the physical laws governing all arrangement of forms in the process of the transformation of matter and energy. Lines and colours affect each other with almost mathematical exactitude; while depth, movement and rhythm function according to special laws. These belong to the fields of physics and technology and bear little relation to the essential human needs that different forms of art fulfil. Many art

1 According to the famous modern sculptor Henry Moore, there are universal shapes to which everybody is subconsciously conditioned and to which they can respond if their conscious control does not shut them off.

critics now pursue this line of investigation of formal relations in art although they recognise the indescribable subtlety with which the generic compositional patterns are combined and modified by artistic genius. Thus new formal patterns emerge in art in the same manner as new mathematical methods and equations through the application of the same principles of mathematics.[1] Herbert Read stresses that if we can get down to the anatomy of a work of art we will come across certain elementary proportions and harmonies involving merely questions of balance or symmetry, or infinitely complicated and subtle ones that always correspond to the proportions assumed by matter under the influence of physical laws. Thus it is possible to resolve the composition of an art work into universal laws and equations like those D'Arcy Thompson discovered in natural forms in his remarkable work on "Growth and Form," and which would appeal to man's æsthetic sensibility. The symmetry of snow and sugar crystals, of the shape of leaves, flowers and branches of trees, of the myriad manifestations of growth of cells, tissues, muscles and bones of animals, of the structure of a bee-hive, termitary and bird's nest, obeys physical laws analogous to those of the formal composition and pattern of painting and sculpture, the artist being guided in his creative impulses by the identical physical laws under which all forms are shaped in the transformation of matter.[2]

Perceptual Laws of Harmony underlying Art Forms and Patterns

The artist with his greater sensibility to objective forms and relations exemplifies in his work the fine and infinite configurations and patterns, unities and harmonies that are found in nature. From the standpoint of Gestalt the whole of nature is, indeed, a series of hierarchy of unit-forms, Gestalten. It is the physical laws governing the form or pattern of matter in transformation that emerge in the mind in those laws of perception, dictated, according to Gestalt psychologists, by external forms that are given or found. This is what Koffka implies when he observes that all perception is artistic. In fact the fundamental principles of beauty such as unity in variety, harmony, symmetry, balance, sense of proportion and concord are derived from the fundamental laws of perception. Perception, according to the Gestalt psychologists implies simplification and articulation at the same time which are therefore regarded as the properties of a 'good Gestalt'. This is verified by the experience that in the mind at the earliest moment of relaxation or fatigue these primal unit-forms that transcend the individual associative processes spontaneously assert themselves as against those to which it may be habituated in daily experience. The 'good Gestalt', observes H. J. Eysenck, "creates the most symmetrical, the

1 Cf. Craven: *Men of Art;* Ghyka: *Esthetique des Proportions dans la Nature et dans des Arts;* also Greene. *The Arts and the Art of Criticism,* pp. 207-210.

2 For certain interesting hypotheses, see Read: *Education Through Art,* pp. 187-195.

most balanced, the most beautiful mental picture which is possible under the external circumstances obtaining at the moment; conversely, these external stimuli will be judged the most beautiful which are in most agreement with the internal forces of perception." Experimental findings no doubt abundantly testify to certain intrinsic laws of objective proportions that govern perception. The experimental work of the Gestalt psychologists in the field of perception, indeed, reveals that visual forms tend to group themselves in determinate ways. Wertheimer, Kohler and Koffka have found evidence of the dictation to perception of external forms and certain laws of harmony that underlie spatial grouping. "There are certain forcefully directed pervading lines which assert themselves very powerfully to vision and will insist upon being completed even though by so doing they destroy the integrity of other less stable near-by forms. Some forms have the tendency to draw neighbouring lines towards them; zones of influence Wertheimer calls these. The right angle is such a form, and yet this is said to occur as such very rarely in experience. There is a tendency for certain lines to become enclosed, thereby affecting certain forms. Different forms have different intrinsic manners of movement".[1] Two figures may be interlinked by the "good curve". Certain subsidiary forms represent good additions as 'pro-structural' or 'contra-structural' relative to the original. The similarity, harmony and contrast of colours aid or obstruct the "logically demanded" pattern. Campbell stresses that these principles of visual perception revealed by the Gestalt experiments are considered in the construction of all great works of art. For example, the laws of proportional grouping, of visual grouping by similarity of pervading lines and forms, of tendency to closure, of objective balance; these are discernible in the world's great masterpieces of painting. Adherence to the objective laws of the relationships of external forms is also illustrated by the painter's 'distortion' of human figures for the sake of plastic designs as illustrated in the art of Egypt, the pottery designs of the Greeks and the works of Giotto, El Greco, and Cezanne. The Gestalt experiments show that different "forms" vary in their "fusion" times, and these times vary according to the simplicity and firmness of the "forms". "But a geometrically simple figure need not be perceptually so; a circle will fuse at a rate that will give flicker for a triangle. Also a triangle seems to enter into larger configurational patterns with more difficulty than does a circle. Forms, which because of their frequent use in experience, might be expected to enforce themselves upon vision, often do not do so, but are easily overcome by primary tendencies of unit formation."[2]

1 I. G. Campbell : Objective Form and its Role in Æsthetics, *Proceedings of the Sixth International Congress of Philosophy*, also *Art : a Bryn Mawr Symposium*.

2 See also Eyrenck : Type Factors in Æsthetic Judgments, *British Journal of Psychology*, 1940-41, pp. 262-270.

The best paintings in their superb arrangement of vertical and horizontal lines and of triangles, diagonals and circles in their structure attain configurational unit forms that "are simply there in vision no less than colours and brightnesses", and at the same time have an intrinsic expressiveness and inherent appropriateness for the embodiment of the artistic visions. Man's profoundest vision of quiet and restfulness are expressed through the epochs in art by horizontals and verticals, pyramidal and circular figures suffused in serene, harmonious hues, while tension and exitement are revealed by the dynamic rhythm of the composition comprised by incomplete circles, curvilinear forms, irregular triangles and acute angles with palpitating colours inflaming the figures with intense vitality. The typical circular composition in sculpture is that of Siva Nataraja, the apotheosis of rest in movement. The pyramidal arrangement is illustrated in the carved image of Trimurti at Elephanta whose repose is even stiller than that of the stone. In a landscape design horizontality is stressed producing a mood of serenity, while the pyramidal pattern is most common in the paintings of the Madonna, as for instance, Leonardo da Vinci's 'Madonna and Saint Anne' and Raphael's 'Sistine Madonna', and most appropriate.[1] Every great painting or sculpture has an inevitable organic unity of design and subject, of distribution of void and substance, light and darkness that eludes an art critic. But the logical appropriateness of the design in communicating the artist's idea rests on the solid fact that all lines and curves and the geometrical figures these circumscribe and define, connect and consolidate, gravitate towards an equilibrium or completeness of form and engender either brain tension or poise. Certain lines, angles and figures familiar from natural scenes and objects and everyday experience become also associated with specific human feeling-tones and meanings with which these are associated in perception and thought. Thus the arrangement of lines and space relations, such as constituting a broken or unimpeded vertical or horizontal extension, a perfect or incomplete circle, triangle or pyramid in the basic compositional patterns in painting and sculpture, becomes invested with all the values derived from an "inner necessity" and the multitude of experiences in the concrete world of nature. Each formal organisation becomes, accordingly, congruent in emotional effect with the essential character of certain types of subject-matter in art. Social attitude and experience greatly strengthen and make definite the association of certain moods, emotions and meanings with specific formal compositions in art.

Painting is widest in its reach and range of subjects among the fine arts that vary according to the contours of a culture or epoch and the purposes of the artist. All new movement in painting is the result of the exploitation of possibilities of the use of formal patterns and colours in adaptation to human emotions and sentiments hitherto unrevealed—as the Chinese painters grasped the

1 Ethel Puffer: *The Psychology of Beauty.*

vitality and spatial rhythm of landscapes, as the Indian painters revealed the majesty and tranquillity of religious scenes, as the Dutch painters elicited the rhythm and design of household scenes and decorations, as Cezanne revealed solid forms and rhythm in nature by means of juxtaposition of colours or tones, as Van Gogh heightened human emotions by deliberate distortions and exacerbations of technique, as the Cubists split Nature into cubes, cones and cylinders for purity of expression and as the Constructivists have elicited the rhythm and intrinsic qualities of shapes and objects of the mechanical world that mould machines into men. But neither the possibilities of technique can be exhausted by description nor the subtle sensuous and emotional attractions of techniques and methods fully set forth. The elusiveness of all great art consists in achieving such subtle combination of the sensuous and decorative qualities with human meaning as is profoundly expressive in a particular setting without man being able to find out why it is so.

Higher levels of Integration of the Gestalt in Art

The more integrated the Gestalt, the better is the artistic experience. The principles of unity in variety, of structuration or articulation, of order in complexity, of integration and differentiation not only obtain in the perceptual field but also in the human meaning and experience embodied in the artistic vision. Psychology cannot reveal the deepest meaning of art as it confines itself to the framework of agreeableness or disagreeableness of perceptions and feelings that have causes and effects. True art is to be judged not from the understanding of technical rules and of their psychological effects but from the belief in over-individual meanings and values that lift the art work above the limitations of space and time, the sphere of personal moods and desires and agreeable fulfilments. The richness and nobility of æsthetic life are constituted not by the elaboration and perfection of technical procedures that may be explained by experimental psychology but by the deepest integrations of self and society. In so far as art is concerned with absolute universal meanings, values and harmonies, it transcends the methods and materials of the laboratory.

This aspect of the Gestalt comprising not only the "whole properties" compositional pattern but also the interpenetration of individual and over-individual values in artistic expression can be brought out more adequately by sociology and metaphysics. All great art no doubt reveals an integration not only of subjective feelings and moods but also an organisation of the cumulative values and experiences of individuals and societies. Its meaning lies in the richness, impersonality and universality of both individual and collective sentiments and attitudes it expresses. It embodies the fullness of the personality of the individual in its manifold dispositions, interests and experiences as well as the entire social experience of an age or culture. It is characterised by a profound synthesis

of the internal and the external in a logical whole, and in fact certain art forms developed in the East exemplify a most remarkable matching of forms and colours, notes and sounds, images and associations, emotions and ideas, meanings and values. For instance, the medieval Indian Ragamalas exhibit a subtle and harmonious blending of music (raga), painting and poetry, all in accord with man's basic emotional reactions to the eternal cycles of nature. The ragas or musical modes represent an appropriate harmony not only of sounds but also of lines, colours and shapes, and of image forms and attitudes in poetry, all elicited by and collectively tuned to nature in its procession of the seasons, the waxing and waning of the moon and the diurnal rhythm. No art work in the world has in its direct expressiveness of sense-forms in vision and audition and its matching of the latter with emotions and attitudes in poetry responded so effectively and harmoniously to the ever-recurrent rhythm of nature from season to season, from dawn, morning and noon to twilight, evening and night, and even from hour to hour. It is, indeed, a unique experiment in achieving a profound integration of the Gestalt, covering human thoughts and feelings at certain times of the day and year in the cosmic envelope that create universal artistic visions and the appropriate external sense-forms that embody such visions. These external and ever-recurrent aspects of nature build up attitudes and sentiments shared by all. Such universal and impersonal experiences, as are embodied simultaneously in the art forms of poetry, music and painting in the Ragamalas, bring about a *rapport* between man and man, and between man and nature, arousing through the reciprocal aids of sound and colour, form and imagery, emotion and meaning, an enduring æsthetic delight that is at once individual and collective, intensive and extensive.

Art and Percipient

(4) The artist seeks the understanding, sympathy and approbation of his fellow artists and fellow beings. Acceptance or rejection depends on his adherence not merely to certain æsthetic tastes and traditions, but also to political and economic doctrines and his affiliations to social groups such as the church, the nobility, the bourgeoisie, the working class, a religious organisation or political party. There is a vital give-and-take between art work and feeling-tone of the audience. As Langfeld observes: "It seems safe to say that no art form would have come into existence if it were not for the hope of the audience. It is only in this sense of permanency for social reasons that the beauty of a work of art may be considered as resting in the object, for the possible audience is presupposed and the beauty is thus a latent possibility.¹" Even if the artist's audience or spectators be very small, there is no doubt that the preferences of this small group keep alive the artist's inventiveness. Tolstoy was wrong when

1 *The Æsthetic Attitude.*

he thought immediate contagion of the percipient as a measure of artistic quality. But every artist is bound to be deeply stirred and stimulated by the hope of a prospective audience. Thus he works to create an audience which may not exist at the time. Tolstoy also stressed sincerity as the essence of originality in art work. But when he dilated upon the obligation of all artists to draw their material from the lives of the common man he indirectly encouraged insincerity. Artistic sincerity would consist in the use of those social materials on which imagination can work without limitation or compromise. Even a "proletarian" writer sometimes shows feeble dependence upon stock materials and conventional attitudes so that his work becomes altogether devoid of vitality. On the other hand, conventional restrictions in art derived from the social field greatly limit the boundaries of artistic experience and the universality of art. In the history of any art how often have current fashions and standards of taste smothered individual genius and a new pattern that deflects from the socially established, the morally conventional tradition! Thus social opinions and preferences outside the purely æsthetic field are correlated to the general tastes and æsthetic values of an epoch from which works of art are judged. On the other hand, an artist who appeals to the esoteric tastes of a small coterie or clientele develops an exaggerated individualism or eccentricity that becomes a real enemy of art by restricting its meaning almost entirely to the technical exhibition of methods and processes as contrasted with the significance of communication.

It is by carrying on sociological analysis along these four independent lines that a real æsthetic sociology can be developed. A synoptic view of the art process can emerge only out of organising the materials whether of art history, or of contemporary art movements in the four separate fields indicated above. Throughout the discussion the rôle of the individual, the class and the collectivity at each stage of the art process will be evident.

The Plea of Art for Art's Sake

The need of an æsthetic sociology has been at no time more urgent than in the modern age when in literature, music, painting and sculpture alike, certain schools of art have claimed autonomy in their search for an expression of beauty, and great thinkers have upheld the claims by adumbrating theories of art for beauty's sake. Lawrence, Eliot and Joyce in literature, the school of Sur-realists and Cubists in painting, Schoenberg in music, and Brancusi, Henry Moore and Lipschitz in sculpture have all captured the imagination of the contemporary world by their appeals to the privately personal, the subjective and the unintelligible. The conviction has gained ground that for the artist as such the subject-matter is irrelevant, and that he is only concerned with successful expression, and that his imagination in the search of a fabulous world is autonomous and unconfined. (Jolas). Many artists have in their work sought constant novelty

in expressing things that are too trivial, personal and irrational, and the public have accepted these as their guides to life, lured by the vividness, intensity and charm of expression.

In our preceding analysis we have shown that the subject-matter of art is derived from the social and the ideological background of the artist. There is selection on the part of the artist. Such selection implies the artist's subordination to the hierarchy of social values, which judges the activity of the artist as man, though not as artist. The artist as man, as the focus and transmitter of the values of life, must take upon himself the responsibility of choosing subjects that not only lend themselves to artistic treatment, but are also worthy of such treatment. In so far, then, as the artist takes recourse to contents according to his own fluctuating and often discordant moods and repressed complexes, and his emotionality and irrationality get the better of conscious selection and mature judgment and experience, his phantasies, which are made the vehicles of beauty, remain as little constructive guides to life as the reveries and delusions of a neurotic. Yet by his clearness, poignancy and charm of expression the artist lets his fears, anxieties, delusions and wish-fulfilments appear as the really significant values for society. The artist thus becomes, through the power of his suggestion, a more powerful arbiter and interpreter of values than any other agency of social control.

We have already referred to the factor of the social acceptance or rejection of work of art. Many artists deliberately or unconsciously choose contents which largely reflect popular scales of valuation, notions and wish-fulfilments. A vast mass of contemporary fiction creates characters and describes situations, emotions and behaviours which can be most easily imitated by an ever-widening circle of readers who show the greatest preference for this form of art as concrete, vivid, impulse-stirring and wish-fulfilling. How often do sadism and aggression depicted vividly and concretely and with emotional fervour in modern fiction, supply the raw materials of behaviour and postulates of thinking of readers who find in these a make-believe release of impulses that are not sanctioned by social values in actual life! Some fiction, no doubt, appeals to the lowest types of personality and behaviour on the basis of the hypocritical plea of art for art's sake. This is not legitimate art; for the artist's creative power is seriously undermined as he succumbs to considerations of profit or popularity. In fact, in no age has the danger of commercialisation of all art been greater than the present. But even where art does not deliberately prostitute itself to the lowest levels of vicarious satisfaction of sex, aggression, fear, jealousy and other strong emotions, the inhibitions and the fear and compulsion neuroses are so overwhelming that the modern novel is too full of these, and hardly represents any processes of conscious æsthetic contemplation or deliberate creation of types of beauty and will. Many contemporary Sur-realist pictures,

too, express not complete sublimations and symbolic transformations but rather morbid and fragmentary fears and obsessions.

The pseudo-artist, whether novelist or painter, does not choose his subject-matter out of his free and uninhibited experience; rather the struggling and discordant elements of his unconscious life force his choice. A prey to fears, obsessions and inhibitions, his morbid self-examining art only reveals the feebleness of his will, his vacillation in the choice of values and the uncertainty of his behaviour.

The Vital Nexus between Artist and Society

Thus the characters of modern fiction or the images and situations of modern painting often run counter to the established social values and build up through imitation personality-traits that tend to be subversive and anti-social. True art is born not of the struggle but of the integration of the emotions, of æsthetic contemplation by which the artist can secure peace with self and with society. It is then that he can exercise a wise choice of his subject-matter, a proper selection of characters, situations, expressions of emotion, symbols, and patterns of overt behaviour. It is the artist's own successful personal social adjustment, his own deep and sincere conviction of the reality of the values of life that alone can quicken the impulses to self-perfection and social or collective adaptation. For the artist's personality-adjustments, the values that he realises and establishes beyond a shadow of doubt in his own mind are not exclusively his, but these are also of the society with which he more or less consciously identifies himself. This nexus between the artist and society explains the 'empathy', the successful and prolonged commerce between art and society which keeps art alive. No true art can, therefore, remain indifferent to society's fundamental needs and values. As a matter of fact the art process and experience at their fullest and highest are integral, in which man's sense of beauty, goodness and truth is indissolubly blended and unified.

All true art has in fact to deal with questions of moral and social values, their degrees, interrelations, and hierarchy in making a selection of the contents. Such problems belong to ethics, sociology and philosophy. The modern artist is often hardly fit or trained to pass a judgment upon social values in making his selection of the subject-matter. More than in any other age contemporary art is expressing and communicating social expressions and types of personalities which are relatively emotional and irrational, unique and insignificant, rather than rational, abstract and universal.

Art as the Autobiography of Culture

True art is the autobiography of society. It expresses fully and profoundly the eternally valuable ideas, sentiments and faith of a national culture. Contemporary

11

social world is characterised by a complete chaos of man's interests and values. There is conflict between individual and individual, and between groups and the interests and values these represent. Man is uncertain of his behaviour and his choice of values as different groups and institutions, such as the family, the economic class, the church and the nation, claim his allegiance. Where society loses the co-ordination of its parts, the principle of harmony in art languishes. Thus man's search for truth, for goodness, and for beauty is sundered, and each tends to become autonomous and exclusive. Art, religion, and science accordingly now speak in discordant accents. Much of contemporary art is a refuge of minds that find no peace with self and with the environment. Disordered minds, torn by conflicts in their value-systems, seek and find art which can give the most effective vicarious satisfactions of their strong impulses and attitudes that now stand rebellious against their own selves and society. An appropriate art arises which is also morbid and irrational, but which creates for readers and spectators realms in which some peace or harmony, however ephemeral, is attainable. Nothing is more welcome than the escape from reality that is sought not merely in reverie and day-dream, but also in colourful love story and adventure, melodrama and fiction and morbid revelation of the unconscious in painting. Fantasies or delusions in art act as an opiate for over-wrought bodies and souls, or, again, there is another motive in art which has been pointed out by Bernard, that of relaxing and letting things take their course as in crying or laughing, which perhaps has not been sufficiently recognised. Some of the anarchic music of recent times, and much of jazz and free verse and "modernist" discordant art, is of this type. It is truly pathological, as is hysterical crying or laughter, but, like them, is a negative form of catharsis in the midst of an overwrought and too complex world of environmental pressures.[1] Similarly Langfeld refers to the subconscious images, dreams, visions, automatic and psycho-analytic drawings put on canvas by the Sur-realists. "As a matter of curiosity, one may be interested for the moment in the picture of a watch bent simply over the limb of a tree, or the view of Western Pennsylvania edging into the harbour of New York, but who cares vitally? Art is supposed to offer means of escape and adjustment, but who desires to adjust oneself to the meaningless imagery of another's mind?"[2] Neither spectators and readers, nor the artists themselves, can, however, obtain stable enjoyment from this type of æsthetic experience. The disorder of the social world and of the moral organisation of the community has also developed an appropriate æsthetic theory of art for beauty's sake which represents a half-truth, since no beauty is worth the expression nor is even true which does not succeed in enabling the artist to find his own poise and freedom. Accordingly,

1 Bernard: *Introduction to Social Psychology*, pp. 380-381.
2 The Place of Æsthetics in Social Psychology, *British Journal of Psychology*, Vol. XXVII, p. 144.

only a radical transformation of social conditions with a corresponding resolution of differences of idealogies and conflicts of economic interests can restore the true, rational and abstract art which may function more effectively as the most efficacious technique of social control. In an improved social organisation where a better orientation of the meanings and values of life and integration of personalities are possible, beauty, goodness and truth will reveal themselves to each individual in the same object, and will be defined in the same manner by all. Great works of Greek, Hindu and Italian art show the fusion of the beautiful with the good and the true. Such sincere, vigorous and beautiful expressions of the whole contents of national cultures were possible because of the order and stability of social life. In an ordered society even in the modern world the artist's apprehensions of beauty will carry with them moral fervour and a full participation in the throbbing life of the multitude, its joys, conflicts and destiny. Truth about human nature and the environment which science and knowledge unfold will also determine æsthetic intuitions and tastes in concrete feeling and experience, and thus abstract thought will actualise itself. The principles of art, morality and religion will be found to be aspects of a single total experience. Thus the artist will rehabilitate the principle of harmony in all things, in both human nature and in the society in which he lives and moves, and when under extraneous pressure society disturbs or challenges that harmony, the artist will realise and transmit newer harmonies and concords, guiding the multitude with the faith and vision with which he is endowed in greater measure than his fellowmen.

CHAPTER III

THE PSYCHOLOGICAL APPROACH TO ART:
ART AND THE UNCONSCIOUS

Art and Phantasy: a Comparison and a Contrast

Artistic activity exhibits in the foreground of consciousness the play and the constructive group of instincts and impulses, but in the background of the unconscious there is a mass of impulses and desires which supply both the source and the driving power of artistic creation. Their rôle is so significant that the musician, the poet, the painter and the sculptor are often described as owing their 'deep inspiration' or creative activity to the unconscious urges. It is, therefore, necessary to delve into the unconscious phases of the artist's mind for a fundamental understanding of the nature of artistic activity. Various dynamisms are at work, often in combination, in the field of the unconscious for æsthetic creation. Of these the most important are phantasy-making, symbolisation, dramatisation and sublimation. All artists are experts in skilful and organised creation of phantasy and its secondary elaboration. Such phantasies have to be distinguished from both dreams and unconscious day-dreaming or rumination. Dreams and delusions stand altogether opposed to logical and directed thinking with the co-operation of consciousness. The day-dreamer unlike the neurotic can return to directed thinking when he chooses. Conscious contemplation, involving the selection, elaboration and evaluation of wishes and aspirations plays an even more significant rôle in the case of the artist. Now, the greater the intervention of the will, the better is the organisation of the thought-structure. But all phantasies spring from repressed unconscious wishes, and thus have to be regarded as 'defences' in the sense that while the wishes cannot be gratified in the actual social life, these become acceptable for the ego in the world of imagination. All art, then, is the result of starvation, which leads to flight from the reality to a realm where abandoned or socially disapproved modes of satisfaction, emotions and behaviours may be permitted to continue. Both day-dreams and artistic creations agree in this that they are free from environmental pressures or demands of reality. Both build up compensations for repressions and starvations, and both are characterised by a deeply-rooted sense of anxiety and guilt which finds satisfaction only through pain and tragedy.

Psycho-analysts often find in phantasies, whether delusions, reveries or art forms, sadistic-masochistic components. For both normal mental life and art the substratum is supplied by the elemental forces of love and hate, creativeness and destructiveness, which are juxtaposed together in the unconscious, without

any call being made for an adjustment between them. Due to pecularities of development of man's sexual function, he combines love and hate of his own beloved objects, and at the same time undergoes torment when the latter suffer from his own aggression. Man's sense of beauty springs from the bio-psychological need to overcome the unavoidable pain and sense of guilt, associated with an instinctual fusion of purely libidinal and purely destructive impulses that is rooted in the break and "dischronous onset" (Freud) in human as contrasted with animal sexual life. Art, like all day-dream or phantasy-formation, provides consolation to man's mental torment, anxiety and guilt. Such is the psychobiological rôle of art work. But the differences between phantasy-formations and creations of art and literature are no less significant. Some of these have been analysed by Freud and his school. Freud points out that the artist, in the first place, understands how to elaborate his day-dreams, so that they lose that personal note which grates upon strange ears and become enjoyable to others; he knows too how to modify them sufficiently so that their origin in prohibited sources is not easily detected. Further, he possesses the mysterious ability to mould his particular material until it expresses the ideas of his phantasy faithfully; and then he knows how to attach to this reflection of his phantasy-life so strong a stream of pleasure that, for a time at least, the repressions are outbalanced and dispelled by it. "When he can do all this, he opens out to others the way back to the comfort and consolation of their own unconscious sources of pleasure, and so reaps their gratitude and admiration; then he has won—through his phantasy—what before he could only win in phantasy: honour, power, and the love of women".[1] Similarly Sachs tells us that phantasies show differences from art productions in that while the main personage in the day-dream in the self and has meaning only for the self, the creations of art even when they may be centered about personal interests must have meaning for many. Then, the day-dream is formless and a mixture of words and pictures intended only for immediate pleasure, but the work of art must have form, unity and clarity. Though the day-dream is often the first step in art creation, it has to be worked into form through the personality of the artist; so the artist must have gifts for self-expression which the day-dreamer does not need".[2] These differences arise out of the greater intervention of conscious will and contemplation in the case of artistic activity.

The Compromise with the Super-ego in Art

Since the creations of art and literature are intended for social communication, these must show not merely an organisation in their structure, and certain formal elements of perfect expression, but also, what is even more

1 *Introductory Lectures on Psycho-analysis*, pp. 314-5.
2 Healey, Bronner, and Bowers: *The Structure and Meaning of Psycho-analysis*, p. 273.

important, these must adopt a more subtle and a more elaborate disguise of the repressed wishes which elicit and gratify similar wishes in others. Secondly, the artist's ego re-establishes in art work harmonious relations with the Super-ego. The Super-ego in Freudian psychology is not only closely allied to 'conscience', but also with the demands of collective living in society. Freud says, "Here we have that higher nature of this Ego-ideal or Super-ego, the representative of our relation to our parents. When we were little children we knew these higher natures, we admired them and feared them; and later we took them into ourselves". Not merely identifications with the parents become important for Super-ego development, but all social taboos and prohibitions are also internalised. Thus the rigorous demands of the social environment, of religion and morality, of law and public opinion, even of superstition and etiquette all mingle in the form of the inhibitory Super-ego. The neurotic is completely unable to come to grips with the Super-ego which, therefore, engenders in him overwhelming fear and anxiety symptoms, as shown in hysteria and the compulsions. The day-dreamer in his high individualisation of conscious fantasies is too much pre-occupied with both his resistances and immediate satisfactions far removed from reality or activity. The artist finds the Super-ego more adaptable and less severe, and can easily come to a compromise with it. It is thus that the entire experience of painful prohibitions and renunciations of the race becomes focussed in the inhibitory Super-ego and so becomes incorporated into the mental life of the individual as 'conscience'. Alexander describes the Super-ego as a faculty which reflects certain phylo-genetic echoes of primitive man. This code which has become relegated to the unconscious is identical with the totemistic code of primitive peoples. Its chief prohibitions are directly in the male against the incest wish and inimical stirrings against the father. Again, he calls the Super-ego "a social faculty, one that guards the individual from the satisfaction in reality of his social wishes and even punishes him for the satisfaction of them in phantasy".

The Principles of Disguise and Tragedy in Art

 Art forms, therefore, are characterised by the operations of two distinct mechanisms subserving important functions in the economy of the artist's mind. First, art productions represent a release of tension between the repressed wishes and the Ego in the form of disguises which escape from censorship that is severe in its repression. Thus art construction, like all day-dreaming, which is manifest even in normal mental life, has an appeasing function for the artist and releases his mental energy for creation and invention. Secondly, art productions attempt to secure a compromise between the Ego and the Super-ego, the latter being "a foreign body within the Ego" and "displays least solidarity with it". Art forms seek to justify "the rancour and rigidity" of the Super-ego which,

however, remains inexorable, through creating psychical distance between the imagined situation and the ego and reality, thus allaying or eliminating the anxiety and guilt feeling. The larger the difference between the imagined situation and activity of the symbolised characters of the art work and the reality and activity of the Ego, the more successful is the co-ordination and assimilation between the two parts of the inner self, the Ego and the Super-ego, and the more enduring and comprehensive the harmony in the depths of the unconscious with their greater influence upon the mind of readers and spectators. Or, again, the artist expresses deep suffering and tragedy, emphasizing the inexorability and impersonality of the Super-ego, highly charged with the aggressions of the external world. Thus many art works exhibit the play of destructive tendencies which also arouse interest in readers and spectators and are able to invoke and gratify their similar unconscious wishes. Freud, on the basis of his Life-Death instinct hypothesis, suggests that a sadistic, hyper-moral Super-ego may be due to instinct diffusion, the Super-ego becoming "a gathering place for the death instincts". Many works of art, outside dramatic tragedy and fiction, focus the supremacy of the Death-instincts. More often man feels the paramount need of abolishing the mental pain, anxiety and guilt which he experiences from his aggressive and destructive impulses—to his good and loved objects. Art stands for the supremacy of the Life-instincts. The æsthetic feeling arises from the primordial human need of life's triumph over death.[1] Art creations pay a dual allegiance: first, allegiance to the intolerable, unconscious impulses which torment man with pain, anxiety and guilt but which the mind gets over by throwing off disguises as these appear in consciousness so that it may turn to pleasure; and secondly, allegiance to irresistible pain and tragedy. In both ways, however, whether by elaborations and syntheses of subtle disguises of the repressed wishes which elude internal censorship, and which thus represent a tribute on the part of the Ego to the Super-ego and at the same time gratify the Ego, or by stress of the irresistibility and cruelty of Super-ego, art lightens the burden of guilt and secures sanity, joy and an abundance of mental energy not only for the artist, but also for the percipient or audience and spectators. In both cases it is the social attitudes, traditions and beliefs which determine the nature and contents of the artist's phantasy, the course of opposition between the Ego and the Super-ego and the ultimate solution of the conflict, anxiety and pain so as to bring about psychical harmony and peace.

We thus see that art derives its vitality and driving power from the unconscious forces of life and mind. All great art derives its springs of inspiration

1 John Rickman emphasises the genetic connection between the sense of beauty and the creative impulses and between ugliness and the gloom and pain man experiences from the destructive impulses. See his suggestive article on Nature of Ugliness and Creative Impulse, *International Journal of Psycho-analysis*, July, 1940.

from the wells of the unconscious, its poignancy from the mind's conflicts and pains, and its poise from the integrations of the self, out of which springs its comprehensive sense of the reality. Wordsworth, Tennyson, and Rabindranath Tagore, among other poets, had experiences of emotions and intuitions from the field of the unconscious which deepened and enlarged their vision of the total reality that they sought to express through poetry. Often the mystic and the artist were merged in each other as they gave perfect expression to subliminal truths which are universal for mankind, and have eternal influence on successive generations. It is through such artists that human consciousness deepens and expands and new dimensions are brought under conscious control and directed to specific channels of art, myth-making and religion.

Man's Unconscious, the Creative Feminine in Art and Phantasy

Recently the unconscious has been coming under the purview of a number of psychologists and psychiatrists who have developed the concept in a different manner from Freud. According to Jung, the unconscious comprises two levels —the personal unconscious and the collective unconscious. The latter is "the mighty spiritual inheritance of human development, reborn in every individual constitution." For every individual, says Jung, the primordial figure discernible in the unconscious is the 'anima,' or the 'animus', which contains the greater part of the materials, that appear in dream, phantasy-making and insanity, in the mythology of gods and goddesses, in the historical religions and also in literary construction. Man's unconscious is feminine, and the woman's is masculine. The anima is the woman in a man and the animus the man in a woman. "Every man carries his Eve in himself." Artists are considered to comprise more latent female components than ordinary individuals. Recent studies on inter-sexuality, particularly that of Maranon, demand a re-definition of the terms 'male' and 'female'; for in proportion as study in sexual biology has advanced, it has been demonstrated every day more clearly that there is scarcely any human being whose sex is completely free from doubt. The evidence for such a statement is largely clinical, as is seen in the true case of a Danish painter who accidentally discovered a female *alter ego* which he developed and finally made by surgical and endocrine operation into a legally recognised functional female.[1] Man's inability to distinguish his self from the soul-image, the anima, would make him a victim of his feminine drives, moods and emotions. The way of self-knowledge and control of the emotional life is through the discovery of one's own Eve. The 'anima' is cultivated more assiduously by all artists. But the anima has a mythological and supernatural character. The great religions of Egypt and India created such mysterious, collective figures of the anima, inscrutable in their wisdom, beauty, and terribleness. In the

[1] Recent Research on Sex Differences, *Psychological Review*, Vol. 32, 1935.

Eastern religions the femininity of the Godhead is almost universally recognised. Just as man's unconscious is faminine, and is personified by the anima, so God's benignant or dreaded power is Sakti—the consort. The incompatible opposites in the self, the conscious and the unconscious, unite in the Godhead. God or the elevated self, and his Sakti, the dark, inscrutable power of the unconscious, symbolically represent a synthesis though they represent contrary and contradictory attributes. This is the general background of the ideology and iconography of gods and goddesses in Tantrik Hinduism and Buddhism throughout Asia. Some of the great poets and novelists of the world have created fascinating and strange figures of the anima upon which they have projected supernatural and transcendental qualities. Some of them are "achetypes" living almost entirely in the "other world" of the unconscious. Others belong to this world, yet remain lovely, mysterious and powerful. They combine contradictory personality traits, embracing the degraded woman and the *femme inspiratrice*, Faust's Gretchen, and the Virgin. Jung gives instances of the reconstruction of the collective pictures of the anima in Rider Haggard's 'She', Pierre Benoit's 'L' Atlantide', William Sloane's 'To Walk the Night', Edouard Schure's 'La Prêtresse d'Isis' and Ronald Frazer's 'The Flying Draper'. He considers that Rider Haggard, Pierre Benoit and Goethe, in Faust, have especially emphasised the 'historical' character of the anema.

The Artist's Femme Inspiratrice

But one of the most vivid and classical figures of the anima in literature has been given by the poet-mystic Rabindranath Tagore, who calls her the deity· of his life. She is the "soul" of his dreams, moods and inspirations, governing the poet's life through joy and sorrow and united with him through eternity in a thousand births and deaths. She is experienced by the poet in personified form, yet the poet would prefer to cherish her more in his imagination and contemplation. She is also described as belonging to the "other world", leading him to the realms of the unknown. It is to her that he has dedicated all his love; she is the intimate partner and playmate of all his dreams and creative aspirations.

THE COMPANION

"As soon as I gazed outside my cottage-door I felt that I have known thee from the past. Oh peerless playmate of my soul, my dearest one! The tinkling of thy bracelets awakens in me the familiar thrill of forgotten days. I recognise thee again in the dim twilight glow of the subconscious.

Thy loosened tresses bring back once more the intoxicating perfume of vanished yesterdays, and thy shadowy anklets ring in the yearning bowers swayed by the warm winds of April. Thy subtle beckonings are wafted into my balcony by

the balmy breeze with the blossoms of spring, and thy liquid glances charm my soul with the low-lying clouds of the rainy season.

Beloved companion of mine, you have sent your messages to me through the winds, through the waves of the swelling river, and in the lonely forest path you have called me off and on in the solitude when I was absent-minded. Do you want your playmate and wish to take him away to the vast Courtyard of your play, under the blue canopy, where there assemble all persons who have no home, nor work, nor hope. You have come back again and again to take me away from my preoccupations, and opened my door by the tinkling of your bracelets.

Have I got again to create the images of my consciousness, and my thoughts, weaned from this world, will these fly afar again in pain urged by an unknown yearning like the humming bees gold-dusted with flower pollens?

My days, alas, are ended, and my life trills the last song of the dying day. I am now a stranger in an alien land, listless and bereft of his songs. Why dost thou call me again to play with thee when the light ebbs, and the heart sinks!

Is it that my life's play is over and that our mutual search will begin afresh in the dim profundity of the lightless night? She whom I have found in the tender creeper of the early dawn, I shall find again amidst the hide and seek of the stars. The baffled desires of the day will then weave the warp and woof of nightly dreams.

Night will then have no terror for me, since I shall come to recognise thee. Though I have not seen thee, O Thou Playmate of Mine, you would not deceive me, for even in the utter darkness the swelling waves of thy living presence envelop me."

(Translated from the original Bengalee)

The World-Images of the Collective Unconscious

Jung's treatment of the concept of the unconscious differs materially from that of Freud. In every individual according to Jung, there are present besides his personal memories and the anima or animus the great 'primordial images', those potentialities of human representations of things as they have always been, inherited through the brain-structure from one generation to the next. Such are the dominants or archetypes of the collective unconscious which it is very important to be able to recognise. Chief among these dominants (phantasies) are the divinities, saviours, magical demons, animals, and other primordial myths and symbols of the race. These are projections upon the physician come to light during the transference, and Jung says his clinical experience has repeatedly demonstrated these unconscious phantasies. Many dreams and phantasies over-reach the personal problems and situations of the individual dreamer, and represent the collective unconscious of the human race to some degree, the

inheritance of past experience and "world images" and as such have direct relationship to racial myths. The fact that symbols appearing in dreams are frequently of an archetypal character, such as are common to various peoples, is held by Jung to be a conclusive argument for the primordial nature of dream life.[1]

It will thus appear that the unconscious has different aspects and that the anima, dreams and such phantasies as those of mythological gods and goddesses, deities, spirits and half-human, half-animal figures illustrate different phases of life of the racial unconscious. Out of the same eternal crucible of the noumenon where mingle all that are unconditional, mysterious, taboo and magical, the mystic and the artist draw not merely their vitality but their profound conviction that the noumenal is not the realm of idea and phantasy but is the real world. Great movements in art have always sought the absolute, the whole, and the transcendent in concrete nature and the world of man.

The Mechanisms of Myth-Formation

Egyptian, Hindu, Mayan, Greek and Early Christian myth, legend and art sought to represent gods and goddesses, symbols and spirits that have arisen out of the unconscious as collective phantasies of the people. The earliest literatures of the childhood of the human species are represented by myth-formations, and in this respect it is true that the state of childhood-thinking as well as dream-formation are nothing but "a re-echo of the pre-historic and the ancient". In myths, fables, fairy tales and dreams, man traverses over again the entire thought of earlier humanity. Thus, as Freud puts it, myths correspond to the distorted residue of the wish-phantasies of whole nations, the secularised dreams of young humanity. The unconscious in this way binds the individuals among themselves to the race, and through successive generations to the earlier epochs of humanity. The investigation of folk-psychologic formation, myth, fable and tale, from the point of view of the new psychology, shows that the solar, lunar, seasonal, vegetal and other explanations of myths have been rather one-sided. Jung's and Rank's researches have shown that the mythological occurrences of nature such as the sequences of day and night, the phases of the moon or the succession of the seasons are anything but allegories of the events of nature, nor are they to be understood as their explanations. But rather early men probably sought to project into the events of nature their own inner and unconscious psychic drama. As Jung puts it, "The primitive is not content to see the sun rise and set; this external observation must at the same time be a psychic event—that is, the sun in its course must represent the fate of a god or hero who dwells, in the last analysis, nowhere else than in the psyche of man. Every analogy to nature which he makes is essentially the language and outer dress of an unconscious

1 *The Structure and Meaning of Psycho-analysis*, p. 281.

psychic process".[1] One of the universal and acute experiences of mankind, primitive and modern, is the individual's persistent attempt to regress into infantilism, to become a child again, to escape from the reality. But this endeavour to live as an appendage of the parents is fraught with danger to the personality. Thus early man creates various myths and symbols of birth and resurrection, of the benignant and the cruel mother, of the conquest of the mother and the betrayal of the son. Throughout the world there are myths also of descent to the underworld, of river and sea maidens inveigling into the depths mortals who venture out to rescue some stolen treasure, of man's acquisition of a fairy wife who leaves him when he breaks a taboo, or of the compassionate dead mother, who from her grave or as an animal or tree, assists her ill-used child.

Myths, Symbols and Archetypes as Raw Materials of Art

Many such myths originating from the images of the psyche have furnished religious symbols, and have been fashioned into transcendental gods and goddesses of art and literature by priests and sculptors in temples, and by poets and minstrels in epics and folk-tales, songs and legends, satisfying man's irresistible urge to assimilate all experience through the outer senses into the happenings of his unconscious, and giving him inner assurance and strength. Myths still play an important rôle in India, China and Japan, and generally in the East in resolving the various psychic conflicts by annulling the separation between the conscious and the unconscious, the latter being the actual source of life, and bringing about a re-union of the individual with the matrix of the inherited, instinctive urges. Not merely myths but also the pantheon of gods and goddesses and the variety of symbols in Hinduism, Buddhism and other religions of the East permit satisfaction of primitive wishes in a manner unavailable to many peoples who have lost their mythical stories and folk-tales, and contribute to educate the young mind in tune with much that has gone on ages before in history. Art has through the ages abundantly and multifariously depicted images of gods and goddesses, heroes and heroines and such archetypal symbols as the World Tree, the Great Mother, the Wise Man, the hermaphrodite, and the half-human, half-animal creature. The dreams and phantasies of neurotics and of normal individuals swarm with man-animal figures, the repressed complexes being readily represented as certain animals which comprise especially the lower half of their bodies. From such roots have probably arisen the theromorphic attributes of the deities and the association of deities with certain animals as their vehicles. Similarly various animals recur in dreams, the bestial life-mass standing for the totality of the inherited unconscious which is thus joined

1 *The Integration of the Personality*, pp. 54-55.

to consciousness.[1] Thus art, religion and ritual have cherished primordial animal symbols such as the serpent, the bird, the horse, the bull and the lion, or, again, geometrical symbols such as the circle, the square, the mandala, the swastika, the wheel and the cross that belong not to one race or culture but to all peoples. Art and myth have obtained raw materials in every case from the mysterious and inexhaustible store of the repressed complexes. But as æsthetic effort and contemplation have drawn them into the field of consciousness, and fixed and externalised these ever-changing impulses in the form of images, these have ceased to disturb the mind. Rather these have been tamed and transformed and supplied driving power to the personality. The integration of personality is rendered easier by the acceptance of mythological and animal symbolism, which externalises and stabilises the ever-changing images and moods that give no peace to the mind. Symbolism renders the unconscious visible before the dry light of reason without giving offence to it. The unconscious being deliberately made accessible to consciousness, the personality ceases to be split into segregated parts through the isolation and remoteness of the instincts from conscious life.

Their Role in Personality Integration

Man's repressed complexes are typical and uniform the world over. It is the uniformity of the mechanisms of the unconscious which forms the deep underlying background of the unity of man, primitive or civilized. Consciousness is characterised by attention to the minute details of biological adaptation. But the unconscious mechanisms secure for man the totality of adaptation which ensures him poise, joy and a sense of competence. These essential deeper adjustments by which man apprehends the universe as a whole, instead of its particular parts without being hampered by the limitations of time and space, are described as intuitions and experiences of Beauty, Holiness and Wholeness, and are recognised through the change of kinæsthetic and visceral feelings. It is the psychology of the unconscious which binds man and man across the boundaries of space and time, uniting civilized with savage peoples and backwards with the peoples of the past. Mankind has exaggerated the rôle of the intellect during the past few centuries, and has largely lost except in the East the psychological and social values of traditional symbolism and mythology. Art and religion in so far as these can revel in the creative play of images and symbols from the unconscious and at the same time bring these into harmonious relations with the conscious life, help in the building up of personalities. For personalities grow not by the flight from the unconscious nor by identifying oneself with the tendencies of the unconscious, but by a synthetic procedure that transforms

1 For illustrations, See Jung: *Psychology of the Unconscious* and *Integration of the Personality*, pp. 112-114 and p. 152.

the latter and uses them as driving power for an integral adaptation to the reality. Art can bring the deep unconscious forces of life to the visible surface by borrowing from the world of sense its materials of perception and using them to clarify the dream-images and phantasies and mingle them with conscious images and even with the formal elements of normal types of art for perfect expression. Such is the real function of Sur-realism and the abstract-symbolic art of today. So long as art remains aloof from those aspects of the being which are submerged like an ice-berg floating in the vast common uncharted sea of the subliminal consciousness, which is the matrix of all noumenal apprehensions and intuitions, it misses perhaps the greater part of human experience.

CHAPTER IV

ART AND THE CONSCIOUS

The Fusion of the Unconscious and the Conscious in Art

Art acquires its significance from such fusion of the conscious and the unconscious as may give the largest measure of satisfaction to the artist and to his readers and spectators. It is through this dynamism of integration that art becomes a personality-builder and social binder. Art arises out of the repressed complexes in the unconscious. No art object can arouse any interest unless it solves some tension of conflict, brings about some balance or integration of the impulses. Thus æsthetic experience is identical with complete poise or repose and fulfilment of the personality. Such fulfilment depends upon, in the first place, bringing into the level of conscious experience repressed wishes and desires; and, secondly, resolving the inner tensions through a number of mechanisms with which psycho-analysis has made us familiar.

This balance or fusion of the impulses and desires is very essential for a vital appreciation of beauty. Out of this comes the complete repose in the object which Munsterberg characterised as the essence of the enjoyment of beauty. But such æsthetic repose merely refers to a concentrated state of attention. In æsthetic appreciation the unity that the self acquires is the basis of profound activation of the will as it emerges victorious out of the uprushes and thrills of contending emotions rising from the depths of the unconscious.

Classification of the Conscious Dynamisms in Art Work

While the revelation and externalisation of the unconscious are of the very essence of art, unconscious thinking cannot be presented in terms of conscious mental processes without undergoing distinctive changes. These changes are brought about by various conscious and unconscious devices or disguises and are designated as phantasy or myth-making, symbolisation, condensation, dramatisation, secondary elaboration, rationalisation and sublimation by the Freudian School. All these dynamisms are characteristic of the art process. Of these processes, phantasy or myth-making, symbolisation and sublimation are the more important.

Phantasy-making "on the conscious level" organised with a view to perfect expression is the *sine qua non* of art creation. The unity, form and clarity of treatment of the phantasies underlie the distinction between higher and lower art-productions, apart from the worth of the subject-matter. For when the phantasy is brought up into the level of conscious mental processes and is

reconstructed for society, nay for all humanity and for all time, the selection of the raw materials of both conscious and unconscious life influences the art work. "A dream is a play with an audience of one." The constructed art work is intended for mankind as a whole.

Symbolisation by which the artist transfers ideas and emotional values from one object to another is widely used in all forms of art. "Man," observes Groddeck, "is at the mercy of the symbol and individual symbolism is pre-determined by a common heritage of symbols". In art forms of different peoples similar symbols are seen to recur, representing common, elemental ideas and interests of mankind. On the other hand, without a knowledge of the meaning of symbols which comprise the peculiar legacy of a people, we cannot adequately judge the emotional appeals of its art in its social and historical setting. Symbols range from those of the universal biological phenomena of sex, birth, love and death to certain abstract intellectual ideas, emotions and actions, and represent the alphabet of the artist's language. Dramatisation also enters into the art-process.

Dream, hallucination and phantasy mainly depict a situation or action, and because they involve much more visualisation than verbalisation may be said to resemble a stage-production. This necessitates the employment of certain characteristics of unconscious thinking *viz.*, pictorial thinking or presentation, and the rapid wiping out of one scene by another, ordinary sequences standing in the place of logical casual connections.[1] It is these unconscious mechanisms which have been elaborated into the conscious procedures in graphic, concrete and tense presentation of the subject-matter, whether in painting, sculpture and literature, especially the drama, that thrill multitudes.

Not merely in dreams, delusions and phantasies but also in conscious art work, rationalisation is a common procedure seeking to evade the recognition of irrational and inconsistent behaviour which really arises on the basis of unconscious urges. If we adopt the use of the term 'rationalisation' in a wider sense, art may be considered as arising out of rationalisation, *i.e.*, the need for explanation and justification to the artist of certain feelings, ideas and behaviour. Jones mentions this as "the necessity everyone feels to have what may be called a theory of life, and particularly a theory of himself." For no one is this a greater felt need than for the poet or the novelist.

Secondary elaboration or the filling out of details and remodelling of the phantasy so as to bring it in harmony with other conscious mental processes is closely allied to the machanism of rationalisation.

Finally, sublimation which implies change of the goals of impulses so that their fulfilment may no longer meet with opposition from the environment is recognised to be a healthy and constructive way of dealing with irrepressible

1 See Healy, Bronner and Bowers: *The Structure and Meaning of Psycho-analysis*, pp. 254, 258.

unconscious urges. All art creations by "throwing off disguises" so depict the course of the instinctive urges and behaviour that these can evade the sense of guilt and pay their tribute to the Super-ego that focusses the ego's social and cultural acquisitions. The usual process is to attach the impulses to others which are ego-syntonic so that "in this good company these get by the censorship. In most art creations the unconscious mechanism of sublimation is integrated with other unconscious devices as well as with æsthetic and intellectual factors."

The Field and Methods of Surrealism

A new school of art has now arisen in the world called Surrealism which has for its object the projection of the unconscious mind in the form of words and images by means of which its exponents claim to embody a higher synthesis than is ordinarily perceived "in the belief of the superior reality of certain forms of association, neglected heretofore." According to Tristan Tzara, 'a shape cut out of newspaper and incorporated in a design unites the commonplace with another reality constructed by the mind', so that 'the difference between various kinds of matter that the eye is able to translate into tactile sensation gives a new depth to the picture'. The method by which the images are "laid" is described thus: "The imagination is a focus introduced into the vague field of the unconscious. Its lenses span over this opaque chaos. Suddenly stop; range into the shadows; contract; concentrate. The image is found and registered."[1] Along with æsthetic contemplation the exponents of Surrealism depend upon automatism. André Breton, a leading poet and exponent of Surrealism, not merely believes that phantasy offers the supreme key to the understanding of reality but also extols automatism. He observes: "It is only at the approach of the fantastic, at a point where human reason loses its control, that the most profound emotion of the individual has the fullest opportunity to express itself: emotion unsuitable for projection in the framework of the real world and which has no other solution in its urgency than to rely on the eternal solicitation of symbols and myths".[2] André Breton appeals to automatism in all its forms as the only chance of resolving all contradictions of principle in life. And Herbert Read quotes Salvador Dali relating how a splash of paint on his palette assumed unknown to his conscious mind the shape of a distorted skull which he had consciously and vainly been trying to discover. The experience of mystics and artists through the ages and modern psycho-analysis have shown that the unconscious is the seat of latent truths which are not verbalised and may be picked up in the form of images and used as vehicles for the expression of the super-reality. It is in this way that myths and symbols are created expressing not the ebb and flow of images and moods of the unconscious but profound varieties in

1 Quoted in *Introduction to Modern Art* by E. H. Ramsden, pp. 10, 11.
2 See Herbert Read: *Surrealism*, p. 106.

13

respect of whole mental personality and the life and the world that envelop it. Similarly many images created by Max Ernst who is described as "the most magnificently haunted brain of today", such as "Couple zoomorphe en gestation" and "A l'intérieur de la vue: l'œuf" have snatched for us glimpses of the super-reality in an irrational yet profoundly satisfying and convincing manner. The mystery of the expansive urge of life and growth and of maternal care and confinement is portrayed without the assistance of much recognisable imagery. Similarly in the works of Giorgio de Chirico and Salvador Dali we do find some recognisable images but these are arranged in an asymmetrical manner under the guidance of the unconscious or symbolise certain unconscious forces.[1] But there is no doubt that even if there be no symmetry nor clear definition of what the images stand for, there is some direct satisfaction due to the fulfilment of some unconscious part of our nature. Salvador Dali's 'Day-break' and 'La profanation de l'hostie' are fascinating representations of the moods of man in early dawn and of the battle of the urges in the unconscious that rages in every heart. All persons can find images of something of themselves in these pictures. In Chirico's works we experience the remoteness and fascination of dreams which similarly satisfy certain creative unconscious urges that yet remain in the sub-liminal field.[2] Some Surrealist painters, however, have externalised sensual desires and satisfactions in their images on canvas, and though these give us a glimpse into the dark and hidden caverns of the unconscious, these are contributions more to psychology than to art except in so far as these have found for the latter new subject-matter. Some, again, in their works give a free play to the destructive impulses, tearing and disembowelling good and beloved persons and objects,—a distinct abnormal trait calling for Freudian psycho-therapy. Dali sometimes represents the human body as deformed and mutilated. In one of his pictures the body comprises a row of drawers from which entrails are hung. Two drawers are at a distance and the body suffers the agony of the unconscious as the drawers are opened, obviously laying bare the repressed complexes in the hidden recesses of the mind. The satisfaction derived from a psychological analysis is here apt to be overcome by the sense of ugliness arising from mutilation.[3]

The Eccentricity and Morbidity of Surrealists

The Freudian approach to art of several moderns is itself an outcome of emotional maladjustment. How can such Freudian art give emotional repose or

1 For Dali see plates 114 and 115 and for Chirico plate 124 in Herbert Read's book: *Art Now;* also plates 22 and 23 in his *Surrealism.*

2 *Vide* Plate No. 25 in Herbert Read: *Surrealism.*

3 R. Allendy, Le Probleme de la Destinee, quoted in Ozenfant: *Foundations of Modern Art,* p. 130.

achieve integration? It goes against the very essence of art, which stresses unity, wholeness, and creativity. Symbolism is not always a safe and reliable guide to the artist, for his wish-phantasies may take the form of horrible nightmares and delusions which may be symptoms of personal disorganisation and profound social maladjustment. Such image-making would be distinctly anti-social. One of the chief functions of art is social communication. If the artist himself cannot express his imagery in terms of the consciousness of the spectators, or if his deformation or mutilation of good and desirable objects of mankind engender in them feelings of ugliness and disgust, art is frustrated. In any case art cannot be invested with any intrinsic meaning if it arouses in each spectator's mind a different meaning. Thus Allendy observes, "When prophetic images are sought for in coffee-grounds, splashes of candle grease, clouds, or any other shape which, having no definite form, is capable of evoking all that is demanded of it, it is clear that it is only an imaginary world that is being discovered, one which issues entirely from the unconscious. For that reason each observer will, faced with the same object, interpret the matter differently. Indeed, certain psychoanalysts methodically utilise this technique in drawing the attention of their patients to accidental stains, so that concentration upon them may people them with definite images."[1] Art that represents objects which cannot convey any impression of symbolical significance to the spectator becomes futile. Thus the artist becomes himself arbitrary. The exaggerated individualism of many moderns has thus become wilful eccentricity. Many Surrealists are not only eccentric but also paint on the canvas their repressed complexes, horrible and naked, without the trappings of disguise which are necessary for them in order that they may be admitted into the field of consciousness without offence or scandal. These urges have disobeyed the censorship of the artist's Super-ego and it is no wonder that the spectator's Super-ego rejects them with feelings of ugliness and horror which are aroused due to the rehabilitation and enhancement of his own sense of guilt and anxiety by the pictures. The spectator makes a 'discovery', but it is a 'discovery' of his own pain and anxiety which is incompatible with emotional orientation and adaptation that is the function of true art. No art can thrive which begins and ends with automatism, yet this seems to be the creed of Surrealism. The fragments of wishes and phantasies, images or forms may come up from a morbid or restless mind as embryonic, deformed or mutilated symbols of the incomplete, ugly and unholy. All images and phantoms that are released by the unconscious as a result of auto-suggestion and adopted by the Surrealists must pass through a sieve of selection of elevated contemplation that alone can distinguish between the wholesome and the abnormal. Surrealism has no doubt found a new subject-matter for art in the changing moods and

1 R. Allendy, Le Probleme de la Destinee, quoted in Ozenfant: *Foundations of Modern Art*, p. 130.

images of the unconscious. Aided by pure and refined meditation it should be able to distinguish between morbidity and intuition and create forms and images that are vehicles of the universal and the eternal. It is thus that its subjectivism and dissatisfaction with man, society and the environment might lead it to create new abstract forms and images which, however removed from the characteristic appearances of nature, might reveal certain absolute and ultimate values.

The Principle of Optimum Disguise in Art

We shall now present a theory of disguise as the criterion of æsthetic production and enjoyment. Psycho-analysis has described the various mental disguises involved in emotional adaptation and wholeness. Phantasy-making, symbolisation, condensation, dramatisation, secondary elaboration, rationalisation and sublimation are, as we have mentioned, the various unconscious and conscious mechanisms which the mind adopts to get over insistent, and yet discordant, urges that cannot bear the light of consciousness in the world of reality. Such disguises help the mind's adjustment to the environment. The artist by his sensitivity to the entire gamut of human passions and his imaginative and contemplative capacity can present these disguises in subtle, elaborate, dramatic and attractive forms as no average man can. He is the pastmaster in throwing off disguises so as to make the unconscious and undesirable urges seem tolerable and even necessary in a particular individual situation and social context. In this he subserves an all-important social function. For it is necessary for mankind in all ages to externalise and fix those ever-changing impulses and moods that cause its inner tensions. Another difference between the artist and the average man is this that the former can maintain such detachment from his own personal experiences and the objective situations which occasion them as enables him to present these in their right perspective and meaning and with full insight. Thus he can unfold the variegated emotional stresses and strains at once with an intense vividness and a profoundly human impersonality and universalism. The artist presents his own psychological processes and experiences in the form of symbols, dramatisations and sublimations that are in his æsthetic contemplation refashioned for his audience. For these are essentially intended for social communication. Thus the symbols fulfil not merely his but also his readers' and spectators' unconscious urges and lower their tensions. Too close and active a participation in life prevents that introspection and recollection without which it cannot be truly comprehended, just as too fervid sensual passion and enjoyment prevent the full working of the mechanisms of symbolisation, sublimation, rationalisation and phantasy-making which are preliminary to art work.

The artist must maintain a 'detachment' or 'distance' from his own action and passion in order that he can reach a true comprehension of what the situation

signifies by representational imagery. An agent or active participant who is too 'close' to life cannot image his mental processes and situation in such manner as to enable others to understand the meaning and significance these possess for him. In the second place, the artist exploiting and elaborating to the full the symbolisation, sublimation, phantasy-making and other processes for obtaining peace in his own mind can succeed in the degree according as his art work approximates to an optimum of "social disguise" of the gratification of unconscious urges. Art work depends for its quality on the "optimum social disguise" of gratification of our wishes and wish-fulfilment that represents the mean between over-elaborate and inadequate disguise. There is an "optimum disguise" for every reader or beholder in any concrete situation although the disguise may be somewhat increased or reduced. Excessive symbolisation and sublimation in art work which completely cover or conceal the unconscious urges will not offer fulfilment to the urges of readers and beholders. There cannot, therefore, be any arousal of "empathy" or identification with or "repose" in the object of the audience. Such work produces the impression of artificiality, thinness or unreality. On the other hand, if symbolisation and sublimation be too little, and the disguises for the representational satisfaction of the unconscious urges are too thin and apparent, the art work is bound to elicit emotional reactions of horror and ugliness on the part of the audience. This is due to the fact that every person seeks to fulfil both his unconscious urges and the demands of the Super-ego in order that he may achieve mental poise. An under-sublimated, under-symbolised or under-rationalised work of art lets loose the unconscious wishes and ideas, unclothed and undisguised in their horror in the field of consciousness of the beholder, who to satisfy his Super-ego condemns it as 'sensational', 'melodramatic', and 'stark in its realism.'

The Garden of Eden

It is thus the degree of social disguise which differentiates between idealistic and realistic, abstract and naturalistic-romantic forms of art. In fact such antitheses in æsthetic theories find a solution in the fundamental conception of social disguise. All great art has a tremendous human interest and significance since it appeals to fundamental unconscious desires and shows how to build up a new world in spite and out of the inevitability of pain, guilt and anxiety that come out of these urges. Art enables us to participate in the forbidden fruit without losing the Garden of Eden. It appeals to us in the degree to which it stirs the depth of the emotional level and brings about reconciliation and harmony in our mind. This it can do successfully in the degree it can, by elaborating various disguises and offering surrogates, provide the widest scope for the harmless fulfilment of our complex systems of impulses and tendencies. The artist, through his system of disguises, creates a sense of unreality in the mind of the reader or

beholder which is the essence of æsthetic enjoyment. In Hindu Alankara Sastra or the science of poetics, æsthetic value or *rasa* is defined as aloukika or 'that which does not belong to this world'. Similarly Konrad Lange makes 'illusion as conscious self-deception' the criterion of art. He observes, "We conclude that æsthetic enjoyment which a work of art as work of art affords is dependent neither upon the quality of its content nor upon its formal nature, but that it rests entirely upon the strength and vividness of the illusion to which the artist brings us through his art". Modern writers on æsthetics have expressed the same notion in the term 'artistic objectivity'.[1] Bullough has developed the cognate concept of 'distance'. According to him distance represents in æsthetic appreciation as well as in artistic production a quality inherent in the impersonal, yet so intensely personal relation which the human being entertains with art as mere beholder or as producing artist.[2] The notion of 'optimum disguise' of ideas and emotions is based on a clarification of the genetic function of art and of the fundamental mental processes underlying both æsthetic creation and apprehension. Gentically speaking, there is an intimate connection between the production and enjoyment of art and the individual and social problems of orientation to the ambivalent desires towards both internal and external objects, of love and hate, creation and destruction that are deeply rooted in man's mental life. Artistic creation and enjoyment depend upon the resolution of an antinomy created by the simultaneous operation of Life and Death instincts, love and hate, creation and destruction. Or dialectically, in the resolution of this antinomy the demand of the libido (the Life Instinct of Freud) may be said to constitute the thesis, the pressure of the aggressive and destructive urges the antithesis, and reparation or the triumph of the Life instinct over the Death instinct the synthesis. The quality of art work rests on its capacity to represent such a synthesis for the reader or beholder.[3] For providing a complete synthesis the art-work must exhibit an optimum proportion in the relationship between thesis and antithesis, *i.e.*, an optimum 'disguise' of gratification of the destructive urges without causing pain to the Super-ego. Now the Super-ego is the social impulse both for the artist and for the beholder. It epitomises social attitudes and values internalised and transformed into the 'Thou shalts' and 'Thou shalt nots' of the conscience. The impulses of life and love, of the creation of enduring goodness and wholeness, and the social impulses spring from a common root. In æsthetic experience we realise simultaneously not merely the full interplay of the creative and the destructive impulses that unburdens us of the load of mental pain, anxiety and guilt, but also the full richness and complexity of our social environment.

1 See Greene: *The Arts and the Art of Criticism*, pp. 236-241.

2 *British Journal of Psychology*, 1912-13, p. 117.

3 *Vide* W. R. D. Fairbairn: The Ultimate Basis of Æsthetic Experience, *British Journal of Psychology*, 1938, p. 178.

CHAPTER V

SOCIAL DISGUISE AS A PRINCIPLE OF ART

The Mechanisms of Disguise in Myth-making

In the dawn of civilisation poets, prophets and priests were often the same persons. Their great task was myth-making. In early cultures, social life was characterised by much violence and retribution and violation of laws and moral and social codes, while repressions of the individual were more severe and mutilating. The poet and the artist dared not describe the terrible deeds of murder, rape, incest and rapine in art work, although similar horrible passions beset and mould the phantasy life of early childhood in all ages. Thus they dreamt and expressed dreams, in which the repressed wishes and phantasies were mingled with the conscious needs of the people in the form of myths, legends and songs. The ancient mythology and epic poetry of the world are characterised by an atmosphere of unreality, exaltation and even grotesque exaggeration of human characteristics. Vedic and epic myths of India and legends of Greece equally illustrate the mechanisms of disguise which the poets and priests adopted to remove the gods and ancestral heroes of the people from their ordinary context of social life. Extraordinary traits and attributes, whether of strength and valour or cleverness and wisdom, were attributed to them. Strange unusual happenings of nature were also associated with these gods and heroes and in fact with the past of the tribes. In the supernatural and superhuman setting unnatural conduct such as the adultery of the drunken Vedic God, Indra, the incestuous love of Brahma for his grand-daughter Saraswati, the abduction by the Moon-God of the consort of his spiritual perceptor, Brihaspati, the murder of children by their mother, Medea, and of the father by Oedipus and his marrying his mother, the incestuous love of Phædra for her step-son, Hippolytus, becomes not merely tolerable but even reasonable. It is the disguise of myths and tales wherein all markedly concrete and individualistic features of the "immortals" are carefully removed that safeguards social morality. Thus the shudder of the forbidden and the unusual does not impair the reverence for the ancestral heroes and gods of the peoples.

The Mechanism of Projection

Another device adopted by the myth-makers whether poets, priests or prophets was to use the name of gods and oracles for composing and communicating songs, verses and legends. The procedure was almost similar in all countries. The priests and poets fell into a trance and their speech became automatic. This

is the familiar state of 'inspiration' in which a person partially loses his consciousness and the co-ordination of his activities. As he speaks in that state of intoxication, he is not conscious of what he speaks. The priest delivers his oracle, the prophet his myth and the poet his song in a semi-unconscious state, induced by hypnosis or auto-suggestion, together with prayer, fasting or other physical austerity and discipline. For each the voice of the unconscious is externalised, but is revealed and communicated as the voice of God. It is thus that the unconscious wishes and ideas of a few gifted or chosen individuals who are endowed with a certain disposition to communicate with the unconscious by the use of narcotics and drinks or certain psycho-physical mechanisms lay down laws and reveal esoteric knowledge, the history of the tribe, and the exploits of its gods and ancestors or guide its conduct in times of social crises. Ernst Kris analysing the phenomenon of inspiration describes it as connected with two emotional experiences that are interwoven, and may not always be distinguished by the individual himself. In inspiration, the impulses, wishes and phantasies derived from the unconscious are attributed to a supernatural being. Thus the voice of the unconscious becomes the voice of the god, ancestor or hero. This is called 'projection'. Secondly, the process of the unconscious urges becoming conscious is experienced as an action of this supernatural being upon the subject, and thus activity is turned into passivity. This is called 'introjection'. "An alternation of cathexis inside the person, the bursting of the frontiers between the unconscious and the conscious is experienced as an intrusion from without."[1]

In myths, legends and tales, then, the poet expresses his own and the tribal unconscious. These are all derived from or touch upon the forbidden sphere of wishes, desires and impulses. The poet's sublimation, dramatisation, symbolisation and rationalisation are all there removing the gods and heroes as far as possible from the context of tribal life, effectively disguising abnormal and anti-social behaviour and its consequences, and at the same time affording free scope to the interplay of the repressed complexes. The supernatural and superhuman setting of the tale is enough to allay anxiety and guilt associated with 'the bursting of the frontiers between the conscious and the unconscious'. Secondly, the poet transfers his burden of responsibility to the divinity, ancestor or hero of whom he is the chosen mouthpiece, and thus further reduces not merely his but the entire tribe's feelings of pain, anxiety, and guilt in giving free play' to forbidden wishes and ideas. Thirdly, such myths and legends became effective social binders uniting scattered folks by common social attitudes and aspirations. Speaking in the authentic and authoritative accents of supernatural beings, these hold an entire people under their sway. The earliest products of creative imagination were 'revelations', and revealed truths and experiences have a superior, dominating quality to any derived through human effort.

1 Kris: On Inspiration, *International Journal of Psycho-analysis*, 1939.

The Forbidden Ground of the Unconscious in Myth and Literature

The power of the mythical, legendary and fantastic in art has hardly declined, human nature being as it is. Through myths, fairy tales and fairy plays, modern art covers even now the forbidden ground of undesirable, repressed wishes and interests in all countries. Literary forms, while dealing with the marvellous and the supernatural, do not fail to appeal if only the disguise is consistently maintained. On the other hand, poets, dramatists, and novelists usually go back to the past and derive their materials from the classical legends in order to unmask the working of forbidden passions, loves and hates that are repressed by modern civilisation. Their social setting being transferred to a dim past, the disguise of fulfilment of these primeval undesirable complexes becomes easier. Familiar examples are Keats' 'Hyperion', Hofmannsthal's 'Elektra', Robert Browning's 'Caliban' and Rabindranath Tagore's 'Chitrangada'. Joyce's 'Ulysses' and O'Neill's 'Mourning Becomes Electra' reveal openly that their models are ancient myths.

Even in the classical Greek tragedies the overshadowing conception of Nemesis or Destiny, which reflects the terrific guilt-sense of the people, and the tragic errors of human individuals in the social situation and their atonement through divine intervention allay the sense of guilt. Sophocles made Oedipus know neither his father nor his mother, while the profound reality of an inexorable fate made the characters of the Greek stage go through the ordeal of guilt and suffering. The guilt and the atrocity were transfused into a material of beauty that has eased the human heart through the ages.

Psycho-analysis have shown that the Oedipus complex is one of the elemental irrepressible impulses of man, and that its modes of expression and repression lay bare the entire mental development of the individual. Thus the theme has recurred in literature in different epochs, exhibiting disguises appropriate to the repressions of the epoch. Shakespeare's 'Hamlet' represents the great Oedipus tragedy of the late Renaissance. The futility of Hamlet's life arose out of his mother-fixation due to which he could not reciprocate the tender love of Ophelia. According to Freud's analysis, Hamlet cannot avenge his father, cannot fulfil the ghost's command to kill his (Hamlet's) step-father, because the murder of his father was a deed which Hamlet himself has long harboured as a design in his unconscious. Hence his irresolution. He hesitates and hesitates until it is too late, and he himself, together with the other main figures of the tragedy, lies dead on the stage. Hamlet's unconscious guilt kills him simultaneously with his victims.[1] Neither the dramatist nor his audience was conscious of those ambivalent desires of love and hate that surged in the breast of Hamlet and inevitably led to his doom. But both Shakespeare and the reader and the beholder touch the forbidden ground of the unconscious, the remarkably successful

1 Quoted in Lorand: *Psycho-analysis Today*, p. 345.

14

disguise in the drama helping them to unload their own pain, anxiety and guilt without their awareness of it. Great art delves into the depths of our being and relieves our heartache, though we are not conscious what the ache is. All great poetry is saturated with profound ethical issues, eternal questions of right and wrong. It spreads serenity and competence and dispels doubt and fear. Poetry began with myths among the primitive hunters and food-collectors, and developed into epics and legends of gods, heroes and great men as society became integrated under a ruling class. But even these "immortals" had their terrible lapses and moral deviations—expressions of the tribal unconscious but assimilated into the super-ego through the adoration and worship they commanded. In the nest stage of evolution, the individual comes to his own and lyrical poetry emerges, more freely and spontaneously revealing the phantasies and unconscious desires of the individual. The entire movement from subjectivism to romanticism and idealism shows poetry becoming more and more personal and esoteric, and in the age of social disintegration and chaos of values poetry has too often become largely bare of real social content, and expressive of individual physic revolt and segregation. Modern literature as in Joyce, Proust, Auden and Spender portrays a world woven entirely of unreal phantasies or in the hands of the inferior, poets becomes insincere, trite and faded.

In the modern age the wishes and phantasies of the unconscious have been clarified and understood by the majority of poets, dramatists and novelists. One result has been that these motives are portrayed and exposed with a lucidity and even brutality unknown before. Yet no novel or drama can afford to be too lucid or apparent. The social disguise has to be maintained in dealing with these primeval wishes if the reader or the beholder has to escape the admonitions of his super-ego and not treat the art work as crude, ugly and repulsive. O'Neill, one of America's greatest play-wrights, in his 'Mourning Becomes Electra' deals with the same motives of incestuous love and hatred, conflicts which underlay the grandiose Æschylian triology. But his setting is entirely modern and the dramatic effect is tremendous.[1] The literacy disguise which he follows in order that the modern spectator or beholder may accept the breaking up of the frontiers between the unconscious and conscious is delineation of the characters as if they were moving on the stage as in a dream with rigid mask-like demeanour, and the use of a symbolical language and stage-technique borrowed from dream and phantasy making and analytical interpretation.

The Community of Spirit with Ancestors, Gods and Heroes

Savage societies establish a community of spirit with the animal ancestor, guardian or totem, but periodically at the festivals the sanctity of the sacred

1 For analysis of this drama see Wittal's Psycho-analysis and Literature in *Psycho-analysis Today*, pp. 346-348.

and cherished animal is deliberately violated, the animal being killed, and its flesh, which has been so far taboo, is eaten by the tribe as a sacrament in the dark sacrifice characterised by an uprush of opposite emotions under the stimulation of drink and dance or procession of the kindred group. Many Semitic peoples had their sacrificial feasts which were considered as means of communion of animals, men and gods, "participation in the divine life and nature or in the kindred blood". In early Greek civilisation there were also similar rites in which the bull, the animal form of the God, was ceremonially killed, mourned and eaten in communion. The tension of primeval ambivalent desires of creation and destruction, love and hate towards all good and beloved objects, both internal and external, is relieved through such terrible ordeals. The tragic drama later on arose in Greece from the tearing of a goat, associated with the Dionysiac ritual which represented the birth and death and rebirth of the god in the voices and movements of the chorus. The traditions of the Attic tragedy, clearly indicate that man, contemplating his own life on the stage, unconsciously derived fulfilment of the same ambivalent desires so deeply rooted in his nature, that were embodied in totem feasts and sacramental eating in communion of the dying god of a remoter past in Hellas. In the great spiritual tragedies of the world like those of Æschylus, Shakespeare or Dostoevsky we see the tragic heroes beset by the conflict of these primeval ambivalent emotions that are externalised in the images of a Clytemnestra, the tempter of Agamemnon, of ghosts and witches in Shakespeare's plays,

> The instruments of darkness tell us truths,
> Win us with honest trifles, to betray us
> In deepest consequence

or, again, human individuals that are too devilish to be human, but are really dark, terrible animals of the hero's own soul. The essence of the great tragedy consists in the sudden revelation to the conscious mind of the unconscious without the screens of sublimation and repression. But the disintegration of the personality has gone too far to prevent the wreckage of the outward life of the hero through such revelation. The true disguise of supreme dramatic art consists in giving full play to our repressed urges by imaging them as characters representing all that is odious and repulsive in our lives. But such characters are also projections or externalisations of the tragic hero's own divided soul. In his doom we see the triumph of love and goodness over hate and aggression which are fused together in the same libido in man's life. At this, each individual's super-ego, embodying the full contents of social attitudes and values, rejoices, and the joy is greater in the degree that the mind integrates itself without the mechanisms of repression and sublimation. This is the real explanation of the otherwise insoluble problem of evil in æsthetics viz., why profound æsthetic

satisfaction that is usually associated with the experience of pleasure may be derived from the emotions of sadness, despair, even horror. It is the full interplay of the instincts of both love and hate, creation and destruction, springing from the same root of the mind, that a tragic tale unfolds, elaborates and synthesises; this produces the strange joy in the representation of painful, even disastrous events. Our mind accepts these as inevitable; even reasonable. Our pity and compassion, surprise and fear, despair and horror shed their narrow human limitations in the glorification of our inner selves. Through the dying heroes we are renewed in our lives, and re-united with our gods and fellowmen, as was the purpose of ancient observance and ritual. Nothing shows better the objective of dramatic art than Euripides' famous phrase that the soul of the individual who participates in the drama is 'congregationalised'.

Social Disguise in the Drama

We have referred at some length to the drama, especially tragic drama, where the maintenance of an optimum disguise by the dramatist is exceedingly difficult, yet in no other literary expression can the interplay of the primeval impulses be represented more concretely and effectively. The difficulty arises out of the fact that on the stage living persons become vehicles of dramatic representation and consequently there is a much stronger lure to under-disguise. But in the great dramas in world literature, the proper disguise is effectively and consistently maintained in spite of the absence of repressions through the uplift of the struggle of the elemental opposite emotions and ideas into the plane of a profound human impersonality and universality. Thus the characters move about the stage not as average men and women but far above the ordinary run of mankind in the primeval drive of their impulses and consistency of their will and behaviour even unto the wreckage of their lives and death. The history of the theatre shows how extraordinary persons, extraordinary behaviours and extraordinary situations imaged in the dramatist's own mind are rendered truthfully through the costume and make-up, lighting effect, scenario and shape and arrangement of the stage. The classical canon of unity of time in tragic drama also contributes towards the concentrated interplay of emotions and human relations within a period which is too brief for any sentimental rumination and shedding of tears. Where the disguise is inadequate or inconsistent due to the lapse of the characters from their steadfastness of impulse and will and deviation from a belief or an ideal, a tragedy becomes sensational, melodramatic or cynical and loses both its moral and æsthetic standards. What a great artist seeks to convey in the tragic drama is the agony of man and the chaos and confusion in his split personality as his unconscious comes to have a tenacious and inexorable grip over his conscious. There is the terrific recognition of his guilt as the unconscious oversteps the boundaries of the conscious and confronts the Super-ego

brazen-facedly without the masks of sublimation and repression. But the recognition comes too late to save him. Yet even in his crushing defeat before the forces of unconscious life he is true to his new discovery. As the theme has in its denouement moved on to a new level of experience, he courageously proclaims at the brink of disaster the triumph of life over death, communicating a profound sense of release. That sense of release or inner poise comes in tragedy out of perhaps the most complete harmony and organisation of man's impulses and experience known.* This is the inescapable moral and social responsibility of art.

The Stream-of-Consciousness in Modern Fiction

The novel in its present literary form shows a definite tendency to become self-introspective and even self-analytical, indicating almost as a rule concrete, personal emotional experiences and situations. Certainly the tendency to under-disguise is more felt here than in any other form of æsthetic production, except perhaps surrealistic art. Many modern novels are no doubt addicted to maudlin sentimentalism or cheap romance or depend upon their interest on arbitrary plots of intrigue and surprise that offer relaxation, like the films of today to the jaded nerves of overdriven urban dwellers. The mass of the people, blindly struggling against the overwhelming economic pressure and plunged in excitement and coarse recreation cannot have much sense of æsthetic charm. Yet not an inconsiderable number of novelists, though they are read only by a few, are artists of genius who have immensely improved their techniques and express the idiom of the hearts of common people. The more significant modern novels show tremendous powers of analysis of the thought-processes that underlie situations and the major decisions or actions of their characters. The traditions of Balzac, Dostoevsky and Thomas Hardy have been strengthened by the present generation of writers. A definitely new trend is discernible in focussing attention to phantasies or day-dreams which represent, as we have seen, the essential nucleus of art work. Thus in Joyce's 'Ulysses', Dos Passos' 'Manhattan Transfer', and O'Neill's 'Strange Interlude' we find the characters ruminating their fantasies and reveries, laying bare with the vividness and concreteness of a hallucination their unconscious. Thus we understand more of the hidden springs of psychic conflicts, decisions and actions of both artists and their characters. Just as in normal life, so also in modern fiction, we find reveries, reminiscences and 'interior monologues' which are interspersed and interpolated with actual present experiences. It is in this way that through what the psychoanalyst describes as breaking of barriers of the conscious by the unconscious in ordinary experience are revealed the deep emotional levels of the characters. In fact Joyce makes us acquainted with a character only from his dreams presented in a "Jabberwocky" language, and yet we seem to know him more than in flesh and blood. For man's daytime routine of conduct, his conversations and limited human relations, dictated by

social conventions, are disguises and masks. Human nature in the raw, in its concreteness and driving power, can only be adequately understood from the sub-conscious level, provided that the artist possesses the requisite psychological technique and wisdom to express in understandable language moods that do not usually become verbalised. In conscious life the network of human relations and actions is conceived by Joyce or O'Neill less in the terms of instinct and reason, desire and duty but more as events or forces which interpenetrate persons in their limited fields, constituting a continuum, but one circumscribed for human indi-viduals' daily living and intercourse. The subjectivism of the older type of fiction is enlarged into what is called 'the stream-of-consciousness-type' in the writings of Joyce, O'Neill, Dorothy Richardson, William Faulkner and Virginia Woolf, among others. Here is exploitation of the solid psychological truth that the ordinary man's consciousness, unless it is controlled by a strong will, is com-pletely at the mercy of phobias and repressed complexes that rise from the sub-liminal strata of his mind and of the changing associations of ideas, memories and moods that sensations and situations elicit. All this is vividly represented in bits of soliloquy and imaginary disputes between one-self and one-self, in dreams and phantasies and in reminiscences and automatic repetitions of frag-ments of popular songs and poems that intermix oddly and freakishly with man's actual experience. Man's two selves, when there is psychic segregation or a split-ting up of his personality, often talk with each other garrulously in modern fiction, thus illustrating the imperfect blending of impulses that we discern often in normal individuals.

The Interpenetration of the Conscious and the Unconscious

Much of the processes of thought are the outcome of interchange of consci-ous and unconscious forces of the mind. The unconscious complexes lie behind the inconsequential associations that link ideas and images with one another, often with little reference to cause and effect and the sequence of events in space and time operative in the objective world. Thus the new literature is occupied in giving a picture of man's conscious and unconscious mind and the movement from the unconscious to the conscious and back again, giving us a knowledge of the self that is far truer than what any previous literature could give us. Freudianism and its applications, such as psycho-analysis and psychiatry, have, indeed, dispelled the old assurance and confidence of man about knowledge of his own inner life. Man's own mind has become as baffling and interesting as the matter and motion he perceives in the objective world. Contemporary literature in exploring the processes and laws of mind is not only discovering a new universe, but is also coining a new language as currency of society. Joyce's words and syntax have already proved a source of renewal of the language, not to speak of his influence along with that of others on man's new feeling about

his place in the universe. The latter is well expressed by the young poet, Charles Madge:

> 'This window by a curious trick can see
> Workaday things and a white rising planet.
> It looks both in and out and on each side
> Is outside. There is no house for such a window'.

The window is man's own awareness. Where the conscious and the unconscious do not blend or are not compromised freely, pathological phenomena arise.

The modern novel has accordingly taken to the delineation of abnormal types even with greater zest. Joyce, D. H. Lawrence, Faulkner, Virgina Woolf and Aldous Huxley have all given us morbid and pathological characters with great force, originality and understanding. Where there are so many social repressions and personal maladjustments it is no wonder that both artists and readers will find high interest and significance in the abnormal trends of human nature. Many of the repressions and maladjustments are rooted in the stresses and strains of sex-life. No modernist has dealt with such vividness, frankness and honest understanding with such problems as Lawrence. It is from his great novels that one understands the deep-rooted springs of love and hate, attraction and repulsion of man and woman, which do not spring from causes that can be understood or analysed in the consciousness, but remain unknown and unconscious, something elemental and incalculable and independent of and antecedent to social conventions. There is the further stress in his novels of an aloneness, and isolated preserve in the depths of man, and woman's being which must be protected against the dreadful all-comprehensiveness and hateful tyranny of sex. Man and woman's full spiritual freedom can only be assured when the opposite sex leaves the other being free instead of trying to absorb or melt or merge. Very few of the modern writers have used myth and symbolism so effectively as well as incidents rich with hidden meanings and overtones of feeling. No modern writer, again, has laid bare the strains and tortures of his own soul as he has done, and that is why his symbolisms and his impersonal incidents are sources of release of deep tensions in the reader's emotional life and of his poise and understanding. While the typical novels of Lawrence express vividly and poignantly the emotional difficulties of the individual, and his rich symbolism shows the way towards an ideal emotional adjustment of men who are happier than himself in their sex life, another novelist, John Dos Passos, has something very significant to say to this generation in respect of man's social adaptations. In Dos Passos we see a significant emphasis of the relations between the individual's defeat and triumph, morality and aspiration, and the social situation and the social ideal. Thus he goes deep into the social roots of the individual's motivation and happiness, and, in fact, his broad canvas, his

sociological understanding of the sources of human futility, strife and unhappiness make him not only more realistic, but more "modern" than most writers.

Disguise in the Craft of Fiction

The modern novel is eclectic in its technique and the recent advances in psychology and especially psycho-analysis have been a challenge to it to explore, analyse and dramatise consciousness and the interplay of consciousness in the social situation, utilising the methods of the masters in previous epochs. In all this the artist no doubt reveals his own intense emotional life, solves its conflicts and finds out a meaning and scale of values, which becomes the organising principle of his and other men's lives, in a form which may enable him to disguise himself and his motivation best. As a matter of fact in a well-made novel the author is as much as possible 'out of the picture', making his characters converse, act and interact with one another; the conversations are presented dramatically not with reference to the reader but to the changing situations so that the reader may dispense altogether with the author's descriptions of the character's psychology. The need of disguise in the novelists' art is thus stressed by Gide: "The poor novelist constructs his characters; he directs them and makes them talk. The true novelist lends his ears to what they say and watches them in action; he hears them talk before he understands them, and it is only after he has heard them speak that little by little he comes to realise who they are". Often do we find in modern fiction some oft-repeated phrase, oath or fragment of a song associated with the character's speech, lighting up his temperament and personality so that these need not be portrayed. Yet even though the characters seem more creations of life than of the author himself, it is he who directs his motivation and behaviour, and enlivens and impregnates these with his own inner tensions, meanings and values of life. In no art work is there greater disguise of the 'artist's mind' than in modern fiction. Such disguise conforms to the æsthetic standards now demanded of the craft of fiction.

Man's Inner and Social Selves in Fiction

But there is another social and psychological reason for strengthening this disguise. The recognition is getting stronger in such talented artists as Dos Passos and Doblin that the great concern of art is not individuals and their moods and sentiments by themselves but as these are conditioned and moulded by a social environment and a social consciousness. In Joyce too we have a full revelation of the interdependence between man's and woman's intellectual, emotional and professional lives. The individual in this new technique floats like a wisp of straw in the swirling, fast-moving currents of collective live and enjoyment. Bewildering news items, disparate objects and conflicting impressions and emotions meet the characters and the readers without logic or

rhetorical organisation; for is not this the manner how the Great Society fashions man and his ever-changing moods today? But out of the 'camera eye', 'news reel', sketches of important personages and of landscapes and fragments of popular songs, emerge the broad, pregnant issues of the collectivity to which the actions and motivations of a few insignificant persons are completely subordinated. The fast tempo of the collective machine to the belted chain of which individual lives and experiences are strapped now leaves man no respite for his emotional, moral and spiritual freedom. "Steam-roller", "roller-coaster", "sky-scraper",—all have caught us like bewildered, buzzing flies in laboratory test tubes. The psychic tensions and conflicts in our inner life have their background in the regimentation and standardisation of our lives, the riot of sensations and appetites into which we seek escape from such regimentation, and the frustration in the whirl of excitement and enjoyment. Man's poise is thus to be found for both the inner and social selves, and the modern literature is seeking to find and communicate both kinds of poise and adjustment. Especially in the mystical writing of Tagore, Yeats, T. S. Eliot, D. H. Lawrence and Rainer Maria Rilke we find both a sense of individual sweetness and fulfilment and a profound merging of the individual in the collectivity. Myth and religion are both being cultivated now among certain schools of contemporary literature. The present generation is finding from some great moderns not only an integration of impulses and meanings out of the present welter and tumult in its emotional life but also a positive and idealistic social outlook out of the disorder, ugliness and irrationality of the over-driven, hectic war-sick world.

CHAPTER VI

THE FUNCTION OF RHYTHM IN MAN AND ART

The Sense of Beauty and Sublimity

Man is pervaded by rhythms in his organic and affective life. His tension and his harmony with the environment are the counterpart of his organic rhythms. Art is an echo in the ideal plane of the ebb and flow of his organic functionings, the fluctuating rhythm of his desires and emotions. As an emotional creature man is dominated by spells of attention and ennui, craving and satiety, contradictory desires for change and routine, ambivalent and conflicting feelings of love and hate, creation and destruction, that subject him to pitiful oscillations of frustration and fulfilment. In external nature rhythm is order. In man's inner life, characterised by the interplay of his impulses and emotions marking the rhythm of his harmony or disharmony with the environment, man unconsciously or deliberately seeks order in a harmonious and integral experience. Out of the need of this perennial inner adjustment art is born, with rhythm as its heart and core, the ultimate condition of its forms and patterns.

Æsthetic satisfaction springs from a harmonious blending and fulfilment of man's antithetical impulses and experience that rhythmically punctuate his emotional life. The greater and deeper the co-ordinations and harmonies, the more satisfactory is the æsthetic experience. The æsthetic attitude is in fact a species of a genus of experiences arising from an ordering and fulfilment of impulses and moods which are conflicting and contradictory. Man's apprehensions of beauty, sublimity and holiness represent species of the same genus, and are associated with similar kinds of kinæsthetic and organic changes. The mystic and the artist often experience the same kind of emotions and attitudes of poise, joy and clarity that arise out of a harmony between conflicting, independent and mutually destructive impulses. Man's sense of beauty is the harmony of his vital impulses objectified in the material thing, like its colour, proportion or size, in a human face or a landscape that orients, integrates and fulfils his heart's desires. An average man as contrasted with an artist may achieve an unconscious co-ordination and singleness of direction of the impulses under the stress of an overwhelming passion, grief or happiness or, again, terror-stricken before a vast expanse of blazing desert and snow-clad mountain or before a mighty tempest at sea. George Santayana considers that there are two ways of securing harmonies: one is to unify all the given elements, and another is to reject and expurge all the elements that refuse to be unified. Unity by inclusion gives us the beautiful; unity by exclusion, opposition and isolation gives us the sublime. Both are

pleasures but the pleasure of one is warm, passive, and pervasive; the pleasure of the other cold, imperious, and keen.[1] Perhaps the distinction cannot be carried far. Man's experiences of beauty, sublimity and holiness are often found fused together. Lyrical poetry is the poignant expression of single emotions and limited attitudes like love, hope and melancholy. It has its place in easing the heart's ache; for the ordinary man, even when swayed powerfully by a single impulse or attitude, cannot imaginatively bring about its complete and ordered development in his mind. Thus he lacks the poise which a lyrical poem gives. But lyrical poems do not represent the highest kind of poetry in which we see the interplay and integration of a wide variety of impulses and attitudes some of which are discordant with one another. As the poet orients himself not to one set of impulses and attitudes, but to many, he reveals more aspects of life and personality. He gives us, not merely 'beauty' but also 'sublimity' by detaching himself from the localised cameos of the world, and limited sets of emotions and attitudes.

Accordingly the artist in the pulsations of his moods or levels of experience identifies himself by one phase with the world; in another he becomes aloof from it in the height and glory of his understanding. The artist can succeed best with a certain aloofness and disinterestedness of sense and consciousness, what Bergson calls a certain 'immateriality of life'. Similarly the mystic raises himself far above the world as he flees from it or again finds life and its pleasures intoxicatingly beautiful as he comprehends these as offerings to God. The truth of the matter is that the æsthetic like the religious experience implies an organisation of the various impulses and moods in which very little is left out. The difference between the æsthetic and the religious experience is that the latter can admit far more of the elements that are mutually hostile without confusion, and hence produces a greater sense of certitude, harmony, and competence. Further, the religious experience often obtained in isolation or detachment from life is dissociated from social communication. The joy of spiritual contemplation may be entirely unique and personal without losing its intensity. Æsthetic delight, on the other hand, becomes more intense through social participation.

The Logic of Expression in Art

Such social participation involves the fixation in sounds, words, colours and other symbols the contents of the artist's inner harmonies. This is called 'expression' in art. Behind the arrangement of words, sounds, metaphors, lines, colours and forms the artist significantly represents his inner harmonies or rhythms whose secrets lie embedded in the depths of his being and yet which embody themselves in appropriate sensuous forms. Such forms and rhythms may be called 'sensuous universals' because of their appeal to men of all races

1 *The Sense of Beauty*

and regions, rooted in the basic character of man as the living creature, bilaterally symmetrical, dominated by vital rhythms and the ebb and flow of his reflexes and emotions and subject to the force of gravity with its far-reaching emotional reverberations.[1] It is because man is rhythmic in the functions of his body and mind, in his spontaneous movements as well as in his acquired reactions, constantly being enriched and expanded by resistance of the environment and fresh equilibrium, by break and reunion, that his artistic expression has taken the form of rhythms in both form and content. It is the larger rhythms of nature that pre-determine rhythm as the significant form in all the fine arts of man. More than his own organic rhythms, man's social and economic adaptation to the rhythm of the seasons, of day and night, of toil and leisure, of sowing and harvesting has been significant in developing the sense of significant form and rhythm in song and dance, painting and sculpture. In true artistic expression there is a profound harmony of the internal and the external, so that the perfect ordering of thoughts, sensations, emotions and attitudes becomes manifest, in some inherently suitable external forms and rhythms. The æsthetic process thus manifests both the creation of internal form, as in the well-known theory of Croce, and the embodiment of this in appropriately expressive external form. The distinction that Croce draws between æsthetic experience and externalisation of art is accordingly unsound. For in art construction the internal and the external help each other. Æsthetic sensibility, indeed, discovers a 'logic' in the presentation of sense-data appropriate to the harmony within the self. Bosanquet refers to this: "The rhythm that completes a rhythm, the sound that with other sounds satisfies the educated ear, the colour that is demanded by a colour scheme are, I take it, as necessary and as rational as the conclusion of a syllogism". But the deduction rests not on reasoning, deliberation and choice, but on an intuition akin to that of the mystic. The artist as the result not of reflection and philosophy but of his natural detachment, "one innate in the structure of sense or consciousness that reveals itself by a virginal manner, so to speak, of seeing, hearing or thinking" discovers certain rhythms and harmonies of life and mind that touch man profoundly and give him a direct vision of the reality. These overreach the external rhythms in nature or even the larger pulsations of relationships that determine the course of man's life. It is not only from these but also and mainly from his immediate intuitive vision of the reality that man essentially derives his joy in rhythmic presentation. The human soul, says the Aitareya Brahmana, is saturated with rhythm.

Words, colours and forms ordinarily come to us in the significance and context of their utilitarian functions and necessities which have brought them to existence. Thus "the ear, the eye doth make us deaf and blind". Our senses which adapt us for the needs of adjustment in limited time and space narrow

1 See Parkhurst: *Beauty*, pp. 5 and 261.

our vision, and limit our horizon. Our comprehension not only of material objects but also even of our own mental states as these come up to the conscious life is largely determined by the innumerable nuances of meanings and associations inextricably bound up with our biological adaptations. Such meanings and associations, indeed, are all related to and circumscribed within the limits of the sensible world with its divisiveness and multiplicity, and its inexorable biological demands that our extroceptive senses and the brain have in the evolutionary process become qualified to deal. It is the artist who can "see into the life of things", reveal words, sounds, colours and forms in their original nature without the screens of the prejudices, labels and "stereotypes" which develop out of the utilitarian give-and-take between mind and its immediate sensible environment, that is but a restricted and selected part of the universe.

Art and Disinterestedness of Sense

Bergson aptly observes in this connection: "One man applies himself to colours and forms, and since he loves colour for colour and form for form, since he perceives them for their sake and not for his own, it is the inner life of things that he sees appearing through their forms and colours. Little by little he insinuates it into our own perception, baffled though we may be at the outset. For a few moments at least, he diverts us from the prejudices of form and colour that come between ourselves and reality. And thus he realises the loftiest ambition of art, which here consists in revealing to us nature. Others, again, retire within themselves. Beneath the thousand rudimentary actions which are the outward and visible signs of an emotion, behind the commonplace, conventional expression that both reveals and conceals an individual mental state, it is the motion, the original mood, to which they attain in its undefiled essence. And then, to induce us to make the same effort ourselves, they contrive to make us see something of what they have seen by rhythmical arrangement of words which thus become organised and animated with a life of their own, then tell us—or rather suggest—things that speech was not calculated to express. Others delve yet deeper still. Beneath these joys and sorrows which can, at a pinch, be translated into language, they grasp something that has nothing in common with language, certain rhythms of life and breath that are closer to man than his inmost feelings, being the living law—varying with each individual—of his enthusiasm and despair, his hopes and regrets. By setting free and emphasizing this music, they force it upon our attention; they compel us, willy-nilly, to fall in with that, like passers by who join in a dance. And thus they impel us to set in motion, in the depths of our being, some secret chord which was only waiting to thrill".

According to Bergson, art is only a more direct vision of reality. But this purity of perception implies a break with utilitarian convention, an innate and

specially localised disinterestedness of sense or consciousness, in short a certain immateriality of life, which is what has always been called 'idealism'.

Levels of Disinterestedness and Detachment

There are stages or levels of this 'disinterestedness of sense or consciousness'. There is, first, in æsthetic contemplation an organisation and synthesis instead of exclusion and repression of the urges, impulses and attitudes in both conscious and unconscious levels. The equilibrium of the unconscious opposite desires of love and hate, tenderness and aggression that are ambivalent must be obtained before the ego can secure the 'detachment' or 'objectivity' which may enable it to image mental processes and situations in art work. With 'detachment' and 'distance' from his moods and passions, these will no longer be screened from him in their inmost, their personal aspect, in the original life they possess. No longer under the grip of these struggling primeval ambivalent emotions and attitudes, he can externalise them in significant images and forms, and through sublimation, dramatisation and other mechanisms adopt optimum social disguise of their gratification for great artistic creations. This process has been analysed in a previous chapter. In more elevated æsthetic contemplation, detachment is carried further, and with the progress of such detachment the artist's deeper emotional level and personality become more completely involved. The ego now sinks into the Being, which it recognises as 'the One, without categories', 'the Universal Mind' or 'God'. Psychological theories of art fail here. We are here in the realm of metaphysics, which alone can give us the clue to the essence of Beauty and the art process.

In the realm of Being, the ego or the personality has to find a profounder balance and reconciliation of opposites, the harmony between Being in the Silence, beyond the categories of time and space, beyond the waking, the dreaming and ecstatic states of mind, and Becoming which is the Many or the World, the Being revealed or externalised. The rhythm or concord of Being and Becoming is the summit of artistic and mystical experience. Everywhere it is a reconciliation of opposites. For has not Plato said: "For nothing can have any sense except by reason of that of which it is the Shadow?" In the most elevated æsthetic contemplation, "His Darkness and His Brightness" are identical.

Beauty as an Aspect of Being

In man's metaphysical realisation Unity and Beauty are found as different aspects of Being. Beauty, in other words, is the expression of Unity and the manifestation in the realm of Becoming of Unity. According to Plotinus, Beauty is the expression in matter of Reason which is Divine. Plotinus observes: "The things of this world are beautiful by partaking in an essential character. For everything that is formless, though its nature admits of form and essential

character, so long as it is devoid of rationality and essential character, is ugly and excluded from the divine and rational. That is the absolutely ugly". "But when essential character has been added to a thing, so as to make it one by organising its parts, it confers system and unity of plan and makes the thing coherent. For since the essential character was one, that which was formed by it had to become one, so far as the multiplicity of its parts allowed. Beauty is then enthroned upon the unity thus created, conferring itself both upon the parts and upon the whole". The unity that man's self realises in the Being as an all inclusive, universal Whole (Purnam) reveals itself also as harmony of parts in the self's relations to all life (Becoming) in a community of feeling (Beauty or Sundram) and of achievement (Goodness or Sivam). The unity of Being becomes the rhythm and harmony (Beauty) in the processes of Becoming. Such is a paraphrase of the Hindu classical conception of Unity and Beauty.

Rhythms, Large or Small, Level upon Level

The function of art is to bridge the gulf between the Being and the Becoming by imitating the rhythm of the soul that in its most intense moments identifies itself with the world around. All nature, all life, show an equilibrium of forces and energies. Physical equilibrium is illustrated by that of conservation and dissipation, aggregation and dispersion, light and darkness, ebb and flow, motion and rest. In man, with the systole and diastole of his heart action, with anabolism and katabolism, waking and sleep, hunger and satiety, attention and ennui, frustration and fulfilment that establish his physical and biological equilibrium with the environment, this becomes conscious as the sense of rhythm. This is heightened by the cyclical adjustment of man's social and economic routine to the procession of the seasons, of day and night, the phases of the moon, the ebb and flow of the waters and the ever-reourring round of birth, maturity and death that govern his agriculture and the welfare of stocks and crops and profoundly affect his interests and emotions. Even with the development of economic life, the round of man's economic and social activities and leisure-time pursuits follows the rhythm of sunshine and rainfall, the natural recuperation.of the soil and the cycle of growth of vegetation from seed to maturity and of reproduction of beasts; while the introduction of rural arts and crafts is fitted into the larger economic rhythms or breaks these into smaller and more clearly discernible cycles.

Man's integrations or equilibrium with the environment are thus rhythms, rhythms of need and satisfaction in the biological level, rhythms of resistance and mastery in the psychological and social level, rhythms of achievement and withdrawal in the metaphysical level. From level to level the resolutions of tension or rhythms give a delight that increases in depth, range and intensity. By stamping the rhythm upon the phenomena of nature or activities in society that lack

order, man obtains his supreme poise, mastery and delight. As he cuts wood, chips stone or drags logs of wood and stone, he finds that his toil is relieved if it is punctuated by rhythms. As he reproduces the rhythmical movements of the serpent, the deer, the elephant and the boar in his cave painting or in his dance, he enters into the very spirit of these animal guardians or totems and enjoys spiritual exaltation. His story-telling, magical formula, lullaby or martial cry, as these take on cadenced forms, become more effective and soul-stirring, and stamp their creators as sages, heroes and prophets of the people. Man's arts of chiselling, moulding and weaving, his collective toil of sowing and harvesting in the fields, his group movements on critical occasions, such as the preparation for war and hunting expedition and return with the captives and spoils of war and the chase, and, above all, his magic and worship, gain in zest and meaning as these fall or are broken into rhythms. It is in this manner that man's arts of utilisation by being embraced in a scheme of rhythm partake of the character of fine art.

The cycles of experience of man's own inner life, of his birth, maturity and death, of the death and renewal of vegetation in the passage of the seasons and of the seasonal alternations of hunting and war, sowing and harvesting, are also caught in rhythm in his poetry and song, music and dance, that reproduce nature's pulsations in terms of his own profound emotions. The shepherds seasonally marching with their flocks and herds across vast open spaces see the profound cyclical changes of the grass-lands by day and the rise and setting of stars and the phases of the moon in the sky by night, and these ever-recurrent cycles weave the warp and woof of myth, song and drama. Man's agriculture is also punctuated by labour and rest with the procession of the sun and the phases of the moon, and regulated by time-reckoning that fits somehow the lunar month into the solar year. Thus does the rhythm of nature determine the round of his toil and relaxation, war and festival, love and worship; and where he does not find rhythm, he creates rhythm to find his order and poise in his group activities and experiences; even in speech, gestures and manipulations of the materials of nature. Such rhythms, though imaginative, work within the limits of the materials and forces of nature fashioned into significant forms or of the community's routines of activity, mass feelings and experiences that are embraced in a scheme of order and cycle. There are other rhythms that the human soul discovers that are much less restricted by the limitations of the visible universe of nature and society. The moonlit nights are favourable for the love-life of man as of other animals and thus the phases of the moon are caught for the celebrations of dance and marriage, festival and recreation. Rhythm as a universal order governs man's philosophical and metaphysical categories. Thus he seeks to present the system of the universe as an interplay of the primordial rhythm of light and darkness, creation and destruction, of manifestation and dissolution, change and changelessness.

Rhythm as the Keynote to Man's Creative Adventure

Man, in so far as he is a living creature, and adjusts himself to the environment, indeed finds his existence and activity of the rhythmical pattern that is the ultimate order of nature. As his consciousness deepens and widens, his sense of rhythm embraces deeper levels of his being, not merely physiological rhythms adapted to the greater rhythms of the seasons and hours of the social economic rhythms and activity conforming to ever-recurring cycles of nature and of body and mind, but also the deeply felt, imaginative and universally obtaining rhythms of birth and death, waking and sleep, male and female, creation and destruction, part and whole, matter and void, that make his universe a cosmos, and himself a microcosm. It is through the imaginative rhythms, fashioned out of the cyclical phenomena of nature or discovered from the deeper strata of his own consciousness, that man may enjoy his freedom in the universe that hems him with limitations on all sides and the capacity to forecast and hence to create. Man's all-inclusive imaginative rhythm through which he achieves the greatest fullness and highest intensity of his experience embraces the concrete and transcendental in his basic cosmic scheme of rhythmic presentation of the universe with its recurrent alternations and symmetries.

All contrasted or antithetical experiences and notions such as resistance and fulfilment, pleasure and pain, life and death, activity and rest, finiteness and infinity, that generates rhythms large or small, corporeal or ethereal, level upon level, are now comprehensively, perfectly and finally harmonised in the mind. Man's profound joys are stirred by the metaphysical rhythms when his soul overcomes all kinds of contrasts of lack and fullness, of opposition and achievement, of concreteness and universality. Such inner harmony is achieved by the identification of Being and Becoming, of man becoming one with the environment's balanced movement of consolidation and dissolution, generation and destruction, manifestation and withdrawal. There is a polarity of man's existence, knowledge and experience. When man is alone and passive, the world merges in this blissful condition of Being. When he is awake and active, he finds Being unfolding itself in the multifarious world of appearances. This is the realm of his Becoming. Like the recurrent alternating moods of his soul, the pulsations of his experience, the world of Becoming also exhibits rhythms and pulsations, the smaller subsumed within the greater and the unseen rhythms.

Man's complete identification with the cosmos of which he is a part comes, then, with his apprehension of the balanced rhythm of repose and activity, withdrawal and renewal that are characteristic of both the human soul and the visible universe. In the perception of such a rhythm, man's mind obtains a scope as boundless as that of the universe itself. Man's highest freedom, deepest poise, and fullest experience are recorded and celebrated by rhythms in his poetry, painting, sculpture and architecture, music and dance. Wherever man encounters

rhythms and harmonies, he is in fact transported to a strange world of rest and silence, he finds Being. There are different ways in which the fine arts, human love or the beauty of nature check the ebb and flow of the human consciousness and bring about an eternal calm. "What is thought takes the spatial form, what is felt takes the temporal form." Bergson has shown that the intellect bent upon an understanding of the nature of things, dominated as it is by the idea of action, stays the ever-altering patterns to dwell upon them, and the better to appreciate their character. In painting and sculpture, arts of space, with which the intellect is so clearly associated, the movement of Becoming is stayed for man's contemplation. Before a Chinese landscape-painting or a picture of Greco or Rembrandt the mind's flux is completely stayed. "The peculiarity of poetry and music— the arts of time", says Dixon, "lies in this that their measures are intensive, not dimensional, the measures of our inner sense of time, of an order in which past, present and future are associated—memory of a past note or anticipation of a chord to come, each of which were of itself without significance or value".[1] As one finds himself in intimate tune with the imponderable rhythms of music, painting and sculpture, and perceives a unity of feeling and expression with a landscape or with the secret rhythm and influence of a living being, his consciousness is expanded and quickened, and effects a reconciliation of Being and Becoming; in such moments of complete absorption, it attains a scope as extended as that of the apprehended universe.

Rhythm, therefore, holds the key to the creative activity that is nothing more and nothing less than the simulation of the activity of the waking soul, its identification of self and not-self ranging from the absorption in love and abandonment in a common tune or a mass dance to the pantheistic apprehension of a landscape and the ecstasy of spiritual communion. Just as the rhythm of a work of art is the outcome of integration of many smaller rhythms composing its form and content, so it produces in man's body a profound harmony of working of its vital organs and processes, sensations and emotions, and in the consciousness a complete *rapport* with the apprehended creation that absorbs both body and mind in its final, all inclusive sweep. From the lowest to the highest levels of æsthetic expression man encounters, then, an experience of uniting himself with something which he does not accept as alien or separate from himself. With the enlargement of self-consciousness and realisation of his oneness with fellow man and with life as a whole, 'Beauty' expresses a harmony of parts and relations which increases its range, until it comprehends the whole universe. Thus the world through the actualisation of physiognomic rhythm becomes one with the self, the seat of the all-inclusive rhythms beyond the reach of the senses, that are produced by the contrasted concepts with which the intellect sifts the multitudinous universe—the concepts of part and whole, finite and

[1] *The Human Situation*, p. 416.

infinite, creation and withdrawal, lack and fullness, that picture for him the ultimate reality.

The Hindu Idealistic View of Æsthetic Experience

In the Hindu metaphysical theories of æsthetic experience (rasa) and rhythm (dhvani) we find the conception of Beauty as unconditioned and supra-sensual, inseparable from the experience of the unity of Brahman. The authoritative text, *Sahityadarpana*, defines æsthetic experience as follows: "Æsthetic experience is tasted by men who have an innate sense of absolute values; it is experienced in a state of pure consciousness as self-luminous, in the mood at once of ecstasy and pure consciousness. Such experience is dissociated from any contact with things knowable. It is a twin brother to the experience of the unity of Brahman. It is indivisible and intrinsic and comes of in a super-mundane lightning flash."

The Hindu idealistic tradition posits æsthetic experience as always there, virtually ever-present and potentially realisable, but that it cannot be realised unless the surrounding "screens" (the same metaphor is used by Bergson in this context) of the self are removed. The visible universe is the reflection (Abhasa) of God. Sankaracharya uses the following beautiful metaphor: "On the vast canvas of the Self the picture of the manifold worlds is painted by the Self itself and that supreme Self itself takes delight in seeing it". It is this world picture (Jagaccitra) which is realised in contemplation as an æsthetic experience. It is born and innate with man; only his many barriers prevent its realisation. This is very well stressed by Abhinavagupta, who is as pre-eminent in the exposition of Hindu æsthetic philosophy as Sankaracharya is in the field of the Vedanta philosophy. According to this famous Hindu literary critic, the reader or beholder should free himself from distractions and obstacles which hinder concentration that is compared with perfect sleep (Susupti) and ecstatic meditation (Yoga). Then his mind can develop certain stable dispositions (Sthayibhava) classified as love, humour, grief, anger, fear, enthusiasm, wonder and renunciation) into æsthetic experience. Æsthetic experience is impersonal (Sadharani), abstract and transcendental (Aloukika) and is kindred to the pure consciousness of Being (Atmananda); in both cases the removal of obstacles to enjoyment is fundamental. But in æsthetic experience (Rasasvada), the sthayibhava persists in the self; spiritual ecstasy is on the other hand free from any mental experience whatsoever. From the point of view of Abhinava, one must make a logical distinction between æsthetic experience, which is dominated by the basic mental states (Sthayibhava) and the mystical ecstasy that is dominated by pure consciousness (Chit). When the self dissociates itself in æethetic apprehension from any objects or situations, the mood or emotion is intellectualised (Chitbishista Ratih); this is the distinction established between love (Sringara) and an abstract or intellectual apprehension of the same (Rati). Æsthetic delight is called the

twin brother of spiritual bliss (Brahmananda Sàhodara) because of its freedom from all limitations, except that it is marked by the presence of a sub-conscious disposition coming into the consciousness (Udbuddha vasana).

One of the schools of Hindu poetics is named the School of Manifestation (Vyakti-Vada) because the perception (Pratiti) of *rasa* is thought of simply as the manifestation of an inherent and already existing intuitive condition of the spirit, in the same sense that enlightenment is virtually ever-present though not always realised. The pratiti of rasa, as it were, breaks through the enclosing screens (Varana, Avarana) by which the soul, though pre-disposed by ideal sympathy (Sadharanya) and sensibility (Vasana), is still immured and restricted from shining forth in its true character as the taster of rasa in an æsthetic experience which is aforesaid the very twin brother of the experience of the unity of the Brahman.[1] The realisation of ideal Beauty or æsthetic experience cannot be distinguished in Hindu metaphysics, from the gnosis of Brahman, the realisation of Being. The artist's apprehension of the world is the delight of Being in perceiving its own unfoldment in the universe (Becoming). A later literary critic Panditraja Jagannath in his exposition of the æsthetic theory of Abhinavagupta in terms of spiritual ecstasy while positing that *rasa* in poetry and drama is the experience of the blissful atman (Being) when the screens are removed, yet points out that while the mystic enjoys the bliss of Being in isolation, the artist or the reader (Sahrdaya) enjoys it along with the primary stable dispositions (Sthayibhava) that are dormant in consciousness and are kindled by reading literature or seeing a painting. Both spiritual ecstasy and æsthetic delight are direct visions of the reality (Aparoksha) and induced by means of words (Sabdi). Æsthetic delight consists in both the realisation of sthayibhava and the enjoyment of the blissful aspect of Atman. Thus æsthetic experience is mainly attributed to the experience of Being which is always supreme bliss, though it may be delimited by its associated attitudes. This is also the position taken in the Kavyadarpana.[2]

Rhythm as the Soul's Primary Oscillation of Being and Becoming

Nothing is truer of elevated meditation, whether of the mystic or the artist, than the alternation of Being and Becoming, of nirvana and activity, of silence and participation in the cosmic-social process. This alternation, the mystic or the artist expresses himself in his figurative language as rhythm which is the distinctive idiom or vernacular of the soul, instantly acceptable by all. It is the rhythm of the soul, which is manifest in the ebb and flow of Nature, the gyrations of matter from the hugest starts to the smallest electrons, the seasonal pulsations on the earth and sky, and the alternation of sleep and waking, death and life, creation and destruction, withdrawal and renewal. Lewis Mumford

1 A. K. Coomaraswamy: *The Transformation of Nature in Art*, pp. 53-54.
2 E. P. Shastri: *The Philosophy of Æsthetic Pleasure*, pp. 245-247.

observes: "The more thoroughly we explore the universe with telescope and microscope, with crucible, test-tube and thermometer, the more wonderful become the rhymes and correspondences that bind man not only to the animal orders from which he has emerged, but to the farthest galaxies of the heavens and the more do our symbols themselves fall into harmonious order with symmetries and correspondences like that of the periodic table".[1] Such rhythm apprehended in the depth of Being is the core of the sense of Beauty. By rhythm the soul enters into its deepest level of experience, that of the simulation of the oscillating cosmic creative process in which the Being remains alternately in rest and movement, withdrawal and manifestation as discrete and extended in the visible world, and thus abolishes the distinction between a Here and Beyond, a microcosm and a macrocosm. All art, then, originates in the ultimate analysis in the physical and metaphysical rhythm that alone can explain those patterns of colour, significant forms and melodious rhythms from which the mind derives profound delight without asking why. The real explanation is that in the metre of poetry, in the pattern of colours in painting, in plastic movement and in the rhythm of dance the soul is awakened to its natural and primary unison with the Becoming. In Europe, Greek, Renaissance and modern art, as it has accepted naturalism, has turned to the more evident and incidental aspects of nature rather than to its structural relationships and preferred identification with the charm of visible appearances in the sensible world to identification with the deeper reality that encompasses both the sensible and the super-sensible world and that manifests itself in rhythm in every art and in every work of art. As it has rationalised and despiritualised itself, and imitated the ensemble of visible characters capable of being scientifically appraised and reproduced, it has rested less on the basic rhythms of existence and failed to touch the deepest levels of feelings and experiences. Aristotle observes: "There seems to be a sort of relationship between the soul on the one hand and harmonies and rhythms on the other". There are significant passages in the Aitareya Brahmana which also attribute the creation of the universe and every art of man to the rhythm. Prajapati (God as Begetter) after creating man ·and the world was disintegrated; He reintegrated Himself by means of the metres (Chandobhir). Another passage reads thus: "It is in imitation of the divine works of art that any (human) work of art (Silpa) is accomplished here; for example, a clay elephant, a brazen object, a garment, a gold object, and a mute chariot are works of art. A work of art, indeed, is accomplished in him who comprehends this. For these divine works of art are an integration of the self, and by them the sacrificer likewise integrates himself in the mode of rhythm (chhandomaya)."[1] The spiritual significance of rhythm in art is plainly asserted by the Vada

1 *Faith for Living*, p. 155.
2 *Aitareya Brahmana*, III, 2, 6; VI, 27.

School of Indian poetics, according to which the essential or soul of poetry is 'resonance', 'rhythm' or 'overtone' of meaning. It is through the processes of suggestion (Vyanjana) that meaning 'echoes', reverberates, 'moves' and animates. Similarly in the first canon of Hsieh Ho which governs painting in China we find a striking corroboration of the notion of rhythm as the essential principle in nature and art. The essence of art is "operation or revolution, or rhythm or reverberation of the spirit in the forms of life". There has been some difficulty in interpreting Hsieh Ho's principle which is rather vague. But looking back to Chinese metaphysics it appears that the "spirit" of Hsieh Ho is the spirit of the Universe as made up of Heaven and Earth. It is through the operations of this "spirit" that the world movement or the cosmic process is possible and motion is produced. This is a familiar Oriental notion. The object of painting, then, is to give expression to this "spirit" which underlies all manifestation or the phenomena of the universe. Painting thus reveals the essence and quiet movement of the metaphysical reality. This is implied also in the statement of Wang Wei that "painting must also correspond with the 'phenomena of the universe" or in that of Ku K'ai Chih that the goal of painting is the perfect fusion of the spiritual and the material. By communing with the spiritual, the artist acquires mysterious vigour and with the mechanical aid of ink and brush, he gives a tangible expression to that spiritual inspiration.[1] The body of rhythm is line that shows not the visible appearances of things but their inner structure or essence. Indian and especially Chinese painting is characterised by the delicacy and rhythm of line, the accuracy, ease and fluency of brush strokes that unmistakably express some intense yet subtle, elusive and impersonal feeling. Thus Chinese painting is described as the visible record of a rhythmic gesture, a dance executed by the hand. Apart from the rhythm or quiet plastic movement in both painting and sculpture on the rock surface, both India and China have, in the numerous forms of fairies, angels and apsaras and the celestial forms of Brahmanism, Buddhism and Taoism, also portrayed figures that dance in the air revealing the rhythm of the spirit. Man's mind cherishes gestures and movements that are not restricted by time and space, and in Oriental art we see these depicted with singular felicity supported by the fundamental metaphysical notion that the entire universe is pervaded by an eternal stream of consciousness of which different forms and appearances are bubbles rhythmically appearing and disappearing. Throughout the Orient the conviction has indeed been fundamental through the epochs that art is a revelation of pulsation of the immanent metaphysical reality in natural forms, and thus the dominant note has been not the imitation of nature but the expression of rhythms that embody this reality in both manifestation and non-manifestation.

1 See Shio Sakanishi : *The Spirit of the Brush*, pp. 47-49.

The basic rhythms that underlie the scheme of the universe and constitute the substance of reality are expressed in the fine arts by the polarity or opposition of their fundamental sensory materials, light, shadow and colour in painting, mass and emptiness in sculpture, tension and ethereality in architecture, repetition and novelty of sounds in music. Man has thus sought through the rhythmic alternation, control and transformation of these opposed elements to insinuate inexpressible and incredible rhythms into a universe whose chaos shocks him to his very·depths. He has even played provocatively with the irregular, unfamiliar and arythmical in his recurrent challenge to disorderliness through the different materials and media of his arts. May it not be that this strange interplay of rhythm and arhythm symbolises the inescapable dualism of order and disorder in the universe that it is the function of art to reflect in its own terms with its particular antithetical sensory elements?

CHAPTER VII

THE MEANING OF ARCHETYPES IN RELIGIOUS ART

The Archetype, Type and Individual in Art

Man everywhere seeks to achieve or contemplates a reconciliation between himself and the world to which he belongs. This is the harmony or integration between Being and Becoming which the concrete world of human experience denies him. In the metaphysical harmonies of Being and Becoming which man realises also as cosmic rhythms of matter and motion, life and mind, we have in the ultimate analysis the genesis of art. Thus great art is religious; the fine arts are divine.

The artist expresses in his images the mysteries of life and the world that have an impersonal and universal significance for the race, nation and collectivity. Or his representations of men and situations approximate to types that are widely understood and accepted. Or, again, such representations express concrete personal moods and situations of the artist that are somewhat removed from universal and impersonal attitudes and experiences. On the basis of this distinction art motifs may be classified into archetypes, types and individuals. Jung has made us familiar with the conception of archetypes in myths and fables that are derived from the "collective unconscious" as contrasted with the personal unconscious. It is well-known that many myths, legends, fairy tales and symbols are similar or even identical among different peoples, portraying in typical images their inner and unconscious psychic drama. The psychological mechanism behind all this is that as the unconscious forces in life or the incomprehensible forces of nature are externalised in the forms of images and myths, these cease to be disturbing and disintegrating, but rather incomparably usefully function in aiding man's inner adjustment against the uncanny living depths of the world and of the psyche. The background of the formation of phantasy, myth, art and religion is the same. Art as it links itself to phantasy, myth and religion expresses the incomprehensible forces of the universe and man's inner life and fulfilment. Religious art is not representative, dealing with persons and objects of nature but is idealistic, being concerned with man's strivings and aspirations, with the world that never was on sea and land. More than myth, legend and fairytale, it orders and evaluates emotions and experiences, and records those that are neither transitory nor disruptive but stable, constructive and unifying. Religious art does not present the mutable objects of the natural world nor the passing moods of man's life, nor even definite types of human life and experience, but reveals and symbolises the meaning of human life and destiny

in certain archetypes. It is the archetypes of religious art that bind together society in close harmony through generic feelings and ideals of man's fulfilment, whether these are grotesque idols of the primitive peoples, marvellous statues of the Greeks or sublime images in Buddhist or Hindu temples. Idol and image, totem-pole or banner, temple or cathedral, stained glass or fresco, all symbolise the thoughts and feelings of the community that have the qualities of permanence, knit together through the generations and rescue it from the fears, tensions and conflicts of the mundane world.

Man through the ages figured the super-sensible and the unconscious in beneficent and protective image-forms that have given complete satisfaction to his heart and intellect. Primitive art fashioned many animal symbols, such as dragons, serpents, crocodiles and monsters which need not be regarded as magical offerings in order that the hunting tribe might be successful in the chase of the figured animals. These image the savage's raw unconscious urges and desires and his attempt at a psychic and social adjustment through art which arose from the same unconscious background as magic, myth and religion by way of externalising the sanguine instincts. Gradually the so-called Venus of primitive sculpture appeared, imaging the anima which was related both to the fruitfulness of the soil and to the dark, uncanny and elfin nature of the unconscious life. Her fecundity is powerfully expressed by the exaggerated size of her breasts. Whether the motive figures were connected with fertile rites and magical sacrifices or not, the archetypes of the primitive Venus, as fairy, goddess or as demonic woman, characteristically released the unconscious, facilitating the integration of the personality and social processes. As civilisation progresses not merely animals, once tribal totems and personal fetishes but now associated with god-ideas, but also heroes, fairies, gods and goddesses are represented by archetypal images that drain the unconscious and assure the stability of the social order.

The Theomorphic Archetypes in Egyptian and Hindu Art

It is inevitable that these archetypes that denote the symbolic figures of the view of the world and man's relation to it, must be modified in the social and ethnic setting. Each region or people would define the archetypes in its appropriate manner according to its objective experiences. Egyptian art was, for instance, largely dominated by the super-sensible aspect of the animal, such as the lion or the bull, and in numerous theomorphic archetypes the artist sought to convey something of the mysterious reality of animal nature as embodying the order and rhythm of the world. Not merely in Egyptian but also in Indian and Chinese art animals such as the ram, bird, bull, elephant, monkey and camel have been carved, giving profound impressions of power, courage and fortitude that bridge the gulf between the human and the non-human. In Hindu art,

there are theomorphic myths and images such as Nara-Simha (the man-lion), Ganesha (with the face of an elephant), Daksha Ptajapati (the man-goat) Haya-griva (with the face of a horse) and Vajra-Varahi (with the face of a sow), not to speak of the Jakshas, Nagas and Kinnaras. But early in the evolution of Indian civilisation human and social values asserted themselves in art and religion. The Inner harmonies at the heart of the world were expressed by these in anthropo-morphic terms. Secondly, in the higher level of culture, man's judgment and scale of values as well as elements of abstraction, conceptualisation, condensation and elaboration are apparent in the forms of the archetypes. Art and religion, for instance, would present these in less naive and understandable forms than myths, fables and fairy tales that would not disguise much the unconscious psychic processes. There is, however, no doubt that it is the myths, legends and tales which first give an explicit form to the archetypes that are then fashioned and elaborated by art and religion as traditional and dogmatic symbols that are immediately accepted and comprehended by many as solemn and sublime through the centuries. In the Orient, myth naively articulates the archetypes, art beautifies them, morality cherishes and religion adores them.

The Archetype of the Yogi in Buddhist Art

In Asia human emotions and social feelings were fashioned and moulded in supernatural cast, expressed in a transcendental context from which the social feelings derive their profoundest significance. Thus the archetypes and symbols are at once metaphysical and ethical in their content, adapted at once to the intellect of the elite, and the feelings and aspirations of the common people. One of the earliest and yet majestic archetypes in Oriental art is that represented by the image of Buddha in his attainment of enlightenment. Gautama obtained his enlightenment centuries ago. This is a historical occurrence. But that the Buddha is in the process of attainment of Nirvana in the heart of every sentient creature, nay in inanimate matter, even in the innumerable sands of the Ganges, is an eternal cosmic truth that Buddhist art has expressed. The fathomless exis-tence of Buddhahood or Being is something more than the immortality of the individual in Buddhism. The Buddha is not a superhuman individual or God who reveals himself to the world in a single incarnation. In the heart of every living creature the Buddha or Being is ceaselessly manifest through a continuous sequence of births and deaths. We are not referring here to the later Mahayana conception. In early Buddhist literature, we come across the term Bodhisattva which means any person destined to become a Buddha in this or some future existence. Gautama himself goes through previous births as man, animal or fairy, and unequivocally states: "I am neither man, Yaksha or Gandharva", so as to stress his primordial metaphysical essence. Buddha is also described even in early Pali canons as the Eye of the World, and the Ineffable Man. It is

accordingly in a cosmic background of the need of enlightenment for every kind of creature that early Buddhist art gives us the archetype of the Buddha image as crossing the boundaries of time and space. The Buddha and Bodhisattva images at Sarnath magnificently combine the older tradition of the yogi in his detachment from the world with the grace and beauty of the human body, itself full of raptures. Buddha's poses, gestures and attitudes, which may have originated in special incidents in the life of Gautama and in myth and history, thus obtain a timelessness in art reassuring to the individual soul its spiritual strength and destiny and complete assurance and freedom from fear in the pursuit of Dharma.

The Archetype of the Prince of Compassion and Heroism

A similar masterpiece is the picture of the Bodhisattva, perhaps Avalokitesvara, depicted in the Ajanta fresco amidst a gorgeous procession of youth and beauty, love and sport. Music and dance, fruits and flowers, sunshine and shadow, love-making, dice-playing, gossiping, play of children, gatherings in the Royal Court, as well as the lives of Buddha, religious rituals and offerings are all there covering walls, ceilings and pillars; past, present and feature, as these well out from the flow of narration of the Buddha's birth legends, intermingle; the beholder becomes saturated with the movements, gestures and moods of men and women as he looks at the scenes painted as if seen simultaneously in front and from above and below. The rock surface itself remains incalculable, opening its contents like the unconscious from all angles and from the variegated settings of houses, palaces and scenery which confine in their rhythmical frames the different episodes and moments of the narration. Interspersed amidst this pageantry of social life, with its many tense emotions and movements, set within the greater oscillations of the rhythm of life are the figures of Buddha and the Bodhisattva, serene and majestic, brooding over the transience of sensual delights, and feeling an unbounded compassion for all whose hearts are set on these. Art here presents the life of the world in all its sensuous perfection and delights with an abundant sympathy. It depicts the luxuriant fullness of woman's breasts and hips, her langour and passionate gestures as emotions sway her, with a wonderful veracity. There is no parallel in the world-history of art of this frank and passionate apotheosis of woman who is depicted as gossiping, love-making or dancing, in repose, standing, or swinging, in her toilet, in play with pet animals and flowers or in lamentation. But in her gaiety she has finesse, in her amours she has dignity, and in her grief she has patience, as every gesture, every glance and every moment of hers tell us. She is the eternal mystery, to whom mankind turns with profound wonder and adoration in her infinite moods, studied and reproduced by the artist with the most discriminating taste and painstaking care. She is in fact the symbol of the joy and perfection of the sensible world. The charm and grace of woman's body epitomise the full glory and beauty of the

sensible world as it rises to perfection in Being. More than the beauty of women or the display of jewellery and ornaments, drapery and flowers, green plants and luscious fruits, the Ajanta frescoes stress however, the beauty of the super-sensible. Rarely are the harmonies and rhythms of the sensible and the super-sensible world, of Being and Becoming so successfully blended as in the art of Ajanta.

Metaphysically speaking, Buddha is Being, the mind in the repose of Nir-vana. The Bodhisattva is the aspiration of all sentient creatures as numerous as the sands on the banks of the Ganges for Buddhahood which is to be attained by everybody. The Buddhisattva strives to attain Nirvana not only for himself, but for all, helping all sentient beings to obtain the Buddhahood. The entire world of Becoming is thus put on the path to Being by the wisdom, compassion and heroism of the Bodhisattva. How thoughtfully is the subtle difference bet-ween Buddha and the Bodhisattva limned in Ajanta: the former more serene, immaculate and impersonal, having obtained the placidity of Nirvana so beauti-fully rendered by the pose and stability of the seated yogic meditative pose; the latter youthful, radiant with compassion and goodwill for all and in a standing posture whose eloquent rhythms express the deep and gracious solicitude of one who has taken the vow that he would not enter into Nirvana before all creatures are liberated. It is the spirit of Buddha and the Bodhisattva that sets the norm of perfection for all creatures from the Brahmanical gods, Gandharvas, Kinnaras and Vidyadharas, kings and beggars, to animals. It is the Being of Wisdom who is the beacon lamp of spiritual ascent for all, the Leader of the Caravan, and who also binds everybody together, gods, men and animals, by his all-encompas-sing compassion.

The Sanctity of Social Obligations

In the frescoes at which hundreds of monks gazed in their lonely hours as they lived in the caves for their meditation, gods, angels and men are shown in sizes and colours that express their moral virtues and imperfections, their rank in the scale of advance to Being. The most illuminated and large-limbed bodies are those of the Bodhisattvas. Kings come next, handsome, graceful, luxurious and amorous. For have not kings like Asoka, Bimbisara, Kaniksha and Harsha accepted the teachings of the Dharma? Women are smaller, shy, slender and fragile. Their amorous poses and gestures are like rituals, chaste, subtle and sensitive. For are not the overtones of a cosmic existence discerned in human loves and passions that make up the texture of domestic life and obligations? Priests and the kings' counsellors are depicted as smaller than the kings. Traders and artisans are yet smaller while of diminutive size are the slaves, beggars, eunuchs and jesters. The colours of men, grey, yellow, red, green and black, are different according to the moral attributes their caste or occupation implies.

The slave and the eunuch are black. The hunter is reddish brown or light yellow or green. No infamy or indignity is, however, attached to the various occupations and castes, including the hunter's or the slave's. For the paintings illustrate that the life of the house-holder, performing his familiar and social duties and obligations, is as significant as the life of saints and ascetics who renounce the world. What is stressed is that it is not lust, greed, cruelty and injustice but tenderness, compassion and sacrifice that yield the rich harvest in future births of lasting prosperity and happiness according to the inexorable law of Karma. No matter what one's occupation or station is in life, whether one is a king, a Brahmin, an ascetic, a beggar or an animal, it is the ideal of supreme self-forgetful tenderness and sacrifice of the Bodhisattva that measure one's true worth in the scale of living. As a matter of fact the Bodhisattva through his merit of sacrifices in a thousand previous births acquires the privileged position of being born as a Prince or Danapati wearing on his head the royal mukuta, but yet as conqueror in the fullness of his detachment, modesty and compassion.

The Exaltation of the Life of the Senses

The Bodhisattva ideal effects a spiritual transformation of worldly life and exalts it. It is this identification of the worldly and contemplative life which underlies the universal quality of the Ajanta paintings and explains the artist's inexhaustible delight in the beauty and sensuous perfection of woman's form. He is an adept in depicting the soft sinuous curves of female figures or the patterns of drapery, the liveliness and grace of birds and animals, or the tenderness and delicate movement of leaves and flowers, while in radiant supernatural figures he reveals his profound appreciation of the transcendental majesty of the Buddha and the Bodhisattva. Addressing the Bodhisattvas, Sanitideva of Valabhi, probably a contemporary of the Ajanta painters, ardently sang thus: "Formed in the hearts of the large, perfumed, and fresh lotuses, and developing their bright bodies, the Bodhisattvas issue from the flowercups as they open to the rays of the sun and are born under his eyes in their perfect beauty "Behold! raising their eyes at the sight of the blazing Vajrapani upright in the sky, the damned feel themselves delivered from their sins, and fly to join him with joyous haste. Behold! a shower of lotuses rains down mingled with scented water. What bliss!". On the fresco the Bodhisattva holds the symbolic blue lotus in his right hand, while his inexpressibly charming face is tinged with the tender, human sadness due to world-misery and at the same time radiant with divine aloofness and serenity. The silent lips over which the word yet hovers, the half-closed eyelids that yet permit the profoundly compassionate glance to pierce through, the inscrutable gesture of the slender arm that is at once nonchalant and yet lovingly bends down to the suffering of the world, do not these symbolise the blending of the profound pity and tenderness of Hinayana ethics

with the transcendence of the Mahayana idealistic metaphysics? To the right of the Bodhisattva stands his young consort, gracious and sweet, bowed in her supplication and pensive in her meditation. Behind them rises a beautiful dream-universe with its aerial chapels, pavilions, fairy gardens and skies filled with sportive spirits of all kinds into which Mahayana absolute idealism has transformed the sensible world. The light that never was on sea and land has given to the painter's world of concrete forms the marvellously elegant and tender shapes of an apparition. The entire sensible and super-sensible realm is in the Mahayana conception like a stage, like the city of the Gandharvas that is neither existent nor non-existent. Mahayana mysticism totally abolishes the distinction between Samsara and Nirvana. '*Tes kleasas so bodhi, yas samsaras tat nirvanam*', that which is sin is also Wisdom, the realm of Becoming is also Nirvana.

It is from this mystical intuition that has welled forth the exuberant joy of the artist who has expressed it in the surpassing elegance and delicacy of women, in the Apollonian nobility of kings and nobles, in the gorgeous procession of the multitude and also in the purity and radiance of vegetation, and the strength and sportiveness of animal life. For who can forget the luxuriant vegetation and the lively animal world in the Ajanta paintings? It is an eternal spring time within the caves at Ajanta with the trees in full blossom, the foliage bluish green and young leaves reddish, while the big ants march off in clusters for the sap and the fruit. Animals are also there in abundance. But all are bound to man in intimate companionship. Gazelle and goose are attracted to man by sweet, affectionate fondness. For the great teaching of the frescoes is the sense of an absolute oneness of life through its different sentient levels. God and Gandharva, Apsara and Kinnara, king and beggar, have the same destiny as that of the Bodhisattva. Through a continuous sequence of births and deaths, god, man and animal obtain their status in the scale of living according to their good and evil desires and deeds. The pageantry of the king's court, the might of arms, the sports of love, the rhythms of dance, the pleasures of hunting and gambling are all parts of a long scheme of things, a continuous chain of causes and effects binding creatures and scenes together in Samsara until the chain can be snapped by all through the attainment·of Buddhahood. In the paintings of Ajanta, heaven, earth and the nether world intermingle. Space here is multi-dimensional. The activities of all sentient creatures in past, present and future lives are seen in a continuous, synoptic vision, as in the cinema, bound together by the immutable law of Karma. In the world of Ajanta time is eternal. Scenes cover walls from top to bottom and then leap to ceilings, contiguous walls, pillars and sides of rocks at all angles. The Being or the Bodhisattva, whether as King, or as some animal like the deer, the horse or the elephant round whom the story fastens is depicted from panel to panel for maintaining the continuity of a series of episodes that:cross the boundaries of time and space, extending from the

sensible to the super-sensible world. Nature comprising the vegetation, the rocks and the clouds is also pictured as sentient, participating with a delicate movement in the vicissitudes of sentient creatures that all live and move in Being. Does not the art of Ajanta echo by these procedures the Buddhist metaphysical conception that it is the Bodhisattva or Being which is the very substance of the sensible world or the world of Becoming, including not merely Nature but also Samsara, all sentient existence? Such is the profound social idealism and undying faith that were uttered by the monk-painters as they worked for several generations in the dim light of the caves in that haven of peace at Ajanta, and laid down the methods and techniques that have guided not only Indian but also Oriental art through the centuries. It is an art that is a hymn of praise to Being and calls man and the entire world of Becoming to the joy and silence of Being. It is unique in the history of art in its harmonious blend of ethereality and supernatural atmosphere with the joyousness of the senses, and the sanctity of social obligations.

Contrasts between the Indian, Indonesian and Chinese Images of the Buddha

Buddhist art created in India the archetypes of the Buddha's nativity, renunciation, temptation, enlightenment and charity to all sentient creatures. These are treated not as historical events but as eternal episodes of the realisation of Being, and as Buddhism spread from India to Ceylon, Java, Siam, Central Asia, China and Japan it was these art motifs which were assimilated into the indigenous traditions of art, giving expression to a broad humanistic mysticism that has informed the culture of the Far East and given an accent of calm and dignity to it through the centuries. The figures of the Buddha and the Bodhisattvas at Mathura, Sarnath and Ajanta, of the Buddha in contemplation at Anuradhapura in Ceylon, at Borobodur in Java, at Angkor Vat in Cambodia, at the cave-temples of Yun-Kang and Horyuji in Japan repeat the same archetype[1]. These are the world's most significant symbols of Being representing at once its serenity, clarity and profundity and the ecstasy of the human frame as it becomes incandescent with the inner illumination. The massiveness of volume and the structural coherence and simplicity of design are blended nicely with the fine tracery of the monk's robe and the prince's ornaments that are everywhere defined in linear rhythms of intimate sensibility and with the delicate and refined expression of the over-sensitive hands and fingers that are eloquent of the message from the super-sensible world. Of all the images, that at Cambodia with its exquisite divine-human smile reconciling the impersonality of Nirvana with a

[1] For illustrations of the Indian images see Coomaraswamy: *History of Indian and Indonesian Art*, Plates XL, XLI, XLII, XLVIII, XCVIII, for the Buddha in Java and Cambodia, see Grousset: *Civilisations of the East*, Vol. II, Figures 104 and 139, for the images at Yun-Kang see *Ibid.*, Vol. III, figure 134, and for the Horyuji frescoes, see *Ibid.*, Vol. I, figures 19, 20 and 21.

profound pity for the world and its creatures reaches perhaps the summit of expression of the archetype that, born of the womb of philosophical Brahmanism in India, could not reach such sweet, comprehending and compassionate humanism in the mother country[1].

Not less majestic and sublime is the image of Prajnaparamita of Eastern Java, now in the Leiden Museum, comparable with the Parvati image of Southern India in its transcendental serenity and yet human sweetness and grace not so marked in the Indian prototype[2]. Is there not also a similar contrast between the Buddhas and Bodhisattvas of Mathura and Sarnath with those of the Yun-Kang caves? The Chinese types are longer, more flexible and delicate. Eyes and lips are also thinner and more sensitive than in India, sometimes represented by exquisitely carved lines that express a charming, reserved smile one does not usually come across in the Indian archetype. The beautifully designed folds and wing-like angles of the drapery and the tremulous inflections of the tender hands emphasise the super-sensible immaterial aspects, but the image is essentially that of a human monk who feels life but not its desires.[3] Saturated also with the sense of human personality are the Bodhisattva images in the Horyuji frescoes in Japan which show richer ornamentation like that of a prince and more meltingly tender limning of beautiful bodies than their prototypes at Ajanta. And yet what a sweet and harmonious reconciliation between the soft beauty and pride of youth and the metaphysical realisation of the vanity of these is achieved in these Japanese Bodhisattvas! Not that the Indian archetypes never expressed the feeling for human personality. In the school of East Indian painting and sculpture we have Buddhist images like Buddha, Lokanatha, Maitreya, Manjusri and Tara painted and sculptured with a human mellowness and tenderness hardly met with in other parts of India. The Bengal design of the Boddhisattva is characterised by extreme simplicity on the one hand and a fine sense of spatial values on the other, while the linear rhythms of drapery and ornaments that mould themselves to the underlying forms of the body give it a combination of the sweetness and delicacy of Botticelli with the joy and purity of Fra Angelico. Particularly emphasised is the profundity of the Buddhist Tara with her sideward way of the hips and gentle compassionate face far less removed from the vicissitudes of the world than that of the South Indian Parvati with her unfathomable profundity. Similarly, Gauri and Parvati among the Brahmanical deities in Bengal and Orissa show a sweet motherliness and tenderness in their expression that are not incompatible with their transcendental mystery[4].

1 See Figures 79 to 84 in Le May: *Buddhist Art in Siam*.
2 For the illustration of Prajnaparamita, see Grousset: *Civilisations of the East*, Vol. II, Figure 127 and for Parvati, Havell: *The Ideals of Indian Art*, Plate XI.
3 Mullikin and Hotchkis: *Buddhist Sculptures at the Yun-Kang Caves*, Plates on pp. 36 and 48.
4 For illustrations of Manjusri see R. D. Banerjee: *Eastern Indian School of Medieval Sculpture*, Plates XXXII and XXXV and for a painting of Lokanatha see Bhattasali: Buddhist and

The accents of humanism and transcendentalism have varied in different periods and art regions in India, largely depending on the intensity of religious experience on the one hand, and the degree of artistic sensibility of the people on the other.

It is, however, through this delicate dynamic combination of transcendentalism and humanism that Oriental art solves the mystery of expression of identity of Being and Becoming. In many single images the divinity or Being keeps aloof from mankind, is sometimes indifferent and even severe like the Egyptian statue. Such effect is usually produced by extreme simplicity and solidity of the design and clearly articulated treatment of plastic planes in contrast to sinuous modelling from one plane to another of the body. But again and again the Orient has sought to stress identification. Thus we have myriads of images of divinities, so outspokenly filled with the human rapture of contemplation, with the pervasive power of what one may call a 'sensual' spirituality or with the inundation of the human feelings of tenderness, compassion and reassurance that art engenders through the supreme awareness of life, i.e., of Becoming. The sculptural technique in this case is a happy blending of firmness and coherence of the skeletal frame-work with delicate, nervous and incisive modelling of the body and definition of drapery and ornaments in curves of intimate sensibility and elegance with all their complex suggestions of mood and character.

Art can thus express the process of Becoming and transmute the formless into form by discovering unending plastic rhythm and linear pattern in forms that live eternally in creation, balanced in their living wholeness. It takes back in the very same process the form, the life and the world into the lap of Being by directing human emotions into the supernatural channels that brook neither form nor image. The transition from the visible to the intangible is rendered particularly effective in Indian rock-cut sculpture by a dynamic plastic movement that transcends the feelings and actions of single figures, or a constellation of figures within a given field, and surges forth into the dark volume of rock-surface beyond. At its best, Indian rock-cut sculpture in the Deccan expresses the states of cosmic consciousness of the human soul in the visible form of the metamorphosed human image, the contemplation of which leads to the identification of self, the image and the cosmic process until all disappear in the all-filling void to which the plastic rhythm and play of light, darkness and depth lead. Just as Indian metaphysics conveys the experience of highest spiritual ecstasy and silence in Being, so does Indian art convey through the integrated volume of the cave or temple, light and darkness and dynamic movement of the mass the highest æsthetic delight in the cosmic form and the cosmic formlessness.

Brahmanical Sculptures in the Dacca Museum, Plate II. For the image of Tara see *Ibid.*, Plates XX to XXII and R. D. Banerjee: Plate XXXIV. For the images of Gauri, see Bhattasali, Plate LXVIII and for Parvati see Coomaraswamy, Plate LXXVI.

The Archetypes of the Anima in Oriental Art

With profound psychological understanding, Being is often represented in Chinese and Hindu myth, religion and metaphysics as the masculine, and Becoming as the feminine force. In Chinese myth these primordial, supplementary forces are described as Yang (male) and Yin (female), "the parents of all nature", that only in conjunction can create anything in the human and the natural world. Agriculture in China is conceived as the outcome of the union between these essential male and female principles. The sun is the Yang and the dew is the Yin. The mountain is the Yang and the mist is the Yin. The heaven is the Yang, the earth is the Yin. Lao Tzu describing to Confucius the state of spiritual ecstasy, when he sat in meditation utterly motionless, remarked: "I saw Yin, the female Energy, rampant in its fiery vigour. The motionless grandeur came up out of the earth; the fiery vigour burst out from heaven. The two penetrated one another, were inextricably blended and from their union the things of the world were born".[1] Chinese art tried to express the harmony that underlies the cosmos in the rhythmical alternation and union of the essential cosmic male and female principles. Art is thus linked in China to the Yin and the Yang, to the Tao or some other metaphysical notion.

In India the Sanskrit word for the male principle is Purusha or the Soul or Being and for the female principle is Prakriti or Nature and Becoming. Modern biology tells us that in each human individual we have the genes or potentialities of the opposite sex and with endocrinal damage or treatment the sexual traits and attributes with which an individual may be born may change. Now in the male individual there is a smaller number of feminine genes that remain incipient and unconscious, but profoundly disturb the psychic life. Jung's conception of the anima as representing aspects of unconscious psychic life may be considered exceedingly relevant in this connection. The anima in Jung is feminine. In Oriental experience all aspects of the unconscious that are unconditional, mysterious and sportive are represented as the feminine. As the unconscious is externalised and imaged in the form of the eternal feminine (Prakriti or Sakti), it ceases to be capricious and dangerous, and man can emerge successfully in his conflict with the repressed complexes. In the average mind these repressed complexes may rise in open rebellion from the unconscious and produce a psychosis. With meditation of and in the images of Prakriti or Sakti, there is a fusion of the conscious and the unconscious, and psychosis is prevented. Art and religion draw the conscious into the realm of phantasies and archetypes, and there compel it to live them by performing them. Thus the symbolic process of art and religion supersedes a living person by traditional archetypes for the assimilation of the ego and brings about a transformation of the personality.

1 Arthur Walley: *Three Ways of Thought in Ancient China*, pp. 33-34.

For childhood, for youth and for old age, myth, art and religion in Asia have produced various archetypes which came upon the people's consciousness as active personalities. For the child, Sakti is embodied in the supremacy of the mother represented as the Mother of Heaven and Madonna. For the youth, Sakti sports as Isis, Aditi, Saraswati, Tara, Parvati, Radha or Venus. For the old, when femininity is at its lowest ebb, Sakti appears as the Queen of Heaven. Many are the archetypes of Being and Becoming imaged as male and female, such as Manjusri and Prajnaparamita, Amitabha and Tara, Siva and Sakti, Krishna and Radha, and the spirits of Earth and Heaven in China. Art in the East takes up these metaphysical realities and realisations and creates numerous archetypal images of the two divergent aspects of the human soul, the pairs of sexual and metaphysical opposites, Being and Becoming, both full of meaning and in the last analysis inexhaustible. Accordingly the sex dichotomy pervades the universe. All things that are attributes and manifestations of Being are from Prakriti or Sakti, and are Prakriti or Sakti (Becoming). All that is unconditioned and absolute are from Purusha and are Purusha or Siva (Being). The human soul in silence, without form and attributes, in its accent of withdrawal is Purusha (Being); the soul in its movement, in its accent of creation and enjoyment, its manifestation of form and attribute within the frame of time and space is Sakti (Becoming). Purusha is the essence of the cosmos. Prakriti is his consort. She is the primordial spirit of manifestation, the symbol of illusion (Maya), the desire of creation or appearance. Hindu metaphysics also speaks of the unity-in-duality. Thus the cosmic male and female principles are the alternate pulsations of the same Supernal Essence.

Art as Expression of the Metaphysical Relations between Being and Becoming

In all such images the male personality or Being is depicted in a universal mood of serene contemplation and profound cosmic impersonality. But Sakti is full of the joy of life and the beauty of youth, and sportively dallies with him, and is at the same time the shadow, the mystery, and the terror, the abysmal womb of the unconscious. It is, of course, the philosophy and tradition which determine the reciprocal moods of Being and Becoming in these images or states of universal consciousness in unending rhythm that express tthe |inner life movement going on permanently. Generally speaking, the attitudes of Siva and Sakti in the Indian images reflect the austere and philosophic aspects of Saiva myth and tradition, while Vaishnava myth and tradition have encouraged a more devotional and humanistic treatment of the art motif. But in Eastern India among the Saiva images the most common are those of Kalyana-Sundara (marriage) and Umalingana (mutual embrace). In the latter the austere, other-worldly mendicant embraces his consort on his lap or sportively touches her chin

or bosom by way of caress as the latter turns her coy and charming face touched with divinity to him. This divine conjugal embrace symbolises the great metaphysical truth—unity in duality; and indeed, schools of Tantrikism have in their meditation and ritual transformed erotic rapture into a consecration of the flesh and exaltation of the' spirit, the sport of Purusha and Prakriti, and the final absorption of the individual soul, the jivatman, into being or paramatman, of Prakriti or Sakti into Purusha.

Throughout Northern India the archetype of Radha-Krishna, the eternal Woman and the eternal Man, represents the same pair of opposites, Being and Becoming, in the vernacular of human love and is reproduced in Vaishnava song and legend, literature and painting, which are most popular among the masses. Sculpture naturally cannot do justice to the devotional mysticism which underlies the lila (sport) of Radha and Krishna. That lila or the sport of Being is eternal. Brindaban or the Garden of Dalliance of Radha and Krishna is in every human heart. Radha is in every human soul as it responds to the call of the Infinite, the far-off melodious flute of Krishna that sounds in the twilight of the sub-conscious. The abandon of the human soul as it sacrifices family honour and caste prestige when it seeks the beloved, and the entire gamut of spiritual moods exhibiting the different degrees of approach to Being can best be represented only in lyrical poems and in paintings. Rajput and Pahari paintings deal with this popular archetype, and nowhere are the relations of poetry and painting closer and deeper than here. Very often a song or a couplet is illustrated by the painting which reveals the specific æsthetic *rasa* centred round the interplay of Radha, Krishna and the milk-maids of Brajabhumi,—the souls of men. Painting, song, tale and dance all repeat and strengthen this archetype among the rural masses of India. The villagers deal with these metaphysical truths in their own way in little poems and songs, in their mystery plays, and in their devout dances and picturesque journeys in the rainy season. And painting also gives expression to the same moods and ideals that spring from the heart of the village population. Rarely is cultivated such art of the people, for the people and by the people.

Among the many episodes of the play of Radha and Krishna that reveal the eternal relations between Being and Becoming, and hence are symbolic and eternal, none reaches greater profundity than the representation of Rasa Mandala or Collective Dance in which Krishna or Being by a sort of illusion (Yogamaya) multiplies his appearances, and dances with the milk-maids (human souls) in a ring, interlaced between each pair, as common to all and special to each. The Being is linked with each and all in an all-embracing love that is the rhythm of the process of creation, the alternation of the seasons, the nuance of human love and the delight of the senses.

Another common device of revealing the intimate relation of Being and Becoming, adopted by Indian myth, religion and art is that of representing the

pairs of opposites such as Siva and Sakti, Krishna and Radha merged in one body, one half being masculine and the other feminine. The Siva-Sakti hermaphrodite image is often met with representing a complete subject-object amalgamation such as is postulated by Franz, von Beader's doctrine of androgynous perfectability or the recent doctrine of hermaphroditism. In China this transmutation of sex could not be achieved and thus the Chinese left the nude out of their art. This rejection of the nude has reacted to keep it entirely in the realm of the pornographic as is evinced, by the 'Ch'un King' or 'Spring Palaces'.[1] Indian Art has accomplished the necessary transformation of sex into the 'expressionistic', representing the feminine principle in disinterested terms of the absolute emotive life, and eloquently revealed the contrast between the two metaphysical masculine and feminine principles, one calm, composed and withdrawn from the world, and the other sportive, guileful and mysterious. This s called Ardhanarisvaramurti in which the face, ornaments and apparel are different in the two halves of the body.

The Cosmic Dance Motifs as Revealing the March of the Soul

We have already referred to the archetype of the dancing Nataraja in which the rhythms of creation, preservation and destruction are revealed as the eternal moods of the human soul. The archetype of Nataraja in the posture of the Tandava dance is found not merely in South India but also though to a much less extent in other parts of the country. In Bengal we have a variant powerful image, sometimes called Narttesvara in which the rhythm of creation and destruction includes both heaven and the nether world, comprising gods and angels as well as Nagas (half-man and half-serpent), Kinnaras and Ganas who all witness the majestic dance or themselves dance in unison. Instead of the dwarf under the foot, we have the Lord's vehicle, the bull, dancing in ecstasy with its face upturned in awe and adoration towards the Lord. Siva has ten or twelve arms, holding various objects that symbolise the meaning of the posture of renunciation. The Universe Serpent (Naga Sesa) symbolising the infinite, is, for instance, held like a canopy over the head. Or, again, he plays on the lyre (vina) as he dances. By the clapping of His hands He calls all persons immersed in worldly affairs: the skull-cap symbolises the adjuration of worldly desires, while He points by one of His hands to His upraised foot. Altogether the image is vigorous but the movement of the ten or twelve hands and of the feet, and the lesser rhythm of the bull's dance are contained, and the total effect is one of spacious repose and rest. In no art in world-history are the metaphysical harmonies of Being revealed in such rhythmic and musical modelling, that is calculated to compose the mind, and lead it towards complete renunciation of the flesh and the devil. The paraphernalia of the symbols aids the beholder in his

1 See Danton: *The Chinese People*, p. 188.

meditation, but the total effect of experience in the image and of the image is the joy of rhythm as renunciation and destruction include in the final analysis all symbols and concepts, and even the image itself. The beholder ultimately finds as his meditation deepens that rhythm and rest, sound and silence are inseparable, alternate oscillations of his Being as of the phenomena of the world of nature. It is thus æsthetic experience becomes an adjunct of spiritual ecstasy.

Cognate archètypes of cosmic dance are those of Tara, Marichi, Kali and Chamunda. In the famous temple of Madura we have a large dancing image of the Devi (Sakti) that resembles in its majestic rhythm Siva's tandava dance. The earliest form of Buddhist Sakti seems to be represented by the ordinary Tara, but this gradually developed into the extraordinary images of Vajra-Tara and Marichi executed with rare grace and vigour in Bengal. Here we have also images of Chamunda, grim dancing figures with garlands of skulls and bones. Some images have the human corpse underneath symbolising death, while others show a child in the attitude of assurance and hope.

The Symbolism of the Tibetan Images Conjoined with Saktis

It is, however, in the art of Tibetan Buddhism which has continued the traditions of the Buddhist art of the Ganges Valley and the Pala art of Bengal that we find a legion of extraordinary gods and goddesses representing the manifestations of Buddhas and Bodhisattvas, on the one hand, and their feminine principles (Sakti) with whom they are conjoined, on the other. A rich and complex symbolism animates this art, whether in bronze images in temples or in paintings on the votive banners in a country where image-making and painting were considered equivalent to spiritual contemplation. The poses, the gestures, the weapons and the colours of the gods and goddesses, all represent some metaphysical principles derived from a mystical philosophy. Thus leaving aside the dozen hands and weapons Samvara, with his crown made of skulls, is coloured blue, while his Sakti is nude, but wears a garland of heads and is coloured red like the pomegranate flower. The trappings are white. Under the left foot lies the corpse of a naked woman with four hands and white trappings and the mace (khatvanga) in one of her hands. Under the right foot we may see a male corpse, blue in colour, girt with a tiger skin and with four hands also.[1]

According to the text of meditation (Sadhanmala) the worshipper should conceive himself as the god, the embodiment of void, which is embraced by Nairatma (the Sakti of the god) whose essence is also void. Thus the meditation leads up from a carnal symbolism that completely drains off the unconscious to a state of consciousness (the Bodhi mind) in which neither existence nor non-existence can be predicated of the deities. The archetypal anima, Dakini, nude and full of amorous passion, conceived at one stage as sensual enjoyment and in

1 *Vide, Asiatic Mythology*, Chapter on the Mythology of Lamaism, p. 170.

the final analysis as void, was thus helpful in the attainment of pure conscious-ness. The features of the sow in Dakini's (Vajravarahi) face definitely indicate the carnal dispositions that enter completely into the image and are lived and outlived in and through it, the image ultimately standing for Nairatma or the void in which both the conscious and the unconscious are completely stilled. For centuries in the Ganges Valley, in Bengal, in Nepal and in Tibet, innumer-able divinities with their appropriate feminine principles (Sakti) were imaged, each being differentiated from another in attributes and hence in the equipment of heads, arms and weapons. The colours were also conceived differently—blue, green, yellow, red, black and white, and had a profound spiritual import. A strict set of rules as defined in the text of the Sutras governed the making and painting of images. Art perhaps was sometimes overladen with an elaborate and sensual symbolism, and became a handmaid rather than an ally of religion that was too esoteric for the populace. But even in Tibet one may come across elegant and graceful images like those of Dakini, nude dancing Saktis of Tantrik-ism, with a fine tracery of head-dress and a weird, frenzied laugh. As a matter of fact along with its markedly hieratic character, art in the bleak snow-covered plateau of Tibet exhibits a rare flexibility and even a palpitating voluptuousness of forms with a profusion of ornaments, garlands and flowers and rich suggestive gestures that originated from the influence of the Bengal school. Gupta art may be said to have entered its Byzantine phase in Bengal. This phase reached its culmination in the Tibetan images conjoined with their Saktis (Yuganaddha or Tibetan Yab-Yum) that were the vehicles of Tantrik mystical attitudes in which worship and enjoyment were so strangely blended in that snow-bound, inaccessi-ble region.

Trimurti, a Symbol of Man's Realisation of Being

The elaboration of the archetypes has become most complex in Eastern India and Tibet, and if art has preserved its autonomy under the system of my-stical religions and philosophies that developed in this region it must have been a signal achievement. Contrasted with these complex images is the simple gigantic figure of the Trimurti at the Elephanta cave in India which is considered to be one of the master-pieces of the world's sculpture. It is a three-headed bust representing the three categories of Being or alternating phases of the soul's activity. The central head with its absolute serenity and inwardness, outspokenly translated into a firm exaggerated closing of the lips, is the Being at rest or in the silence of meditation of Himself. The head on the right, loving and compas-sionate, is the Being as Becoming, symbolising the activity of creation. The head on the left which is grim and somewhat frowning is the Being as Trans-forming, symbolising the activity of withdrawal or destruction. The dominating motifs of the icon is the oneness of the self in its alternate pulsations of activity,

withdrawal and repose that are apprehended as rhythms of the cosmic process in the visible universe. The three aspects of the Trimurti may also be considered as Brahma, Vishnu and Siva according to the Hindu pantheon, representing the three primordial accents or variations of the supreme cosmic Spirit or Being. The three different countenances of Being, representing differentiated phases of mind, are magnificently reconciled in the same bust by a design exceedingly daring in conception and the result is a profound repose and symmetry symbolising at once the unity of self-consciousness in each of its original moods and the immanence of self in the cosmos. Roger Fry points out that the success in expressing the idea of diverse emanations of a single essence is largely due to the sublime invention of the three towering head-dresses which unite into an almost architectural whole, as of a central dome supported by semidomes.[1] The delicately carved and ornate head-dresses and necklaces represent a marked contrast to the extremely simple and massive treatment of body and countenances and like the thin delicate tracery of mantle in the Buddha images give an immaterial and celestial character to the representation. Does not the exaggerated ornamentation of the tiaras and necklaces setting in bold relief the plainly rounded forms of the body and haunting faces also proclaim India's well-tried mode of conquering life and its pleasures? With the illumination of the soul the matted locks of the ascetic and the bejewelled crown of the prince may exchange places. Never have silence and activity, renewal and withdrawal in the soul's dialectical onward march ordered in such perfect plastic harmony and rhythm. Never have the clarity and stillness of the human soul derived from complete identification with the realm of Becoming found such majestic expression in stone. Like the slokas of the Upanishads and the open and illuminated pages of the mystic's mind, the stones of Elephanta impressively and unequivocally utter this profound message: "Activity is true worship when every act is done for the sake of Siva or Being; silence, again, is true worship when it is an absolute repose of meditation", and call man to choose the path of self-realisation and peace.

1 Roger Fry: *Last Lectures*, p. 160.

CHAPTER VIII

ART MOTIFS IN ASIA AND EUROPE

The Variety of Archetypal Personalities in Oriental Art

Archetypal images are found in the history of mankind in myth and fairy tale, in literature and fine art. Such images have through the epochs satisfied man's intellect as well as his unconscious urges, and in higher religion and art have been foci of spiritual contemplation and moral discipline of the common man. Because these are surcharged with the intensest emotions, religions have used them for their own ends; but these should not be called 'religious', if by religion is meant an aspect of human experience separable from culture. On the other hand, it is because these embody a total, harmonious and vivid experience that myth and metaphysics, art and religion can cluster round them, enriching them in turn by their own treatment and elaborations. In Buddhist, Hindu and Christian art such archetypal images have been the themes of subtle metaphysical discussion, the foci of whole people's devotion and worship and the subjects of artistic decoration and achievement for long centuries. These express emotions of a universal character, direct these latter to beyond-human and super-social channels, and catch and communicate them in a transcendental plane in which they derive their profound meaning. Buddist art as it represented in stone, bronze or on the wall surface the episodes of Gautama's life from renunciation to enlightenment, as eternal and ever-recurrent in India, Indonesia, China or Japan, not merely afforded a gratifying visual delight, but was also a means to man's realisation of Being and his cosmic identification with the Becoming. Buddhist archetypes were impersonal and universal, and it was therefore no wonder that the Bodhisattvas of Gupta India, T'ang China, and Nara Japan were touched by the same feeling of infinite compassion which was, indeed, a supernatural vision that was by no means limited to one country. As a matter of fact, the images of Buddha and Bodhisattva in Cambodia and Japan exhibited a fuller and more virile human sweetness than their prototypes on the Indian soil, marked by their more distinctive metaphysical depth and detachment. It was these heroes of holiness and charity, and their gentle, compassionate gestures to man that thrilled the imagination of Asiatic peoples through the centuries, and not merely in the Mahayanist age. It was these archetypes which became purveyors of a sense of social order and of amity not merely between man and man, but also between man and every sentient creature. Non-violence (Ahimsa), tenderness to all living beings, the sense of the vanity of all things and the supremacy of the metaphysical life were the great social values that Buddhist painting and sculpture

expressed. No art was superior to Buddhist in communicating a sense of order as the foundation of the metaphysical-temporal world.

Brahmanical art had on the whole more variegated archetypes, animated by a more complex religious symbolism. In fact, both Brahmanical and Mahayanist art missed in some measure the accents of impersonalism and universality, characteristic of the Indian Gupta tradition. In both Brahmanical and in some phases of Mahayanist art the metaphysical harmonies as the source of all life were pictured as the interplay of masculine and feminine principles, embodied in the images of myriad gods and goddesses, Buddhas or Bodhisattvas and their Saktis. The archetypal Saktis or feminine deities were the animas that direct into themselves the unconscious of the people. They are personalities as full of life and passion as living archetypes on whom often depends the fate of individuals who 'possessed' by them revert to mother-fixation, infantilism and primitivism and suffer from various neuroses that might wreck their lives. On the other hand, the divine historical personalities, such as the Saktis, are accepted by the individual by deliberate choice. Man's conscious yielding before the Sakti that art and religion bring about permits the successful blending of the conscious and the unconscious. As the *Sakti* succeeds in completely assimilating the ego, personality is no longer split due to the gulf between the conscious and the unconscious, but gradually moves towards integration that may be brought about in a single short moment of exaltation or through years of disciplined meditation and transformation.

Besides the archetypes of Saktis, art in Asia imaged other archetypes of transformation that resolve various complexes of human experience. Each of the fine arts, each branch of learning, each profession or type of labour has its own archetypal personality or Sakti, confronting man as a goddess of power and sublimity, thus expelling his unconscious from the mind to a realm beyond the limits of time and space, and bringing about both individual sanity and peace in the social order. Other archetypal forms are represented by the images that fulfil the philo-progenitive desires. Numerous are the mother and child images in Asia. Many madonnas are known in Buddhist and Brahmanical art: Maya Devi, mother of Gautama, Hariti, mother and protectress of all children against epidemics, Devaki, mother of Krishna, Jasodha, his foster-mother and Parvati, mother of Kartikeya and Ganesh. Sculpture in Bengal depicted the primordial Mother with the images of Kartikeya and Ganesh placed above along with the planets and with Siva, her consort held in her own bosom. Siva is here the child just born (Sadyajata) in the Mother's breast sunk in deep meditation. There are also images of Maya Devi and of Devaki nursing the gods at their breasts. In Rajput and Pahari painting the sports and pranks of the sweetly wayward child Krishna are placed in the tender setting of his foster-mother Jasodha's love which is as much inspired by religious exaltation as the romantic love of the milk-maids for

the youthful Krishna. The foster-mother Jasodha's love for the Divine child Krishna is the norm and the standard in India for all the affections and devotions that a mother can bestow on her own child, and these have been consummately portrayed in medieval paintings, songs and lyrics.[1] Krishna's persistent cry for the moon and refusal to accept the moon reflected in a basin, his stealth of butter and other baby pranks as well as his return, after a whole day's absence in the meadows, with the herd of cattle in the evening when the mothers crowd the balcony windows fixing their gaze on him, are all illustrated in the Rajput paintings. Such episodes are aids to the Indian mother to transform her heart's fondness into a spiritual aspiration. For is not Krishna the Divine Child, unknown but loved by the whole village of Gokula? And is not every child the reflection of Krishna who demands his toll? Not merely motherly love and affection but also the sweet companionship of Krishna with Sudama and other shepherds and with the herds of animals, lovingly depicted with adoring human eyes, were the means to spiritual contemplation in these delightful domestic and pastoral scenes.

Their Role in Social Integration

Myth, religion and art created the archetypes utilising and woman's elemental desires and urges and cherished experiences. Loyalty to these archetypal personalities affords a full draining of the unconscious and an organisation of the desires and emotions so that there is less of mental conflict. As different archetypal images are cultivated, man develops a harmonious system of sentiments and attitudes, and effects a successful social adjustment. Not only the erotic archetype, the anima (Sakti), but archetypes of parental love, fidelity and companionship have been elaborated by art and religion permitting the organisation of stable social attitudes and integration of social bonds. The animas and the numerous archetypes of art canalise the elemental urges of sex, self-assertion, companionship or parental impulses and develop loyalties that establish a complete reconciliation of the ego and the super-ego and hence contribute towards the stability of social life and relations. The more variegated the archetypal images adapted to both man's and woman's psyche, and to its different stages of development with ageing that art and religion develop, and the more concretely they are presented before the consciousness as living, active personalities, the less is the danger of the individuals from regression to the past, to infantilism and primitivism. Social integration, thus, becomes one of the major functions of the archetypes of protective and beneficent images into which the figures of the unconscious have been fashioned. Thanks to the discipline of contemplation and the exposition by myths, legends and scriptures for centuries, these traditional archetypes are moulded into a comprehensive system of metaphysics and a

1 *Vide* the painting, *Yashoda and Krishna* in Gangoly: *Masterpieces of Rajput Painting.*

harmonious ethical code for human behaviour, or again into religious creeds, dogmas and rituals that have all contributed towards personal integration and social solidarity.

The Archetypes of Peace and Charity in Christian Art

Early Christian European art, whether represented in the Byzantine School, the Northern Gothic mode in Europe or in the Siennese School in Italy, represented Madonnas, Crucifixions, Passion incidents and stories of the Saints as familiar archetypes in the Christian world. The art of the 13th century Europe was a profound and sincere expression of the Christian ideal, and expressed supernatural beauty and silent human adoration, stillness and peace. Paul Vitry observes: "This was the golden age of medieval sculpture, its classic period, because its development is serene and its mastery of its material complete, while it seems to shun all movement and over-expression. It shows simplicity, rhythm, infinite amount of research, and an extraordinary precocity. All the intricacies, all the awkwardness of earlier art have gone; only a monumental grandeur remains. In human scenes a homeliness and justness of inspiration is combined with an austerity, terse and synthetic, which exclude all anecdote and mere picturesqueness". The Christian faith and certitude left an indelible stamp on the impersonal charm and majestic dignity and stillness of the statues that looked down from the Church altars, pillars and walls upon the fret and foam of human life: "All the violent sentiments are discarded; what shines on the face of the statues is not suffering, neither is it anxiety, nor worry about the infinite but a profound peace, unperturbable repose, silent love. Death itself is conceived as a supreme beauty, as a mere appearance. Stretched out upon their tombs, the dead are represented with a charm of youth, and instead of closing their eyes they have them open to a light which the living do not see as yet."[1] The idealism of the 13th century was gradually superseded by naturalism. As the spirit of the Renaissance began to spread and dominate, art began to reveal doubt and pessimism instead of faith, joy, and peace, and soon turned to the enjoyment of the pleasures of life, true to the far-reaching social and moral revolution that the Christian world experienced. This change, however, took decades. And even in Italy that led the Renaissance, under the influence of the humane, compassionate mysticism of St. Francis the painters of Sienna presented the life and crucifixion of Jesus with such touching kindliness, simplicity and sweetness that the scenes and incidents have, like those relating to Gautama in Asia, become eternal not merely for Christian but also for universal human spirit and experience. At last the Christian world found an art that rehabilitated the true Christian vision of the identification of the individual soul with all life in unity created by God. Such unity is the outcome not of asceticism and renunciation of the world, as in

1 Male: *Art et Artistes*, p. 16, quoted by Sorokin: *Social and Cultural Dynamics*, Vol. I, p. 322.

many phases of Asiatic religion and art, but of sweet goodwill and charity that spring from the innate goodness of human nature. It is no wonder that like many artists of the Orient the monk-painter Fra Angelico, who was typical of other artists in the Franciscan age, prayed as he painted and painted as he prayed. It was an inner vision from the super-sensible world that gave him the glowing, colourful figures of Madonna and Christ as he remained kneeling the whole time while painting these, and as he wept continuously while working on the frescoes of the Crucifixion. This was an art which not only was easily comprehended by the people, but was also a source of their religious inspiration and enthusiasm.

The Renaissance Stress of Individuals and Personal Situations rather than Archetypes

Things changed with the waxing of the spirit of the Renaissance that introduced an intellectualism far different from the Franciscan spirit. Scientific Naturalism, Realism and the Neo-pagan spirit led painting and sculpture far away from the realm of gods and angels, and men and women came to be treated as individuals in their passing moods and attitudes in a coldly naturalistic manner, alive at once to the new dignity of the individual and the new knowledge of perspective and of natural light and shadow effect. Such knowledge, gained of course outside the craftsmanship of painting, became incompatible with the convention of "flat" rendering of ecclesiastical themes ruling in the Churches. For something more than sacred, decorative and formal now demanded expression. The subject-matter of art became less and less Hebrew and Christian, while the new technique, born of new social experience, was also better adapted to the depiction of secular subjects and purposes. The Florentine school of painters revelled and excelled in sculpturesque lines and forms. The new magnificence, luxury and sensuality of Venice elicited the use of colour and of light and shade and atmosphere for the same technical aim of binding forms together in harmony as achieved largely by delicate lines and rhythmical curves in the past, symptomatic of the fateful secularisation of values. While Naturalism that was a result of the growth of the intellectualism of the Renaissance thus brought about the revolution in technique, the rehabilitated Pagan way of living simultaneously stimulated the worship of physical beauty, reminiscent of the Hellenic spirit, and also the exact depiction of individual and personal situations as contrasted with the archetypes of the past. Fine drawing, rhythmic surface composition, light, shade and colour effects, and perspective produced precise, pretty and appealing figures. But the figures represented only individuals that were reflections of an artificial, luxury-ridden social regime, and not of those deep mystical values that underlie the attractions of the lovely figures of Fra Angelico. Artists worked from memory and not from imagination, picturing Madonnas from their

lady loves and Venuses from the courtesans of the town posing for them in the nude. Leonardo da Vinci's 'Mona Lisa' is one of the most celebrated paintings of this age, characterised by the mysterious smile of a worldly-minded woman, more sinister in its import than expressive of any mystical illumination. The Pagan enjoyment of life, the luxury, pageantry, licentiousness and cruelty of the Italian cities, the new supremacy of intellectual values, expelled mystic overtones from art, and dissociated it from those formal as well as social values that inspired the artists of the preceding age. As painting drew away from the Church, and found ready and lavish patronage in the ducal palace and private mansion, it ceased to concern itself with Hebrew or Christian myths and legends or the struggles and hopes of man, but turned to portraiture, pageantry and arcadian landscapes. It was no longer frescoes but easel pictures that titillated the senses of the emancipated youths of the Italian Renaissance, and for the first time in the history of art, art-dealers grew more powerful in the lives of the artists than guilds, Churches or fraternities. The technique, the purpose and the patronage of art were all changed into those, largely holding to the present time. The lure of poetry, romance and sensualism in the Renaissance painting is such that merchants and traders all over Europe sold the Italian Madonnas, Venuses and nymphs, and some of them continue to be popular in the modern world.

Contrasted Motifs in Greek and Indian Art

In a sense the Renaissance in Europe renewed the naturalism, rationalism and the sense-born and sense-bound approach of the classical art of Greece. The Oriental and Greek art methods and traditions are fundamentally divergent. The Buddha of Mathura and the Hermes of Praxiteles may be contrasted as types of the male human ideal, and the Venus of Milo and the Parvati of Southern India as types of the feminine ideal. In the Greek specimens we find a perfect idealisation of man's physical poise and strength, in the Indian specimens a perfect representation of spiritual depth and equilibrium. In the former we see the glorification of physical man conquering all fear of the universe; in the latter the understanding of the metaphysical reality that conquers life and conquers death. The Greeks derived their inspiration in art from a sense of the joy and rhythm of life in the sensible world with perfect clarity. They reproduced the rhythm and symmetries of the body in marble, consecrated to honour the best in physical manhood that won laurels in their natural games. In India, art sought to express the rhythms of the super-sensible world, caught in stone and bronze emotions and attitudes that were impersonal and universal and that were derived from realms far beyond and above man's rational analysis. The Greek sense of rational or mathematical rhythms found expression in the proportioning of their temples and in the harmonious designs of their vase paintings. The vase shapes

are exquisitely harmonious with a logic of structure that indicates the working of rationally conceived and controlled canons of art at their best. But what is depicted on the vases are human loves and beastly passions, exploits of heroes and gods, Satyrs and maenads, drinking, racing and love making, the whole drama of the chase and excitement of life which is essentially bound and confined within a purely sensible world. The intimate joys and experiences of Hellenic life are measurably communicated not in Greek sculpture which early degenerated into a formal naturalism, but in the painting of the vases. What a contrast these, with their combats, excitements and obscenities, present with the quiet, eye-filling landscapes in Chinese pottery and porcelain! An art which understood and communicated nothing beyond the things of the sensible world and the moods of the artist came to be accepted as the norm in Europe with the spread of the Renaissance. In painting in the West, colour, space and form were all brought into play for the purposes of æsthetic imitation, not for the production of real beauty of form and creation of movement as in Indian or Chinese painting. The use of colour in Oriental painting is something very different from that in the West, where only the hues of visible forms, both natural objects and human bodies, are sought to be reproduced meticulously, except by a few painters such as Van Gogh who have utilised colour for emotional expression, red for warmth and excitement, orange for lovableness and blue for coldness and distance. In Indian painting colour is used symbolically having quite different spiritual connotations producing enjoyment that is of a higher order than mere sensuous delight. Certain conventions have been also developed in painting in respect of the use of colour as the intrinsic property of visible forms, living or non-living. Red is the internal property of fire, white that of light and dark that of the earth. There is also the distinction between lightness and heaviness of colouring, the former constituting rather than representing solidity, the latter lightness or brilliance. In all Oriental, and especially Chinese landscape painting, the spatial values have also received far greater prominence than in the West. In Western painting the proportion of suggested spaces are hardly used except by the highest artists. It is only recently that the importance of spatial values has been recognised by the Western artists. "The sensation of organised space produces in the observer the effect of Infinity in art," observes Jan Gordon.[1] In Oriental painting the stress of spatial quality is associated with the revelation of the super-sensible. Apart from such formal values, art in the Orient has never left its moorings in the scheme of community values and aspirations. Since the Renaissance art in Europe has become individualistic in its origins and, as it has removed itself more and more from the community feeling that religion could express at its highest and best, its development has become chequered and often incongruous. Christian art soon got rid of both its idealism and formalism

1 *Modern French Painters*, p. 120.

inherited from the Italo-Byzantine tradition. It was only in the Russian icon painting that such Russian artists of the 15th century as Rublev and Dionysius expressed, as in Oriental paintings, their abstract religious ideas, entirely divorced from the sensible world, that inner contemplation and religious tradition aroused in their minds. In the Russian icons we come across a strangely ethereal intensity of blues and whites and rhythmical pattern of silhouettes that reveal a world of abstract and supernatural beauty almost unknown in Christian art in other countries in Europe.[1] Throughout Western Europe it was the Renaissance that led Christian art from the directness and immediacy of inner experience and communication to the world of visible appearance. In Western European Christian art the familiar Christian figures and scenes came to be invested in both painting and sculpture with a new naturalism and emotionalism derived from the familiar world of human life and nature, while gradually the idealistic element slipped out of the humanism, as the pomp and sensuality of the Italian cities overcame Franciscan innocence, purity and simplicity of life. Angels of the Christian heaven were painted by Correggio as voluptuous nudes. Filippo Lippi and Raphael limned Madonnas with the sentimental charm that one bestows on beautiful mistresses, wives and mothers. There was little revelation of beauty of the soul. The sweetness that Raphael's angels and saints breathe, the radiance they emanate, belong to this world.

Michael Angelo's Conflicts

Michael Angelo's profoundly vital and grand figures are superhuman rather than divine, set above and scorning the historical tragedy of man as he has set his heart on non-Christian values. We see in his art the majesty and sublimity of Man not as the suffering, loving son of God, but as the victim of an inexorable destiny represented by Titanic forces that bring just retribution. His soul was too full of conflict to create loving figures of faith, goodwill and sacrifice that Christianity envisons as it proclaims the identity of the human soul with the world in the unity created by the redemptive love of the Man of Sorrows. His titanic figures are made up of ample pulsating bodies designed into heroic poems by his chisel and brush. Never were human bodies so effectively utilised for expressing majestic conceptions. But the conceptions are half-Christian, half-Pagan. His mind revolted against the acceptance of a Christianity that combined other-worldliness with the ideal of Pagan wisdom, but his art broke away from his wish. Seldom has any master been beset by such conflicting energies in his soul that expressed themselves in the violent counter-balancing of taut limbs and muscles, sometimes from head to foot in his major works. Are not Michael Angelo's inner conflict and pent-up force rooted in the social background of the age itself, characterised by the contrast between the vestige of Christian devotion

1 See Farbman : *Masterpieces of Russian Painting*, especially the chapter by Roger Fry, pp. 35-38.

and asceticism and the rising tide of Pagan enjoyment, between the emerging lofty cultural and humanistic ideal and the sordidness, vice and political unstability in actual life? Yet Michael Angelo never relented nor compromised, never made soft, pliant or sentimental figures for pleasing the people, nor deviate an iota from his stupendous dream of a superior human race. Michael Angelo's masterpieces thus show marked contrasts with the placid equilibrium of balanced life in Egyptian, Greek or Oriental figures and eloquent plastic rhythms that are not sacrificed to emotional expression. It is thus that among the artists of the West his is a lonely world figure comparable with the Indian, Chinese and Egyptian masters.

Subjective Moods and Fantasies *versus* Æsthetic Contemplation

As the civilisation of Europe became more materialistic, art and culture lost the community feeling and unity of the human spirit with all life. Science and metaphysics could not bridge the gap. The artist, in the first place, in spite of his mastery of anatomy, light and shade, and fidelity of representation became limited to a narrow segment of man's emotions and experiences for expression. In the second place, he developed subjectivism, and while the vast, all-pervasive forces of the machine system and standardisation engendered new fears and anxieties in his subconscious mind he lost his archetypes that expressed universal ideals and defended him against the hostile forces of nature and society, on the one hand, and the irruptions of the unconscious on the other. Often the art of the post-Renaissance epoch in Europe is sterile because it hardly appeals beyond familiar fact and apart from interest in a model, and expresses individual moods in reaction to the hostile external world, fantasies of the unconscious, unrelated to the larger community values that easily attach themselves to the eternal realities. Man's memory or the mind's associated mechanisms can merely depict or recreate external living. These cannot express the deeper ultimate values that link the self with Being and with all life. Out of this identification art obtains the abstract, plastic and deeply rhythmic values characteristic of Oriental practice. Due to the dissociation between art and religion in Europe, the modernist painter in that continent, moving away from Realism, Impressionism and Post-Impressionism, now in his search for these abstract and rhythmic values or order seeks inspiration neither in religious thought nor in the contemplation of the physical universe, but in complex and ingenious mathematical ratios and formulæ, and subjects nature to experimental distortion and dissection under the guidance of the instinctive and the unconscious. The modernist abstract art in Europe resembles Puritanism in its mistrust of the physical order in Nature, and at the same time is an antithesis of Paganism that established a method of achieving communion with nature. Unsupported by either religion or reference to the natural order, it confuses the essential rhythms and symmetries

that underlie the scheme of the physical universe and man's relationship with fellowman with the mathematical ratios that are either jealously guarded secrets in certain studios or are found only in the recesses of agitated brains. True, abstract and rhythmical values in art cannot be conjured up in day-dreams and fantasies nor mathematically calculated, but emerge out of imperative human needs and life experience that represent the fundamental realities. Not ingenuity but the irresistible pressure of human situations can give such realities their internal arrangements and methodology. Plasticity, rhythmical pattern or solidity in painting are of no use, except perhaps as solutions of geometrical puzzles unless directed to express universal human realities. The preoccupation with mere cubes, cylinders and cones is not art but algebra. The impulsion, representation and transmutation of experience, fraught with tremendous human meaning, are accordingly indispensable for the creation of abstract and rhythmical values that the artist derives from a severe æsthetic detachment and contemplation, achieving a profound unity of his self, experience and Being.

It is this metaphysical realisation that is the fountain of all formal excellence, plastic orchestration and universal rhythms in artistic forms, qualities which the modern art theorist associates with Expressionism. These cannot be explained in words, but are more sought and achieved in the East than in Europe since her cultural disturbance of the 15th and 16th centuries. It is now only during the last two or three decades that it is realised that the above essential qualities of Expressionism hold good of Oriental art. Both the motifs and methods of art in the East have been favourable for this. In the first place, the archetypes of the Orient take the artist far away from human models or casual aspects of ordinary nature with which the Western academic artist has been chiefly concerned. These are seats of impersonal and metaphysical values which the Oriental artist must review in his own mood and experience by contemplation. Charged with the execution of a work on Buddha, Bodhisattva, Siva or Parvati, he must secure the stillness of the mind and distillation of that mood and emotion, which the archetypal image expresses, and in this process bring about not only his identification and performance with the image itself but also a complete unification with all life created by that particular universal attitude.

Human Sentiment or Anecdotal Interest *versus* Generalised Attitude in Landscape Painting

If he executes a landscape, unlike the Western artist he would not seek fidelity of representation nor the capping of the effects of nature, but would silently brood with nature, concentrating his contemplation upon the most sublime as well as the most trival phenomena, the shimmering mist covering snow-capped heights, or the dew drop on a blade of grass, the flight of birds of passage

across a storm-tossed sea or the transient radiance of the morning glory. So long as his soul does not catch the mystery and profundity of nature by soaring beyond the sensible to the super-sensible world, he gazes ecstatically at the paling rays of the moon, listens to the lamentable cries of the monkeys or the sound of bells and the chant of monks from the distant monastery. Li Lung-mien, observed Su Tungpo, did not meditate on any objects when he was in the mountains, but his soul entered into communion with all things and his heart permeated the secrets of all acts. Similarly Wu Tao-tze said about himself, "Without sketches returning from a trip I have the landscape in my heart". Danton observes in this connection, "It is the divinitory grasp of the essence of things, the Tao, which is the object; thus, there is no difference between the great and the small, between the mountain and the leaf, between the cicada and the tiger—all manifest the great spirit of eternity which it is the task of the artist to express. There is in this an explanation of the seeming preference for genre; but when one sees such genre work one is compelled to regard each piece, not as a segment of society and a criticism of social conditions, with a desire for social reform, but as a part of the Ta Yi, the Great Universal".[1] Not merely Taoism but Zen Buddhism also supplied inspiration to the landscape art of the Sung Masters in China. The characteristic of Zen meditation was to apprehend the fullness of life more surely in small things than in great, in the power of a hint to the imagination than in the satiety of completed forms. All this revealed itself in the exquisite treatment of tufts of grass, frail bamboo shoots and fragile birds and animals in Chinese painting, where the human figure was also represented as tiny and insignificant in the background of a vast mist-covered landscape that extends into infinity. The Zen monks loved to teach by enigmatic axioms and even more by significant silence. They practised painting as a means of worldless communication. They relied on the suggestion given by a few sensitive, brief blossoms, a single leafless weeping willow, the moon-rise from among the bare, snow-covered branches of the pine trees or the vast hollowness of mist-covered valleys and water. In Chinese landscape art, writes Lawrence Binyon, "There is no infusion of human sentiment into the pictures of birds and beasts, of the tiger roaring in the solitudes, of the hawk and eagle on the rocky crag; rarely is there any touch of the sportsman's interest which has inspired most European pictures of this kind. The Sung artists painted birds and flowers as they were in nature, with no explicit symbolism, with nothing factitious added, and yet the inspiring thought, the sensitive feeling that was in their minds as they worked has wrought its effect and still finds a response in the minds of those who understand

1 *The Chinese People,* p. 181.

"To see the world in a grain of sand
And a heaven in a wild flower".[1]

To see the infinite in the finite was, indeed, the acme of intense meditation of the solitary Zen anchorite, who regarded images and even scriptures as value-less, and sought the Buddha in the soul and in the universe by the simplest procedure. It is solitary reveries and meditations that bring forth the intimation that becomes the mould of a Chinese or Japanese landscape, where the universal mood that rushes forth with unification of Being with the heart of nature rather than the detail or outline of composition is more significant. In the design of the Chinese landscape emptiness or space is as, and sometimes even more, eloquent than figures. For the Taoist, universal spirit encloses everything, visible and invisible, and flows through and oversteps both form and emptiness. It is thus that the universal mood can be engendered in the human soul through the proper uses of hollowness in figure design and of the infinite all-encompassing void in "mountain-water picture" or landscape—an opportunity that has hardly been effectively utilised outside China and Japan. Among the Western masters it is only Perugino and Raphael who have made the empty spaces in some measure significant. In the landscape art of the Sung masters of China, we not only come across vast spaces and serene horizons, soaring mountains and foaming cataracts, flights of wild geese and storms and waves of the sea in which the human spirit is liberated, but we also find the Great Universal in a blade of grass, a bare gnarled tree, a spray of flower, a trembling reed or a tiny fluttering bird, each unfolding the same intense cosmic stirring. "The finest landscapes", writes the Chinese painter Kuo Hsi, "are those in which one can wander, in which one can live". Again, "Landscapes are an inexhaustible source of life." It is the trailing cloud vapour or mist blurring the details of mountain-tops or distant lakes, rivers or valleys that gives the impression of majesty and vastness to the Chinese landscape, and, so to speak, imparts its facial expression. No less than the face of the Buddha, Bodhisattva or Siva, the landscape in Chinese and Japanese art is pregnant with mystery and elusiveness as it shimmers in mist and water and is lost in boundless horizons of the everlasting pines and peaks. This is no casual sentimental mood nor romantic fervour, but an intellectual generalised attitude transcending personal emotions.

Interplay of Human Attitudes and Values with Nature in Indian Landscape Painting

Landscape painting of the Rajput and Kangra schools shows features distinguishing it from Chinese and Japanese works. In the Indian paintings the

1 *Painting in the Far East*, p. 164; *Chinese Art*, p. 21; also Grousset: *Civilizations of the East, China*.

setting is that of the interplay of the familiar human loves and emotions, pregnant, however, with the mystery and profundity of a religious quest. Cloud and sunshine, river and lake, tree, bird and animal are here pictured as participating in sympathetic resonance to the action of the myth or legend. As Radha and Krishna unite at a distance, Krishna neglecting his charge of the cattle, the trees are depicted to become cogitated aware of the danger of the discovery of the escapade by Nanda, Jasodha and other members of the household, who unexpectedly appear on the spot. The cattle in most of the Rajput paintings have human eyes and are endowed with human imagination. As they come back home at sunset from pasture, they participate in the rejoicing of the milk-maids who have been the whole day anxiously awaiting the return of the Divine Cowherd, Krishna. Again, as Krishna sounds his flute beneath the Kadamba tree, the bees hum, the birds sing, the peacocks dance and the cattle listen with delight together with the thrilled milk-men and milk-maids; while even the cumulus clouds behold the scene through the trees. When Radha and Krishna are under the bower in intimate union, the pair of cuckoos sings the love notes, leaves of the trees look fresh and delighted and the cattle bow in human reverential gesture, while in the horizon the slender figure of lightning exhibits her dances in delight. Or, again, when Siva begins to expound to the fair Parvati in his lap the secrets of spiritual salvation, he takes as many as twelve years for the exposition. Meanwhile Parvati falls asleep. But the parrots in the tree begin to hear instead and indicate by their responsive sounds that the lesson is being heard. Meanwhile the great bull stands as sentinel in the slope of the Himalayas, preventing the intrusion of any living beings while the trees also act as screens. As Radha goes out in her lonely spiritual adventure through storm and rain, the lightning flashes show her the destination and the tall perpendicular deodars stand as mute witnesses of her courage, oblivious of the serpents of the forest. When she waits in vain for her Divine lover in the cloudy night in the forest, the branches of the tree swing down in profound sympathy and the pair of deer also look around in nervous expectancy responding to the agitation in her heart. As she unites with Krishna hand in hand, the profound joy of the unitive consciousness is shared by the flowered creeper as it twines round the tree and by the pair of birds who no longer can brook separation. Finally, as she is forsaken by her Lord, the desolation of the human soul is reflected in the affection and sympathy of the stooping forest and the inky flow of the river Jamuna. In medieval Indian landscape painting, trees, flowers and leaves, light and darkness and all sentient life participate in the drama of human emotions staged in a cosmic background. The expression and integration of human feelings and attitudes in the larger background of nature is, indeed, one of the leading notes in Indian literature handed down from the Aranya Kandam of the Ramayana and from the dramas of Kalidasa and Bhavabhuti. Landscape as such does not lead the beholder to the

universal as in Chinese and Japanese paintings. But it is pictured as in profound *rapport* with the human desires and attitudes that transcend their barriers and limitations and reach out to the universal. Thus does man, together with Nature, finds his oneness with Being. Differences in metaphysics appear to underlie the modes of artistic treatment of the landscape. In Chinese landscape-art the universal is symbolised as the interplay of the metaphysical opposites, Yin and Yang, heaven and earth, mist and mountain, and Nature which is a profound harmony that includes Man obtains a philosophical interpretation. In the folk art of Hindustan, the universal is symbolised as the sport of Love in which the dichotomy of body and soul, heaven and earth, enjoyment and renunciation disappears, and Nature together with Man obtains a lyrical interpretation, but the lyrical expression here is not romantic nor picturesque, but impersonal and transcendental. The difference between the Indian and Western pastoral landscape art is even more striking. The representation of pastoral themes in Rajput art displays neither the luxurious langour and voluptuousness of Giorgione and Titian nor the grandly impressive romanticism of Poussin, neither the extraordinary elegance of Watteau nor again the honest realism of Corot and Millet. It transfigures the commonplace village and pastoral scenes, the milking of cows, the return of the shepherds with their herd in the twilight from the pasture, the fetching of water by the milk-maids from the river, their way-laying by Krishna who makes them deposit their pitchers and levies the lover's toll, the gifts of curd by the milk-maids on their way to the market, their plucking of flowers for the worship of Krishna into enchanting images of events in heaven that are true for all times and places. The pastoral setting of Krishna and Radha (Brindavan) is heaven; eternal are its happenings and experiences. The entire folk-poetry, song and festival of the people bring about this transformation which the artist must represent if he is true to the cultural heritage of the people. Each episode is thus transfigured in painting and distils a universal truth; the familiar landscape is illumined by a mystic vision into a magic realm, where the light that never was on sea and land perfects and etherealises everything.

The Interfusion of Abstract Form Values and Social Values in Art

First, both the archetypal images and landscapes of the Orient convey impersonal and universal messages, concentrated universal essences or crystallisations of the cosmic plan of life. In the second place, as the artist seeks to depict the super-sensible and the inexpressible, he relies mainly on abstract means in respect of colour, line, plane and volume in space, on formal organisation rather than on outlines and material, or accidental aspects. It is the abstract, rhythmic and expressive form-value of Oriental art that yields an æsthetic experience, purer and profounder than that usually obtained in the gallery of European or American art.

Finally, Oriental art is, like metaphysics, religion and philosophy, an instrument for release of the community from its anxieties, fears and despairs. It serves as an agent for a complete integration of the conscious and the unconscious by directing the repressed complexes into the channels of the archetypal images where they obtain complete fulfilment. It aids towards the identification of man's consciousness with the archetypal image, the deity or Being and with the realm of nature and society or Becoming. By creation and renewal of symbols and images through seizing and utilising the various attitudes, loyalties and dispositions in the family life, Oriental art aids in organising man's permanent attitudes and weaving the patterns of his social bonds. Images and symbols of Oriental art are largely fashioned out of the raw materials of man's primordial dispositions and feelings, of child and father-love, of self-abasement and self-affirmation, of gregariousness and companionship, and of ardent man-woman love, but transmuted into impersonal and universal symbols and motifs with none of the personal expressions and idiosyncrasies that limit the range of their appreciation and application. Derived as these are from society by art, it gives back to society a hundredfold. For the images, motifs and symbols become charged with a new glory and holiness by the religious tradition and mystical consciousness and with new beauty and sublimity by art. Art thus brings not merely clarity in the mind and silence in the soul, but also offers ideals and norms of social relations and behaviour. For centuries the images of Siva-Sakti, Radha-Krishna and other eternal couples have elicited conjugal devotion and love among the peoples of the East that extend beyond death to future worlds and births. Similarly, the Mahayana image of the Bodhisattva with his serene and compassionate face, bending down with the gesture of infinite pity and sacrifice for suffering fellow creatures, keeps alive among the masses in Asia the ideal of non-violence, goodwill and self-forgetting service. Oriental art reveals the joys, sufferings and experiences of social life and relations in the ideal plane, at their best and most abstract aspects, as portions of the Absolute, saturated however with human sensibility. It is most intensely charged with community feeling, and is thus chiefly responsible for the historic continuity of Oriental cultures. In European culture the dissociation between art and religion and community values that has been sharpened since the Renaissance and aggravated by modern science and technology has implied the loss of ancient and familiar archetypes that Christianity bequeathed to Europe. These were vivid personalities and images that symbolised man's view of the universe and his relation to it, and not only integrated human emotions and sentiments and brought about a harmonious social adjustment but also bridged the gulf between the sensible and the concrete, and the super-sensible and the metaphysical. The decadence of art in modern Europe is rooted in the profound moral and cultural crisis that had its beginnings in the Italian cities after the middle ages. European science

and metaphysics have not been able to create the universal human realities, archetypes and symbols that can restore the individual to his harmonious relationship with his social milieu and the universe. Neither the truths of metaphysics nor the axioms of science can supply the stable ground and intense zest for man's ardent and ever-expansive communion with fellow-man and the universe that is assured by art, surcharging and transfiguring the human and the concrete with the feelings and emotions of the beyond-human and the universal.

CHAPTER IX

ART AS MORAL VISION

Integration of Personal Emotions and Attitudes into Social Universals

The more significant the art work, the more universal and impersonal is its appeal. It is a paradox that the artist selects and presents his subject-matter for interpretation through the mediation of a specific decorative or pictorial pattern, but the success of his artistic expression lies in that pattern embodying some universal quality or relation. Artistic genius consists in the expression of universals from concrete relations and situations. For man is so constituted that his profound satisfaction can come only from a conscious or unconscious identification of himself with other-than-self. A lyrical poet, a musician, a painter, or a sculptor may so express the individual passions and sentiments of love, grief and exaltation that these become abstract, typical and universal as embodied in all actual or possible relations and situations.

When personal emotions, attitudes and experiences are thus intellectualised or organised into the abstract, the impersonal and the generic æsthetic pattern, there is change in quality and intensity, breadth and distance associated with a sense of competence and insight. These are lifted to another plane and aid in social adaptation and integration. We call these æsthetic expressions 'social universals'. Their appeal unlike that of the 'sensuous universals' in art work is not of the widest range, bound up as they are in some measure with the mental and social characteristics of a particular civilisation. But within a particular civilisation they are the chief instruments of the good, and working through the desires and emotions of man disclose human relations not to be found in axioms and admonitions, precepts and codes.

The social universals are products of a complex process of creative imagination in which idealisation, synthesis, selection, variation of individual features and attributes and evaluation are involved, so that personal moods and eccentricities are eliminated, on the one hand, and the type does not become too abstract or insipid, but elicits a large variety of human reactions on the other. Thus the social type, symbol or universal in art is created, and it may be created in such form as by its power and imaginative unity acquires far greater strength, and pre-eminence than a living example, the experience of single individuals, the moral precept of scriptures or the injunction of the state. Art thus becomes the incomparable implement of education not directly but through appeal to man's imaginative experience, through the creation of the social universal that raises him above the narrow range of personal moods and emotions, and envisions new

human relations and possibilities that are as yet unrealised and that insinuate themselves into his consciousness and purpose. Art has been the means of clarification and strengthening of man's aims and goals of life that transcend morality and social conventions. Tradition and custom, myth and religion come to reinforce the expression of the social universal that an individual artist presents out of the crucible of his own experience. These also create the so-called archetypes that the artist adopts, beautifies and strengthens, capturing the imagination of a people and eliciting their devotions and sacrifices. Much of the material of artistic vision is in fact supplied by the religious and poetic heritage of a community.

The moral function of art lies in the artist's individual gifts of selection and interpretation of such human relations and experiences as may induce social universals, *i.e.*, generic social attitudes, values and aspirations and bring about the integration of self and society. But the artist is guided in this by the experience of his race, community or epoch, that creates and recreates ideals, symbols and archetypes as well as by the less conscious purposes and faiths—the powerful and cherished products of the collective mind comprising the pervasive moral and artistic environment without which neither morality nor art can be kept alive. Their massed constant influence shapes culture and the desires and purposes of the individual in a manner that anything directly taught by word and axiom can never do.

In Europe, however, this encompassing moral and artistic environment has been largely disintegrated since the Renaissance, and the artist, left to his own moral resources, fluctuates between an extreme form of subjectivism and a pale and futile reproduction of past ideology and emotional unity. In a well-integrated society or epoch, the problem of art for art's sake would not arise. All art work is moral vision. The archetypes of the community do not permit the separation of art, morals and ordinary life and bring about on the plane of meanings and values the fusion between man's emotions, imagination and achievement.

Art and Social Control

Art widens the range of human emotions and experiences by opening up new vistas of man's oneness with fellow-man, and with the entire realm of Becoming. The power of art consists in the presentation of the universal and symbolical in the individual. What is presented with great charm and attraction as the social, the impersonal and the typical thus determines and regulates the thoughts, feelings and faiths of large bodies of men in all epochs and religions. All great art has created archetypes and symbols of social universals that have contributed towards the cohesion of society and solidarity of the race and the effective and sure guidance for the individual in selecting the values of life. Art has been the

chief and easy means by which man's collective consciousness or the insight of an individual artist into the finer things and relations and profounder truths and values of life has aided him in facing the trials and tribulations of the world. Both the genius of single individuals and the creations of the people or race have enriched the heritage of expression of social universals in art.

Art and Social Tradition

The greatest of the world's art forms have not been the work of single individuals. Myths, parables, stories and doctrines have given the world the finest and the noblest ideals, types and symbols. What more beautiful and truer products of imagination can be conceived than the majesty and detachment of the Sphinx and the mystery of the triad, Osiris, Isis and Horus, in Egyptian art, the fortitude and enterprise of Hercules and the physical charm and alertness of Hermes in Greek art, the severity and poise of the Himalayan ascetic who has conquered life and conquered death and the compassion of the Bodhisattva, who has tendered his life as sacrifice for all sentient creatures in Indian art, and the suffering and faith of the Man of Sorrows on the cross or the immaculate purity and universal maternity of the Virgin in the Gothic art of Europe? All these gods of religion and living faith differ from those of metaphysics. They have been loved and adored as ideals of their own hearts by men, and art forms, Hindu, Buddhist and Christian, have been the spontaneous embodiments of this passionate love and adoration. Thus the materials of metaphysics, faith, history and tradition are melted and refashioned by the pious imagination of sculptors and painters into the glorious figures of Siva, Buddha, Christ and the Virgin in art that command the loyalties, penances and charities of men through the centuries. On the other hand, art spreads and conquers territories and peoples by bearing its message of social universals and morals. A remarkable example in world's history is the establishment of Indian art in Central Asia, Pegu, Siam, Cambodia, Ceylon, Java, Sumatra, Bali and Borneo. Chinese art made little impression in these territories that came under the ambit of the influence of Chinese traders for long centuries, chiefly because it could not, unlike Indian art, present through imaginative vision such social and moral ideals with attraction and clarity among the indigenous peoples of these lands.

Art as an Escape from Society

Though mankind's vision of truth, beauty and goodness is the same, in the context of the social system morality assumes different accents among different peoples. Society in the Orient has shown a sharp and rigid gradation of castes and classes that have thwarted individual initiatives and achievements. Thus both religion and art stress the supreme values of compassion, non-violence and self-sacrifice, while the doctrines of transmigration of births, of Karma (deed)

and its fruition, and of God's immanence in every form, however fixed that may be, enter into their very substance. It is thus that art smooths the acerbities and excesses of the social system, enabling the individual to accept his lowly status and position in society with greater complacence and his adversity in a long sequence of births and deaths with greater fortitude. Art, therefore, is a most efficacious cultural instrument for expressing man's repressed and baffled emotions and sentiments for securing his psychological and social adjustment. As a matter of fact the success of Oriental art in bringing about social equilibrium is illustrated by the stress of different levels of existence and the sequence of births and deaths and transmigration of souls in a vast panorama of life, where sorrow and joy, despair and promise intermingle bridging the gulf between actual conditions and possibilities. The notes of frustration, sadness and pessimism are in fact drowned by the elegant display of the delights of the senses and the intoxication of enjoyment, embodied in the array of surging and dancing angels and courtesans, the scenes of domestic life and love, the sports of animals, the blossoming of flowers and the ripening of fruits that one comes across at Ajanta, Borobodur and Angkor.

At the other extremity of the world of art, we find in Greece a kind of art that stressed the harmony of proportions in statuary, temple-building, vase-making and composition of the tragedy that are in such utter and sad contrast with the political turmoil and moral chaos of the Hellenic world. If the social and political system could not assure sanity and serenity to the Greek citizens, the harmony and the order were to be found in the magnificent art works of Hellas, glorifying Gods and heroes rather than the ordinary mortals, and depicting the ideal events or myths and legends rather than the affairs of the earth. But the Hellenic gods and heroes were imbued with all human desires and passions, acting and suffering like the mortals of the earth. Yet the sovereign power of Zeus, the heroic manly strength of Hercules, the womanly dignity of Hera, the noble wisdom of Pallas Athene and the redemptive love of Psyche, though largely conceived in human terms, were the sources of consolation for the individual, though not of integrity of the Hellenic city states that pursued their sanguinary course of class struggles and internecine conflicts.

Similarly the High Renaissance painting of Italy, with its marvellous linear rhythms and colour harmonies and idealisations of the human situation, was a counter-balance in the domain of art to the egoistic individualism and license of the aristocracy and the common people and the chronic turbulence and wickedness of the Italian towns. The immense vitality and terrific vigour of the art of Michael Angelo, who denied himself all the pleasures of companionships and good living and devoted himself to endless toil, had their counterpart in the grandeur, magnificence and brutality of Italian life. On the other hand the touching humanism and mysticism of Fra Angelico revealed the faith and

devotion of the ineffectual minority that were being smothered by the sensualism and luxury as well as the storm and the stress of life. Art expressed the social universals that were challenged by the crass materialism, unashamed vice and extraordinary release of energies in the new social milieu. Through the epochs, art provides a refuge and an escape to the individual when society appears to him as a system of chaos and disorder.

Art as Remaking Society

Art by bringing about the unity and the order in the ideal plane, saves civilisation from disintegration and bears within its bosom the elements of its remaking. It is for this reason that one cannot call art, 'religious', 'secular', or 'ethical' for art mobilises all the truths of religion and metaphysics, and all the axioms of morality to give peace to the individual in his social regime. Art in fact combines metaphysics, philosophy, religion and ethics, and makes all these human and concrete in its task of bringing about the equilibrium between the individual and the society through an ideal collective representation that sometimes has an even greater power to mould humanity than the actual society and its institutions.

The Social and Ethical Significance of Early Buddhistic Art

In the Orient what largely passes for the religious content of art is social and ethical. In those early Buddhist sculptured decorations at Bharhut, Sanchi, Bodh-Gaya and Amaravati we see illustrations of the birth-legends of Buddha (Jatakas) with exquisite characterisation and loving attention to details, neither articulating a religious experience nor portraying a religious episode, but depicting moral tales that for all time to come stand for the glorification of certain generic social virtues like self-sacrifice, tenderness, compassion, purity and truthfulness that have been accepted by the Oriental peoples. At Sanchi we find illustrated in several reliefs the generosity of Prince Vessantara who gave away all what he had, including his children and wife, thus exhibiting "the perfection of benevolence". Similarly there is the story depicted of the monkey-king who to save his suite of eighty thousand monkeys against archers who surrounded them cleared the river Ganges by a prodigious leap with a rope permitting the monkeys to cross safely. But a malevolent monkey who was no other than the traitor Devadatta in his past birth dropped on his back and broke his spine. Or, again, among the reliefs at Amaravati and the frescoes at Ajanta we find the touching episode of the royal elephant with six tusks (Shaddanta), sawing off with his own trunk his tusks in order to gratify the wish of the Queen of Benares, once his wife, who devoured with jealousy due to the favour unconsciously shown by the elephant to another wife of his sought her own death to wreak her revenge. Again, there is the well-known story of the king of the Sibis

portrayed in sculpture, who in order to save a dove that had sought refuge against a pursuing hawk in the king's lap gave his own flesh and ultimately his whole body as offering when the weighing balance showed that his freshly killed flesh grew lighter and lighter in comparison with the dove's.

The Jataka Illustrations at Ajanta

About the frescoes of Ajanta a whole book may be written. We have here the entire procession of Indian life from love-making, dice playing, hunting, procession of horsemen and elephants and march of armies in foreign lands to the episodes in the birth, life and death of the Buddha, from the sports of monkeys and elephants, and cock and buffalo fights to the flowering palasa trees along the trunk of which a swarm of ants climbs up. Nothing is here left out. A strong sense of naturalism and a broad humanitarianism have mingled with an intense spirituality to animate the graceful men and women and their chaste, gentle poses and gestures. Even lovers have a refinement in their reciprocal attitudes and gestures which make amorous approach something of a ritual. The drama of human life, of love and separation, happiness and suffering, passion and compassion, set within a panorama of successive lives and deaths and transmigration of souls, is dominated by the sense of the transience of existence, the swirling movement of life from level to level and from appearance to appearance and a profound emotion of their piety, with which the beholder becomes saturated as he devoutly wends his way from cave to cave in this sanctuary. In fact the idyllic scenes of Indian life, the rich panorama of the flowering jungle or the pomp and pleasures of the king's court merely form the setting of the enchanting figures of the Buddhas and Bodhisattvas, some of the loveliest and holiest visions ever dreamt of and executed by artist, the beacon-lights of wisdom and compassion for man in the bondage of desires and ignorance. It is they who epitomise in their lovely slender bodies and meaningful, supernatural gestures the universal values that are dispersed among the variegated scenes of the pageant of Indian life at Ajanta. Just as Asvaghosa's Buddhacharita and Aryasura's Jatakamala, described by I-tsing as the popular books of Buddhism in the age, supplied the inspiration of the scenes from Buddha's lives in the frescoes some of which quote the latter's verses, so the tender ecstatic songs of Santideva's *Sikhsa Samucchaya* perhaps underlay the beatific supernatural visions of Manjusri or Padmapani, the ever-compassionate, beautiful Bodhisattvas at Ajanta. As an embodiment of the social ideals of Buddhism, Ajanta vies with Mathura, Sarnath and Borobodur, and influenced Central Asia, China and distant Japan.

The Borobodur Bible

Buddhist legends as well as tales from the Ramayana and the Mahabharata are depicted in bas reliefs and paintings in a thousand temples within the

frontiers of India and also in Java, Siam and Cambodia, where the Indian art traditions spread. In the great stupa at Borobodur in Java we have the procession galleries adorned by a series of some two thousand bas reliefs, illustrating the life of the Buddha according to the Lalitavistara, the Divyavadana, the Karmavibanga, the Gangavyuha and the Jatakamala as well as various other legends. Referring to these Coomaraswamy observed, "We have here a third great illustrated Bible, similar in range, but more extensive than the reliefs of Sanchi and the paintings of Ajanta. This is a 'supremely devout and spontaneous art', naturally lacking the austerity and the abstraction of the early Buddhist primitives, but marvellously gracious, decorative and sincere".

The episodes represented are by no means so exclusively courtly as is the case at Ajanta, but cover the whole circle of Indian life alike in city and village. The narrative element is more conspicuous than at Ajanta, the craftsman closely adhering to the book, while he portrays social life, birds and animals and vegetation of his own land. The reliefs at Borobodur are so extensive that if laid end to end they would cover a space of about three miles. In these magnificent sculptured panels which have been seen by thousands of devoted pilgrims through the centuries, we see unfolded a poignant epic drama of human emotions in a cosmic setting where man reaps the fruits of good and evil deeds in previous births, where god, angel, man and animal form links in a continuous chain of sequence of existences, inexorably working out the universal law of Karma, and where the profound lesson is to end the uninterrupted cycle of births and deaths through the absence of desires and the good deeds of love, compassion and sympathy for all. Nothing is discarded in the scenic representations, the pomp of wealth, the might of arms, the ardent passion and serene grace of women and the beauty of nature, but all is subdued by the sincere expression of the triumph of purity and wisdom as embodied in the story of Buddha's enlightenment. This triumph is expressed in every single gesture and mood of gods and angels, men and women, animals and birds in the vast panorama. Step by step from gallery to gallery pilgrims are led through illustrations of the law of retribution of good and noble deeds, the stories of Buddha's preparation in the course of hundreds of past lives, the episodes in the life of the historical Buddha until they witness the search for the highest wisdom revealed by the Bodhisattvas of the Mahayana. "When at last," writes Vogel, "the pilgrim has reached the summit of the *Stupa* the phenomenal world vanishes from his sight and he is transported into the sphere of mere thought".[1] The unity of the realm of Becoming has nowhere been more sincerely expressed in sculpture than here. Over the procession of human episodes which are linked together under a master-plan, and in each of which every figure is absolutely unique and sincere in expression of face, gesture and pose of body, there broods the ineffable mystery of the oneness and

1 J. P. Vogel: *Buddhist Art*, p. 100.

harmony of life. Art here has immortalised itself by transforming small episodes and personal moods into the universals that help in the realisation of the oneness of life and of the divine wisdom which creates it. In all ages the transformation of the metaphysical doctrines of the unity of life and immanence of the deity into an emotional mysticism bridges the gulf between the concrete and the abstract, and between the human and the spiritual. Such idealism elevates, deepens and intensifies the artistic consciousness, inspiring some of the highest achievements in the realm of art.

The Intermingling of Gods and Men at Angkor Vat

In Siam and Cambodia as well as in Java we similarly see the legends of the Ramayana, the Mahabharata, the Srimadbhagvat, the Harivamsa and other tales connected with Vishnu and Siva illustrated in fine sculptures adorning the walls of the temples. The churning of the milky sea, the death of Bhishma, the banishment of Rama, the loss of Sita, the fight between Vali and Sugriva, the alliance of Rama and Sugriva, the meeting between Sita and Hanuman in the Asoka grove in Lanka, the fight between the armies of Rama and Ravana as well as the episodes of the life of Hari and of Krishna are all depicted in the famous temple at Angkor Vat. Here, again, art has truthfully portrayed social universals among peoples who did not know the legends, but who have absorbed them so sincerely and deeply that modern artists now draw frequently on them for their mural decorations in the pagodas of today. In the sanctus sanctorum Buddha, Vishnu and Siva are installed in their divine aloofness like stars that dwell apart. But in the paintings and bas-reliefs on the walls of the corridors, leading up to the divinities, are depicted the conjugal love and trials of Rama and Sita, the brotherly attachment of Lakshmana, the fidelity of Hanuman, the marriage of Siva and Parvati and the trials, sufferings and sacrifices of the Bodhisattva in an all too-human setting. The gods who are the apotheoses of the social virtues come down with their human desires and sufferings to the level of the common people, while the men and women in their devotion, thanksgiving and purity raise themselves to the level of the gods. Siva in order to save the gods and all living creatures undertakes the stupendous sacrifice of drinking the poison cast by the ocean or by the universe serpent, Vasuki. Vishnu, Ramchandra and Krishna go through their hundred adventures for the sake of the protection of heaven and earth, gods and men against the Asuras. Similarly Buddha prepares himself for his message of enlightenment for humanity through innumerable lives of sacrifice and compassion. Then they come down to the earth, and mingle with all life. What brooding pity and tenderness for all living creatures then radiate from them, and this is reciprocated by what trustful adoration of all! The figures of nude female worshippers arranged in serene yet animated, throngs, with their infinitely sweet and chaste poses and gestures of adoration, cannot but be an

unfailing source of inspiration for the pilgrims. Even the foliage of the forest, the sheep, the elephants and the lambs, the nagas or the water-sprites and the ripple of the waters participate in the cosmic devotion, not to speak of the homage of gods, angels and spirits of the upper air. Such is the picture that the succession of mural paintings and sculptured panels unfolded before the throngs of observant pilgrims as they used to wend their way to the main shrine. Religions may change, kingdoms may perish, but the art which aids in elevating the moral tone of social life lives so long as society endures. It is the stress of the social universals that has brought about the merging with irresistible power of Beauty and Truth at Ajanta, Sanchi, Amaravati, Borobodur, Angkor Vat, Pagan and Sukodaya.

Biblical Scenes in European Christian Art

The Javanese sculptured panels have been compared with Ghiberti's Doors of Paradise in Florence designed at the opening of the 15th Century. Ghiberti, Jacopo della Quercia, Donatello and the della Robbias presented many Christian scenes with marvellous versimilitude and elegance of composition. The creation of Adam and Eve, the Temptation and Expulsion, the story of Cain and Abel, Esau and Jacob, Christ before Pilate, the Crucifixion and the Resurrection were all pictured by Ghiberti in delightful natural backgrounds with superb illustrational effect. Like the Javanese scenes the various events from the Old Testament and of the life of Christ and the Fathers of the Church formed the source of inspiration to generations of pilgrims who visited the Baptistry at Florence. Similarly, Donatello presented with tragical pathos the Scourging, the Crucifixion and the Deploration of Christ and with great dramatic vigour the scenes of Salome and St. John. A profound pity, tenderness and compassion as revealed in the poignant Christian drama were unfolded and the figures of Mary, Christ, Magdalene and the dancing angels and cherubims were especially depicted with great fervour and piety.

But the difference of treatment between Oriental and Renaissance art in Europe can hardly be missed. There is, in the first place, a tendency towards sentimentality marked in the Christian sculptors that found its apotheosis in the delicious bambini and sweet Madonnas of della Robbias and Raphael. This is far different from the chastity and restraint of movements and the serene rhythm of gestures of men and women in the Amaravati or Borobodur reliefs. Many of the angels, Madonnas and cherubims in Christian art are similar, pictured it appears from local models. In the East there is no attempt at naturalism or realism, but at the same time a marvellous plastic beauty of nude figures has been reached, soft, smooth and chaste, that is enhanced by the rhythm of the poses and gestures, everyone of which is of high plastic value. The beauty of the human body in Oriental sculpture is far different from the Grecian or the

Renaissance conception. Such beauty, constituted by the harmony of limbs and movements and expressions of the face, is plastically transmuted into something more subtle and expressive of the deep and noble stirrings of the human soul, thus aiding in its attainment of wisdom and bliss.

The Notion of Supersensual Perfection in Art

Man's physical beauty appears in Indian art as the rapture of the soul; it suggests supernatural capacity transcending the limitations of physical well-being. It is far different from the norm of physical perfection derived by classical Greek sculpture from the spectacle in the national games, and that became almost an obsession of Europe for several centuries. Mankind has also dreamt of other kinds of perfection, and so the norms and types of physical human beauty differ. The luminous beauty of Buddha, Bodhisattva, Vishnu and Siva is in subtle unison with the supernatural aims of the body as the receptacle of the soul. The serenity, majesty and poise of these gods in Indian sculpture represent the apotheosis of man's beauty. Woman's charm in India with the emphasis of full rounded breasts and ample slanting hips is the grace of motherhood that hides in the fair sex her supernatural possibilities. For every woman the ideal of physical perfection is that of the primordial Mother of the Universe in the full radiance of her maternal glory.

The ideal of beauty of the human form in the West no doubt has been largely dominated by the inclinations and standards of classical Greece where friendship was preferred to love and the well-poised athletic form of the human male became the standard of human beauty. In the Orient the norms of the perfect male and the perfect female are different, and woman's beauty is the flower and herald of motherhood. The Orient in its sense of beauty shows on the whole not merely a sounder biological judgment but also a deeper psychological insight. In Western art, except in the Middle Age with their Madonnas, Angels and Saints, woman's loveliness and charm rather than the serenity and beauty of her soul have been stressed. In Oriental art we have not only the Apsara's and the Nayika's captivating loveliness, like that of Aphrodite, but also the wisdom and tranquility of Prajnaparamita, Tara and Parvati. Like the unique serene and well-balanced figures of Buddha and Siva, Indian sculpture, stirred not merely by the physical charm but also by the tenderness, wisdom and mystery of womanhood, has produced new types of feminine beauty that only have a spiritual import.

Metaphysical Conceptions in Art

In Indian metaphysics the feminine symbolises the mind in creation and movement, not in rest and withdrawal that are symbolised by the masculine. Indian art represents the female divinity in the state of profound meditation and

poise only in such Buddhist images of the goddess of wisdom as Prajnaparamita and Tara, seated in the rigid padma and bajraasanas with the legs firmly locked in. In some Buddhist images of Tara and the Brahmanical images of Saraswati, Lakshmi, Kali and Parvati we find even a relaxation of the rigid meditative pose by the adoption of sukhasana or lalitasana, with the right leg hanging down and the foot resting on a lotus. Usually, however, the female divinities express movement, and are in the standing, gentle tribhanga or in the vigorous alidha and pratyalidha poses, in grim, yet compassionate action against the forces of evil.

The female divinity or Sakti in Indian religion and art symbolises form, energy or manifestatian of the human spirit in all its rich and exuberant variety. Thus the images of female divinities are far more diverse than those of Vishnu, Siva or Bodhisattva. The icons of the mother deity range from the benignant, brooding motherliness of Parvati, the serene dignity of Prajnaparamita and Saraswati and the nubile charm of Uma to the omnipotence and majesty of Durga, slaying the demons, and the weird vigour of the dancing and grinning Chamunda and Kali, wearing the garland of skulls.

Religious doctrines in India lay down the injunction forbidding the sight of the nude female figure. But in India this injunction is got over by covering the female form with thin or transparent apparel or by representation only of the upper part of the body as undraped. This has been due to the ancient and medieval Indian habit of clothing for women who did not cover the upper part of the body or used loose garments. Such, however, is the dominating sense of mystery and elusiveness in Indian iconography that the nude mingles freely and unconventionally with figures of religious or symbolical import.

The Significance of Poses and Gestures: Feminine

Of the poses of the female form the most characteristic is the three-fold inflexion, tribhanga, that combines the fullness and straightness of the woman's torso with the soft and graceful slant of the right, or occasionally, the left hip, and that expresses a most delicate and harmonious blend of poise and charm, serenity and springiness. This characteristic flexion goes back to the images in Bharhut, Sanchi and Amaravati. The most elegant instances are afforded by the images of the Tree spirits (Yakshi or Salabhanjika) at Mathura, Konarak and other places, of Parvati at the Elephanta cave, of the river goddesses—Jamuna and Saraswati—at Ellora, of Tara at Munshiganj, of Mahesvari at Bhuvaneswar and of the South Indian bronzes, Parvati with Subramanya in her arm, Parameswari and Gouri. This pose is obviously derived from the Indian woman's natural movement as she carries in her arm her child or a pitcher of water that cannot but strike an Indian artist.

The exaggerated hip effect (atibhanga) produced by the mother bearing the child in her own arm is seen at its best in the image at Khajuraho and the

Tanjore bronze image of Parvati with Subramanya. On the other hand, the atibhanga flexion is also illustrated in the voluptuous forms of the couple on the railing post at Amaravati, of Rati (with Kamadeva) at the Kailasa temple in Ellora, of the Apsaras in the temples of Bengal and Orissa, of the many maithuna couples at Khajuraho and Konarark and of the South Indian bronze, Mohini.

The tribhanga pose is formed, as Stella Kramrisch remarks, as if brought about by a rotating movement, now circular, now flattened—a movement which proceeds from below upwards; like a chalice it raises the globular breasts almost to shoulder height. The dynamic movement proceeds beyond the physical reach of the figure and symbolises the urge within the perfect human feminine body to ascend towards its ultimate spiritual destiny, *i.e.*, towards salvation. It is noteworthy that the tribhanga pose is adopted for masculine divinities in Indian art whenever the softer qualities, such as love, compassion and benignity are sought to be stressed. Thus this pose is characteristic of the figure of Bodhisattva at Ajanta, of Buddha at Bagh, of Vajrapani at the Visvakarma cave, of Maitreya and Lokanatha in Bengal and Orissa, of the many figures of Krishna throughout Northern India and of the South Indian images of Siva as Gangadhara or Kalasamhara.

The balanced tribhanga flexion has been adopted in images in all Asiatic countries from Central Asia and China to Java and Cambodia wherever Indian art traditions have established themselves. Thus both man's and woman's body in Oriental art is, in the first place, so transmuted as it may attain something beyond the possibilities of physiology that confine the Grecian and Renaissance search for physical beauty; and, in the second place, the human body is so abstracted and rearranged in its essentials as to be useful in formal shape, proper to stone, metal or wood. The significance of Oriental art forms lies not merely in its rich symbolism and attempt to create super-sensual norms of beauty but even more in their abstract formal rhythms and movements.

No attempt is made here to imitate human anatomy, but the features of the body, especially the face, hands and feet are so represented as to make the supernatural aims of the body easily comprehensible. Thus in a sense the representation of Buddha, Vishnu and Siva is a symbol. It expresses the idea of Being or Becoming. Secondly, if it be a stone, bronze or wooden image, its abstract formal or geometrical quality transcends the naturalistic, for the copying of nature is the real enemy of symbolism. In different Oriental countries man's beauty or perfection is represented by art in different media in a blend of formal element and naturalism that has markedly differed in different epochs. But the emphasis is always twofold: first, towards the notion of extra-physical or supernatural perfection; secondly, towards the formal, highly simplified image, almost geometrically conceived, that can express the inner life where the

conflicts and struggles are resolved into a profound tranquillity, competence and majesty.

The supernatural beauty of the male divinity such as Buddha, Bodhisattva, Siva and Vishnu is expressed in Indian sculpture by the smooth modelling 'of broad shoulders, such as those of the bull or the elephant, and of a slender waist such as that of the lion, and by an elegant roundness and softness of the limbs such as those of the female body. All divinities are youthful and should look like sixteen years old, as enjoined in the Vishnudharmottara, should never show any muscles, veins or bones, and should bear a nimbus. The Vishnudharmottara adds that the face of the gods should be well-finished and benignant; large arches, triangles and other geometrical shapes should be avoided in representing gods. A smooth and rounded bodily frame in which anatomical details are largely eliminated easily suggests superhuman grace and power.

An elaborate variety of ornaments decks the undraped divine figures. The crown or tiara, the ear-ring, the chain and the girdle are especially carved with great artistic effect contributing towards the enchantment and elusiveness of the figures. An abstract, supersensible form becomes the fit vehicle of ideal attributes of the deity that are further symbolised and supported by the addition of hands and heads so harmoniously balanced in the whole plastic composition that they do not engender any suggestion of the abnormal or the grotesque but on the contrary logically and happily translate the underlying motif of the icon.

The Significance of Poses and Gestures: Masculine

Most of the male divinities in Indian sculpture are in rigid standing or sitting meditative poses. The heavy solidity of the lower part of the body and of the firmly placed legs (samapadsthanaka) that are not much articulated as well as the unshakably straight vertical line from the crown to the feet express powerfully in stone or bronze the omnipotence and inflexibility of truth asserting themselves above the impermanence of life and the world. The same notion is also represented by the rigidity of the seated pose of meditation in baddha padmasana, with the legs firmly interlocked and the soles turned upward. Buddha, Vishnu and Surya that belong to the highest level of spiritual existence are usually depicted in the above poses. But Bodhisattava, Siva and, above all, Krishna show curvilinear movement (bhanga) and rhythm of the body symbolical of the grace and compassion to man that are stressed. Since the deity is not a human individual but the embodiment of a supernatural or metaphysical abstraction, there is also often a striking departure from the human form or symmetry in the multiplicity of heads, hands and feet so as to suit the cosmic vision. Oriental sculpture over-steps anthropomorphism, and seeks nothing more and nothing less than the expression of the Beyond, reached by cosmic meditation with none of the limitations set by measurable human goals and ideals. Thus

what is asymmetrical from the standpoint of naturalism and realism becomes in sculpture the vehicle of the cosmic and the transcendental. It must, however, be remembered that in certain schools and epochs art retained its human and anthropomorphic character, as instanced by Gupta art in India, Tang and Sung art in China and Nara art in Japan.

Finally, the play of fingers of the hands (mudra), as these hold some flowers or implements, the sway of the limbs as well as the general movement are devised in Indian sculpture as suggestive of the deity and of His or Her Divine actions (divyakriya) far remote from human gestures and movements. Yet these are invested with a remarkable tenderness and subtlety of expression of what are really superhuman and spiritual emotions and attitudes. On the other hand, the practice of such movements, postures and gestures has been found in Oriental yogic experience to engender the spiritual atmosphere, attitudes and virtues associated with the particular deity. Thus the artist for his image-making must resort to spiritual and æsthetic contemplation (dhyana) and not the imitation of any human model that he has been strictly enjoined to eschew. He works directly from his own mental image that represents some aspect or other of the cosmic essence. Even where the image of a horse is to be made from a horse actually seen, the artist is required, as we read in the Sukraniti, to form a mental image in Dhyana. Defect in portraiture is attributed in the Hindu canon of art not to lack of observation but to imperfect identification (sithila samadhi). Thus the practice of Hindu art is a discipline of meditation which eventuates in the skill of operation and technique (silpasthana-kausala). On the other hand, those who look at earthen images "do not serve the clay as such but without regard thereof honour the deathless principles referred to in the earthen images".[1] It is serene perfect meditation that can beget the perfect bodily poise of Buddha, Bodhisattva, Siva and Vishnu.

But while the Orient has produced some of the world's most perfect, inevitable and inspiring male and female images and poses of the profound serenity and silence of Being, certain other spiritual moods that embody the processes of Becoming or Divine actions (divyakriya) have also received magnificent and unique plastic expression. These have usually taken the plastic forms of the various Saktis, Hindu and Buddhistic. Such mother goddesses are found both in their static as well as active poses. In their postures of repose as in the images of Parvati, Prajnaparamita, Tara, Mahapratisara and Saraswati, they represent the very incarnation of youthful charm and energy. But sometimes they are also represented as engaged in strenuous struggle against the Asuras or powers of evil when their gestures and movements become wild and terrible, although their faces depict unperturbed tranquillity. A profound detachment

1 Divyavadana, ch. xxxvi and Sukranitisara quoted by Coomaraswamy in The Part of Art in Indian Life, *Cultural Heritage of India*, Vol. III, pp. 501-502.

and absence of emotion in the movement or action are, combined with an absolute sense of omnipotence, devoid of any the least inkling of brutality or vulgar exhibition of physical force. The Asuras, again, seem to succumb without opposition or conflict, as if pre-ordained according to the immutable cosmic law of the supremacy of truth and righteousness that the goddess symbolises. Or again, the goddess is represented in a single image symbolising the struggle within the human soul, the power of destruction of the flesh and the devil in the mind of the worshipper and the beholder. Such are the awful animated images of Durga, Kali, Chamunda, Tara or Paranasavari that yet exhibit a magnificent beauty and feeling-import contrasted with those implicit in the more serene and pleasant types of beauty as Parvati, Prajnaparamita, Uma and Gouri. Their sitting posture is also relaxed in sukhasana or lalitasana, with the right leg pendent or placed on a lotus in soft self-conscious gesture of love and benediction to man. It is noteworthy that in Buddhist or Brahmanical art outside India the perfect pose and symmetry that the Indian sculptor could give to the various images in their various seats and gestures (asanas and mudras), following the Indian yogic traditions, could not be achieved. Many of these poses were no doubt unfamiliar to the Buddhist and Brahmanical converts in China and further India. Finally, when the divinity is represented in Indian sculpture in its wild destructive aspects, dwarf and pot-bellied bodies having none of the youth and elegance of Buddha, Vishnu, Siva and Parvati are figured. Heruka, a dancing Buddhist divinity terrible in his aspects, is a well known illustration from the sculpture of medieval Bengal.

The Terrible in Art

In the art of very few countries has the universal mood of the terrible (bhayanaka) been expressed and that in such cosmic significance. Nara-Simha or the God-lion and the female deities such as Parna-Savari, Marichi Durga, Chamunda, Kali, Hayagriva, the horse-headed, and Mahakala, a form of Siva, and Tara symbolise the destructive aspects of the cosmic process. All that is terrible and repellent are combined in such images intended to detach the beholder or devotee from the life of the senses for reaching the Truth, which is indeed assured by the grim dancing figures through the gesture of hope (abhaya) in one of her many swirling hands, the other hands usually holding skull, corpse, spear, knife, sword, kettle-drum or bone.

It is easy to understand that in the human mind spiritual Truth or Wisdom becomes grim and fierce resentment or righteous indignation when it encounters wickedness, vice and ignorance, and that Love and Compassion that encompass everybody enforce themselves upon those who deny its power of deliverance. It is this psychology that underlies the expression of the terrible in Oriental painting and sculpture. In Mahayana Buddhism and Tantrikism of Bengal, Tibet

and China and in Shingon Buddhism in Japan several representations of the terrible are met with[1]. In Eastern India and Tibet Yama or Yamantaka, the God of Death, is a familiar figure. In many Oriental temples the gate-keeper is often a divinity with terrible aspects, cleansing the pilgrim with the fear of the Lord. Such is the Rakshasa or demon, holding a club and serpent in his hands in Chandi Sewa in Java, described as "a tangible terror in stone". But Javanese art has also produced the magnificent bronze image of Trailokya Vijaya, with four faces revealing different moods and eight hands, crushing Siva and Parvati under his feet—one of the most powerful and majestic images of destruction ever executed by the human hand. In Japan there are the formidable images of Dai-Itoku and Fudo. The former is a modification of the Brahmanic Yamantaka, the god of death; the latter is a fierce manifestation of Mahavairochana, representing the subjugating powers of Buddha over the human passions.[2] Often in Oriental religious doctrine and art the serene and the fierce, the compassionate and the furious are contrasted phases of the supreme manifestation of the deity.

No such reconciliation of opposites, of grimness and hope, darkness and light, sacrifice and renewal of life, will be found in the treatment of the terrible in Michael Angelo's 'Last Judgment', Goya's 'Saturn' or Delacroix's Medea, three of the rare representations of the terrible in Western art; while the representation of the Dance of Death by Holbein, Rethel or other master-artists or the recent treatment of the same theme by A. Egger-Lienz in Germany we encounter a morbid consciousness of mortality, of the omnipresence of death that has not freed itself from the narrow, medieval spirit.

Impersonal Love and Beauty in Art

Contrasted with the silent and the poised, or the vigorous and the grim, supernatural types of beauty in Indian art are the types of loveliness as represented by the Yakshis, Vrikshakas and Salabhanjikas in Sanchi and Mathura and the Apsaras and Nayikas (celestial nymphs) in Khajuraho and Orissa of the later centuries. The Apsara is the danseuse of heaven as the Nayika is of the earth. Each is free in her loves and wiles, unattached to the home and the family. In these figures Indian art expresses the delights and sports of sex, the incomparable charm of woman that lures men and gods. Such figures abound in the temples of gods and goddesses and embody the Indian ideal of feminine loveliness. About these Apsara figures Rothenstein observes: "Today we look at Sanchi, Badami and Ellora, or at the loveliest of all the medieval carvings at Konarak, Bhuvaneswar and Khajuraho[3], and accept them gratefully with the

1 See Hackin and others: *Asiatic Mythology*, pp. 99, 166-170.
2 Anesaki: *Buddhistic Art*, pp. 37-44.
3 And also at Mayurbhanj. See the figure in R. D. Banerjee: *History of Orissa*, Volume 2, p. 420.

dancing Greek nereids, the figures from Botticelli's Primavera or Venus rising from the sea as enchanting manifestations of man's delight in human beauty. The Apsara takes an equally important place in the Buddhist, Brahmanical and Jaina art. So racial a conception could not be changed with the form of religious dogma."[1]

The tree spirits, the nymphs and the heroines of love embody in plastic language all the similes that classical Sanskrit poetry has used to meticulously delineate the features of female charm. The beautiful woman's face in Sanskrit Kavya is like the red lotus or the full moon; her eyes are like the petals of the blue autumnal lotus; her eye-brows rival the bow of Cupid; her lips are ruddy as the new leaves of spring or the ripe bimba fruits; the lines of her neck are like those of the conch-shell; her breasts are firm and full like a pair of inverted cups of gold or a bunch of thick fresh flowers; her hips are smooth and heavy like the swelling banks of a river; and her movement is like that of the swaying creeper, the swan or the elephant. The norms of beauty and of expression of erotic and seductive attitudes are in this case also not derived from any human models. Thus the Apsaras and the Nayikas of the medieval temples of Central India, Bengal and Orissa do not suggest gross sex but the sport and delight of the primordial energy (Sakti) that underlies the causation of the universe and of every manifestation or appearance. Such images of female beauty have in fact contributed towards the sublimation and elevation of sex to a supersensible plane, following up the entire medieval Indian religious thought that found the sex motif as the symbol of the cosmic energy explaining the conception and creation of the universe.

Enchanting male forms of human beauty are represented by the figures of Krishna in the medieval temples. There are, for instance, the South Indian bronze images of dancing Krishna (15th century) and the supremely elegant wooden image of Krishna Govinda of Southern India (17th century). It was, however, Rajput painting that created the most graceful types of human loveliness in the figures of Krishna and Radha, the incarnations of eternal youth and beauty in the Brindavan mystery, where Krishna represents the ideal and the divine Lover, and Radha, the human soul, the apotheosis of charming womanhood in diffident yet ardent love-search of the Bridegroom; while the Sakhis or confidentes typify the kindred emotions of human nature that lead the soul through storm, lightning and darkness to the place of trysting where the Lord waits for her. Nowhere in Oriental art has such bewitching loveliness of the female figures been limned with such lyrical intensity and tenderness, tempered at the same time with a shy and tranquil devotion. In fact the symbolism of the human soul (Radha) forsaking the home and the family to unite with the Divine, the eternal and universal Bridegroom Krishna, lends a profound mystery and

1 Codrington: *Ancient India, Introduction*, p. 3.

other-worldliness to the treatment. Oriental art metamorphoses and exalts man's natural delight in human beauty and the associated eroticism into an abstract, intellectualised and universal sentiment that becomes the clue to profound knowledge, insight and striving. The incomparable figure of loveliness becomes also the social symbol or universal that effectively drains the unconscious of the individual, and prepares him, according to the state of his psychological development, for a generic and impersonal vision of love and beauty.

CHAPTER X

THE TYPE VERSUS THE INDIVIDUAL IN ART

The Sense of the Oneness of Life in Oriental Sculpture

Art, like religion, sets its heart in the Orient upon universal feelings, attributes and situations. This has governed not only methods and patterns of art, but also the relations between art and the concrete and ordinary social values and experience. Oriental art is saturated with an ubiquitous and profound sense of the unity of life, feeling and action whether in religious painting or sculpture or in secular landscape painting. It has sought to represent types and symbols rather than individuals, impersonal, abstract and universal moods rather than the fluctuations of the emotional life. The movement in Oriental art is not only away from realism and standardised naturalism, the marked features of Western European art since the Renaissance, but there is also a much deeper sense of the oneness of life which stimulates a broadening of ensemble, including god, angel, man, animal and foliage and a palpitating plastic rhythm of movement in which every figure fits in with unconscious grace and dignity and without any posing for effect. In that remarkable sculptural panel at Borobodur depicting the Buddha standing in the full glory of his divinity on the bank of the Nairanjana, immediately after bath following his attainment of nirvana, we find entire Nature reverentially responding to the occasion. From the sky the Vidyadharas and the Siddhas scatter flowers and garlands, the gods bow down seated on the bank and scoop up the water of the new sacred river; while the Nagas of the under-world also appear on the surface of the water to witness the consummation. The deer in the forest on the other bank of the river whispers to her young one about the memorable spiritual event that sends a thrill of gladness through the whole cosmos. Mahayana idealism finds the salvation of all in the salvation of the Enlightened one. How finely and how devoutly the composition of the sculptured figures, and the movement of the plastic ensemble record this oneness of consciousness and feeling! Men, animals and plants as well as gods, angels and beings of the upper air and the nether world are in Indian, Chinese or Javanese sculpture apprehended as akin to one another; these form fragments of Being, of the same process of Becoming. Such a dominating conception contributes towards massive sculptural conception and plastic vitality. The complete harmony of man, nature and a long scheme of things develop an art neither aiming at pictorial and illustrational virtues, nor seeking agreeable and surprising effects, but at recovering some of the deeper values and universals screened by the working of man's mind and the fret and fever of life. The artistic heritage of

Europe has been dominated by the Greek conception of art, which has its national and regional limitations, and which, though exquisite in its representation of human forms and archetypes, has hardly touched the fringe of the super-sensible and supernatural. In the art history of the Occident the Hellenic human symbols and archetypes were later on responsible, with the added contribution of the Roman portraiture, exact, disillusioned and even brutal, for the stress of naturalism and the transitory human features of the individual as distinguished from the enduring symbol and type. The newly acquired competence in the technique of handling space-effects and anatomy and the Gothic interest in nature further helped to swell the tide of realism. The clarity and idealism of Greek sculpture were replaced by faithfulness to life and sentimentality. Naturalism was bound to introduce even into generic, religious archetypes individual rather than cosmic emotions and attributes.

The Expression of Emotions in Sculpture

In the European art of the Renaissance Donatello's Deploration of the Dead Jesus, Crucifixion and deposition from the Cross show not only a tremendous dramatic vigour but also a tumult of the emotions and bodily suffering of Jesus. In many groups of figures his boldness, nay his fierceness, have the effects of catharsis of the feelings through the portrayal of the humiliation and agony of the Man of Sorrows. In fact this is the leading characteristic of Christian art of the Middle Ages that has given us the vision of man's purity and holiness brought about by pain, self-denial and suffering on the purely physical level. In Amaravati, Borobodur and Angkor Vat we have also thrilling episodes but these are framed within a suave dramatic flow of events that have a long sequence, while the emotions and facial expressions and attitudes portrayed are never violent. Even when the god or goddess kills the antagonistic evil power, there are soft melting benignity in the countenance of the deity and a supplicating look of adoration and offering in that of the vanquished that are nevertheless pervasive, even acosmic in their significance. The Asian artist deals with subtler, deeper and more pervasive feelings and sentiments. Take, again, the representation of the 'eternal triangle', of the brothers, Sumbha and Nisumbha fighting to death for the hand of the lovely apsara, Tilottama, in the stone pediment at Banteai Srei in Siam. An exquisite rhythm of composition is here combined with a poise and a strength that are remarkable for such a violent scene that is witnessed by a group of seated Brahmins and two flying angels in the air.[1] In classical or renaissance art, portraiture as a distinct branch of sculpture developed with the definition of details indicative of man's individuality. In Asia when gods were depicted, the type of face was created as impersonal as possible, eliminating all features associated with human individuality and

1 For illustration see Le May : *Buddhist Art in Siam*, Fig. 62.

stressing attributes and possibilities, with the aid of a rich symbolism, that were beyond the reach of mortals.

Symbolism of Super-human Forms, Poses and Gestures

Super-naturalism rather than anthropomorphism, symbolism rather than naturalism represent the keynotes of artistic representation of the deity in the East. The nimbus around the head and the urna or mark in the forehead which later on developed into the third eye of Buddha, Siva and Vishnu and of the various goddesses are the familiar symbols in the Orient for the representation of the divine figure expressing supernatural strength that transcends human thought and experience. In oriental art man's perfect figure is conceived when he is in the summit of his spiritual exaltation that fulfils his destiny on the earth. Thus the familiar attitude of the body is that of serene meditation in padmasana, with the legs firmly locked together and the soles of the feet turned upwards. It is the gestures of the hands (mudras) and later on the various implements and objects held that symbolise abstract qualities such as wisdom, beauty and compassion or movements such as creation, preservation and withdrawal. Oriental iconography has developed the symbolism of pose and gesture most elaborately, and it is the same symbolism that underlies the movements of Oriental dancers. Colour symbolism has been also intricate and elaborate. Red, blue, black and white colours, gods and goddesses. Thus we read in the Vishnudharmottara "The universe is regarded as the transformation of the Supreme Being. All transformation consists of black colour, and through that is the sustenance of worldly life. That lord, the creator of all creatures assumes the Krishna form." Thus the colour of Vishnu or Krishna responsible for world manifestation and maintenance is explained. The black colour of Kali, the primordial Mother, is however explained in a different way in one of the Tantras: "As all colours are absorbed in black, so all the elements are in the end absorbed in Kali, who is without substance and without attributes". Finally, gods and goddesses are sometimes endowed with a number of heads and hands, indicating superhuman attributes and possibilities that are beyond the range of the human form. The abstract concepts of the movement of creation, preservation and withdrawal as significant accents of Being are expressed, for instance, in the image of the three-headed divinity such as Brahma and Siva. The different quarters of the Universe pervaded by Being are also represented by the multiplicity of hands. The different faces and hands usually express different kinds of attitude and action, the divinity combining the attitudes of wrath and reassurance at the same time. Or, again, certain superhuman qualities associated with animality are expressed in images that combine the man-animal shape, such as Ganesa and Nara-Simha. Supernatural attributes are also represented by the various weapons, implements for material objects held in the hands such as the wheel,

trident, conch, club, flame, lotus, serpent, noose, skull, bowl of blood, etc., the meaning of which is well understood by both artists and the common people. These appear in the mode of contemplation (dhyana) of the divinities, and express the religious experience of the people that art adopts and utilises. The dhyanas also specify the poses and gestures of the divinity, as for instance, gestures of exposition, charity, compassion and destruction, each artistically fraught with a meaning in relation to the whole image. Again, there are vehicles of the divinity in the shape of an animal (vahana) associated with the supernatural activity of the god or goddess. It is thus that each divinity in Oriental art is invested with a language of poses, attitudes and gestures and canon of forms, implements, colours and vehicles that objectify for them both the purposes of meditation and the complex qualities of the deity, transcending human attributes and limitations, and yet embodying man's spiritual destiny.

Art in fact seeks to present the divinity in the whole ensemble of the myth and religion, which have fashioned the social universal and given rise to the communal vision; while it is the sincerity of vision in spiritual and æsthetic contemplation that prevents the conventionalisation of motifs form blocking the expression of inner experiences. The symbolism of poses, hands, implements, gestures and colours of gods and goddesses assumed the most elaborate phase in Mahayana Buddhism and Tantrikism, especially in Bengal, Nepal and Tibet. The Oriental tradition is that unless the image is made with great care, and with all the marks (lakshanas) of divine form, the divinity would not enter it, and this would bespeak ruin to the country. On the other hand, a good image brings luck to the country, the king and the maker of the image. As for ordinary mortals, what are depicted in Oriental sculpture are not individuals but types,— kings, nobles, warriors, merchants, monks, lay devotees and so on, chiefly by difference of dress, pose and gesture.

The Expression of Universal Moods and Emotions

The Vishnudharmottara classifies five types of men according to their height and breadth: Hamsa, Bhadra, Malavya, Ruchaka and Sasaka. Similarly there are five types of women. Measurements are given for each class of persons, men or women, that typify certain physical and moral traits and dispositions. Similarly with reference to the expression of the emotions, while Greco-Roman and Renaissance art excelled in producing types of physiognomy and character in great variety and with marvellous preciseness of expression, Indian art produced persons who were far less individualised, and who in fact brooked no separation between self and not-self, unswayed by desires and passions that sunder man from fellow-man. They were not, however, quiet vegetative creatures but possessed souls that sought or found peace with everything and with everybody. They expressed universal attitudes and emotions whose cultivation is bound up

with the social process itself. They were thus ideal types and symbols standing for certain general ideas, moods or emotions. Such universal ideas, moods and emotions were never conceived too abstractly, but nevertheless acted constantly to correct the accidents, the vagaries and the inconsequentialities of the living personality. It is remarkable that in Rajput paintings, that portray the interplay of human lives and emotions in their most delicate nuances in the divine legendary setting, the countenances of the charmingly limned milk-maids (who symbolise human souls in love with the God Krishna) are almost the same. For these represent not individual moods and temperaments that sunder them from God, but universal, typical moods and attitudes that bring them nearer to Him. It is the difference of colours of their apparel and of movements that prevent monotony in the composition[1]. The identity of faces aids towards the distillation of the common impersonal attitude and emotion. Even in the presentation of the nude in Rajput painting, as in the toilette of Radha, who is suddenly awakened from maidenhood to youth, "for the first time comes to know of her youth" from the mirror, the artless and impersonal adoration of the charms of femininity that are offered devoutly as fresh flowers at the feet of her Divine Lover makes the painting far different from the self-conscious voluptuous nudes of Gascoigne and Rubens or the impassioned and seductive figures of Renoir. As Radha looks at the beauty of her undraped body in the mirror her profound joy is due to the thought of the gift she would bring to Sri Krishna. Nudes in Indian art are wholly impersonal and uncharacterised or are reflections of otherworldly delights and attributes. The universal mystical conception in India of the oneness of the flesh and the spirit, of the inner and the outer self is, indeed, responsible for the unsophisticated delight in physical enchantment that stands for the beauty of the undefiled human soul. Thus the physical aspects of woman's charm when she is glimpsed at her bath and toilet, while occupied in the kitchen or when she finds her clothes stolen by Krishna in the river-ghat do not make a painting amorous. Even the most bewitching loveliness of the nude in Rajput painting accompanies a profound humility, shyness and reticence, born of the conviction that what she can offer to her Lord is so trifling. It is this which eschews any eroticism or sentimentality from the representation of the beauty of the human form, and makes the Indian nudes far different from those in Western paintings that display woman's charms, in the peculiar cultural background of conflict between the soul and the body, the flesh and the spirit, teasingly, even provocatively.

Individualisation of Representation in Europe

The delineation of moods and temperaments in real details of individualised people is the essence of European portraiture that developed as a result of the

1 *Vide*, for instance, Crying for the Moon in O. C. Gangoly: *Masterpieces of Rajput Painting*.

mingling of the Greco-Roman tradition and the new ideals of liberalism and realism of the Renaissance. 'Mona Lisa' is regarded as the most beautiful portrait in the world. Donatello produced some of the most marvellous bronze and terracotta busts and the Gattamelata, the finest equestrian statue in the world. Contrasted with these European Renaissance portraits are the metaphysical Chinese presentations of Sakya Muni and Vanabasi of the 13th century that entirely overstep the features of the human individual, and indeed express through human countenance certain superhuman and cosmic attributes. Chinese portraiture concentrates itself towards the representation of universal and impersonal forces that manifest themselves in the guise of human beings, giving us a direct glimpse into the eternal and the cosmic within the human vehicle. Similarly the portraiture of the medieval Rajput school in India is characterised by the stress of idealisation of human attributes and character, whether those of a warrior, an artisan, a saint, or a musician, for all of whom the Indian code of ethics has defined the social norm. Moghal portraiture, which is largely confined to the representation of kings and the nobility, is on the other hand realistic and shows a most meticulous observation of nature and passionate drawing, representing a trend that is foreign to truly Oriental art, and that is attributed to the influence of European painting reaching India through Persia.

The new art of the Renaissance sought the representation of external reality rather than of inner essence, and its universals were derived from the passing features of the landscape and the moods of individualised men and women. Perspective as a method of representation is obviously derived from subjectivism. For the artist wishes to represent the external reality, not as it is known to exist but as it appears to his observant eye from different positions, with its relative magnitudes and the relative courses of its lines. The next step in the individualisation of artistic representation is Impressionism which has recognised the relativity of both forms and colours. The Impressionists began to paint forms and colours what they perceived and felt they saw—not merely what they knew to exist. Donatello's contemporaries, and among them his friend, Paolo Uccello, put the finishing touches of perspective. It has also been pointed out that Donatello's flat reliefs were the beginning of modern impressionism.[1]

Perspective in Indian Art: Effects of the Multiple Space and Time

By way of contrast Indian art has developed what has been called the 'multiple perspective', as discernible in the paintings at Ajanta which set the art norm. There we find layers upon layers of scenes at different levels, but the eye can take them all at once in a glance without effort of imagination, and in fact profits from a panoramic view of the air rocks, houses, pavilions and the flat ground which are all held firmly knit together by the colourful rhythm of the

1 Goldscheider: *Donatello*, p. 6.

composition. Only the pillars and balconies exist, neither walls nor roofs, but the men and women are quite at ease, deeply absorbed in their play, conversation or worship. (Cave 2, Ajanta: Vidhurapandita Jataka illustration). The children play in the foreground without however disturbing the meditation of Bodhisattva or the silent adoration of the women a little above, while the Vidyadhara flies his own course in the air, and the eye can see them all in their palpitating rhythm, balance and unity. The surface of the rocks, the side-wings and ceiling are all often covered over with paintings and sculptures in an exuberant rhythmical flow of the creative spirit that spills on all sides and at all angles.

A larger panorama in Indian art aids in the crystallisation of the emotion through the focussing of attention not to one mood or episode, but to the sequence of the moods and events that are linked together in the Indian imagination by a universal metaphysical law that governs the scheme of the universe. Thus in the well-known Saddanta Jataka illustration at Ajanta (cave X) we find the well-shaded dark forest with a herd of elephants, the palace at Benares and the queen's apartments depicted all in one scene. The queen to wreak his vengeance upon the elephant, her husband in the past birth, instructs the hunter to kill him. The elephant sacrifices himself. Sonuttara, the hunter, carries the huge heavy tusks to the jealous queen. Finally, the repentent queen faints and dies. Here the chain of causes and consequences of karma is telescoped in one single scene bringing the poignant past and present incidents together with dramatic vigour for the purpose of inculcating the supreme sentiment and virtue of self-sacrifice. A multiple time and space perspective is of great aid to the Indian painter as he leans less upon idealism and symbolism and more upon the feeling for the dramatic and direct humanitarianism in his presentation.

In Rajput and Pahari paintings too the perspective is of the multiple kind in respect of both space and time, aiding in the distillation of the emotions that work themselves out to their logical conclusion through a connected series of episodes and stir different types of persons participating in the drama of life differently. A view, for instance, from a high attitude enables one to portray and behold a series of synchronous scenes. Thus in the same painting we see Krishna being nursed in Jasoda's breast in the inner apartments, the rejoicing of the multitude in front of the house as well as the play of music at a distance and also alms-giving to beggars.[1] Similarly in the painting that depicts the return of the herd of cattle in the evening from the pasture, we see Krishna and other shepherds, the eager and pushing cows and some gopis in the foreground, the welcoming women on the balcony windows, the entrance to the door as well as a portion of the inner courtyard with Krishna's mother, and Balarama giving berths to the cows that have entered, and finally, father Nanda in the central compartment of the inner apartment with the back-garden attached to the house.

1 The Birth of Krishna, in Gangoly: *Masterpieces of Rajput Painting.*

The ensemble of scenes and episodes helps in the concentration of feeling and attitude, as in Ajanta art, much of whose technique is also followed in these medieval works[1].

It is evident that the techniques and methods of representation would vary according to the nature of artistic content prized by the art tradition. In portraiture as it developed in the West after the Renaissance, we find the closest approach to expression of man's moods and emotions that have unfolded human nature and human dignity to a marvellous extent as in the works of Jan Van Ecyk, Rembrandt, Velasquez, Watteau among others. The aims and methods of Chinese portraiture are fundamentally different. First, Sung portraiture sought to express the manifold nature of human personality by combining in a single picture several surveys of a man's character. Thus the three-quarter pose was adopted that made it possible to give simultaneously an impression of the face, and of the profile, a different look for each of the eyes, and in general a synthesis of the moral attributes of the same person. Secondly, man was treated as an incarnation of the psychological quality of his environment in which he lives and moves, whether a sage, a monk or a peasant. Thus the sage with his contemplative face half covered by white mist, which floats over the foreground, embodies the essence of that tranquillity that characterises the landscape. Or, again, as Grousset remarks, "the gnarled trunks of the ancient trees and limbs or garments of the figure represented are contorted by the same animistic influence. The figures and landscapes alike are no more than a symbol, and invitation to spiritual soarings."[2] In contrast European portraiture is much more individualised, treated not in an idealistic spirit but with realism and meticulous attention to actual bodily features and external circumstances of life for the delineation of the individual rather than the psychological type. This does not hold good only in the cases of certain masterpieces of ideal representations in Europe, such as Leonardo da Vinci's 'Mona Lisa', Goya's 'Maja' or Hogarth's 'Shrimp Girl' which reveal definite complex types of human mood and experience with an intense concentration of purpose.

Individual *versus* Impersonal Moods and Passions in Landscape Art

Similarly, landscape painting attained great exactitude in pictorial treatment in Europe until the Impressionists sought to stress the endless play of light and shadow, warm and cold colour, or again the patterns of leaves and branches of trees as the background of the poignant drama of man's variegated moods and passions. Or again, with Cezanne, landscape painters discovered three dimensional solidity in their scenes and the contrasts these represent visually with their background. Apart from the revelation of attractive harmony and formal

1 The Divine Herdsman: Cowdust, in Coomaraswamy: *Rajput Painting*, Plate LI.
2 Grousset, *Civilizations of the East, China*, pp. 306-307.

structure in the scenes, much of landscape painting in Europe exhibits individual moods and passions that express themselves in the fluttering of light and inter-weaving of curved lines and sinuous forms, of which Rubens was the greatest master. In Van Gogh we actually find the tumult of the soul pouring itself out in blazing colours according to a new technique, which shows both formal organi-sation of space and volume as well as the movement of unearthly vivid hues that rage like the tempests of passion within under his fervid, strenuous brush strokes. Van Gogh's sketches stand at poles as under from the Indian and Chinese landscapes.

The Reflective Mood in Chinese and Indian Landscape

Man is a part of the landscape in the East. The Sung or the Rajput and Pahari landscapes seek to express feelings of cosmic penetration and peacefulness that come out of communion with nature that is disturbed by the working of the mind. It is the soul of nature, blended of calm and majesty, that is revealed, and not the struggling passions and desires of the artist that exhibit themselves in the Western canvases where too often the landscape is but a mere setting and background of human moods and events. The mystic ideals of Lao Tzu, the founder of Taoism in China, account for the romantic and symbolical features in Chinese landscape painting and its saturation with the sense of the infinite just as the ideals of Confucius promoted portraiture as well as the representation of exploits of heroes and the classical stories of filial piety that the latter sage set forth as stimulating examples for the Chinese people.[1] As Buddhism was first introduced into China from India it inspired in Chinese painting the represen-tation of heavenly figures of univeral compassion and sacrifice that were beacon-lights to man's love and enlightenment set in a cosmic scene in which man, animal and nature are caught by the same spirit. Just as in the rock-cut caves at Yun-Kang and Lung Men, the Buddhas and Bodhisattvas are one with the cliffs in their sombre silence, majesty and permanence, so in the Chinese landscape painting Buddhism also introduced passionless serenity and contemplation as typified by the tiny human figure set against a vast background of mountain, valley and water. Later on Zen Buddhism mingled with Taoism and promoted a profound love and contemplation of nature and a passionate appreciation of its most elemental and august features as well as of its tiniest objects as symbols full of meaning for human life and destiny. It supplied religious inspiration to the great landscape painting of Sung that in its stress of tones rather than forms, of elusive spaces and intangible phenomena of the air and sky rather than of single objects and points of vision uniquely revealed the super-sensible aspects of nature. In India the ancient hermitage life in the forests and the Buddhist emphasis of love and good will to all sentient creatures and evangelical wandering on a grand

1 See Binyon: *Painting in the Far East*, pp. 61 and 69; *Chinese Art*, p. 5.

scale, fostered a delicate sensibility to nature that became the legacy of classical Sanskrit poetry and drama in which all nature was classified into similies that aroused human affection and tenderness. Sunrise and sunset, the procession of the seasons, the rain and clouds that separate lovers and enhance their grief, the splendour of the moon before which the lily opens its petals, the bee drunk with the honey of the lotus were all finely observed and painted in diverse and elegant colours in Sanskrit poetry that leaned towards lyricism. The rich tradition of emotion and enchantment of nature formed the background of Indian painting. The mango, the tamala, the asoka, the champaka and other trees, the lotus and the kumud flowers, the kalpavalli and other flowery creepers, the deer, the cuckoo, the crane, the parrot and the peacock as well as the humming of bees, the blossoming of red asoka and karnikara and the intoxicating moon-shine of spring, the lightning flash in the dark sky and unceasing downpour of the rainy season, all responsive to human moods and aspirations, among which the minds of lovers are fashioned in Indian poetry and drama, are abundantly portrayed in Indian painting. Similarly, in the sculptures at Sanchi, the erotic sports of the Yakshas and the Kinnaras in the background of the wooded Himalayan slopes and mountain streams, with peacocks strutting and elephants playing in the waters, are strongly reminiscent of descriptions in classical Sanskrit poetry, that Kalidas of a later age made his own. Sculpture at Amaravati and Ellora and painting at Ajanta often repeat the amorous attitude with the cup of wine and the lute in the hands of the lover, and the lotus and the mirror in the hands of the beloved so familiar in the Meghaduta or the Ritusamhara. Another striking note is furnished by India's fundamental conviction, so ingeniously revealed in Sanskrit drama and fable, that the animals do not comprise a different world from men. Thus we find that as early as in the frescoes of Ajanta the favourite animals of classical literature, viz., elephant, deer and monkey are portrayed with great tenderness and imagination. In India there is discernible a much greater interdependence of painting, poetry and drama than in any other country.[1] Later on both the cult of Krishna and Radha in the background of meadows, pastures and forests, the scenes of their sports and amours, and of Hara and Parvati amidst the sombre Himalayan scenery, gave to Indian painting some of its most romantic themes. In the Radha-Krishna paintings we find the same beauty of nature, blended with human love, as revealed in Sanskrit or Hindi lyrical poems, the beauty of the verdant pasture in sunshine and rain where Radha and the Gopis meet Krishna in the company of cow-herds and flocks, of the spring moon-light piercing the shadows of the groves of Brindavan, the blossoming forth of the kadamba trees on the banks of the Jamuna, the rain-clouds throwing their shadows on the dark tamala trees, or the song of birds and

[1] For a discussion of this point see Masson-Oursel, Willman-Grabowska and Stern: *Ancient India and Indian Civilization*, pp. 390-398.

sports of animals in praise of Krishna, just as in the Siva-Parvati paintings we find depicted the austere mountain landscape with its rugged precipices, swift streams, lotus-filled mountain lakes and tall deodars, where everything is hushed into silence for the calm contemplation of the god and goddess. The shimmering mist-covered horizon of Sung landscape or the elusive moonlit groves of a Rajput painting equally silence the inward strife and make us feel the unity of the spirit of man with the infinite that surrounds him. In both the Indian and Chinese landscapes the aim is the distillation and revelation of a universal mood or sentiment which subordinates to itself the mere visual truth. The tiny twig, the meanest flower, the bird that flits about, the silent lake or the gray mountain in Chinese landscape, each has its own cosmic essence that animates it as individual, and is as full of beauty, strength or majesty as human life itself and should not be apprehended or interpreted in terms of the latter. Nature, man and man-made things become here perfectly co-ordinated. The subject-matter leads up to that, adding overtones of meaning. The treatment is also characterised by a plastic organisation of formal elements, the rhythmic interplay of lines, colours and patterns which produces a tremendous sense of poise amidst the sense of extraordinary movement. Thus both the subject-matter as well as the treatment lead up to that silence which is at the centre of man and nature's being, to that oneness in which all men, all sentient creatures and all natural phenomena live and move. It was the Zen Buddhist emphasis of the universal brotherhood of all forms of life that achieved for Chinese painting an extraordinary sense of form and perception of its simplicity, delicacy and pervasiveness that was of course backed by long and minute contemplation of the artist, who sought not to copy what he observed but to symbolise what he felt and remembered after obtaining his own composure and delight in solitude. The traditional symbols and conventions in landscape art with their rich and profound implications were of course of tremendous aid in stimulating the feeling and imagination of the artist. The blue-fringed mountain, for instance, cut off from the rest of the world by the serried clouds stands in the Chinese landscape art for serenity and aloofness, for at such height human passions cease to agitate man; the white trailing vapour or haze that covers vast horizons over waters and valleys symbolises emptiness and immensity; the mighty sweep of the river, the wheeling flight of birds of passage, borne on the wind, and the swirl of falling leaves in the autumnal forest, all express the transitoriness of things; the gnarled, writhing tree, bereft of leaves and lashed by the wind as it stands alone at the foot of a hill, or the drift of a solitary frail bark, abandoned like a wisp of straw to the caprice of the waves, symbolises human destiny; the bamboo bent but never broken by the winds symbolises man's courage and determination that overcome the buffets of fate. Similarly the dragon through the epochs of Chinese painting expresses both the mystery and the terror of the super-sensible

world of nature as the tiger symbolises the mighty strength and determination of the sensible, non-human world. In cloud lands and mist-covered lakes and rivers or in rugged mountains, the dragon and the tiger, powerfully drawn, reveal profound meanings and values well understood by the people. May not, again, the blank, so marvellously and uniquely used in Chinese landscape art, be the outcome of contemplation of the void in Mahayana Buddhism, pregnant with spiritual import? It was thus that the Chinese painters sought deliberately to express through symbols and conventions certain intellectualised cosmic values of nature that have been hardly reached in European landscape art under the stimulus of carnal sentimentality or personal romanticism.

Man's reflective moods in their purest and most detached, and hence most universal, forms can be best expressed in figure compositions that represent types or archetypes rather than portraitures. It is the archetypes that supply the symbolism which aids the artist in presenting the subtlest and highest spiritual experiences in a language which may be acceptable to all. Religious art at its best, as in Ajanta, Java and Horyuji in the East, or in the hands of Giotto, El Greco and Roerich in the West has relied less on explicit symbolism in its revelation of the social universals. Similarly landscapes if properly handled, as by the Chinese and Japanese masters, or again by the painters of the Indian Ragamalas or musical modes can be powerfully expressive of universal sentiments and harmonies. Often the flowers and animals in Oriental art are symbols, such as the lotus, the bamboo, the deer, the swan, the dragon or the lion, but these have also a charm and significance of their own as expressing some aspects of the mystery of life as completely as any human mood or experience. Now the mystery and majesty of life can be revealed as much by the painter of a landscape, that is also a poem expressing universal moods distilled through meditation by solitary streams and mountains, as by music in the solitary dawn or quiet midnight that lifts man far above the madding crowd's ignoble strife. Just as in China the painters carried landscape painting to some of its finest and most synthetic levels, so the painters of the Ragamalas of India, who composed in accordance with the psychological suggestion of the different notes of music, reached a plane of apprehension of universal rhythms nowhere sought outside India.

The Collaboration of Poetry, Music and Painting in India

The Ragamala paintings depict the scenes of circumstances appropriate to the invisible presence of the Raga or Ragini or musical composition, conceived as the Spirit of Nature and his consort, that the appropriate melody of the season and hour of the day or night embodies. In the Indian system of music each major melody or Raga is in tune with a generic human mood or sentiment that Nature in a particular season and time of the day elicits among the entire gamut

of human passions. Recent studies in the psychology of music show that certain notes in the octave (sa, re, ga, ma, pa, dha, ni, sa) arouse certain moods and sentiments, such as self-assertion, passion, creation, exaltation, self-abasement, compassion, withdrawal and destruction. In the Indian system of music each Raga comprises the distinctive notes associated with a particular mood and emotion elicited universally in the cyclical recurrence of seasons and hours in the human heart. Each Raga comprises, again, five or six derivative Raginis or tender forms of the Raga conceived in the feminine, because of its subordination to the Raga in the basic structure of its notes. The songs of early dawn, morning, noon, twilight and midnight differ in their characteristic notes in India. Rabindranath Tagore observes, "Our songs speak of early dawn and the embroidered, starry midnight sky of India; our song is the world-sundered separation pain of dripping rain and the worldless ecstasy of the deep madness of the early spring as it reaches the utmost limits of the forests".[1] The vast seasonal changes of the Indian landscape are accompanied in the Indian musical tradition by the appropriate melodies evoked by the basic feelings periodically recurrent in the procession of the seasons, spring, summer, rains, autumn and winter. Such moods find a fitting expression somewhat abstractly in a particular background of scenes and episodes in both song and Ragamala painting. The words and characteristic notes of the musical composition and the scenic representation in the painting aid in the distillation of the generic feeling or attitude of the particular season or time of the day. Consider, for instance, the representation of the morning melody, Ragini Bhairavi, in one of the Rajput primitives from Orcha as the consort of Siva, dressed in the colour of the rising sun on an autumn morning, and proceeding to the temple of Siva for worship as her companions dance to the accompaniment of drum and cymbal. The hymn of worship of Siva is sung in the early dawn by Indian musicians in the Bhairavi tune (subordinate to the Raga Bhairava or Siva) that arouses a poignant sense of futility and impermanence of life and the mystery of the Infinite. Take, again, the representation of the melody, sung in spring, Ragini Basanta of Raga Hindol, depicting the universal lover, Krishna, dancing with his flute in hand, while two milk-maids play on the drum and cymbal. The scene, full of the excitement of love and youth in the spring season, is appropriately placed on the bank of the river Jamuna under a tree in full vernal blossom, and the flowers also seem to dance in unison, while a tender creeper rhythmically twines round the tree in the spring-tide of love. Consider, again, the Megha-mallara Raga, sung in India during the rainy season. The pictorial representation here is that of a woman, draped in a skirt of leaves that are agitated by the high wind, and sitting on a lotus in the island of a lake filled with flowers, geese and other wild birds. No better imaginative transfiguration of Nature during the rains in India can be conceived, translating into the

1 *Jiban Smriti*, quoted in Coomaraswamy: *Rajput Painting*, Vol. I, p. 65.

vernacular of line and colour a universal mood in profound unison with Nature that both lyrical poetry and music seek to express and elicit.

In India there are appropriate melodies of the various seasons, there are Ragamalas or paintings of musical modes and there are also *baramasi* or seasonal lyrical poems as well as paintings in which each illustration takes the form not of a symbol or icon but of a dramatic situation conceived in the abstract and expressive of the universal mood or sentiment appropriate for the season and the time of the day or night. With great vitality and simplicity of lines and organisation of places by means of deep colours, the aim of painting has been far less to illustrate an episode or to produce picturesque effects than to analyse, epitomise and consolidate abstract moods and situations in a vigorous, yet impersonal style. Music is essentially an abstract art; its linkage to painting aids the latter in achieving a degree of abstraction that is normal to music, directing the human soul to Being, who is behind all patterns of sounds, shapes and colours. The descriptive imagery in the lyrical poem, the harmony in the Raga or Ragini and the scenic representation in the painting, all alike and collectively symbolise and evoke the eternal and universal sentiment of wholeness, wonder and thrill, associated with the experience of the noumenon or Being in the realm of Nature. The Being is the deity of the Ragamala painting, and his fiancée the feeling of wonder and awe that the human soul through lyrical poetry and melody expresses and symbolises in the cycle of the seasons and hours. For about three centuries, from the 15th to the 18th, three aspects of folk art, *viz.*, poetry, music and painting, developed in India parallel with one another expressing the same impersonal moods in different idioms. All were impregnated with religious motifs from the legends of the Bhagvata and the Puranas that reached the masses through a galaxy of mystics, poets, musicians and painters. Rarely in the history of the world's culture has there been such collaboration of the arts expressing the communal vision of a whole people and epoch as was then witnessed in Northern India.

Painting as the Vehicle of Man's Universal Moods

Many Chinese painters were poets and philosophers who distilled in terms of the visual medium the same universal moods and sentiments that elicited the poems. Thus it has been remarked of a famous Chinese painter: "I can taste in the poem something of the picture's flavour; and in the picture I see something of the poem." As in China, so in India, the same apprehension was used to compose poetry and paint scenery of surpassing depth and delicacy. In India the additional aid of music was sought to crystallise the apprehension, thus contributing to achieve the same simplification and abstraction as in music. In the ancient days the Ajanta frescoes were inscribed with verses from Aryasura's Jatakamala; while in the medieval period verses from the Gitagovinda of

Jayadeva, the Resikapriya of Kesava Das and other Nayika poems were quoted by painters of the Rajput School in their works. Vaisnava poetry, comprised often of the couplet (doha) and the quatrain (chaupai), and pregnant with deep thought and intense feeling, is of the nature of the most delicate miniature painting, and thus poetry and painting interpreted and interpenetrated each other. Man sang and danced what he felt in the lyric and saw in the painting the sports of Krishna and the passions of Radha in the universal love-drama of Nature. In China as well as in India painting was akin to literature, and what was achieved by calligraphy for Chinese painting towards abstraction was achieved by calligraphy for Chinese painting towards abstraction was achieved by music for Indian painting. One of the greatest art critics, Berthold Laufer, has characterised the paintings of the T'ang masters "as belonging to the greatest emanations of art of all times" and observed: "The psychological difference of Chinese painting from our own mainly rests on the basis that the Chinese handle painting, not as we handle painting, but as we handle music, for the purpose of lending colour to and evoking the whole range of sentiments and emotions of humanity. In depth of thought and feeling, the great T'ang masters in their symphonic compositions vie with Beethoven and in line and colour almost reach Mozart's eternal grace and beauty. Chinese pictorial art is painted music with all its shades of expressive modulations". In India Rajput painting has similarly sought the elusive, abstract values of melody, and music and painting have aided each other in the apprehension and interpretation of the same deep emotions and attitudes. Rajasthani and Pahari paintings have often risen to the level of painted religious lyrics, that flash like diamonds on the fingers of Time.

It is through an intimate union of poetry, music and painting, to which the West does not provide any equivalent, that universal moods and sentiments, delineated with passion by the lyrical poems and paintings and with corresponding sets of melodies, can best be stabilised. The universalisation of man's sentiments is not merely a matter of inner religious discipline which may bring about spiritual serenity and repose. It may be facilitated by the painter adapting his art to music and poetry so that he may elicit and translate the theme of the latter into visual values. One sense is interpreted by means of another; sounds and sights and overtones of mystical meaning from poetry, with their longer climaxes of feeling, are unified into a rich and vivid æsthetic pattern that arouses deep and subtle joy and insight and has a long duration. Music easily transports us to the delights and meanings of the super-sensible. It is by becoming an adjunct of music and mystical poetry that the art of painting may reach its highest flights in expressing the super-sensible in visual terms.

Sculpture as the Vehicle of Man's Universal Moods

In one of his remarkable essays Max Beerbohm observes: "Sculpture just as it cannot fitly record the gesture of a moment, is discommoded by personal idiosyncrasies. Sculpture's province is the soul. The most concrete, it is also the most spiritual of the arts. The very heaviness and stubbornness of its material, precluding it from happy dalliance with us fleeting individual creatures, fit it to cope with that which in mankind is permanent and universal. It can through the symbol give us incomparably the type". Bronze, stone or marble fixes for ever the expression of man's emotions and attitudes, his movements and gestures. Thus anything occasional, trivial or slight in human life, expression and gesture assumes a disproportionate even ludicrous significance in sculpture. The scope of sculpture consists truly in the revelation of man's deeper and more enduring joys, loves and griefs rather than 'human nature's daily food'. Mentally and socially conditioned as man is, those emotions, moods and sentiments are higher and more stable and enduring that are social rather than ego-centric, and that unite persons in ever-widening range and in ever-deepening integration. It is these which form the basis of the higher personal and spiritual values and are the appropriate themes of sculpture and bas-relief. Thus in churches and temples, parks and forums in all countries sculpture has given us man's visions of love, purity, patriotism, holiness, devotion, poise, sacrifice, peace. Where the sculpture has succeeded in most effective portraiture, it has done so by revealing man's inner life or secret of personality, treating even arbitrarily the mere husk in order to show the soul. Familiar illustrations are afforded by Lederer's colossal statue of Bismarck, Rodin's Balzac, Saint Gaudens' Abraham Lincoln, and Mestrovic's portrait of his mother, in all of which there are features which rise far above the personal, the individual presentment of the persons concerned. Sculpture is most at home with the enduring social universals rather than with ephemeral personal moods and emotions, with the nature of human nature and destiny rather than with the adventitious circumstances of life. Sculpture achieves its highest excellence in association with architecture with which it shares its features of unity, massiveness and monumentality, but while architecture records the collective needs, sacred values, memories, hopes and aspirations of men, sculpture expresses the enduring or immortal elements in the life and experience of individuals. The singleness of the material that is used here, wood, stone or bronze, facilitates greater unity and compactness of design and concentration of purpose, while architecture using a variety of materials and also forms of energy such as gravitation, tension and light, serves simultaneously more varied aims. Thus ideas, emotions and sentiments that are sharply defined and unique in individual lives and history, and yet have a profound generic or universal import for humanity go well with sculpture. Accordingly, while the æsthetic values in architecture are peculiarly derived from man's collective

achievements and aspirations, those in sculpture are derived from the uniqueness of his personality and achievement if they have significance for humanity. The sentiments and attitudes most appropriate for sculptural treatment are man's poise, devotion, concentration, tranquillity, perfection—all which set him above the vicissitudes of time and history. The difference between Hindu and Greek sculpture lies in this that while the enduring attributes of man were sought by the former largely through the relation of larger masses and planes and its greater austerity in the conquest of the senses and transcendence of the human moods and emotions and even of human existence, the latter sought these largely through the greater use of modelling and rhythm of lines in the grace and symmetry of the human body, the balance and peace of the human emotions and the refinement and perfection of the life of the senses. European statuary, dominated by the Greek norm, but faced with the uncertainty, conflict or chaos of values in actual society, has failed to reach not only the super-sensible in human aspiration and achievement but also the idealisation of human attributes, often recording what is trivial, dramatic or episodic. It is only in recent years that sculpture in the West has begun to be moved by the desire to reveal man's inner being, giving up both self-centred subjectivism and calculated realism, as illustrated in the master-pieces of Mestrovic, Eric Gill, Brancusi, Epstein and other modern sculptors. The organic rôle of sculpture in society is perhaps, next to literature and religion, the most significant in social integration with its overtones of meaning brooding over man's progress in his generations.

The Blend of Abstraction and Warmth of Feeling in Sculpture

Through the centuries, in the Orient the sculptor has given us symbols of mankind's universal attitudes and abstract values with a dignity and majesty that are more soul-stirring than the realism of Michael Angelo's Pieta or Bernini's St. Theresa or the romanticism of Rodin's Burghers and the Kiss. Michael Angelo's Pieta in Rome or Reid Dick's modern treatment of the same subject in the Kit-chener Memorial Chapel, London, equally shows the prostrate Christ in physically perfect proportions, held tenderly by a noble and beautiful woman. They are two idealised persons whose human beauty and elegance far outshine the emotion-al significance of the universal maternity of the Virgin and the glory of Christ's sorrow and sacrifice. Similarly, Bernini's Ecstasy of St. Theresa presents two idealised but perfectly real persons of superb and noble beauty in the physical sense of the term. There is nothing here of a combination of repose and raptur-ous emotion conveyed, for instance, by the image of Sundaramurti Swami in Ceylon. Let us in contrast with the famous Western examples also remember the Buddhas and Bodhisattvas of Mathura and Sarnath, the Trimurti at Elephanta, the images of Siva and Parvati at Ellora, the Buddhas at Borobodur and Angkor vat and the Natarajas of Southern India and Bengal. Their counterparts in the

modern age are represented by Mestrovic's Annunciation and Madonna, Epstein's Rock-drill and Night, Tisa Hess's Prayer, Eric Gill's Prospero and Ariel and St. Francis, Einar Jonsson's Dawn or Warren Cheney's Famine,—works of typical modern symbolists expressing the social universals through extremely simple but profound rhythms of lines, planes and volumes. Of great power and full of life and movement are the sculptures of Vigeland at Oslo depicting the vicissitudes of human life and Rodin's Gate of Hell, representing the passions and sufferings of humanity with great tenderness and pity. It is remarkable that contemporary sculpture in the West, due to the better adaptation of techniques and methods to a large variety of materials, the return to the geometrical simplicity of the ancient schools and the stress of universal and eternal values has shown greater depth and power and is on the whole more promising than contemporary painting. In the Orient within the rock-cut caves and temples the artist has fully utilised the modulation of light and dark effects for facilitating the process of concentration and absorption of the beholders in the vast, intangible body of the divinity that shimmers beyond their vision. The arrangement of the array of lamp-maidens (dipa-lakshmis) and carved worshipping figures in the dark corridors of the temple or cave interior favours the communion between pilgrims and stone worshippers that constitute full preparation for the entry into the luminously dark presence of the god in the *sanctus sanctorum.* Or, again, the artist takes advantage of the rock surfaces out of which he carves out his monuments, connects the movement and direction of his images with an unbounded architectural mass of unformed rocks and spreads these out in deepening gloom and brightening or shimmering light, according to the demands of psychological characterisation, much in the same manner as the light and darkness and vibrating atmosphere have been superbly utilised in painting by Rembrandt. It is in this manner that at Elephanta and Ellora the stillness and majesty of the Trimurti, the poise and serenity of Siva, the soft melting love of Parvati, the mystery of Ravana shaking the earth, the vehemence of Siva destroying the demons and the strength and gravity of the guardians of the sanctuary have been depicted with striking emotional contrasts through the variations of enveloping light and darkness, flatness and depth in the rock-cut caves, as well as roughness and smoothness of modelling of the figures hardly reached in sculpture anywhere. At Ellora we find a vivid illustration even of the passion of the moment in the Kissing Couple, which is yet so different from Rodin's familiar treatment. In the Indian pair of lovers we have a harmonious blend of rapture and restraint due to the roughness of the surface and firm handling of the torsos of the couple as compared with the smoothness and pliancy of Rodin's figures. Smoothness of modelling with angularities of face and limbs is particularly characteristic of the Chandela, Bengal and Orissa Schools of medieval sculpture which have reached greater psychological suggestiveness than anywhere else in India. The images of the divine couple at Khajuraho, of the

nuptials and embrace of Siva and Uma, and Krishna and Radha in Bengal and Orissa exhibit modelling with sharply curved outlines that reveal both the majesty and dignity of the male figure and the soft allurement of the charming female figure, approaching the god with ardent though innocent passion. Conjugal bliss is here transmuted into a spiritual ecstasy that permeates every limb and gesture of both the tranquil god and the coy and captivating goddess welded together in the plastic composition as a single reverberating whole. Such combination of abstraction and warmth of feeling, of poise and vitality in each individual figure shows the psychological possibilities of sculpture hardly discernible in the West. In the images of the female divinities such as Tara, Chandi and various forms of Sakti and in the figures of the Celestial Nymph, the Nayika and the Salabhanjika in Bengal and Orissa, we meet with a smoothness of limbs and skin, a fullness of the torso, with devices of chains, girdles, necklaces and jewellery organically one with the limbs, and an emphasis of the three-fold flexion of the body in a gliding sinuousness that remain significant contributions of the Eastern Indian school of sculpture to psychological characterisation. Indeed, the sculpture of Bihar, Bengal and Orissa has produced a remarkable combination of monumentality and stillness with a quiet but alluring physical grace and pliable exuberance of human moods that is unique in the world, akin only to the Gothic Angels, Saints and Virgins in the famous cathedrals of Chartres, Amiens and Rheims. May not this be the outcome of the strange spiritual discipline in Eastern India associated with the development of Tantrikism in which erotic rapture and spiritual bliss were one and the same? And thus in the execution of icons the suggestion of sex in the full, rounded breasts and heavy, slanting hips of the female deities and in the broad shoulders and thin strong waist of the male deities, along with their caressing poses and gestures, was coupled with the elaborate, even exaggerated ornamentation and sinuous flow of garments and garlands and the lively sport of the gandharvas, flying in the midst of clouds inscribed in the steles above. And yet the god and the goddess, so remarkable for their sensuous charm and exuberance, overwhelm us with a profound abstraction and other-worldliness that set them far above the plane of the senses. This consecration of the flesh was, indeed, the essence of Tantrik ritual that produced its own formulæ of erotic meditation (Sadhanmala) and its own sculptures in which transcendentalism and humanism were so marvellously blended. In fact a familiar erotic-cum-spiritual Tantrik meditation is that of Siva fondly embracing Sakti, seated on his lap (symbolising the vision of the One in the Many), which was reproduced in sculpture in composite images that were nowhere else discernible in India and characterised by a most remarkable integration of impersonalism and delight of the senses. This æsthetic quality spread to all other plastic forms on which was left the indelible impress of the transmutation of the senses in Tantrik contemplation and ritual. In some of the little-

known illuminated manuscripts of medieval Bengal such gods and goddesses of Buddhist Tantrikism as Lokanath, Maitreya, Amitabha and Tara are painted with Botticellian delicacy and sensitiveness of line and colour combined with profound depth and impersonalism that were the gifts of the Tantrik spiritual meditation. Carrying forward the traditions of Ajanta and Ellora and enriched by the idiom of tempered lyricism in contemporary Pala and Sena sculpture, these paintings deserve a place by the side of the great works of the world. The close association between the higher and ideal things of experience and the life of the senses and emotions may seem somewhat strange to the Western mind, but there is no doubt that in the history of European morals there have operated special social factors and forces bringing about a contempt for the body, fear of the senses and opposition of flesh and spirit.

The Abolition of the Barrier between Earth and Heaven

But the appropriate province of the intense emotions and sentiments, of the tumult rather than depth of the soul, is painting, assuming, of course, that detachment and objectivity without which these cannot be fitly recorded in art. No passion is more intense, pervasive and at the same time elusive, none has been a more common and attractive theme of painting than human love. Of human love nothing is again more poignant and stirring than the feeling of the woman for the beloved who may or may not reciprocate that love. In the Indian literary tradition this is described as the love of the *Abhisarika* type, who braves all alone the dark, stormy night in the forest, full of perils, to meet her beloved. Such a deep passion is universalised in Indian Mystical poetry and painting as the approach of the soul in the fearsome night to the Bower of God's Love. Drenching shower, lightning flash, gleaming serpent are all depicted in such paintings to stress the utter loveliness and self-forgetful devotion of the soul. Often the *Abhisarika* is represented as arriving at the trysting place or God's bower in the lonely night, when she waits in anxious expectancy that is shared by the wild deer sniffing the wind. In the rainy season, as it drips and drips, the entire universe feels an inexpressible agony of separation, and the song that is sung in the Indian fields and cottages is Hindola Raga and Madhu-madhavi Ragini. Hindola is represented in Rajput painting as a swinging scene in the forest grove during the rains, the pair of swingers being the divine lovers, Radha and Krishna. Madhu-madhavi literally means 'honey sweet'—the beloved in the bower. The painter depicts the sentiment appropriate for the rainy season that the poet expresses in the couplet:

A woman fares on *abhisara* to her Lord and King Hindola;
The eye sees less than all, and the eye is at variance with thought (so dark it is). But the journey of the soul through the storm and rain, up hill and down dale is rewarded. For God's sudden presence honours the

soul's courage. In both verse and painting God bursts into amazement and praise. "You have come unasked. The night is very fearsome, and you are alone." The soul replies in happiness: "Nay, Lord of my Life, the clouds called and led me hither and my companion was Love."

Music expresses the wordless, disconsolate grief of the rainy season as the dark blue clouds rumble, and the rains patter and patter in a landscape that sighs with the high wind and is bedimmed with the ceaseless flow of tears of separation from the Beloved. Painting also provides its inspiration to reveal the super-sensible in visual images. It is thus that lyrical poetry, music and painting pool their inspiration to transmute human into universal love and make of earth a heaven. Such metamorphosis of the personal into the symbolical and social universal emotions and attitudes is one of the delicate and unique products of Indian æsthetic experience. Patterned sounds in enchanting music, forms and colours in exquisite painting and deep religious meanings in poignant verse here achieve in reciprocal interaction an artistic content, extraordinarily rich in detail as well as powerful and wide-spread in its appeal. The combination of several lines of appeal for reaching the most fundamental of human motives assures an æsthetic enjoyment that is at once intense as well as stable and sublime. Sculpture in which Gods, angels and heroes express ideal types and symbols revealing man's super-human, other-wordly aspirations and realisations or his ideals of love and devotion, renunciation and holiness cherished by the social world; painting in which men, animals and phenomena of nature are fused together into a profound oneness of the spirit; music and dance that are powerfully expressive of universal moods and rhythms palpitating with the oscillations of Nature, have all aided in the Orient in revealing society as part of a cosmic scheme of things and human relations as seats of the ultimate values. Thus have the five arts contributed to express and intensify those generic and impersonal moods and sentiments, interactions and values that have forged fresh bonds between man and fellowman and the rest of the universe in ever-deepening unison of feeling and faith. The five arts in the Orient have served the significant rôle of impregnating social life and relations with overtones of meaning and joy brought down from the supersensible to the sensible world, and of thus abolishing the barriers between the real and the transcendental Samsara and salvation, home and heaven.

CHAPTER XI

THE REGIONAL BACKGROUND OF ART

Regional Mould of Pre-historic Art

Art depends for both its materials and techniques on the region. Mountains, plains, rivers and seas largely determine the distinctive economic pursuits of a people as well as its mental patterns including the modes and forms of artistic expression. The region as a common and co-ordinate set of stimuli elicits a similarity of responses, feelings and sentiments, which are re-inforced by gregariousness, developing the characteristic social tradition of a particular people, not less important as a formative factor in art than the geographical environment. Region, race and tradition are the collective determinants of art work, and it is not easy to isolate the influence of each single factor on the art products of a particular country or people. As a matter of fact, the fixation of cultural characteristics and mental patterns, including forms of art, is the effect of the accumulated forces of region, race and tradition. This is naturally more evident in the early history of man or among populations who are now in the lowest stages of economic evolution.

If we accept Griffith Tailor's zonal theory of man's evolution and migration, according to which man originated somewhere in the centre of the Asian continent and spread in a series of waves towards the peninsulas projecting from the central mass, *viz.*, Western Eurasia, Africa, Oceania and America, we can find an important clue for explanation of similarities in forms of pre-historic art in regions far removed from one another. An early wave of human migration, according to Taylor's hypothesis, was represented in Europe by the Aurignacians who were significant pre-historic artists and left behind their paintings in the caves of Spain and France. But in Africa the Bushmen, and in Oceania the Negritos survive in the present world as outliers of the same earliest migratory stratum. Now a remarkable similarity has been discerned between the cave paintings of Southern France and Northern Spain, more especially those of Cogul of the Aurignacian phase, and those of Africa which are attributed to the Bushmen. Another group of paintings, at Singanpur in Raigarh district, Central Provinces, India, belongs to the same wave and represents an inlier or island of survivor left by the peoples of the same wave in the course of their passage across India to Oceania.[1] Here the pre-historic paintings show representations of an animal resembling a kangaroo and also of bison, elephants and deer which bear marked resemblance to the drawings at Cogul. In the deer-hunting scene men are found

[1] See Rice: *The Background of Art*, p. 111.

probably dressed in masks. Most of the men appear to be dancing or engaged in some religious ceremony. The Palœolithic peoples were great hunters, and it is no wonder that they could represent in fine rhythm the movement of men and animals, especially deer, rhinoceros, ostrich and buffalo-hunting, their principal occupation. Drawing in these Palœolithic wall-paintings was rigidly restricted to the essential outlines that could, however, reproduce fully the exitement and animation of the scenes. In fact the few skilful and powerful lines are characterised as 'expressionistic interpretation seeking to render life and movement', the outcome not merely of careful observation of animals at rest or in movement, but also of the excitement of the chase, the hunt or the magical ritual that could not but arouse strong collective emotions of fear, anxiety or power. The social tradition of the practice of sympathetic magic not only gives the true meaning to art among the Palœolithic hunters but explains also its naturalistic character.

Plant and Animal Motifs in Primitive Art

Many savages who are now in the hunting stage use animal designs abundantly. The Bushmen in South Africa still maintain the tradition of animal painting, their pictures showing fine and vigorous lines drawn with admirable precision and careful observation of nature. Different objects, besides men and animals, appear in these pictures which are probably symbolic in their significance that is, however, not fully understood. On the North Pacific coast of America the hunting peoples have developed art in connection with the construction of monumental totem poles in front of their houses. The totem animals and crests also cover their large wall paintings. According to Boas, the association of art with the totemic idea explains the unparalleled application of animal motifs in that region which is one of the most important centres of primitive art in the world. It may have also contributed to preserve the realistic character of this art. The natives of Australia, New Guinea and other islands of the Pacific similarly picture animal and plant totems on bamboo, tobacco pipes, drums and other objects, realistically and conventionally, sometimes modified into a wealth of scrolls, curves and circles[1]. Another hunting folk which has shown extra-ordinary skill in painting and carving is the Eskimo who depict various phases of hunting, migration, etc. in their drawings on ivory and also make a great variety of wooden masks. Among the Semang and Sakai of the Malaya Peninsula the engravings on combs and bamboos include representations of various kinds of fish, some of which are drawn with the meshes of a net. Other designs are charms for rain, for the protection of the harvest and plantations against injurious animals and also for protection against diseases. Fishing tribes in North-West America have developed what has been characterised as marine art incorporating all the creatures, real and fabulous, with which their imagination

1 Boas: *Primitive Art*: also Haddon: *Evolution in Art*.

has populated the sea. It is in this manner that the resources of the region, its flora and fauna supply the raw materials of artistic imagination and expression that is intended to fulfil a symbolical, *i.e.*, a magical or religious function as determined by social tradition. Painting, sculpture, dance and magic were combined in order to elicit the proper mood of unity, and as preparation for chase or hunting by a sort of practice or rehearsal in savage society.

Stylized and Vigorous Animal Motifs of the Steppe and Desert

Coming no to the pastoral peoples of the grass lands, the large biennial migrations in winter and summer of the herds and flocks, connected with the needs of pasturage and of water, leave an indelible impress upon the arts of these peoples. Cattle rearers, camel raisers and shepherds or the mounted nomads who traverse vast spaces across grasslands and deserts can carry little of their wealth with them. Most of the wealth in nomadic society is constituted of personal belongings that have utilitarian significance and are decorated in a most lavish yet concentrated manner so as not to hinder mobility. Leather trappings for the animals, cloth for tents, woollen fabrics, rugs and carpets represent the chief art products of nomadic peoples, we have no houses, nor sculpture nor painting on a large scale. Some of the earliest remains of nomadic culture are represented by two finds, those made at Pasirik in Central Asia and Noin Ula in Siberia that show us beautiful textiles with unusually vigorous motifs.[1] In Central Asia trappings for the beasts of burden take the form of vivid yet stylized animals, as we see in the wood and leather bridles or in the bronze bits and harness adornments from Luristan (Persia), the southern division of the great area of Scythian art. It is significant that in a relatively recent painting on a Shaman's drum from Siberia, probably Ostiak, the horses with their slim bodies and long necks are somehow reminiscent of the type frequently represented in the beautiful appendages of horse-bits from Luristan[2]. The personal paraphernalia of the moving and fighting horsemen, such as brooches, pins, talismans, plaques and daggers, are very often profusely decorated. Such decorations are also characterised by a rigorous stylization of the beasts that form the chief art motifs. The forces and traditions at work are geographical. Man in the steppe, the desert and the tundra has to travel light and at short notice. With ampler leisure than that of the plainsman, as he guards his flocks and herds roaming in the pastures at ease, he often becomes his own artist, but all his skill and artistic expression are lavished on small and light things. Thus his treatment being confined to a limited space, becomes, as a rule, formal and stylized. Stags, reindeer, horses, mountain goats, lions and birds are represented by rigorously confined designs, certain portions of the animals being used in stylized form

1 Rice: *The Background of Art*, p. 123.
2 Adam: *Primitive Art*, p. 160.

to decorate other animals that are shown complete. Stylized beasts, whether real or imaginary, and confined within the limits of vigorous patterns of small size, are characteristic of nomadic art. Secondly, the endurance and privations of nomads in their long marches across the boundless horizons of open prairie and desert, where there is nothing on the horizon to satisfy and titillate the vision, lends an ascetic character to their art. The form and spirit of artistic expression are here quite foreign to a bright landscape with its green verdure and foliage, river, dale and hill and the interplay of sunshine and cloud. At the same time, the cyclonic movement of the mounted nomads explains their unusually vigorous motifs. Thus stylized form comes to be combined with vigorous animation and spirited movement as well as rich variegation or repetition of minor forms exhibiting the dominating single animal rhythms. The efflorescence of the art of the nomads is represented by Scythian art, which is regarded by Rostovtzev as a style first conceived in Mesopotamia, whence it travelled by way of Iran, where it took on its characteristic form, to China and Russia. The formal animal designs with concentrated energy and rhythmic outline within a profusely decorative frame are met with whether in Scythia or in Luristan, in Southern Russia or in the western borders of Old China. Future art history will reveal more of the influence of this mother art of the Eurasian grass lands.

The Earth Goddess of the Early Farmers

The art of peasant folks is far different from that of the hunters and the pastoralists. Primitive agriculturists who eke out a precarious living from the soil and live in constant fear of droughts, cattle diseases and pests develop an extraordinary variety of magical rites to ensure bountiful harvests and to deter evil spirits, and when well settled worship boundary gods and godlings and the fecund Earth Mothers. The Earth Mother is represented in pre-historic sculpture as a large-limbed woman, with the size of the breasts, hips and abdomen greatly exaggerated. Such are the misnamed Venus of Willendorf or the Venus of Brassempony, and other corpulent female statuettes found on Aurignacian sites in Europe constructed at least 15,000 years back when the pre-historic hunters of Europe suddenly multiplied in numbers. Similarly there is the bronze image of a goddess-mother, with a child in her lap, "a sort of pre-historic Demeter", found among the Megalithic monuments of Sardinia. In the Valley of the Nile the most famous ancient goddess was Isis wearing in her image the horns of a cow and nursing Horus in her lap. Isis was identified by Herodotus with Demeter and her child Horus was the Sun-god upon whom both king and people depended for the wealth and prosperity of the land. Reference may also be made to the Great Anatolian Goddess Mother standing on her sacred lion found in the bas reliefs at Yasiti-Kaia near the Hittite capital (about 1500 B.C.). Or, again,

there is the Primeval Madonna discovered in the Indus Valley and considered as the representation of the Vedic goddess Aditi, or Universal Mother with her hands on her bosom in the gesture of giving milk to her progeny, and an exaggeration of the hips. The Earth Mother not only secures fertility of soil or beast but also protects crops, cattle and men against innumerable diseases and enemies that mankind faces when it first gives up its wandering habits and settles on the land. She is sometimes depicted with a plant growing from her womb. Mankind had an increase of fertility with the introduction of agriculture throughout Southwestern Asia about 6000 B.C., and its drawing population consciousness and interest in reproduction expressed itself in the worship and representation of the Great Mother or Nature Goddess with large breasts, obviously typical of fecundity and in bizarre phallic symbols[1]. The figures of the Great Mother sometimes show great plastic vitality and rhythm while the symbols that find a ready and practical application in decorative art show abstraction and conventionalisation.

Characteristic Features of Peasant Art

The Huichol of Mexico, who are primitive agriculturists place conventional representations of a small cactus on ceremonial objects or paint it on the face, the cactus being considered to be the votive bowl of the god of fire that is to be appeased for rainfall. Girdles and ribbons, inasmuch as these are considered as rain-serpents are in themselves prayers for rain and for the results of rain, good crops, health and life; also the designs on these objects may imitate the markings on the backs of the real reptiles[2]. Rain gods and goddesses with marks of lightning on their faces are also found amongst many primitive agriculturists of to-day. The Hopi and Haida Indians make statuettes of these. Rainfall or the zigzag boundary of the Indian village is symbolised in the form of serpents that are sculptured on stone tablets before which the villagers still take oaths during the adjudication of land disputes.

The return of spring, the beginning of the rainy season and harvesting are occasions for joyous festivals accompanied by song and dance among the Indian agriculturists. The harvest festival is especially important, and villagers celebrate the reaping and home-coming of the rice crop by worshipping Ganesa in the fields, making an image of cowdung or rice paste with a culm of grass on the top and by weaving artistic garlands and sheaves of paddy that are hung on the lintel. The women also make on the occasion auspicious drawings in the courtyard and door-front with rice paste and turmeric and decorate a water vase with vermilion and sandal, coconut fruits and mango leaves. Inside the cottage they adorn a circular wooden plate with fresh symbolical drawings on which they place the cowrie-woven basket dedicated to Lakshmi, the Goddess of Wealth.

1 Mukerjee: *Political Economy of Population*, pp. 70-71.
2 Lumholtz: *Unknown Mexico*.

Or again the Lakshmi ghata or earthen jar bears the freshly drawn image of the goddess holding paddy sheaves and lotuses as well as conventional forms of owls and bundles of paddy all vigorously outlined. The owl is the vehicle of the goddess of wealth, probably because it destroys rats which do great damage to crops in the fields. Throughout Southern India, pottery horses, dogs and elephants are provided by villagers for the god Ayanar or Sastha who rides round the fields at night to drive out agricultural pests, blights, diseases, and evil spirits. Potters show their skill and artistry in making these animal images. Each art province in India has its distinctive pottery, its tasteful patterns in weaving, basket work, wood carving and utensil manufacture in the rural areas. In many Indian villages, village gates, guest houses and temples as well as places of family worship show a rich variety of artistic decoration. On the walls we find the scenes of the epics as well as the varied assortment of popular folklore and tradition treated as themes of painting. In the peasants' cottages the ears of corn are tied in beautiful designs and hung on the roof. Pillars, doorways, architraves and windows are carved and the clean earthen walls show paintings of animals, real or fabulous, and of the lotus, the holy mountain, the tree, the swastika, the trident and other familiar symbols[1]. In front of the cottages the women-folk draw circular patterns of design with a white liquid paste of ground rice (alipana) representing the pedestal of the Goddess of Wealth (Lakshmi) worshipped by the agricultural folk. The footsteps of the Goddess are always painted and the paths leading from these to the granaries. In various alipana designs, painted white, red, green, yellow and black, the sun and the moon and the sixteen stars, Siva and Parvati on Mount Kailash, Vishnu and Lakshmi on the lotus leaf as well as various heroes of the epics are reproduced, sometimes with great originality and imagination. The women-folk of Bengal design and stitch tattered rags into large and small-sized cloths and quilts (Kanthas) and the textile symbols have close connection with the alipana figures. The inner field has sometimes exquisite shades of colours, and the cloth is framed by a sari-border weaving pattern. Apart from the visual symbols of the lotuses, trees, flowers, leaves, the Sun and the stars, animal and human figures are freely dis-tributed in the crowded field; while scenes from the epics and Bengali *Mangala Kavyas* are also illustrated. The Kanthas made in Eastern Bengal are charac-terised by great elaboration and flexibility of designs exhibiting clear and vigo-rous rhythms.[2] One may come across painters, called 'patuas' in Bengal, while travelling in rural India. These draw pictures of dead relatives completely in colour with the omission of the iris of the eyes that are supplied on obtaining presents from the relatives who believe that the deceased have been wandering

1 For Indian folk art see *Principles of Comparative Economics*, Vol. II, Chapter XXIII.

2 For illustrations, see Kramrisch: Kantha in the *Journal of Indian Society of Oriental Art*, June-December 1939

in the other world with no eyes. The patuas also paint in scrolls episodes from the legends of Krishna and Rama, especially the dance of Krishna with the milkmaids, the episode of the theft of garments (Vastra-haran) and the way-laying of the milkmaids (Danalila) and Ramchandra's fight with Ravana. Satya Pir and Satya Narayan, two new deities of the Bengali pantheon, as well as the Tigers' Gods are also represented in these scroll paintings.

In some parts of Western Bengal mural paintings characterised by vigorous outlines and representing themes from social life are found yet untouched by any foreign influences on this simple and imaginative folk art[1]. As a matter of fact, the ancient art of India still survives in the villages and temples of Bankura and Birbhum to an extent unknown in most parts of India.

Similarly, rural Japan exhibits a vigorous peasant art. In small shrines there is a display of votive paintings (ema). Horses seem to be the favourite subject for these votive pictures. Here and there some villages produce vigorous cartoons which are celebrated all over the country. Such are the paintings of Ukiyo and Otsu that are sold as souvenirs. Pictures are also painted in the villages on pottery containers and dishes exhibiting corn and thistle, bird and flower in vigorous outline and rhythm of composition. In most rural areas in South-east Asia and the Far East that are away from the corroding influences of mass standardised production of modern industrialism, agricultural peoples have kept alive a vigorous peasant art that not only produces textile products and clay and metal works of beauty, but also paintings and sculptures in which the Indian lotus, natural and conventional, mango and vine, and animals, realistic and fantastic, are all represented in profusion. But, on the whole, such peasant art, set within a rigid routine of agriculture and an unchanging procession of the seasons that dominates both agriculture and social life, is characterised by uniform and monotonous motifs and designs. Neither passion nor movement nor dramatic character are nourished by the art of the agriculturist that is charac-terised, however, by spiritual certitude and depth in its slow, sedate and uniform designs and patterns.

Regional Origin of Generic Art Types

We shall now consider the regional influences on the more complex and advanced art of agricultural peoples living under a sunny or cloudy sky, in a desert, a savanna-like or a tropical landscape. Examples may be adduced from the art history and traditions of different regions and peoples, although very little attention has been paid to the subject by students of art. Demolins has suggested the fruitful idea that the route which peoples and races traverse in the course of wanderings in their formative stages largely mould their arts of civilisation

1 See A. Mookerjee: *Folk Art of Bengal*, figures 32, 33 and French: The Land of Wrestlers, *Indian Art and Letters*, 1927, Plates II, V. IX.

and patterns of living. This is true also of art patterns that form together with social organisation, religion and even metaphysics an integrated experience shaped by the regional factors and forces of the people's route. On the whole the Oriental peoples who have encountered the prairie and the desert in their long pre-historic wanderings have been infused by artistic visions of the infinite, the universal and the transcendental. The procession of the sun, moon and stars in a translucent sky, the passage of the seasons and the long tedious marches across limitless open spaces by day and by night, where nothing intervenes to titillate the senses, arouse the artistic sensibility to abstraction and geometrical regularity. Early European peoples, traversing in the pre-historic period forests and mountains, and with their vision constantly circumscribed and at the same time beguiled by trees in broken lands and hills, have leaned more to the artistic expressions of the finite, the individual and the concrete. The contemplation of the limitless sand-dune and the unobstructed plain in the East suggests abstract rhythms and pure geometrical patterns. The contemplation of vegetation and broken landscape in the West suggests realistic, imitative patterns and the symmetry of finite, including human, forms. Thus do the generic art forms and patterns diverge, although there must be fusion of styles, as the result of cultural contact, borrowing and assimilation in different epochs. Oriental art is more intuitive and mystical, saturated with the sense of the infinitude of nature and of human destiny and poise and tranquillity of the universe of which man is treated as an inseparable part. Occidental art is more realistic and subjective, dominated by the rich interplay of human passions and desires which determine the treatment of the landscape, and greater sensitiveness to the elegance and subtlety of finite forms of nature and the variegated, albeit fleeting, charm of humanity. The rigidity of lines and crystallisation of forms as well as stylization in Oriental art translate man's inner poise and harmonious adjustment with the universe. The vital lines, the sinuous curves and delightful rhythmical compositions in Occidental art express material and psychological individuality and man's independence of nature that in fact answer to his own moods and feelings. The former strives towards abstract rhythm and structure, the latter towards realism and the derivation of norms of beauty from the accidental forms and uncertain movements of finite things.

Regional Influences in Egyptian Art

Such a broad comparison of art types is no doubt basic and essential; but it will be even more useful to deal with the regional characteristics of particular countries and their influence on art patterns. A striking example of regional determination of art forms and motifs is afforded by the art of ancient Egypt. Here the Nile pursues its monotonous course through the years hedged by two identical banks, while its rise and fall on which depend man's agriculture, works

and experiences are regular and ever-recurrent like the progress of the sun-god Amon-Re in the sky. At a little distance beyond the line of alluvion are the sand-dunes that scatter in the winds but form and re-form into the same flat, uniform stretch that extends into the bare, boundless horizon. In the arid country nothing easily rots or decomposes with the lapse of time; everything appears to be permanent on the earth. On the clear translucent sky of Egypt the stars also are seen to rise and set in the eternal procession of the heaven that subordinates to itself the rhythm of flow of the river and the sequence of sowing, ploughing, harvesting, herding and the entire routine of man's economic and social activity. Renewal or resurrection is writ large on the face of the Nile valley symbolised in the Osirian myth of death and immortality. Thus art in Egypt is a search for immortality; it is an art in the guise of religion and philosophy that seeks to confer immortality on man, and on his life and enjoyment on the earth. Statues of kings, priests, chiefs and sphinxes, carved out of granite or sand-stone cliffs that are everlasting, embalmed bodies hidden away in sepulchres from the destructive elements of nature and provided with an elaborate supply of edibles, drinks, harpists, dancing girls, slaves, farm-hands, horses, jewels and knick-knacks express man's irrepressible desire in the valley of the Nile to become as eternal as the monotonous landscape. Thus the uniformity of the boundless desert, the everlasting character of the granite rock, the procession of the seasons, the periodic migration of the sacred animals and the ceaseless toil and moil of the multitude regulated by the rhythmical rise and fall of the river—all have their impress upon Egyptian religion and art. A peculiar combination of desert and regular mass of water along a ribbon-like stretch of land has certainly given a definite tilt to art seeking symbols of perpetual growth and renewal in every form and appearance. Architecture has built the houses of the dead who live and enjoy there eternally the life of the senses, and sculpture has been fitted into the enduring and architectonic frame, scooping out of the granite rocks giant figures that seem to stare straight ahead eternally into the immensities of space. The intense, evenly diffused light without mist and fog, the immense shadows that are cast on the sands as the blazing sun marches across the sky and the hardness of the diorite or granite stone imposed upon Egyptian sculpture a simplicity and rigour of style not seen anywhere in the world. Low reliefs that are a distinctive feature in Egyptian art are also well adapted to a region of bright sunshine and sharp and deep shadows, and had a long and successful history in that country. The reliefs on wooden panels in Hesi's tomb are indeed considered to be among the most perfect in the world. The straight course of the Nile without any tributaries in the flat peneplain, the straight tall palms that fringe the river banks, the straight and absolute lights and shadows that the blazing sun in Egypt distributes have made the architect and the sculptor a geometer, seeking to illustrate in the arrangement of the pyramids,

avenues, temple porches, colonnades and rows of colossal, cubical statues the mathematical laws that govern the procession of the seasons, the march of the terrible sun and the rhythm of the life-giving river. The sombreness of Egyptian sculpture, dedicated to express symbols of eternity and resurrection, is accentuated by the regional impress of impersonal logic and severity of geometrical lines and planes derived from a milieu where the sky, the land and the waters as well as human life, toil and death are all subordinated to universal laws of order and rhythmical sequence. But with painting things are different. The painter turns his back on the dreary desert and the boundless horizon of the sand-dunes; on the walls he reproduces the intimate daily life and toil of the oasis, herding and milking, sowing, ploughing, harvesting, threshing, rowing, fishing, wrestling and sport. The world of the Egyptian painter is saturated with the coolness and soft murmur of the morning breeze of the oasis; it abounds with oranges and dates, papyruses and lotuses, jackals and antelopes, fishes and rabbits, and hums with the cackle of the geese, ducks and cranes, the bleating of sheep and the bellowing of cattle, all ministering to the needs of the oasis-dwellers, kings, priests, chiefs or the multitude.

Landscape and Art in Hellas

Contrasted with the other-worldly and funerary art of Egypt is the art of Greece where the indented coasts, islands and small meandering bays, all well defined in their outline and the sharp boundaries of the clean-cut, lofty hills enclose a cameo bathed in illumination that is softened by haze by day and by night. Everything in the landscape is defined in its structure. The climate is equable and the soil fertile. Neither is there bounty, nor poverty while all arduous toil is relegated to slave labour in the semi-independent city-states of Hellas. Neither deserts nor snow-capped mountain heights nor inaccessible jungles engender fear of the unknown or the sense of man's powerlessness. Man does not live here under the over-awing authority of any priests or kings. Greek religion and art express the rational order of the world, as is comprehensible to the senses and the intellect. Man's life-goal is concentrated towards *mens sana in corpore sano*. His apparel is simple and natural in style, clings to the body lightly and is thrown off quickly for the local or Pan-Hellenic games, where he learns to admire the beauty, strength and symmetry of the human body. Greece introduced into sculpture and painting the infinite grace and reason of the real and natural, the perfect proportions of the human body as discerned in the poise and movement of the nude athelete, who typified all the virtues belonging to god-head. Man's reason and idealization of physical attributes were harmoniously blended in the images of Greek gods and heroes in which instead of the inwardness, mystery and phantasy of the forms in Eastern art, were embodied man's typical and universal qualities in a grand manner. The fine sense of harmonious proportion

and logical symmetry expressed in the sculpture of the human form in which Greek art excelled, was equally true of the scientifically calculated and designed temples of the city and vases of the home. The mountains of Greece, lying bare of vegetation against the clear sky, show themselves in accents of light and shade, sunshine and cloud, sinuous mass and depth that contributed to make sculpture the leading art as the imaging of human physical beauty in stone was facilitated by the sport of naked bodies of athletes in the gymnasium. Man's physical form attains perfect grace and harmonious proportions as the result of exercise, and is spread out in the light penetrating into the limbs and accentuating their structure. The chiselling into perfection of human limbs in white marble becomes the standard of Greek art, just as nature has chiselled the Greek landscape into symmetrical sculptural forms everywhere. Greek art is anthropocentric; it shows neither sensuous elaboration nor spiritual refinement. It is objective and human, sense-born and obvious, and has since been accepted as the norm for European civilization.

Regional Influences in Indian Art

The sea-girt promonotory or islet, the desert, the oasis, the tropical jungle or the savannah, each regulates in a distinct manner the dominant ideas, modes and motifs of art. A remarkable illustration of this is the contrast between the ideals, designs and modes of artistic expression in India and Persia. In the lush bounty of the tropical and sub-tropical monsoon forests of India where grow, multiply and jostle together infinite forms of plant and animal life, we find both sculpture and painting crowded with beings, gods, angels, creatures of the upper air and of the nether world, animals and birds that are all caught in a single and exceedingly animated plastic movement. Rocks and boulders are carved into colossal forms of elephants, bulls, deer and monkeys that roam in the wilds or offer allegiance to man, while plants and flowers change into the beautiful shapes of angels and gods. The exuberance of life that sprouts up from and spills on all sides is reflected in the crowded bas-reliefs and paintings on the walls of the rocks, on their side-wings, pillars and ceilings that become as dense as life in the tropical jungle. Sometimes the mere multiplication of columns in a temple hall and the dense massing of figures that occupy rock-surfaces, walls, platforms, pillars and colonnades, literally squirming and pulsating with life, have an overpowering effect on the beholder. In the midst of the lavishness of life, that spills on all sides in a land where the wind is sometimes a gentle zephyr, sometimes a tornado and sometimes a blazing hurricane, where the rainfall is life-giving and equally distributed for agriculture but sometimes works havoc by continuous and torrential downpour, where the river brings the fertilizing silt as well as the devastating flood, and where famine and prosperity alternate recurrently, it is the pageant and metamorphosis of cosmic life and existence that

constitute the major themes of sculpture and painting. Not single figures but a constellation of figures are created by sculpture whose treatment becomes rhythmic and musical, and at the same time diffuses a spirit of stillness and detachment over the intermingled and even overlapping plastic mass. Painting too is instinctive and colourful, and as exuberant as the immense mass of life-forms and their transformation in the Indian scene.

Indian art expresses the sensuous charm and exuberance of outward life and at the same time reveals its impermanence and man's destiny in a long scheme of Life, comprehending both the inner and the outer worlds. Whether in sculpture or in painting the mass is eye-filling. The rhythms are melodious and fluent. The bodies of single figures are sense-delighting, even swelling and seductive. Rarely in art history has sculpture reproduced so well the soft and chaste charm of the female body within plastic repose capitalising the silence and texture of the stone as well as the light and darkness in the cave or temple for either movement or stillness. But the accent in Indian art is on social, psychological and symbolic as well as sculptural values that lead man unobstrusively and yet surely from the gorgeous array of lovely and caressing nudes and their insinuating gestures and movements and the rich swarming figures and floral forms in the walls, columns, platforms, panels and friezes to an other-worldiness and stillness, of which the supreme expression is represented by the figures of Buddha, Bodhisattva, Siva, Vishnu, Tara or Parvati. Over them all broods the profound sense of the oneness of life, whatever its forms and appearances may be, and its continuity through infinite manifestations and births. Ajanta, Amaravati, Mahavellipore, Borobodur and Champa equally illustrate the dominating concept of the mother-art, born of the semi-tropical forests of India, that the myriad appearances of the world are embodiments of the same essence passing through transmigrations from birth to birth into the ultimate state of Being. Such Being is the Buddha or Bodhisattva, Siva or Vishnu, who embodies at once the cosmic largeness of life and creation (Viswarup) as well as the state of withdrawal or silence of life released from the bonds of birth and death and the limitations of time and space. It is thus that other-worldliness, abstraction and detachment throw into bold relief an art which is often appealing to the senses by smooth and caressing modelling and its interplay of sinuous lines and glowing colours. The vast panorama and moving levels of life in India's temples and rock-cut sanctuaries can only be understood from her profound artistic intuition of the Unity of Life that extends from matter to spirit and back again from spirit to matter in a rhythmical movement within a common inexhaustible matrix. Where life is comprehended as a ceaseless movement differing in levels but the same in essence and spirit in a mystical pantheism, sculpture adopts the methods of painting in a riotous extravagance and linear rhythm of figure groups, chiselled with incredible toil out of the rocks and walls, in the extravagant decorative artistry in the

pillars and arches, panels and friezes that sometimes transgress the limits of the frames, and in the stress of curvilinear movement and smoothness of modelling for the expression of the entire gamut of man's fleeting passions and moods. In Indian sculpture the gliding sinuosity and fullness of the human female sometimes extend to birds, horses and elephants, and even to fruits and flowers while these are equally adapted to the revelation of profound silence and purity as well as mirth and voluptuousness. There is something palpitating and fluid in the treatment of groups of figures in the plastic mass that Indian pantheism, no doubt, has introduced into Indian sculpture. A profound sense of the interconnection of life abolishes the distinction between painting and sculpture as sculpture seeks to express the Life that sleeps in every rock, wall or pillar or finds enjoyment and asceticism, movement and abstraction, phases of expression of the same Life that it translates into plastic form.

The single images and single faces are, however, equally distinctive in Indian sculpture. In expert hands these have become symbols of human life and destiny, saturated with India's religious and metaphysical experiences. The same impersonal majesty, the same eternity, the same inwardness are to be found in some Indian as in Egyptian single faces. Indian sculpture has modelled images of aloofness and severity that partake of the solitude of the Indian forests and mountains and of the inter-stellar spaces in the autumnal Indian sky. The isolated figures thus equally represent a true and supreme expression of Indian art —the images of Buddha, Siva, Vishnu or Devi that are characterised by their combination of profound abstraction or universality and poignant human tenderness, and that bridge the gulf between worldly life and enjoyment and the silence and aloneness of the Soul. But the leading note is neither isolation nor overwhelming majesty but tenderness and compassion that compel the gods to descend from heaven to mingle with men and animals, angels, yakshas, nagas, and spirits of woods and waters in their thousands, the figures of which are juxtaposed in the walls, platforms, pillars and stairways of temples in mysterious fellowship and communion. Indian sculpture exhibits plastic rhythm and movement in a mighty sweep that models rocks and cliffs and the temple-walls, columns and steps into a hundred forms pulsating with life, and that repeats the elemental creative process fashioning all forms and appearances from the unconditioned and the unmanifest.

Immortality is impressed in the Egyptian images by the linear rhythms and absolute contrasts of light and shade derived from the straight course of the Nile and the features of the desert landscape. In Egyptian religion and art immortality is personal, exclusive, born of the solitude of the desert. In Indian religion and art immortality is the oneness of the person with all sentient life, with the collectivity, born of the aggregation of creatures and gentle symbiotic way of living in a sub-tropical jungle. The Indian sculptor has revealed it in figures

that tend to overlap, mingle with and penetrate into one another, carved out of a background that is itself moving, and in which a whole universe is sought to be compressed. It is the abundance and exuberance of life that rises and throbs on all sides in the fertile valleys and forests of India that indeed explain her mystical pantheism and the mighty palpitating rhythm of gigantic sculptures and bas-reliefs in her cave temples and sanctuaries. Here we appreciate the highest and the noblest not in the geometrically modelled isolated giants as in Egypt, but in the plastic fluctuating mass of the ensemble in the temple wall or in the hill or mountain-side that has been converted by tools into the expression of the human spirit. Indian pantheism, growing out of the excessive fecundity and mortality of the sub-tropical scene, rests on the unceasing alteration or rhythm of the human soul between creation and destruction, between manifestation and withdrawal that has furnished the majestic motifs of the Triune Being and other single metaphysical icons, and at the same time determined the fluent rhythm of the ensemble of images that sprout up from the rocks and walls in lyrical intensity and abundance in Indian art. The lushness of artistic expression of Indian art also found a suitable home in the virgin forests and rich plains of tropical Ceylon, Java, Siam and Cambodia where the indigenous art tradition easily adapted itself to the dominant culture and the way of gentle, co-operative living of India, that embraced sentient life in all its infinite multiplicity and exuberance. Indian art motifs and forms of expression could not have succeeded unless the people throughout this region adopted the Indian conviction about life and religion that does intangibly control artistic expression.

The evolution of Indian art was chequered by foreign, and especially Muhammedan, conquests and invasions. Sculpture decayed and was banished from Northern to Southern India after the establishment of the Moghul Empire. But in the independent and semi-independent states of the deserts of Rajputana and the hills and valleys of the Himalayas where the Persian and Moghul influences could not penetrate, the distinctive characteristics of the ancient art tradition still survived. Both the desert and the snow-clad mountain helped to nurture the traditional spirit of mystical pantheism, symbolism and detachment in the medieval school of Rajput painting, a vernacular folk-art inspired by the renaissance of popular Hinduism in which the old metaphysical conceptions of the oneness of life and the immanence of the Divine were brought home to the rural masses by Hindi poetry, music and painting in terms of the popular Radha-Krishna motifs. Art was more humanised and brought into closer association with the daily routine of life and toil and the ordinary happiness and sorrow of man and woman than ever before. Not only the love-sports of Radha and Krishna but also the penances of Siva and Parvati were depicted in painting with deep lyrical tenderness and reverence,—the symbols of the common man and woman's supreme exaltation in love and faith in the Divinity. The School of Rajput painting

thrived in different environments, and it is noteworthy that while the artists of Jaipur found a romantic setting in the holy land of Brindavan on the banks of the Jamuna, flowing with milk honey, for the revelation of the subtle nuances, moods and gestures of the human soul symbolised in the forms of Radha and the Gopis, painted with bewitching and serene loveliness, the Hill Schools of Kangra, Garhwal, Basholi and Chamba revelled in the delienation of the penances of Siva, and the devotions and activities of Sakti in her varied manifestations in the austere and rugged background of the Himalayas and mountain lakes,—equally representing the transformation of human attitudes and passions into divine moods. Once again we find the fusion of spiritual and humanistic values and outlooks giving birth to a supreme manifestation of creative art and experience. Siva in Indian metaphysics is the human soul in silence and withdrawal, and his abode is in the forests and mountains. Krishna, the flower-bedecked flute-player and prince of the shepherds, is very different from the ascetic God, clad in tiger-skin and steeped in meditation. He is the human soul in love and action, yet completely detached from enjoyment, and has his home in the flowery groves, verdant pastures and tree-lined river banks. Kailash, the home of Siva and Parvati in the Himalayas, looms large in the pictures of the Pahari schools; while the schools of Rajasthan revel in picturing Brajabhumi on the Jamuna, the romantic pastoral background for the love-sports of Krishna and Radha. Many painters of the Pahari schools have no doubt represented Krishna and Radha themes just as the Rajasthani schools have also dwelt upon Saiva subjects. For Siva and Krishna represent indeed two contrasted eternal archetypes of human approach to the Divinity, of renunciation and of action, comprising different accents of the human soul that the poets and painters of the plains or hills have under-stood and interpreted. But there is no doubt that the Sombre-Himalayan land-scape with jagged cliffs, deodars, snow ranges, torrential streams and camp fires of the north, familiar to the Pahari schools, has shone with greater vividness in their paintings of Saiva and Sakta themes and of subjects from the Ramayana and the Mahabharata. Equally local and appropriate is the background of flowering mango, champaka and kadamba trees, lakes with rose lotuses, green meadows with deer, cranes and peacocks, sunshine, heavy cloud and rainfall, characteristic of the paintings of musical modes in the School of Rajasthan. Here the integration of the values of nature, metaphysics and concrete daily ex-perience is more profound, and the nuances of human love, the modes of melody and the elements of the landscape all become perfectly fused in a generic stable feeling and attitude in which the distinction between the self and the rest of the universe, between Man and Nature, is completely abolished. In the marvellous procession of the seasons in the Indian scene, the languor of summer, the fruition of autumn, the intoxication of spring and the longing and pain of separation of the rains become deeply-felt, universal experiences and attitudes. These are

celebrated not only in popular rituals such as the dance of Krishna and the swinging of Krishna and Radha in heavy rain, the spring dance of Krishna and his sport with the milk-maids with coloured powder or the penance and worship of Siva and Parvati but are also represented as Ragas and Raginis in paintings, mainly based on the motifs of human and spiritual love in its various nuances, either in union or separation. These paintings reveal the spirit of the particular season and time of day and night, and thus help towards consolidating the same universal feelings and sentiments that certain appropriate notes of music evoke in the receptive consciousness in India. In the music-paintings of India, Indian art has achieved interpretations of the landscape something different from the Chinese landscape painting, symbolical and dramatic rather than philosophical. Chinese landscape art shows us the infinite in the mist, the waters and the mountains. Indian landscape art reveals the infinite in human loves, delights and sorrows that spill from the undefiled soul into the heart of Nature that throbs in sympathetic resonance. It is thus that the region, metaphysics and collective feeling and vision blend in the creation of árt work that has a unique place among the great arts of the world.

Desert, Oasis and Art in Iran

The art of entire south-east Asia is contrasted with the art of Iran, a mother-art of the steppe and savannah. The neat park-like landscape of Iran and the trimmed garden associated with the palace, emphasising the joys of outdoor life, that were celebrated in Persian songs and lyrics, formed the background of the designs of all visual arts that spread to Armenia, Turkestan, Syria and the whole of south-western Asia. The tendency towards conciseness of designs and vigorous and subtle formalisation became central to the style of Persia that was emphasised also by the taboo on images and the calligraphic ornamentation of the Arabic language, turned into the designs of pottery, textiles, illuminated manuscripts and architecture. In India and Indonesia flowers and plants obtain the swelling mass and seductive curves of female bodies; in Persia, Arabia, Syria and Egypt these shed their natural identity, are distilled into their pure geometrical forms, and are repeated in elegant, eye-filling traceries on brocades and carpets, on manuscripts and pottery, on screens and friezes and on the columns, gates and architraves of mosques. The unrivalled elegance of form and colour that characterises Persian art is the outcome of the search of the aristocracy for the delights of open air life in the well-trimmed, elegant and bright gardens of the oasis where they take refuge from the bare walls and dusty streets of the city. Nightingales there sing among the roses, and lovely women converse over wine cups by the side of quiet pools, fresh fountains or running streams. The brilliance, solidity and stability of colours in Persian art reflect not only the ever-recurrent, sharp, seasonal alterations of the Persian landscape but also the

contrasts between the blankness and dull monotony of the desert and the green verdure of the oasis garden. "The garden", observes Pope, "was Paradise, literally Paradise, for our word comes from the Persian word for walled park which is their conception of a garden, and Paradise it is, for it offers rest at the end of the heat and dusty strife of the day like unto the perfect rest that crowns the struggle of life."[1] The garden in the Persian scene symbolises man's withdrawal and serenity, his peace with himself and with the world that were often facilitated by music, poetry and intoxication with Shiraz wine, poured in turquoise bowls from the hands of the beloved.

The notion of the well-trimmed, well-arranged and colourful garden has important consequences for design in many fields of Persian art. It is this which stamps itself on all Persian art products from magnificent carpets to gay pottery that have captured the artistic imagination of so many countries through the centuries. The carpet depicts the starry beauty of the Persian garden with its glistening fountains, pools and canals, and with fishes and ducks swimming, birds fluttering or beasts prowling about or being hunted. The use of colours, intense and yet mellow, is here so adroit and elegant as to give an aerial perspective to the whole oasis landscape. Thus is created the dream image of the garden that Persian art celebrates, symbolising the beauty of the universe as the glory of God. The green cypress, the emblem of life, and the flowering golden plane tree, the emblem of eternity, are also typical Persian art motifs, along with the vine, the rose, the jasmine and the iris, all reappearing in arts and crafts in conventionalised patterns and thus recovered as realities of the super-sensible world. Inside the household, water that is very life itself in a land like Persia, is stored and dispensed in lavishly decorated painted potteries where the exquisite and conscientious craftsmanship is a tribute of gratitude and exhilaration and in which also the garden design is discernible. The Persian style is thus dominated by the notion of the garden, and the oasis which gives to art and craft both economy and loveliness of line, concentration of ideas and poetic flight in short compass or miniature with the blank that is as eloquent as the densely crowded space. Finally, the central dome repeating the absolute vault of the desert horizon and the tall minarets of Muslim architecture that shoot up to the sky like the morning and evening cries of azan of the priests, calling the faithful from the open country, bear the impress of the desert and prairie. Inside the mosque it is bare and simple unlike the temples of India, Egypt or Greece; for neither is the Muslim mosque the habitation of God nor is God conceived in the tangible form of an image; while the faithful, accustomed to live in tents in the desert, squat on the floor facing a bare niche on the wall indicating the direction of Mecca. But the walls are seldom bare; these show over-elaborate, geometrical or floral drawings or calligraphic ornamentation from the Koran. Tile-making

1 *Introduction to Persian Art*, p. 204.

for the floor of the mosque has developed as a fine art to an extent unknown in other regions, for the faithful walk, sit and pray bare-footed on the well-glazed or multi-coloured tiles. The inhabitant of the empty desert, who becomes colour-blind, seeks and finds luxury in the gorgeous feast of colours on tile, marble and glass in the mosque of the oasis-city. He obtains refuge from the blazing sun, scorching heat and pitiless wind in the coolness of the mosque maidan, trees and waters. In front of the mosque there are pretty gardens, fountains and pools where he washes his limbs and cools himself before his prayers, an observance appropriate for the desert and prairie region. The provision of fresh, cool and running water and oasis gardening are indispensable parts of Muslim architectural arrangements, born of desert requirements, while the search for the abstract and inexpressible in the creed of the desert, with its open space and emptiness, reveals itself in a kind of ornamentation, geometrical and repetitive, that is as elusive and unstable as sand and ends in nothing through its infinite permutations and combinations. Plants and flowers that symbolise life in the pitiless heat of the desert are fashioned in Muslim architecture into the elusive and infinite forms of sand-dunes, directly echoing the refreshing contrast between Paradise and the desert.

The Himalayas in Indian Architecture and Sculpture

Architecture in fact shows naturally a much stronger regional impress than sculpture, painting and minor arts. In India the curvilinear roof of the bamboo hut, with an inverted water-pot at the summit to prevent the percolation of rain water has given the form to the spire of village temples scattered throughout the country. But the designs of the larger temples of India, with massive and serried contours and buttresses attached to the sides and ending with a steeple, follow the sky lines of the gods' Himalayan abodes, just as mountains also give the designs to the crowns (mukutas) of Siva and Vishnu. From the Punjab and Rajputana down to Bengal and Orissa in the East the principal temples of India reproduce the swelling curves of the Himalayas that gradually rise from lesser to greater heights capped by the steep and majestic snow-bound summit. Very harmoniously the verticality of the steeple that is called sikhara or peak is combined with the spread of the rising tiers or planes (called bhumis) through the superimposition of projecting buttresses on all sides of the temple that reflect the solidity of the mountains, buttressed as these are on all sides by lesser peaks. The spirit of the mountains is discernible not only in Kangra, Tehri or Garhwal, but also in the deserts of Rajputana, the uplands of Central India and the plains of Bengal and Orissa. In the temples of Bhuvaneswar and Khajuraho the harmony of verticality and horizontalness stressed by the building of the temple on a broad, lofty platform, the piling up of miniature turrets rising rhythmically from plane to plane with the soaring lines of the central tower—the lines of the

mountain peak—and the skilful use of miniature sun-windows and friezes filled with groups of statuary has achieved an exquisite architectonic unity and rhythm.

The spirit of the open expansive plain, echoed in the horizontal design of temple structure as a pavilion with several smaller subsidiary temples affili-ated to the main temple, has combined sometimes with great beauty and dignity, sometimes with less coherence with the serried verticality associated with the sacred mountains, the Meru, Kailash and Himalaya.[1] Thus the pattern of the lofty, ethereal spire and wide-roofed pavilion or pyramid in temple architecture equally reveals the imprint of the Indian environment, while it is not seldom that the contrasted temple structures, with their different gods, make a symbolic pair and at the same time an effective architectural synthesis whether in the hills or in the plains. Regarding the temple spires that recapture the graceful, mount-ing contours of the Himalayas, it should be remembered that the Himalayas were regarded not merely as the abode of Siva or Vishnu, but as Siva or Vishnu himself. Sages say truly,

"Vishnu is thy name,
Spirit breathed in thy mountain-frame,
Within the caverns of thy boundless breast,
All things that move and all that move not rest."

Thus Kalidasa spoke about the Himalayas. Havell points out that the Indian belief that the Golden mountain was planted firmly in the centre of the earth (Sumeru) as the column which supports the heavens was symbolised in Asokan pillars and in Indian temple architecture. Siva, sitting cross-legged in his yogic power of meditation by which he creates the world, symbolises the majesty and serenity of the Himalayas and is the prototype of the seated figures of all Indian gods and goddesses, Hindu and Buddhist. Similarly Vishnu, up-holding the heavens, and preserving the balance between creation and destruc-tion, is tall and erect, with a rigidly symmetrical pose like the imaginary golden mountain, Meru, in the centre of the earth. He is the prototype of various standing figures of Indian deities, representing law and order in the universe. All Indian iconographic practice, we may say all Asiatic practice, has been governed by the seated image of Siva and the standing image of Vishnu. Like the Himalayas, the mighty life-giving rivers, the Ganges and the Jamuna, as well as the sea have also governed Indian art motifs. Images of the river-goddesses, Ganges and Jamuna, on the crocodile and the fish, have been carved, while the descent of the Ganges on the earth is magnificently displayed. The architectural designs and decorative motifs derived from the geography of India have left their imprint on the art of Asia.

1 For illustration see N. Bose: The spirit of Indian Temples, *The Four Arts Annual* 1936-1937.

CHAPTER XII

THE ECONOMIC DETERMINANTS OF ART

Primitive Art and Economics

At the early stages of the evolution of art we find music and the dance-ritual as the most important phases of artistic expression; while these were intimately related to economic activity. The aim of the primitive dance and music was to weld together men in collective tasks with a deepening sense of group unity; to prepare the group for the chase, the hunt, the war and the field by mining or rehearsing these activities in all the fullness of their meaning and emotional experience by the unity and sureness of the dance rhythm. Art, in the first place, dissipates and resolves fear, suspense and anxiety, and integrates men into the mood of unity in feeling and action which is indispensable for success in the practical tasks of food collection, fishing, hunting or war. It enables primitive man to tide over the psychological crisis brought about by overpowering excitement and fear that lead to failures or disturbances in such imperative primitive enterprises. Secondly, art completes each enterprise by representing it in the mimetic gestures in all its entirety without slips, errors and disturbances, adding to the sense of collective competence a profound joy arising from the rhythm of the chant and dance in which the entire group participates. Art thus creates a favourable atmosphere and discipline, both of which enable the primitives to define and undertake successfully their practical tasks and raise these to a new level of meaning and experience. In primitive society ideas of utility, beauty and supernatural power are inextricably interwoven. Success in the daily routine of tribal life is rarely attained without the cult and the ritual in which art plays the crucial role in focussing attention, meaning and effort towards peculiar social needs and objectives.

In the prehistoric paintings at Cogul we find that a sacrificial dance is being performed by the women nine of whom with skirts dance round a male satyr-like figure. In the cave-paintings such as those in the Abrillege of Dordogne in Europe or in Raigarh in India we find the ancient hunters dressed in animal masks. Just as on a bone found in the Pin Hole Cave of Derbyshire in England we find a rudely engraved masked human figure, standing erect apparently and in an attitude of ceremonial dancing, similarly in the cave-paintings at Raigarh we find men with upraised arms in some kind of ceremonial gesture. Men with cross-legs and raised hands and holding tridents appear to be engaged in some ritual or observance[1]. No doubt most of pre-historic dance ritual is of magical

1 For illustrations see Mitra : *Pre-historic India.*

significance, depicting the mammoth, the bison, the rhinoceros and the reindeer being chased and slain or with lances, traps and sledges upon their flanks with a view to attune the thoughts and emotions of the primitive hunter to the expectation of success on the basis of sympathetic magic. Clear evidence of this practice in the Stone Age has been adduced by the studies of Kuhn. Thus is art largely born of hunger, of the crisis of the struggle for food and the quest of wild beasts in the forests. Art does not portray merely the fleeing, slain or cajoled beasts; it also shows the beasts browsing, fighting and charging. All through, the artists who have drawn the animals on the cave walls have been helped by their minute and concentrated observation of the animals while living and while these are skinned and their skeletons laid bare. It is their chief aim to portray single beasts. Of these the edible big animals predominate, cave-lions, wolves and other beasts of prey being hardly represented. While the range of themes of pre-historic painting is governed by the economic importance of the animals, the strenuous and hazardous fight with beasts with primitive tools and weapons expresses itself in violent, powerful and epitomised drawing seen at its best in the frescoes at Altamira and Font-de-Gaume. With economic evolution the naturalistic representation of animals, depicted on the cave walls in their full vigour and fury, is gradually superseded by decorative and symbolical representation. This also records the change in primitive culture from observation of, and alliance with, nature to control as in totemism, magic and ritual. Thus conventionality and decorativeness in animal motifs are characteristic of developed tribal cultures in which animal representation in the plastic arts partakes of the formal nature of magic and religious observance.

As pre-historic man's tools improve, engraving, sculpture and bas-relief appear, and the subject-matter is also no longer restricted to hunting and fighting the animals. For the primitive artist is also the lover, and portrays the forms of the woman he delights in, sometimes slender, sometimes immensely corpulent, but with his eyes always on his woman and children whom he tells the story of his adventures in the forest on evenings in the cavern before burning lights. A type of such obese and steatopygous beauty is represented by the Venus of Willendorf in Austria, which some writers suggest is a fertility charm. In this case the economic significance of pre-historic art is further illustrated. Pre-historic art is of immediate economic usefulness to man. Just as he fashions his tools and weapons from the claws and teeth of the animals he hunts, his garments from skin and bark, so he also makes his baskets, pots, and vases in imitation of the flowers and fruits that surround him, all for his immediate use. But at the same time he never fails to ornament and carve his weapons, adorn his body, decorate his girdles and loin-cloths, baskets and pottery. Under different circumstances economic condition or utilitarian custom, totemism and magic

THE ECONOMIC DETERMINANTS OF ART

may have directed art but man's delight in the direct, abstract and emotional self-expression is the mother of art from the dawn of history.

The Economic Significance of Savage Art

Many savages of today perform the same dance-ritual of animal masquing as the Stone Age hunters and with similar magico-economic implications. Savage songs and dance rituals generally simulate the voices and movements of animals, intended to attract the latter by magic or spell or repeat the operations according to which the dreaded beasts are chased, captured and slain. Animal masks are used by many primitives intended to lure the animals into their hands during dances. Among the Bushmen in Africa men wear heads of antelopes while the others, men and women, clap their hands to beat time. Among the New Hebrideans dances represent the culmination of pig-killing rites that symbolise plenty of food. "The Naleng dances" (in the New Hebrides), observes Tom Harrison, "include dramatic performances and improvised pantomime, sometimes exceedingly funny. Dancing is not done independent of ritual. Music is used almost exclusively with dancing, not as a thing in itself. Songs are a form of story-telling. Words are a native art with an intricate circular pattern." In the North-west Coast of America the Indians till recently used to simulate in dances the leaping movements of fishes which constituted their chief food supply. The Kwakitul sing their food song as follows: "I am going around the world eating everywhere with the Cannibal spirit. I went to the centre of the world; the Cannibal spirit is crying 'food'". The singer beats time, but the Cannibal dancer accompanies the song with descriptive movements expressing the various ideas in the song[1]. Many primitive agriculturists perform what are characterised as fertility dance-rituals in which as the dance rises to fury some men imitate the copulation of various birds and beasts; while naked women also dance round, and scatter imagined seeds on the ground. All such savage dances whether in the secrecy of midnight or in the broad light of day are intended to evoke the fertility of the earth, and assure a bumper harvest. Other dances of agricultural peoples simulate various agricultural operations, especially sowing and harvesting, that may have lost their magical import but greatly relieve arduous toil and elicit team work in the fields.

The Transformation of Art and Ritual

In the primitive community every body is an artist. None is unable to sing, dance and tell stories. Singing, which represents the recital of an event either anticipated or belonging to the past, and dancing go together. The artistic aim of the performance is generally the mimetic representation of certain occurrences and operations, such as hunting, cultivation and war, or, again, birth, puberty,

1 Boas: Literature, Music and Dance in *General Anthropology.*

marriage and death that elicit intense emotional reactions of the group. Art and ritual (and religion) intervene in these social situations, and discipline the impulses and emotions. The participation of the group or the entire population in the dance-ritual checks tension and excitement and aids men to individual and collective adjustments. Instead of violent gestures and outbursts art lays down a traditionally prescribed set of movements and gestures which re-enact a whole cycle of pre-birth to after-death or the chase, hunting, sowing, harvesting and other critical operations. Not merely are the emotions accordingly co-ordinated and rendered durable and the activities generalised and abstracted, but there are introduced into rites and observances conscious purposes and ideals in the form of myths and folk-tales. Thus the rituals which subserve at first the function of releasing emotional tension or conflict are elaborated and repeated for their own sake, bringing with them not only the joy of rhythmical or harmonious action or movement, but also of emotional and intellectual integration. Through all this process rites and observances become more efficacious as forms of social control and guides of behaviour, enabling the individual to secure an effective adaptation, and the group its solidarity and unity of feeling and action, when these tasks become peculiarly difficult in the vital crises and momentous events of human existence. [1]

With social evolution the tribe or the community seeks to eliminate license from the fertility-rite, obscenity from the initiation and marriage ritual-dance and horror and disgust from the mortuary observance. Sympathetic magic is also slowly given up. Just as in fertility-dances the performers often represent the inferior members of the tribe or community, or the shamans, medicine men and others, so dance movements also become independent of the pantomimic representation. Gradually the dance and the music somewhat dissociate themselves from their biological and economic sources. Fertility-rites no longer express the miming of copulation in the fields but are enjoyed for their mass rhythm by the whole crowd or by groups with the other individuals acting as chorus. In the Karam dance of the Oraons the stooping poses and swaying arms and other movements imitate the cutting of paddy, while in the Kesari dance, the girls squat and thump the ground as if gathering kesari. "Karam dances are rude representations of the occupation of the people", observes Roy. As in their work in the fields, so in their dances during this season the men and women are not intermixed but are arranged in separate groups[2]. One of the dance poems is as follows:

"The tiger and the bear are ploughing
The dog scatters the seed
The bear and the monkey pull the seedlings

1 See my *Theory and Art of Mysticism :* p. 59.
2 S. C. Roy: The *Oraons*, pp. 273-301.

The black farmer ties the bundles
And the mouse breaks the string " [1]

There are also festival or marriage dances among the Oraons. Dances also come to represent historical occurrences, folk-tales and myths or the beautiful rhythmic movements of birds and animals. The Indians of British Columbia represent in their dances the contents of their myths and family histories. Those of South-west America impersonate in their dances flying eagles. Some of the aborigines of Australia imitated the movements of the kangaroo or the emu. The Fijians, Boas mentions, perform a group dance imitating the surf of the ocean. Similarly the swaying of trees in the wind and the noise of streams also have inspired song and dance. It is in this manner that art gradually represents the intensification of life beyond mere economic and biological necessities discernible in the songs and dances of hunt, war and agriculture, and of birth, initiation and marriage, into beauty and ecstasy. Man collectively finds in rhythm the release of the tension between himself and the environment. At the beginning the intensified consciousness which was the outcome of rhythm in economic tasks was the basis of solidarity in the tribe and the community. But gradually rhythm embraced the whole field of man's relationships to the environment, expressing itself not merely in dances connected with hunting, fishing, agriculture, religion and war, but also in ornaments of wood and basket-work, pottery and textiles and the forms of sculpture. Savage representation of the ordinary scenes of life, hunting, fighting and dance is common. The most beautiful is that of the Eskimos incised on the tusks of the walrus. A leading motif of primitive art was the acquisition of power over animals and men by making their images, but no doubt story-telling and artistic construction for their own sake had always a charm of its own for man, however, uncivilized. But along with pictorial art, primitive peoples have also their abstract art in which decorative forms arise out of a mixture of man's innate sensibility to geometrical rhythms and plastic values as well as symbolism and magical purpose that are not easy to distinguish. At a later stage sculptural representations become commonly images of ancestral spirits, animals, spirits of prosperity, disease or death. Many such images are anthropomorphic but enable a primitive man to come in rapport with superhuman or supernatural forces or entities these embody, profoundly affecting his life and destiny. Thus the most remarkable of primitive images, such as those of the Negroes, embody high plastic values combined with an expression of beyond-human vitality and force.

The primitive tribe or community was relatively speaking homogeneous. Although division of labour between the sexes established itself early in social development and among many primitive peoples such important crafts as weaving, basketry and pottery were the monopoly of women, it is at a more advanced

1 Archer: *The Blue Grove* : *The Pottery of the Oraons.*

stage that we find the differentiation of craftsmen and artists into classes. Entire fields of primitive art such as wood-carving, stone or metal work or those which were associated with magic and ritual were altogether excluded from the woman's sphere. On the whole, the more extensive the departments of tribal life over which magic ruled, the greater was the range of workmanship for the male, that was later split up into occupations or classes of specialised craftsmen, while the women applied themselves to and improved the decorative arts of weaving, pottery, basket and wicker-work. Remaining within the ambit of the family these domestic crafts did not give rise to special occupations or economic groupings. Gradually economic ranking established itself, and so we find in primitive art persons are depicted as larger or smaller according to their position and status in the community. We have a remarkable example in a Bushman painting in Central Africa, where the vanquished Negroes in a battle scene, attempting to carry off cattle, are represented as of diminutive size. As civilization advances further, there is a sharper cleavage between the economic and social classes that govern styles and motifs of artistic expression. On the one hand, song, dance and ritual and the display of masks, totem poles or idols bind together the tribe with strong unified feelings. On the other hand, social stratification is supported by decorative art and the monopoly of prized art treasures. Malinowski observes: "Hierarchy, the principle of rank and social distinction, is very often expressed in privileges of exclusive ornamentation, of privately owned songs and dances and of the aristocratic standing of dramatic fraternities such as the Areoi and Ulitao of Polynesia".

Rank and Power in Nilotic Art

Art in Egypt bears the impress of the stormy life in the Nile valley, and displays the power and majesty of the divine despots, the nobility and the bureaucracy of Egypt. It shows a tendency towards the colossal, which finds expression not merely in the huge pyramids, temples and frowning fortified palaces with their colonnades and gigantic pillars, but also in the huge statues of gods and god-descended rulers and officials. The forms of the latter far surpass the size of ordinary men; their faces, though characterised by individual features in the chin, nose and eye-brows, do not exhibit at all any human emotions, while their fixed intent gaze seems to apprehend a world beyond the reach of mortals. They are supermen and their superiority is also symbolised by representation of their portraits on the lion body as in the statues of Khafre, the king-builder of the Sphinx. In the seated figure of the king we find, for instance, the hawk, symbol of his semi-divine status, associated with him in the head-dress. Thus the divine majesty and isolation of the king are most powerfully expressed. Another method of artistic representation of glorification is the endless repetition of the same imperial figures. Seated figures of the Pharaohs, statues placed

against piers and sculptures, sphinxes and rams from 20 to 30 ft. high are not unusual. Memnon, with its gigantic companions is 70 ft. high; and the famous sphinx at the pyramids of Memphis has a length of 142 ft.[1] On the walls of the temples, palaces and tombs in Egypt we have an exuberant variety of reliefs representing the daily life of the Egyptians. But the king when depicted is always shown colossal in size with his battle-chariot trampling over the small bodies of his fallen enemies, or again the people are depicted as kneeling before the king, being seized by their common hair by the king who hurls his battle-axe at them. Or, again, we meet vast hordes of men rendering abject homage to the enthroned King-god. The Egyptian nobility, who gradually usurped the royal rights of mummification and complete funerary equipment, loved to display in slabs on their tombs a whole host of personal servants and slaves shaven and clad in white tunics, harpists and slender dancing-girls that used to attend them, along with an elaborate variety of food prepared for their luxurious banquets. Or we find the eminent nobles at sport in the pursuit of game in the desert, hunting hippopotami and fowls in the papyrus marsh on their reed-boats accompanied by their family or watching agricultural operations in the fields. Nakht is represented as of colossal size seated in a booth supervising the common man engaged in ploughing and the measurement of corn. The ladies are represented as picking lotuses. The common people are usually depicted as hard at labour, work in the fields supervised by the noble or official, herding of cattle, women gathering fallen corn-ears, pulling flax, bringing food and drink to the men, cattle and donkeys, building of papyrus boats, carpenters and sculptors at work, and brewing beer. Thus the wide cleavage between the king, with his court and nobility and the peasants who worked as serfs on the land belonging to the former left its deep impress on Egyptian art. A distinguished Egyptologist, Ehrmann, maintains that in the paintings of the Nile Valley the human body is represented in a number of different forms according to the social rank: it is natural for ordinary men, conventionalised for superiors; virile power is represented by a wide chest, not foreshortened as perspective would require; among the Egyptians the chest is always given its full width, even if the figure stands in profile. Thus did Nilotic art carry on a worship of power in the bearing of the figures of men according to their rank and grade in society.

The Worship of Power and Violence in Assyrian and Babylonian Art

In Assyrian art we find a similar glorification of the king and abasement of his subjects and enemies. The ruler is attired in rich apparel, wears the jewelled tiara and is surrounded by a numerous retinue. Or, again, as in Egypt, he is depicted in colossal size and as routing and trampling over his enemies. Bullock-carts carry the captives, women and children to exile, and herds and flocks that

1 Lubke: *History of Art*, p. 34.

comprise the war booty are also driven away. The arrangement is frequently repeated as in Egypt for the purpose of emphasis. Priests, who help the king in maintaining his domination over the people, are represented as superior and mysterious beings by the addition of a mighty pair of wings and sometimes of an eagle's head instead of the human one. Forbidding and gigantic in size also are the figures which flank the gates of palaces. A bearded human head is placed upon an animal's body with bull's and lion's feet and huge wings. Much more significant in its effect on the psychology of the population is the representation of massacre, cruelty and suffering. "Assyrian art is full of life; the life is harsh and cruel and tries one's nerves; but it is neither fictitious nor conventional—it is genuine and therefore the more appalling. The artist is attracted especially by scenes of death, destruction, torture, and suffering. No one has ever surpassed the Assyrians in conveying the death-agony of animals killed in the chase. The figures of dying men are stiffer; but in them also, and in the men who are being flayed alive, or whose eyes are being burnt out, the genuine awfulness of suffering is palpable".[1] Terrible scenes of blood and violence, the trampling of enemies, the holding of nets filled with decapitated heads, the soldiers bowling with severed heads, or the slaughter and pain of beasts as these drag their paralysed body or leap wildly, run through by arrows, before dying, are nowhere represented in the world's art with such sadism. It is an art completely dedicated to the glorification of rulers and priests and subjection of the general population, and concerned only with imperial luxury and magnificence, that could present life and power with such coarseness and brutality. In Egypt the boundless horizon of the sad desert has given a vacant impersonal stare, introspectiveness and mystery to the human face; in Assyria the face is severe, exterior and closed to everything except the violence and cruelty that form the ensemble. The monsters that guard the Assyrian palace gates threaten to overpower man by their sheer animality; the Sphinxes in the avenues of Egypt do not excite horror or fright but lead man both inward and outward to the limitless space of the desert or the perennial flow of the Nile that lies in front.

In Babylonian art we similarly find the glorification of kingly majesty and magnificence. The king has a colossal figure as in Assyria and Egypt. He seizes by the horn the fantastic horned lion which attacks him furiously (representing the brute forces of nature) and kills him with the sword. He wears a diadem and is surrounded by a large retinue and a group of body-guards. He tramples on the enemy writhing on the ground or receives in solemn repose a long train of captives all strung on one rope or representatives from subject peoples bringing to him rich treasures from different countries. Such is the mighty, austere and even cruel art of kingdoms and empires that placed war-gods in a pre-eminent position in society and maintained a sharp social distance between despots

1 Rostovtzeff: *A History of the Ancient World*, p. 137.

and subjects whose person, labour and property all belonged to the ruling class.

The Gentle, Tender and Compassionate Princes and Heroes in Indian Art

Contrasted with the mighty figures that Egyptian art loved to fashion in colossal size or with the coarser creations of Assyrian art are the gentle and tender figures in Bharhut, Sanchi and Ajanta of princes, heroes and saints, of men and women in forests and gardens, palaces and cities, creatures of the nether-world and messengers of heaven in a vast throbbing pageant of life. The scenes of Indian life depicted especially on the hundred walls and pillars of the rock-carved sanctuary and temple at Ajanta exhibit man's delight in the pleasures of the senses, and enjoyment of beauty, on the one hand, and the impermanence of life and the injustice, cruelty and disaster that may come out of earthly desires and passions, on the other. There is a common brotherhood established of sentient life at Ajanta, including the animals such as the elephants and deer who show human eyes and feelings; over them all preside the spirits of Buddhas and Bodhisattvas with their unbounded compassion that is in such utter contrast with the imperious might and aloofness of the war-gods of Egypt, Assyria and Babylon. In India we had the sharp economic and social cleavage between the Aryan and the non-Aryan peoples which led to caste stratification, and the relegation of certain castes to helotry. But the self-government of villages, castes, guilds and brotherhoods and the authority of traditions and of the priesthood contributed towards the development of social cohesiveness, mitigation of economic inequalities and protection of the common people against the authority of kings and feudal nobility. The emphasis of the ideal of purity and asceticism curbed the ostentatious display of magnificence and enjoyment of luxuries on the part of the kings and nobles. Religion and art both combined to bind together the people in bonds of love, charity and goodwill. For there are different ethnic groups, brown, yellow and black, that are discernible in the Ajanta paintings, but all show physical nobility and grace, in their spontaneous gestures and movements; none shows coarseness, crassness and cruelty. Even the hunter carries on his calling with dignity and decorum. No scenes of massacre, torture and agony, as in the Middle East, but conjugal love and happiness, social obligation such as alms-giving by the house-holder, wholesome delights, recreations and adventures and protection to all sentient creatures are portrayed. The joy and radiance of the world become a reflection of the ordered pattern of the metaphysical reality on which India pins her faith.

Contrasted Ideals of Power in Art

Art in the world-empires, founded by the despots of Egypt, Assyria and Babylon, was the apotheosis of power and magnificence; like the monumental

architecture, grand and luxurious, sculpture also was impressive in its severity and ordered discipline as its subject-matter was 'the boast of heraldry and the pomp of power.' The architectural wholeness or plastic synthesis was soon lost due to the love of ornamentation and floridity of an Imperial courtly art of luxury and advertisement. Art in India, rooted in the gentleness, social cohesiveness and goodwill of the people, was introspective; it applied itself to the depicting of an inward mental condition rather than to the representation of outward events. In Egypt, Assyria or Babylon kings and emperors were glorified into gods and mysterious or supernatural beings in art. In India gods and heroes came down from heaven to the human level, and lived and suffered for ordinary mortals. In Greece, where in spite of slavery the life of each free-born citizen was subordinated to the common interests of the state, and the idea of the use of power for personal enjoyment and for the adornment of one's own existence was discounted, art devoted itself to the representation of healthful exuberance and power of man, in which body and mind co-operated with each other. Greek art, like Hindu art, found its highest splendour in the images of the gods, but unlike Hindu art it created the gods after man's own image. In Hindu art, the gods expressed transcendental emotions and abstract concepts, and their countenance was invested with the superior and dominant features associated with the uplift of the human spirit. Physical nobility was of course there, but it was the reflection of the beauty of the soul. Greek art, even while representing gods and heroes, aimed at the characterisation of bodily movements and attitudes, studied with great care, due to the free habits of the Hellenes, in the public gymnasium. The deeper levels of being, the transformation of the moods and feelings of man into spiritual ecstasies, the march of the human soul, are represented in Hindu art in the form of deities by symbolical divergences from nature. Such divergences are not intended to be forbidding as in Assyrian or Egyptian art. Greek art, on the other hand, not merely brooked no such departures from nature but rather based the delineation of the gods on the contemplation of the beauty, dexterity and elegance of the human form, or the idealisation of human characters and attributes at the merely physical or social level. The institution of slavery and the social distances between the Hellenes and the slaves or the Barbarians could not overshadow the civic ideal of the Greek city state, that evaluated individual talent and power wholly in relation to the aims of the state, and directed a sense-born and sense-bound art to represent the legends of gods and heroes rather than the doings of ordinary human beings, and the harmonious combination of manly dignity and animal spirits rather than the depth and expansion of the mind.

In Egypt, Assyria and Babylonia it was the royalty or the higher priesthood who controlled art and artists. In Assyria and Babylonia it was the emperors,

and in Egypt it was the priests who directed art production. In ancient Hellas art came under the support of the city states. Pericles of Athens entrusted his friend Phidias and his pupils with the execution of the sculptured ornament of the Parthenon, of the splendid votive temple of Athene and the celebrated statue of the goddess herself. Similarly, after the completion of his works on the Acropolis at Athens, the city state of Elis invited Phidias and his band of pupils for similar work. It was thus that the Greek democracy gave opportunities to Phidias, Polycletus, Alcamenes and other sculptors to represent the highest ideals of the Greek conception of the divinity. In republican Rome it was the patricians and the victors in arms who decorated the forum and built the temples, and much of Roman art was accordingly a vainglorious display of personal talent and power. In the East, Chinese painting, Persian painting and Moghul painting were court arts, dignified and distinguished, and rarely lapsing into lack of restraint or decorum. At Pekin, Ispahan, Teheran, Samarkhand, Agra and Delhi kings and emperors commissioned the greatest artists, while the nobility and petty rulers also emulated their example by the patronage and appreciation of the lesser artists. Thereby a kind of court art was encouraged, an aristocratic art of high technical quality, elegance and grace, although there was a tendency towards loss of æsthetic freshness and vividness due to the sway of conventional motifs and traditions. In India the difference between Moghul and Rajput painting is largely the difference between court and folk art. The Moghul School, associated with the courts of the Moghul Emperors, presents portraits of kings, nobles or saints, episodes of hunting, recreations, and court scenes. The Rajput and Pahari Schools, belonging to Rajputana, Bundelkhand and the independent Hill States of the North, generally deal with themes from the epics, and myths and legends relating to Krishna and Radha or Siva and Parvati that appeal to all classes. Like Persian painting Moghul painting is tense, severe and methodical; Rajput painting is lyrical, vivid and intense. The former is academic and conventional, associated with the opulence and refinement of the upper social classes who find their quiet emotions and distinguished manners reflected in the conventional faces and gestures of the paintings; the latter is full of passion, vitality and poetic imagination, deriving its inspiration from the background of folk-life, literature, music and erotics. In point of technique and style, the former is characterised by preciseness of line drawing and soft tonality; the latter by swiftness and flow of the drawing and bold colouring skilfully used with plastic sense of space. The former is in the tradition of a miniature, the latter of a fresco. In this manner the art of the upper social classes and the art of the people represent differences in theme, style and technique, and it is not unusual to have two different schools of painting side by side giving admirable and contrasted expression to the character of each age. Wherever elements of folk art have mingled with an aristocratic court art,

lyrical, dramatic and realistic effects lend a new charm and fluency to a formal, abstract and highly specious tradition.

The Decoration of Pleasure and Sensuality in Renaissance Art

After the Renaissance, when the Italian cities developed a flourishing, trade with the East and grew into immense wealth and prosperity, it was the commercial oligarchy that patronised the artist and controlled his products. In Venice the commercial barons vied with one another in building and furnishing sumptuous palaces and in contributing funds for the decoration of the churches, guildhalls and community palaces. Venetian art arose to idealise pleasure and sensuality that could delight the nobles, merchants and their mistresses in palaces and private houses. Landscapes, local episodes, pageants, allegories and pastorals that comprised every thing that was exciting, sportive and voluptuous, and excluded every thing that was serious and stern in life delighted the Venetian aristocracy. Even the churches of Venice were adorned with paintings from Biblical history that showed not an other-worldliness but an addition to sensuality in the seductively rounded forms of Madonnas and angels. Thus did the hedonic life of the nobles who raised sensuality into a state institution set the norm of Venetian painting, seeking to represent man's delights of the senses into a harmony of supreme loveliness. Further, the nobility of Venice demanded of painting that it advertise the Republic, celebrate her charms and flatter her rulers. "In Florence", observes Craven, "an artist was a master of all the arts of design, an architect, sculptor, scientist, engineer and humanist. In Venice he was merely a painter, devoid of intellectual interests, depicting perpetually one phase of life without the leavening of deeper feelings and dramatic complications. And the freedom of expression, accorded to the Florentines in their public commissions, enabled them to depict, in their own way, themes of the profoundest human significance and intellectual content denied to the Venetian decorators".[1]

Architects, painters and sculptors were employed not merely in Venice and Florence, but also in Rome, Naples and Padua for adorning churches and palaces with canvases, frescoes and sculptures. The Italian cities had their carnivals, processions and festivals that created an atmosphere of animation in which art flourished, while the colourful elements provided by the *festa* directly aided visual representation. But the economic and social domination of the merchants and traders in the cities of Italy, and later on in those of Flanders determined that painting should be dedicated to the show of grandeur, luxury and magnificence; there was hardly any portrayal of the life of the ordinary people. The familiar details of the ordinary scene, flowers, trees and gardens, rivers and boats, domestic life and manners and even the homely moods and expressions were

1 *Men of Art*, pp. 163-164.

discernible, but these were incorporated into the usual gold background of what were really luxury pictures painted for the rich or show pictures for the churches and monasteries, exhibiting seductive figures, feasting, drinking and "joyous worldliness, qualities that seem to have been particularly welcome to those who were expected to make their drink and meat of the very opposite qualities". Some painters like Titian became immensely rich, and owned palace-studios from which they carried on diplomatic relationships with magistrates and princes, merchants and traders in their own country and abroad and sold them religious pictures, Venuses and nymphs according to the dominant spirit of luxurious languor and holiday abandon of an age that regarded art as the highest adornment of wealth.

It was in this manner that painting in Venice which grew out of the soil of the somewhat refined and orderly sensuality of the Venetians and focussed itself on one single note to the exclusion of other passions and interests in life,—the decoration and idealisation of physical loveliness appealing to feminine sensibilities, set the standard for the nobles, merchants and traders, the palaces, courts and monasteries for the whole of Europe. About four centuries have passed since art took to the celebration of pleasure for the delight of the upper classes in Venice and other rich and flourishing cities of Italy, but this conception of painting still remains popular in Europe. In the commercial towns of Northern Europe where there was lacking the liberalising influence of a cultivated aristocracy and the splendour of modern princes, as in Italy, the narrow mercantile and mechanical outlook was responsible for a vulgar display of wealth and elaboration of dress, and thwarted and fettered the artist. The Flemings, roused to the pleasures of the senses by the new wealth of Bruges, Ghent or Antwerp, showed grossness but sincerity in their physical enjoyment as contrasted with the sophistication and refinement of the Italians who made a cult of sensualism. And the paintings of the nudes they produced had nothing of the composed elegance and idealisation of the Italian masters but were voluptuous, fleshly and plump, more true to the real and the familiar in Flanders and perhaps more effective. Rubens has in fact been characterised as "the painter of the most fleshly but at the same time the most spontaneous, the most decent and genuine nakedness in modern art". The merchants and burgesses of Flanders obtained in painting not merely seductive and opulent nakedness but also minute observation of many rich materials and gaudy forms such as flowers, brocades and precious stones that they sought in real life. Art in Northern Europe on the whole was tied down with many restrictions of guilds that discouraged competition or individual talent, and there were few painters like Rubens who were independent of guild control. Thus Durer wrote from Venice to his friend at home: "Oh, how I shall freeze up again when I turn back on this sunshine. Here I am a lord; at home I am a nobody."[1] Durer beautifully practised the democratic art of

1 See Lubke: *History of Art*, pp. 246-247.

prints in Germany, but the larger arts were still for the aristocracy and the commercial class in his country. Both Durer and Cranach were Court painters, and Holbein, last of the great Germans, went over to the single task of immortalising the features of kings and aristocrats.[1] After Durer and Holbein German painting lost its power and vitality. But the nobles of Bavaria and the wealthy and powerful middle classes patronised "art handicraft", devoted to execution of designs for armour, domestic utensils and furniture in which remarkable fineness and originality were achieved by the so-called Little Masters.

The Rise of the National Bourgeois Art in Holland

Flanders succumbed to the might of foreign kings, but not Holland. It was in the Dutch Republic which threw off heroically the vassalage of king and over-lord and the authority of the Roman Church that the common trader, artisan, burgher and farmer early reached their full worth and dignity in Europe. Theirs, however, was a dull and insipid, though clean, comfortable and self-respecting life, which was transcribed in the art that became materialistic, national, and democratic in the full senses of the words for the first time. Dutch painting loved to paint the cow-strewn polders, canals laden with boats and the green fields interspersed with picturesque wind-mills, along with the frugal burghers and housewives in their homes and topers in the taverns. It opened the avenue to the representation of familiar scenes and ordinary incidents of life, the portrayal of the common folk and common surroundings, including the interiors of homes and cottages. Its tidiness and neat documentation, with the most meticulous attention to details, were a reflection of the temperament and routine of life of the calculating merchants and thrifty burghers and their home-keeping, industrious wives that built up the economic supremacy of Dutchmen all over the world. Industry, commerce and navigation brought immense wealth to Holland which was well distributed among the masses. The small merchant, the burgher and the wealthy farmer sought a kind of painting appropriate for decorating small interiors at reasonable prices, and depicting not the courage and heroism that made Holland a republic, but the homely virtues and the quiet landscape, the much esteemed country house and the decent home, where they wanted to enjoy comfortably their hard-won wealth and leisure. Not to speak of the middle and trading classes, even the small artisans bought and enjoyed paintings in the Netherlands. Thus in 1640 a traveller observed, "many times, black-smiths, cobblers etc., will have some picture or the other by their forge or in their stall." Taine aptly remarks: "The Dutch School almost always paint man in a well-to-do condition. When they exalt him it is without raising him above his terrestrial condition. They confine themselves to reproducing the repose of the bourgeois interior, the comforts of shop and farm, outdoor sports and tavern

1 Cheney: *World History of Art*, p. 686.

enjoyment, all the petty satisfactions of an orderly and tranquil existence". The tastes and ambitions of the merchant and middle classes demanded a new type of painting that was intimate though it represented only a small corner of nature, and was appealing though it depicted humdrum existence and familiar homely moods and emotions. It was essentially a bourgeois painting, appropriate to the display of new comforts and adapted to the mental habits and emotions of the bourgeoisie, perfect in its inventory of wished-for domestic things and harmonious even in its superficiality and empty-minded concentration on bourgeois wish-fulfilment.

But soon painting turned into a business in the hands of the Dutch. The middlemen appeared between the painters and their patrons. Fashions came to be responsible for standardisation and over-production of paintings, and those who dictated fashions were not connoisseurs of art but successful appraisers of the market which absorbed paintings like other wares of the Eastern trade in prodigious quantity. Artists who dared to experiment met an evil doom quickly. Popularity and neglect had both a chilling influence on art and artists. Thus did Rembrandt, one of the greatest painters of all times, rise in celebrity and die almost like a pauper in an obscure ghetto. Art provided a living, but it was the mediocre and familiar style or mode that satisfied the bourgeois desire to possess and display pictures. Thus it was in Holland that the pursuit of art first entered upon its uneven and precarious phase that became more and more marked with the progress of capitalism as the artists first produced the picturesque and genre painting that became more and more popular in the subsequent centuries.

The Democratic Art of the French Republic

Prior to the French Revolution that swept away from Europe the vestiges of the feudal regime and authority of the Church, a baroque emotionalism was prevalent in painting, and the rococo style in architecture, characterised by fantastic decoration of the interiors and even the exteriors. Their economic basis was the domination of an effete and profligate aristocracy, composed of hereditary nobles who sold their titles, and the new rich who bought these titles, farmed state revenues and acquired wealth by dubious financial transactions. The grand passion was superseded by philandering. The frivolity and licence of the age were reflected in the courtly, decorative and sensual painting and the excess of ornamentation and the profusion of sinuous curves in rococo architecture. When the Revolution was on in Paris, the painter David did not produce voluptuous landscapes and episodes for the aristocracy but went back to the classic tradition in order to purify painting of all that was courtly, trivial and effete, and sought to express the democratic virtues in the vernacular of Republican Rome, following the maxim of Diderot that art must have the purpose

of glorifying great and fine deeds, of honouring unhappy and defamed virtue, of branding flagrant vice and of inspiring tyrants with fear. David was the dictator of art in France for a decade. Instead of the glittering, erotic and baroque art of the French Empire, rooted in the grandeur and vices of the court at Versailles, David sought to create a national democratic art of the French Republic, taking his models from the ideals of ancient Rome. Soon, however, such kind of picturing was found too cold, unreal and devoid of social significance. Chardin and Greuze were representatives of a new tendency in French painting which appealed to the people, *viz.*, the stress of domestic scenes and virtues of the middle class along with a charm of documentation and emotional fervour inclining to sentimentality, following the tradition of Dutch genre painting. Again, the first effective movement in realism began, led by the romanticists such as Gericault, Delacroix and others, who produced historical genre paintings of thrilling interest, and by Breton and Millet, who represented the life and labour of the peasants in the fields with profound sincerity and chaste simplicity. For the first time in the history of art the labour of the common people in the fields was represented with an almost religious earnestness, insight and truth of expression. Such portrayal of peasant life and labour in its simplicity and depth of sentiment was synchronous with growing industrialisation and the steadily increasing exodus from the countryside. On the other side, Daumier was the social historian of the city of his epoch, exposing powerfully with his cartoons the miscarriage of justice, the callousness and hypocrisy of the bureaucracy, the meanness of the bourgeoisie, and social inequality of all kinds and dramatising the struggle of the Have-Nots. Thus he opened up a new vista for art in the industrial age with a tragic emphasis. But his talent and self-expression were inhibited by long drudgery at journalistic lithographs, and he died in poverty in a country cottage provided for him by the painter Corot. Another painter with distinct proletariat leaning was Courbet, the son of a wealthy farmer and the friend of Proudhon. He depicted peasants and their women with an intense sympathy and realism that shocked the Salon painters and the public, and had to his credit two 'socialistic pictures', 'Le Retour de la Conference' and 'L' Aumone d'un Mendiant,' which gave him such a reputation that he was condemned by law and died as an exile in Switzerland. Meunier was another artist of repute, full of proletariat realism, whose sculptures obtained considerable support from the revolutionary thought of the time. From Daumier and Millet to Meunier there was a definite increase of the revolutionary urgencies to which a larger and larger proportion of the intellectuals and artists subscribed.

Art and Industrialisation: Turner and Van Gogh

In England where industrialisation had preceded and progressed at a quicker pace than in France, the smoke, the dirt, the rubbish and the squalor of the

industrial towns, producing human ugliness and wretchedness on a colossal scale, as a reaction gave birth to the landscape painting of Constable and Turner who depicted the loveliness of the English heaths, cottages and farm-lands that were fast being darkened by large-scale industry. Turner by his ethereal treatment of colours and plastic handling of planes and volumes produced some of the most imaginative and harmonious works in the entire range of the world's landscape painting. And at least one of his pictures, 'Rain, Steam and Speed', discovered poetry in the movement of the locomotive, symbol of the industrial age. The school of landscape painting in England expresses deeply the regrets of a nation that has turned its back upon the beauty of the countryside and the virtues of the yeomanry in an epoch of wholesale expropriation and rural exodus and the first advent of smoke, dirt and squalor with industrialisation that is destined to make her the workshop of the world. In France the Barbizon School and the Impressionists such as Monet, Pisarro and Corot similarly produced idyllic scenes of woods, hills and meadows, and are said to have 'universalised landscape as the Dutch working in a flat country and a minor key had not done', and invested it with true poetic beauty.

But the most original and powerful of them all is Van Gogh, one of the significant moderns, whose life was a complete and an overwhelming tragedy. From early days Van Gogh was struck by the "almost complete vulgarity, the provincial drabness, ugliness and meanness of modern civilization". He lived in the gloom and fog of London, but was enchanted by the beauty of the English countryside, its laburnums, chestnuts and apple trees. He also knew first hand the ugliness and degradation of modern industrialisation, for he was for some time a sort of chaplain and charity worker in the slums of London. It was his contact with terrible poverty here which first aroused in him the desire to express himself in pictures. Then he lived for some time as an evangelist in the Borinage, the 'black country' of South Belgium, among the miners in their hovels to share their life, practising Christian communism. With the austerity of a saint he even blackened his face with coal-dust and dressed himself in sacking.[1] He cared night and day for the miners, gave away his blankets and clothes, and when a pit accident occurred he tore up what was left of his underclothes for bandages. He wrote poignantly to his brother: "To love much is the best means of approaching God. I love these poor miners. Disdaining clay and colour, I work in living flesh and blood as did Christ, the greatest of all artists." Miners and their wives became the models for his art. Thus he painted the gnarled bodies of the miners, the almost animal stupor of their faces, bent over their bare dinner of potatoes, the eternal blacks, grays, dark blues and soiled yellow of their poverty-stricken homes.[2] Soon he was reduced to vagabondage, roaming the country but always

1 Burra: *Van Gogh*, p. 41; Faille: *Vincent Van Gogh*, p. 10.
2 Mumford: *Technics and Civilisation*, p. 201.

sketching miners, peasants and their wives, old and ugly, depicting real men and women, and their souls, "not like imitation saints or ideal images" of the old masters. Subsequently he went to France where his painting became much lighter under the delicate and clear French sky that "seemed quite different from the sky of the Borinage which was close and foggy". From Paris he migrated to the South where he hoped to establish "the studio of the future". "Life is after all enchanted", he once cried here, and he saw a vision of Nature that none could dream or portray before. For he actually felt the intoxication of the red oleanders under the full sun, raving mad, and the ascent of sap in the fresh flowers and in the green of the row bushes, continually renewing itself in fresh, strong jets, apparently inexhaustibly. Once he had painted miners with the very dust of the coal they were digging and the peasants with the very earth they were ploughing. "I want to paint humanity," he had then written to his brother Theo, and "again humanity." Now he painted the sun, the sky and the field in spring and autumn with the force and concentration of one who had lived in nature as if he were a blade of grass and a fresh flower. He strove after a religion of nature that combined an intoxicating, sensuous delight in irises, sun-flowers and cypresses with a vast imaginative power by which he could enter into unison with the grasses and flowers, the seasons, the wide aspects of the countryside, and human life, whole and entire. His failure in life, unhappiness and tragic death symbolise the bleak denial by industrialism of man's natural happiness and sources of strength, and the muffling of the bright colours of the countryside by its smoke and dirt.

The Isolation and Individualism of Some Moderns

Van Gogh lived and died as an irrepressible individualist. "Life", he said, "is like a single journey in a train. You go fast; but cannot distinguish any object very close, and above all you do not see the engine." Hardly did any artist paint so personally; hardly was there one whose outpourings were expressive of utter loneliness and unhappiness and yet of an undying faith in humanity that is one of the best fruits of the domination of scientific thought and industrial economy. Like Van Gogh, Cezanne was also an individualist and hated the sordidness and ugliness of bourgeois life whence he fled to his countryhouse near Aix where he developed in isolation a significant trend towards an abstract art. Similarly another rebel was Gauguin who gave up his money-making on the Bourse, retreated from the artificiality of Parisian society to the South Seas, 'went native' and painted a series of exotic pictures, remarkable for their decorative effects and colour harmonies.

Much of modern art is the expression of an exaggerated individualism, of much loneliness and unhappiness that are the outcome of a profound lack of integration between economic, social and æsthetic values within the modern

mechanical industrial culture. An artist seeks self-expression and separation from the machine system in which he plays no part, which become exaggerated into eccentricity. If mass standardised production finds no room for art work, the latter becomes esoteric, spiritual and independent. Thus is brought about a gulf between the artist and the common man, between æsthetic values and the general current of life, values and achievement. There are gulfs between man's aspiration and behaviour in the economic, æsthetic and moral fields in ·each of which patterns of behaviour and values develop which do not fit into a harmonious whole. Thus result a chaos and confusion of values and individual insecurity on a scale unparalleled in the past. Capitalism, directed by the profit motive and governed by the competitive systems of production and distribution, has not merely given no rôle to the artist, but has also exaggerated the significance of his subjective moods, and is now responsible for a chaos of styles and moods, or rather a complete æsthetic anarchy. Modern industry and machinery have made man a servile automaton, an insignificant cog moving to the rhythm of the irrational machine process. A school of art has seized upon this, and finds in geometrical organisation and mechanical symmetry the essence of artistic expression, utilising the soul-killing standardisation itself as the source of inspiration of the soul. It upholds the logic of the machine by mathematical symbols, and interprets life in terms of inorganic mechanical equivalents. Art, losing its vital contact with social life and relations and faced by the stupendous power of the machine and the force of mass standardisation, has shown a new mechanical and geometric preoccupation unknown in the past.

Mechanisation and Geometrisation in Art

Not that geometric or abstract art was not practised before. Even in primitive art we find the representation of symbols of an intuitive and abstract kind. Worringer suggests that the primitive man who lived in perpetual fear of the environment took refuge in fixed conceptual images that symbolised a desire for order and control and escape from the casual perceptual images that were a source of anxiety and terror.[1] Just as animism converted dangerous beasts of prey into animal guardians and totems, similarly primitive art, guided by the impulse of self-preservation, produced the generic or "stylised" animals that offered protection and good will. Rhythm is a more familiar experience in labour, music and dance of the primitive as compared with the civilised peoples, ·and this converted the animal totems and guardians into rigidly symmetrical or harmonic designs whether in textiles or wood work, fetishes or totem poles. Primitive decorations were, however, not esoteric but perfect communal expressions of tribal experien:es and ideals. Geometrisation is found not merely in primitive decorative art but also in Scythian, Byzantine, Hindu, and early

1 *Form in Gothic*, p. 29.

Gothic art. It is commonplace that geometric verticals, horizontals, triangles, diagonals or circles produce the same effects in mind of the beholder whether in painting, statuary, architecture or dance. A few familiar examples may be adduced. The Egyptian statue of Ka-aper, the Hindu standing images of the Buddha of Mathura and the Bodhisattva of Gandhara (Lahore Museum), the South Indian bronze images of Subramanya, the images of the Jain Tirthankaras and the Greek bronze known as the Charioteer of Delphi are excellent examples of the vertical expressing balance, poise and dormant force. The horizontals, expressive of complete cessation of movement, are well shown by the mother and child images and the Parinirvana of Buddha in Hindu and Buddhist art and by the Dying Gaul in Asia Minor. This is described in Hindu Silpasastra as the samavanga (equally bent) as contrasted with avanga (little bent) and atibhanga (greatly bent) or tribhanga poses. The diagonal expresses the maximum of movement so marvellously represented by the images of Durga in Ellora and in Java (Chandi Singasari) and of Agasias (the Borghese Warrior). The triangle on a wide base remains in equilibrium, and suggests firmness and stability. The seated, meditative postures of all icons in Hindu and Buddhistic art with their triangular outline and broad base convey poise and firmness. Of these the most distinguished are the Buddha images at Sarnath, Ceylon and Borobodur. Of the rectangles the pyramid suggests the most complete equilibrium and absence of movement, and hence eternity, as in the case of the pyramids of Egypt. More than any curved shapes the circle is the most poised and restful. Thus all the dancing images in Oriental art form by their numerous hands and their gestures and equipment a moving circle. The most celebrated of these are the Siva, Krishna and Ganesa Tandava and the Mahisamardini images of India.

Geometrical form and symbolism are often combined in Oriental iconography. Most seated figures of the divine couple or of the single goddess or Sakti show a triangular yantra-like composition, brought about by the triangles of arms and torso pointing downward and corresponding triangles pointing upward, i.e., from feet or knees to point of crown or flame halo and sometimes again from the two upper hands to the same point. Familiar illustrations are represented by the Uma-Mahesvara and Saiva images of Bengal in which the god and goddess are represented as embracing each other, and the images of Tara, Kali, Gauri and Parvati of various types and epochs. Tantrikism has made the Oriental familiar with the significance of the triangle, Sakti or the universal feminine principle being regarded as the presiding genius of the triangular space in the mid-most portion of the human body (muladhara) whose awakening implies the birth of spirituality. Thus a profound æsthetic and spiritual effect is produced by the blend of symbolical and formal or geometrical elements in the modelling of images.

Lines, planes and curved shapes are all now being used by the school of Constructivists in the West in a more abstract and simplified manner than ever before, seeking to reveal delights and insights of the mystical realm beyond visible nature's. Constructive art tries to present the reality that is indefinable in mystical experience in terms plastic. "The constructive idea has revealed a universal law that lines, colours and shapes possess their own forces of expression independent of any association with the external aspects of the world". At no time in man's history have the machine and its processes touched almost every phase of human experience as now and it is no wonder that man interprets human perfection and destiny in terms of the machine. In the era of standardised machine-production, when man constantly encounters architecture, furniture and appurtenances of daily living made by machines, his habits of perception become dominated not by green meadows, tree-covered and irregular mountains and meandering streams but by the masses, volumes, planes and colours typical of industrial products. Thus there is brought about a reorientation of æsthetic values. Industrialised civilisation develops preferences towards shapes and proportions associated with economical adaptation of parts to the function of a whole. But a balance is always struck between beauty and utility so that the useful and efficient things that satisfy do not represent bare geometrical shapes or figures but have dynamic artistic forms. The mass and symmetry of vast steel and concrete architecture, the transparency of glass and the high polish of wood and steel furniture in spacious rooms, the simplicity of form of many commercial products, stripped of embellishments, have all educated the eye for the appreciation of powerful lines and curves, absolute shadows, simple colours, and unity of designs, that are so clearly discernible in modernist painting and sculpture. The uniformity of a vast row of products of glass or polished steel stretching for over a long distance, the symmetry of a big engineering or steel work like a suspension bridge or a skyscraper, the power and the magnificence of gigantic cranes that combine enormous strength with flexibility, the intricate harmony of cell activities under the microscope, all arouse a new sensitiveness towards mathematical organisation. Spengler has observed that "the sense of form of the sculptor, the painter, the composer is essentially mathematical in its nature". Artists like Léger, Grabo, Mondrin, Moholy-Nagy and Hausmann are thrilled by the contemplation of lines, circles and planes, and are giving us a new satisfaction that is rooted in the sense of balance that is an innate necessity of the geometrical universe. In the art work of the Constructivists, we, indeed, find the machine system and processes reduced to some kind of simple mathematical formulæ that help us in finding out what emotional values we may seek in our mechanical environment. Epstein's Rock-drill and Brancusi's Bird alike powerfully exhibit certain generic ideas or symbols through the transformation of mechanical rhythms or relations of form and volume into æsthetic delight. It is

thus that the Constructivists are seeking to dispel the prejudice against the machine as necessarily hostile to æsthetic apprehension.

The Gulf Between Geometrical and Popular Art

But for the common people the machine is not yet assimilated to the mind and personality, and geometrical and abstract art remains aristocratic, intended for the few. Nor is art wholly geometry or conics sections. These latter have a place in art in so far as these may aid in achieving interpretation. This involves that all art work must bear some resemblance to visible nature, although such resemblance may be confined only to the details and not to the general form. Art, therefore, cannot completely abandon the realities of nature through which alone it may bring social appreciation to bear on abstractions and symbols. Visible nature is also an unfailing and infinite reservoir of suggestions that man's senses receive in respect of rhythmic arrangements of lines, forms and colours. In the West while the varied schools of Abstractionists are creating forms of art, that remain indifferent to social appreciation, a new school of muralists, represented by Rivera and Orozco, has risen who are combining an abstract and symbolical art with a profound interest in the social and the economic milieu. They seem to be bridging successfully the gulf between a popular and an abstract or esoteric art through their intense social consciousness.

The giant machine system guided by the profit motive on the competitive basis has now become all-pervasive in its influence through the system of distribution, banking and finance, and makes it impossible for the individual to understand and participate in its processes. This largely explains why the machine system and its by-product, geometrical art, remain alien to the mass of the people. It is collective control of the industrial machine and of distribution through some kind of state socialism that can alone change the animus of the machine system from exploitation to social effort, afford adequate security to the individual and give opportunities to his creative enterprise. This is the chief promise for art held out by Soviet economy that has offered opportunities for creative experience that is essentially social in both its aims and processes. Thus Lenin observed: "In a society based on private property the artist works to produce ware for the market, he needs purchasers. Our revolution has freed the artists from the yoke of these very prosaic conditions. It turned the Soviet Government into their defender and placer of orders. Every artist, everyone that considers himself an artist, has a right to create freely accordingly to his ideals, independent of anything".

Art and Economic Insecurity

As a matter of fact the present distinction between a popular and an esoteric or aristocratic art, divorced from its social and teleological basis, is too firmly

rooted in the present economic structure of the society organised on a competitive rather than a co-operative basis to be too easily abolished. It is the absence of the artist's security and his complete dependence on the dealer and the critic that have placed him in a world of his own, and stimulated the unique individuality that erects a pure æsthetics by the separation of methods and technique from expressive ends. The very unreality of modern abstract or esoteric art is a symptom of disequilibrium of the social and economic order.

The present decadence of art is associated with the rise and spread of industrialism and capitalism that have thrown the individual artist on his own limited economic and spiritual resources at the cost of profound maladaptation and individual neurosis and revolt. The artist in all ages is unique in his imaginative gifts and sensibilities. But no true and enduring art work can be achieved so long as there is no fusion nor integration between the artist's unique faculties of apprehension and insight and the collective values and aspirations of the people. Modern capitalism with its profound economic insecurity for the majority of the population and the striking disparity of standards of living of the different economic classes prevents such integration, and thus art has become more of the nature of an escape, a reaction or an adjustment to something external. This explains not merely the hiatus between art for the *elite* and art for the mass of the people, but also the wild extravagances of certain art modes and schools, characterised by a complete divorce of technical procédure from both experience and intelligible meaning.

With the restriction of the values of art to mere technical procedure, the conviction no doubt gains ground that art appreciation rests on special training or the unusual experience of the elect. Thus artists and their supporters form a privileged coterie which scoffs at humanity and its cares and conflicts. It is the artist's immediate environment of critics and collectors, parvenus and politicians that bolsters up his fad and cult with its pompous denomination, and fosters his snobbery and cynicism. On the other hand, as art divorces itself from its social functions and meanings, the artist spins round and round in his futile imaginary world, driven by his repressed urges, reveries and fantasies. He makes no serious attempt to achieve the fusion between the unconscious and the conscious aspects of his nature. It is in this manner that the unbalance in the social and economic order is poignantly reflected in the pathetic suffering and lack of poise of artists that are some of the most sincere and sensitive souls living.

As long as modern industrial culture fails to achieve some solidarity of purpose and social integration through a general idealism, art can find neither its inner harmony nor its mass vision. Art rises to its full spiritual glory only as collective vision: it is then recognised not as property or as selfish enjoyment but as the fairest and most enduring fruit of a rational culture in which the entire community shares up to the limit of its capacity of enjoyment.

CHAPTER XIII

THE SOCIALIZATION OF ART

Art and the Guild

For a great part of the history of mankind, man's achievements in the realm of art were the monopoly of special groups of castes which obtained economic and social advantages or privileges from their calling. Among the savages there is clear recognition of the artist's rights in the product of his own creation, and this is especially strong when the works concerned are of a religious character. Adam has shown that among the North-west American Indians, the various clans are distinguished by crests, clan religions and songs. The elder of the clan or family is invested with their ownership. It is he alone who has the right to use the crest and the right to carve, say, a new mask representing it. Property in craftsmanship is thus exclusive. Nobody but the owner is permitted to make a wooden statue, a fetish, or a mask, just as nobody but the owner is allowed to tell the legend or perform the dance. Other primitive peoples, such as the natives of the Eastern Torres Straits Islands and the Central Eskimos, have developed incorporeal property on the same or very similar lines[1].

In advanced cultures, economic differentiation reaches a more complex stage, and caste and craft guilds arise that claim and obtain the exclusive right to pursue certain arts and crafts. In India, even up to the present time, many arts and crafts are inherited from fathers to sons, and the entry of outsiders is strongly resented or disallowed. This prevents the over-production of art wares and contributes to maintain the standards of craftsmanship and of living of the artisans and artists. On the other hand, within the craft guilds, there is an upward economic movement of apprentices and artisans who may rise to the status of master workmen and artists. We come across references to the painters' guild as early as the Buddhist period in one of the Jatakas (VI, 427). Brihaspati mentions the guild of painters (Chitrakaras), among other guilds of craftsmen, as laying down its own laws to be respected by the king.[2] One of the most important architectural monuments of ancient India is the Visvakarma Chaitya Hall at Ellora (about 6th century A.D.), dedicated to the Divine Architect, the presiding deity of all arts and crafts. Havell suggests that this was the chapel of the guild of sculptors and masons who resided at Ellora and for several generations dedicated themselves to building temples out of a mountain and modelling sculptures

1 Adam: *Primitive Art*, p. 59.
2 At Pallakdal, Codrington mentions, the name of the guild of the Sarva Siddhi Acharayas is inscribed.

that are some of the most marvellous for their vigour and plastic rhythm in the whole world. Just as Pericles beautified Athens by employing architects and sculptors, so a succession of princes who were responsible for the magnificent architectural undertaking at Ellora supported the guild of sculptors and masons for centuries during the gradual process of temple building and the production of monumental works of art. Craft guilds in both India and China and the medieval West have served as adequate means of protection for individual artists and workmen who produced for a limited market that could be foreseen, and who could not with impunity lower the standards of art or craftsmanship. In medieval Europe, art was in the hands of the guilds that were strong, powerful and exclusive. Maritain enthusiastically observes: "In the powerfully social structure of medieval civilisation the artist ranked simply as artisan, and every kind of anarchical development was prohibited to his individualism, He did not work for society people and the dealers but for the faithful consumers; it was his mission to house their prayers, to instruct their minds, to rejoice their souls and their eyes. Matchless epoch in which an ingenious folk was educated in beauty without even noticing it, as perfect religionists ought to pray without being aware of their prayers; when doctors and painters lovingly taught the poor, and the poor enjoyed their teaching because they were all of the same royal race born of water and the spirit."[1] But with the growth of wealth the guilds soon came to be imbued with a spirit of commercial oligarchy and also discouraged the initiative and genius of the individual artist who became miserable. In the cities of Northern Europe the guilds controlled art more rigidly than in Italy, with longer apprenticeship and little incentive to individual talents. The Guild of St. Luke in Antwerp, for instance, included painters, saddlers, glass-makers and mirror-makers; only painters were allowed to work in oil and the right to use water-colour was restricted to the illuminators. Even after an artist became a master-craftsman, unless he were in the direct employ of a prince, his contracts, materials and tools were supervised by his guild. The system insured thoroughness, durability and the fine craftsmanship, qualities in which Flemish painting has never been equalled.[2] Rubens in his early years was a free master of the Guild of St. Luke, but after his visit to Italy became independent of its authority. In India and China, such artists as painters, sculptors and architects, who follow the indigenous tradition and have not come under Western influence, still belong to guilds. In the Italian cities authors could have political status only as members of working guilds.

Artists' Guild in Europe and India

In Europe the Renaissance and its intellectual product, the Humanist

1 Quoted in Sorokin: *Social and Cultural Dynamics*, Vol. I, pp. 324-325.
2 Craven: *Men of Art*, p. 199.

Movement, led to an emphasis of the study of Greek and Latin and theology which sharpened the cleavage between the class of producers and artisans and the intellectuals, that was brought about by the new capitalism and the disintegration of guilds in the commercial cities. Even Leonardo da Vinci had to justify himself in his private notes against the general assumption that his interests in painting and science were *infra dig*. In the Orient the craft guilds supported one another and did not experience the internecine conflict, characteristic of guild history in the West, and obtained recognition and important social and economic privileges from the community. Many industrial and commercial guilds in Southern India still levy contributions on looms and anvils or derive their income from collections of a certain percentage of sales or profits and maintain a variety of charitable institutions and temples. These have usually their own caste temples, but also undertake to supply daily offerings and requisites to the major temples of the city to which they belong or regularly meet expenditure for temple and city festivals and processions. For centuries in South India public beneficence has expressed itself in the endowment of villages or lands for the construction and restoration of temples and of images of gods and goddesses by architects, sculptors and artists and the provision for various services and offerings to the deities including the supply of oil, flowers, garlands, rice and ghee, the performance of dances and representation of dramas.[1] A large variety of temple officers and functionaries has been thus maintained through the centuries by liberal endowments of kings, the nobility, village assemblies and the common people as abundantly recorded in South Indian inscriptions. Such temple functionaries usually comprised priests, accountants, purohitas, goldsmiths, dancing girls, painters, men who ring the bell, makers of garlands, watchmen, the blower of the conch and torch-bearer. (South Indian Inscriptions, No. 157 of 1913). In one of the grant plates (Kuram grant, S.I.I., Vol. I, p. 154) we read that the priests (Archakas) were entrusted with the task of repairs of the temple (Nava Karmartham). It is remarkable that not merely kings, princes and rich merchants provided substantial endowments of lands, revenues or sums of money for the construction, maintenance and restoration of temples, but villages and towns and petty artisans, shop-keepers and cultivators contributed their quota towards these objects. Thus shares of grain at each harvest, imposts on looms and cesses on trade profits were often set apart for temples and gods. All this received the sanction of kings, village assemblies and guild councils. It has been in this manner that Indian temple building and sculpture, while these have represented mass vision, have been undertaken through the support and enthusiasm of the entire population. This has also contributed in no small measure

1 See Mookerji: *Local Government in Ancient India*, pp. 298-365, for such religious and secular charities; also Minakshi: *Administration and Social Life under the Pallavas*, pp. 173-178.

towards a large diffusion of artistic culture, as illustrated in the folk arts and handicrafts of India.

For the celebrated temple of Meenakshi in the city of Madura rent-free lands are even now provided for families of temple artists along with those of priests (Archakas), accountants, seal-keepers, watchmen and other temple servants. Thus three families of Devadasis are maintained whose duties are to sing and dance at the end of the daily worship and to accompany the processions of the temple god in the city and make offerings at intervals. Then there is the musician, who sings pious songs (othubar) at the end of the worship in the temple and also in the street processions, and who is also given rent-free land. There is the actor who plays the rôle of a fisherman in the pageant exhibiting the god's sport of fishing. His family also enjoys the possession of rent-free land. Then there are fifty families of sculptors and masons, ten families of carpenters, two families of blacksmiths and six families of potters, who enjoy the similar privilege of rent-free lands. Artist priests are not unknown in India. In the ranks of a certain group of artisans within recent years, Percy Brown found "a cleric, one of the temple staff whose duty it was to paint the images at the festivals and perform art-work of a like nature, and who was accepted by his fellow-craftsmen in the dual capacity of both painter and priest. As shown in the case of medieval Europe, the building of temples in India was not done by priests trained in the art, as sometimes supposed, but entirely by the hands of lay artisans, professional masons by heredity, known as silavats or salats."[1] Priests, masons, sculptors, painters, dancers and menial servants, all are maintained with their families in Indian temples and monasteries by liberal gifts of land or revenue from land. Artists and artisans here are freed from the dependence on the market. It is the temple which places orders for a variety of art objects and provides the background of experience, tradition and culture, in which the artist, assured his subsistence and security from the temple endowments, can create freely according to his ideals. Each individual artist obtains from the traditional technique, preserved by the guild, the necessary guidance enabling him to rise to a higher level than is possible in a regime of divided personal effort.

Art and the Social Vision

Art history has shown on the whole that the highest achievements are due more to the expansion of an archaic convention and heritage that expresses the national mind through the centuries than to the effort of individuals. It is not seldom that after the acme of individual achievement art has quickly declined, leaving behind a legacy of a varied but sometimes incoherent expression. On the other hand, whenever art presents a collective vision and experience, it has a far less chequered history and shows a higher aggregate level of work. Tradition

1 Percy Brown: *Indian Architecture*, p. 139.

which is seldom discarded not only maintains a high degree of artistic excellence, but also assures popular acceptance and appreciation of the art where the familiar is accepted, and yet the variation is as inexhaustible as human insight and vision. The themes from the lives and loves of Radha and Krishna, Siva and Parvati in Indian Rajput painting come back again and again to us in innumerable pictures with the freshness and variety of concrete human situations; their ever-renewed charm guarantees their assimilation into the life and thought of the people of India. Similarly the Japanese colour-prints handing down from generation to generation a rich artistic tradition are inspired by scenes of daily life and episodes familiar to the Japanese people, and invest man's common place existence with a grace and richness unparalleled in any other country. It is a popular art created by artisans and shop-keepers cherished for the sake of their colour and design by an entire nation. It has contributed to make the Japanese more sensitive to beauty in every phase of their existence than probably any other people; while the rejoicing of the common people in art work from generation to generation assures security and support for the artist. Art in the Orient is a product of social vision and a controlled, co-ordinated effort of centuries, and it is the collective support of artists that ensures that freedom from insecurity without which true artistic inspiration cannot bear fruit in full harmony with the artists' concrete experience in the world.

We have seen in our preceding analysis of the artistic conciousness that social values and attitudes as represented by the Super-ego enter into the mechanisms of artistic expression and resolve the inner conflicts of both the artist and the beholder. At a deeper level of experience the artist's ego finds a harmony or concord of Being and Becoming through its unison with the entire environment of experience. Art from this point of view ensures sanity and emotional harmony for the individual in which the entire social or cultural process is also implied. The Marxist philosophy has recently stressed this latter aspect. It regards value in art as consisting in its power to give emotional systematisation to social life as a whole, to achieve expression of the emotions of collective experience, apart from yielding a greater emotional balance and richness to the psychology of the individual. On the one hand, art is the product of social experience; on the other hand, its value in any particular case depends on the generality and social significance of the emotional experiences which it symbolises.[1] Art in Soviet Russia claims unity of style, a single historical trend defined by the term Socialist Realism characteristic of all its branches. I. Moskvin observes: "The prime maxim of Socialist Realism is that art shall be true to life. We learn to see life in its movement, in its development, in its endless variety. In the U. S. S. R. new human relations are developing on the basis of a totally new, socialist attitude towards labour, property and the home country.

1 Dobb: *Russia Today and Tomorrow*, p. 39.

It is the mission of art to reflect this new outlook. Its fulfilment requires a deep insight into human psychology, emotional power and monumental form." Karl Radek defines the doctrine of Socialist Realism in art as follows: "Socialist Realism means not only knowing reality as it is, but knowing whither it is moving. It is moving towards socialism, it is moving towards the victory of the international proletariat. And a work of art created by a socialist realist is one which shows whither that conflict of contradictions is leading which the artist has seen in life and reflected in his work."

Socialist Realism and Mass Art

It is difficult if not impossible for an artist to achieve this end without a close participation in the constructive life of the country. In Russia artists are sent on free annual tours to various parts of the country, and encouraged to have as close an acquaintance with the larger collective undertakings and experiments as possible. Sholokhov, the author of 'Quiet Flows the Don', has made his permanent home in the village whose collective undertakings he depicts sincerely and powerfully. On the one hand, all authors, painters, sculptors, actors and play-wrights receive an encouragement unknown in any country in the modern world. The state gives regular orders to painters and sculptors for the purpose of decorating public institutions, parks and factories, and also arranges for the cheap supply of the materials they use. Artists are relieved once for all of the anxiety lest the products of their art should find no sale—so wide has become the demand for works of art. There are also special co-operatives for authors, painters, sculptors and other artists which also help them on a new and lavish scale. The various arts also form a part of every day teaching, and all professional training in hundreds of schools is free of charge, all persons being also given an allowance and the free use of living accommodation, reading rooms, libraries and other opportunities. On the other hand, the artists must be true to the proletariat ideal, and view life as the proletariat view it. In the first place, the artists and the public are regularly brought into intimate touch with one other. Thus a painter, a sculptor, a novelist or a dramatist are expected and encouraged to meet their audience and to discuss with them the principles of artistic production and obtain their criticisms and suggestions. If the artists do not follow the generally prescribed path of Socialistic Realism, the ruling party in Soviet Russia is strong and resolute enough to discourage any individualistic deviations. Ideological opposition as well as the withholding of orders and ostracism are enough to check the erring spirit. In painting, for instance, the object of proletariat art is to give pleasure and regard life with optimism, and the dominant themes are modern life with its fresh possibilities and strong wave of optimism as well as neutral subjects. Landscapes, still-lifes, interiors, and above all, portraits, are still permissible themes for Soviet painters. But strenuous

resistance is offered to 'painting which distorts the lines of reality and pictures chaotic fragments in place of landscape and people; which shows humdrum and insipid themes instead of joy and heroic reality.'[1] The majority of good Russian paintings is a revelation of the new landscape and the new people expressing the sincerity, joy and aspirations of a people, working towards a higher social integration and harmony. It is also significant that many of the master artists are coming from the working class. At the same time the danger of the working class, who have not obtained adequate artistic education in such a short period of emancipation, suppressing stylistic distinctiveness of individual artists is not small. If new styles of mass art cannot obtain free expression due to the verdict of the proletariat which is apt to develop standardised artistic outlook and tastes, Soviet art may degenerate into a mere pictorial representation of the environment without any profound implications in emotional experience and form of expression. Yet there is no doubt that there has been a gain to art for the world in that at least in one country art is a social inspiration, is far removed from a thing in the abstract that subsists on the support of a small coterie but expresses the emotional experience of the community at large whose reactions to it have an immediate effect on the attitude and style of the artist. Well has Lenin expressed his conviction that art belongs to the people and ought to extend its deep roots unto the very thick of the broad toiling masses. It must be understood and lived by them and no other. It must unite and lift them up in their feelings, thoughts and aspirations. That art alone, and nothing else, can be a substitute for religion. It is noteworthy that in Soviet painting the dominant art motif is an abundant social optimism that stands over and beyond the storm and stress of events, while a considerable proportion of the artists, especially sculptors, comes from the working class. In the U.S.S.R. art is regarded as a national legacy and has become an essential component of education and is sought to be made available for all. No state in any other country has been so active in both the encouragement of artists and the diffusion of artistic education and culture among the people. Only where art ceases to be an individual experience and a luxury for the few, but represents a mass experience for the enjoyment of all can it play its due rôle in the organisation of society.

In Soviet Russia remarkable, if not epoch-making, advances have been made in the spheres of architecture, the theatre and the cinema: "all significantly enough, collective rather than individual, forms of art." The basic subjects of Soviet architectural production are structures of a mass character which constitute entirely new types never erected before. Workers' clubs have, for instance, been built in all the large towns of Soviet Russia, and these accommodate within their premises a studio, a theatre, a gymnasium, a nursery, a library, a reading

1 Kurt London: *The Seven Soviet Arts*, pp. 272-283.

room and halls for meetings, class rooms etc. Similarly the numerous "palaces of culture" comprise halls for theatres, libraries, laboratories, games etc., serving the varied cultural requirements of thousands of people. The residential houses for workers are also equipped with club rooms, reading rooms, kindergartens and public dining rooms. Soviet architecture has sought new forms and new styles that represent an organic unity of the principles of functionalism and constructivism with artistic expression in line with the motifs of buoyancy characteristic of Socialist Realism. Soviet theatrical art is also a mass art comprising thousands of the population who in any other country have no opportunity of going to the theatre. The Soviet plays have taken up the tasks of interpretation of the psychological interaction between individuals in the various strata of Soviet society, workers, collective farmers and intellectuals and the new economic system. Exceptional attention is paid to the actor so that he may represent all that is new and that is coming in Soviet society. The stage setting characterised by the use of movable platforms, ladders and bridges endeavours to accentuate the intrinsic development of the action and even the psychology of the *dramatis personae*. Some of the best Russian plays, focussed towards the expression of emotion and turmoil of large masses of men, have elicited new talents in Russian actors, directors and scenic designers. A most interesting phase of development of the Soviet theatre is represented by the mass plays such as the 'Liberation of Labour' which are arranged on a vast scale and in which the action oversteps the boundaries of the theatre and is transferred to the street. These owe their origin to the festivals of the French Revolution and also resemble the plays and pageants of the East. It is the talents of the Russian actors and directors producing dramas of mass passion and action that have contributed to make the Soviet theatre the most artistic and unique in the world.[1] The Soviet cinema has also led the world in presenting sociological ideas and purposes, on the one hand, and experimenting with scenario methods, especially appropriate for the movement and action of large masses of people on the screen. The masses are personified while individuals also grow into social generalisations. Combining realism, psychological insight and ideological significance, the Soviet cinema has now reached of all arts the closest to the masses, actively contributing to the further consolidation of the new system of society.[2]

Cinematography's great achievements have been in the presentation of history or natural history, the sequences of social events or the interpretation of subjective moods, dreams and phantasies. The abolition of the boundaries of time and space and the co-ordination of visual images with sound make it possible for the cinema to present in symbolic form things and experiences that are

1 Markov: *The Soviet Theatre.*
2 *U.S.S.R. Speaks for Itself, Culture and Leisure ;* see also *Art in the U.S.S.R.*

not available completely for direct perception. Yet more than any other art, it has been grossly diverted in most countries of the world from its proper function by commercialization that shows itself in the production and distribution of thrilling, sentimental or erotic pictures for urban populations seeking in these their major recreation. The true social rôle of the cinema as an art is far from being realised under the modern competitive system of production based on the profit motive although the cinema counts with radio broadcasting as a most significant influence towards the democratisation of art. Lewis Mumford observes: "The moving picture with its close-ups and its synoptic views, with its shifting events and its ever-present camera eye with its spatial forms always shown through time, with its capacity for representing objects that interpenetrate, and for placing distant environments in immediate juxtaposition—as happens in instantaneous communication, with its ability, finally, to represent subjective elements, distortions, halucinations, is today the only art that can represent with any degree of concreteness the emergent world view that differentiates our culture from every preceding one".[1] Above all, the cinema may enter into close alliance with myth, poetry and music for portraying the experiences of the super-sensible world that elude ordinary perception and thus throw open to human understanding new vistas of beauty and rhythm from the Beyond. Walt Disney's remarkable production "Fantasia" for instance, represents a unique visual interpretation of melody and harmony whose mystical quality illustrates the possibilities of the art of the cinema in a new direction altogether.

Art Work as Community Service

The arts of life are created and enriched from generation to generation mainly through accumulated wisdom, technique and tradition; the contribution of an individual artist or even one epoch is trifling as compared with the legacy of the past. In the Orient until very recently even schools of philosophy bequeathed important works anonymously to posterity, and individual authorship was hardly claimed. In the Indian temples and caves no painter or sculptor ever sought to indicate his original contributions. The tradition is very strong throughout the East of the poets, philosophers and artists remaining humble, and even oblivious of their personal importance. Creative activity has been regarded here as the fulfilment of one's obligation, the redemption of debt to the community of intellectuals of the past. It is only an exaggerated emphasis of private property in the modern economic regime that has led not only to the use of the artist's talents for egoistic enjoyment and massing of individual fortunes on a scale unparalleled before but also to the conception of art works as unique private possessions. The loss of the workers' control of the productive machinery and of their interest in the processes of production in capitalistic industrialism

1 *Technics and Civilization*, p. 342.

is as, if not more, responsible for the lapse of art as the extreme division of labour and standardisation in machine technology itself. Large-scale manufacture of homogeneous and uniform goods produced with the enterpreneur's eye towards cheapness and utility discourages novelty and variety, and expels from the productive system the artist who also loses the consciousness of being an artist. He suffers loss of status and swells the rank of artistic handicraftsmen or even of an artistic proletariat. With greater freedom and participation of the workers in productive operations, creativeness and art will recover their organic rôle in civilisation. The cultivation and enjoyment of art by the common man will depend, to be sure, upon such tranformation of social and economic relations as would prevent the control of his labour and leisure for the private gain of a small directive class. Like wealth and economic power, art has now become the luxury of the few who show a preference of real or fabricated treasures of past ages to highly valuable contemporary works of art.[1] This all the more discourages artistic achievement on the part of artists of talent. Thus while in larger and larger sectors of work the æsthetic interest is suppressed, the artist is also thwarted by the desire for ostentatious luxury on the part of those who can buy art wares. On the one hand, this encourages æsthetic egoism or eccentricity, leading to the segregation of art and the artist from the main currents and values of life. On the other hand, the gulf between ordinary and æsthetic interests, values and experience widens. Man's ordinary habits and practice of living become less integrated with the normal tenor of social values and services. The routine of living and labour is vulgarised. Art work which in the previous systems of production was the opportunity of collective service for different groups of craftsmen becomes the privilege of a small specialised profession or coterie whose earnings are either colossal or trifling and precarious and bear little relation to community values and services. The capacity for enjoying art having seriously diminished in the case of the majority of the population, there has been a gradual regimentation and control of leisure-time pursuits by commercial interests, facilitating the debasement of taste and the craving for the sensational and sensual instead of the beautiful. Nothing short of an overhauling of the industrial structure and the system of property with special reference to works of art can arouse the emotions and the creative imagination of man, abolish the present divorce between his creativeness and toil, and make the pursuit of art less of a specialisation and more of a general endowment, and its enjoyment as much for the common man as for the privileged few. The epochs of great artistic achievement whether in India, China, Greece or medieval Europe cherished the masterpieces of art as communal legacy and art work as communal service. It was in Europe from the time of the Renaissance, when the aristocracy and the bourgeoisie began to own paintings to decorate walls in

1 Carl Brinkmann: Article on Luxury in the *Encyclopaedia of the Social Sciences*.

their own homes, that easel paintings developed and gradually superseded fresco works in churches and city halls where these could be enjoyed by the multitude. As Europe has grown richer by industry and trade a larger proportion of the upper and middle classes has bought and owned pictures that no longer minister to the culture and recreation of the common people; while certain types of art that can satisfy the class standards and tastes of the bourgeoisie are encouraged, leading to huge fortunes for mediocre artists and neglect and poverty for the more original ones. The economic helplessness and misery of unsuccessful artists, poets or philosophers stand today in marked contrast with the acquisition of enormous wealth by the successful ones. This is at once the cause and effect of commercialisation which has taken into its fold the major arts and grossly diverts them from their proper function. It is imperative that like the sciences that have built up modern democracy and that have grown during the last few decades in intimate contact with the work-a-day life and needs of the people, the arts should be socialised and become impersonal in their stimulus and inspiration. If such a tendency becomes stronger in modern democratic societies there will be a corresponding change in art form. Sculpture will certainly regain its old prominence in recording enduring social realities and visions in close unity of spirit and perception with architecture—the major social art—that will set itself to the task of satisfying the collective requirements and aspirations of the urban masses and regulating their collective routine of life and movements. Mural painting will rlso rise to importance and eclipse easel painting. On the walls of public buildings the artists will express their communal vision, providing delight and inspiration for the common people. Rivera and Orozco are the great living masters whose best work is in murals that are saturated with a social message and have given a fresh impetus to wall painting on a grand scale through out the modern world. The improvement of the processes of colour printing will also enable copies of masterpieces to be widely and cheaply distributed, their originals being preserved in public museums or art schools. This would combat the present tradition of securing for oneself unique art treasures at fabulous prices, while the master artists themselves may be requisitioned by the state or any public institution to work for them.

The State and the Arts

What social arrangement is necessary in order to free the artists from the insecurity of modern life and create a regular and systematic demand for works of art, will vary according to the social and economic traditions of different countries. But the organisation of guilds, co-operatives and brotherhoods for artists that may assure them subsistence and freedom and state patronage is essential. Democratic governments can foster contemporary artistic effort by wise expenditure on art work for decoration of public buildings and in public

festivals, ceremonies and recreations. In Sweden a remarkable development of the industrial arts was initiated recently by a planned Governmental programme established in that country. The Republic of Mexico by commissioning a group of Mexican painters to paint murals for public buildings similarly sponsored an influential art movement that has spread beyond the confines of that country. Similarly, the Federal Art Project of the United States Government employed about 5,300 artists in various activities under a national programme, which is bound to carry American art to new heights. Something like the master-pupil relationship has been developing under the Project arrangements in which young artists are directed by the mature professionals, while work in the midst of familiar surroundings in local or regional creative projects gives art the opportunity for regional and contemporary expression.[1] State aid and protection must not, however, be incompatible with complete liberty of artistic expression for the creative artist. Great art is timeless. It is at once a social product and an individual creation. If the artist's environment be such as to give him security at the expense of loss of his individuality, his art will be ephemeral. The world of art is faced with this dilemma which has to be solved for the true development and right functioning of the arts. The artist has to be rescued from his acute insecurity and dependence on the market. Both commercialisation or creation and multiplication of shoddy products that sell in the open market and the development of esoteric groups that offer protection to the artist as he turns out luxury products for the elite are enemies of art. The quality and range of artistic expression are bound to suffer if the artist has to live in abject dependence either upon a wealthy and luxurious upper class or on a poorer but no wider clientele. Even with affluence art suffers if the artist lives in isolation, depending upon the influence of his refined and esoteric art work on a small closed group of patrons; for neither subjective moods, nor the mysteries and faiths of a sect but generalised and collective emotions and feelings are the soul of creative activity. The collective emotional unity that religion and a common intellectual tradition furnished in the past is now completely destroyed in class-ridden society. Mere politics and economics cannot fashion that unity of human feeling in the community which can furnish the basis of true and enduring imaginative creation. The state and state-ism may sponsor and stimulate art, but a close association between the state and the artist may bind art to the crude and unassimilated ideology of a regime and make of it a mere contemporary portraiture.

Art needs to be socialised but not regimented; the social environment of the artist needs to be so modified as to aid in making his individual vision a collective experience, which may unify the feeling and will of the people and elevate them, in which the artist at once expresses, and soars much beyond, his country, his people, his regime. Neither subjectivism with its trends towards romanticism,

1 See Cahill's Introduction in *New Horizons of American Art.*

sensationalism of form and colour or methodism nor state-ism, with its trend towards economism as created and determined by the multitude, holds the key to the development of the art work of the future. It is some form of acosmic idealism or mysticism that opens out a more-than-human channel to man's community of feeling and experience and to his search for beauty, rhythm and harmony that can supply the true ground and intense zest for the artistic expression and culture of the future. This is the irreconcilable contradiction in true art. The highest, says Geothe, is ever silent. Yet art that is true, sincere and enduring is communication. It is thus that the highest art, reached not without some hesitation in silence beyond the stresses and strains, joys and sorrows of life, enables each and every man to have a glimpse of what is really unique and incommunicable in the artist's perfect vision.

Neither humanism, the child of the French Revolution, nor dialectical materialism, the child of the Russian Revolution, holds as a philosophy of life the key to that profound synthesis that may embrace not merely art and science, but all other adventures of the human mind. It is an acosmic mysticism and the faith and the vision that emerge from these that can expand and deepen man's solidarity, and oneness of feeling and experience in the Marxist society and act as spiritual leavens mitigating its harshness and acerbity. Thus may both Marxism and the social evolutionary process be humanised. A universal mysticism, a revolutionary faith in man's common spiritual destiny, a transcendent belief in the dignity and majesty of the common man will produce and sustain the atmosphere for the art of the future.

CHAPTER XIV

THE SOCIAL MEANING OF ARCHITECTURE

The Social Art

Architecture is essentially the community art, since in its origin and develop-
ment it fulfils the needs of the community rather than of individuals as such. In
the history of man's social development his dwellings were adapted to the require-
ments of the large kinship or family group, and arranged due to the exigencies of
shelter, defence, worship and other associated activities with reference to the chief's
house, the dormitory, the temple, the manorial establishment, the royal palace and
the family hearth and home. The solitary hunter and food-gatherer did not build,
but sought caves and tree-shelters. The nomadic shepherd, who lived away from
his family and kinsmen, carried his tent with him and did not construct any dwell-
ings. Architecture expresses the social cohesion of man, his living and working to-
gether in the community. Man's fear of the dead and worship of ancestral spirits
and gods, his love and defence of the territory, the vigilance and majesty of kingly
power, the amenities, devotions and rejoicings of the kinship group, or again the
exultation of festivals and recreations, that knit the community into a single
whole are eloquently expressed by architecture, and the private dwelling form
cannot free itself successfully from the sphere of the social art. Throughout
man's history architecture defines, recreates and shelters the hopes, fears and
aspirations of a tribe, people or culture presenting a clear pointer-reading for its
economic and social progress. It is out of the essential human needs for security
and defence that a social art emerges which reveals and consolidates with great
clarity and order the intangible social purposes and values.

Expression of Poise, Movement and Ambition in Architecture.

Architecture has been defined as the functional organisation of enclosed
space, vertically and horizontally. Man with his erect posture and bipedal habit
feels deeply the gravitational pull and its alterations as he moves his limbs, and
also the profound need of balance and symmetry for his body. Architecture
expresses those deeply sensed organic co-ordinations and rhythms of his body
that underlie his physical poise and movements. From the stability and endu-
rance of human shelter, facilitated by the use from age to age of wood, stone,
brick, steel and cement that defy the elements, architecture selects for emphasis
the expression and celebration of the immortal features of man's social life and
destiny. Manipulating the materials of nature and elemental forces like gravity
and cohesion, thrust and counter-thrust, stress and strain in the raw and in bulk,

architecture is indeed the appropriate medium for the recording of immortality of existence, of life and death, of power, achievement and enjoyment. A totem pole or an obelisk, a sepulchre or a pyramid, a temple or fort, a town hall or a palace equally expresses in a massive way the elemental desires of man for poise, mastery and endurance on the earth. Are not the fluctuations of man's feelings and experiences, his sense of change and movement elicited by kaleidoscopic changes of nature's scene as he marches from prairie to plain, and from plain to forest and mountain, stilled when he encounters solidity and massiveness, symmetry and repetition in architecture? A wandering people first obtains its lessons and images of stability and permanence in colonnades and corridors, with their indefinite multiplication of arches and columns, or in domes and towers that overpower the consciousness by magnifying and rendering dynamic the enclosed space through illusion caused by the artificial dimness of the ceilings. In an enduring building that outlives his strife and struggle, man finds the symmetries and tensions of his own limbs and muscles given back to him magnified, profoundly satisfying his incompatible desires for rest and movement. Each hut has a bamboo pole, each temple has its spire, each fort or palace has its steeple, and the modern sky-scraper also has its lofty tower, symbolising effort, ambition and success in the history of the building art. Brute matter thus gratifies man's elemental collective feelings of quiet repose and tumultuous movement.

Firm Poise and Audacious Flight

What endures amidst the variegated forms and phenomena and circulation of energies of nature is structure or constitution of nature. Architecture, as it deals with the raw materials and elemental forces of nature directly, and on a big scale, expresses stability and endurance through geometrical patterns. All great architecture is geometrical, incorporating also into itself the enduring human values of a people or an age. It is of the earth earthy, cognate in its constitution with the structure of the universe, and at the same time it is transcendental, revealing more than any other art the equilibrium of human interests and values, the structure of the human soul. More than any other art, architecture, which is an extension and reinforcement of the repose and tension of the frail human body, enters into, shapes and moulds the human soul in its poise and rest, excitement and flight.

The Meanings of Basic Geometrical Patterns

All significant architecture is a monumental legacy of garnered experiences of the community as well as a beacon-tower of its cherished achievements in the future. The inert wood, stone or brick as it rises to the sky or as it circumscribes a forest, meadow or field according to a set plan reveals and magnifies

man's own vital rhythms and forces. The lofty totem pole, the obelisk, the flag pole (dhwajastambha), the temple pillar, the arched gateway and the colonnade, all glorify man's profound emotional delight in verticality overcoming the cruel, universal pull of gravitation. In architecture it is not inanimate wood or stone that climbs up the heights but man himself. The soaring column, minaret, temple or church spire becomes the image of man with his eyes and muscles always directed towards the sky. Similarly man seeks not only to climb higher and higher but also to seize space horizontally, and as he appropriates his domain in the form of a circle, ellipse, square, or hexagon, it is his deep kinæsthetic or muscular delights that underlie his emotional appeasement. For, it is the circle, the ellipse or the hexagon that are adapted to man's organic rhythms of action and movements. But man also inevitably seeks rest and peace which can be best expressed only by inanimate matter. Within the enclosed walls of the pyramid, temple, mosque or rock-cut tomb he experiences a cosmic brooding stillness that neither mountain nor plain, nor desert can yield. Out of hard un-yielding matter he has discovered and fashioned visions of stability and sym-metry, or wild, soaring and tumultuous movement that the rhythms and func-tionings of his own body can but imperfectly articulate; while nowhere can the unsculptured landscape engender that profound mystery, weight, changelessness and silence that belong to architecture. Thus does architecture by bringing about a marriage between man's kinæsthetic or muscular experiences and the spirit of wood, brick or stone, through the eternal play in different patterns and rhythms of the circle, the rectangle, the ellipse and the triangle, reveal and stimulate in a supreme way man's emotional stability and integration of persona-lity. Architectural forms are derived from the generic unspecified kinæsthetic experiences and emotions of man that underlie his sense of poise and competence in his relations to matter and space as these in turn profoundly affect his behaviour and ideals, personality and social life.

The Circular and Triangular Motifs in Architecture

Mankind in its earliest history as it marched across open spaces bounded by the circular horizon under the circular vault of the sky seems to have started with the geometrical symbol of the circle as it enclosed grass lands for its secu-rity, settlement and shelter. The circle reveals man's profound sense of poise and organisation in movement. The biological core of this geometrical pattern is represented by the round-defence and round-dance of some of the higher gre-garious mammals. No doubt the circle is the basis of primitive corrobories and dances round the protecting light and warmth of the camp fire. The patterns and rhythms of dance that aroused strong collective emotions with the aid of song and intoxication brought out into the full consciousness the significance of the basic geometrical forms that underlie order and symmetry in art and technique.

Thus large Megalithic stone-circles with inner rings and dolmens in the centre are met with in Europe, Asia and Oceania. Even now the Todas, the Irulas, the Kurumbas and other backward tribes and castes in India make use of rude circles of stones as temples and soul-houses or graveyards; while stone circles erected in honour of Vetala or the king of the ghosts or spirits are to be found throughout the Deccan and Western India. These circular patterns of places of worship and burial were the precursors of sacred enclosures, circular in form, with altar and idol in centre encountered in advanced civilisations. The villages of the Vedic Aryans in India were circular, enclosed by wooden palisades or ramparts with bamboo gateways, the railings and archways later on furnishing the designs of Buddhist and Hindu architecture in India, Further. India and the Far East. In India the Vedic forest dwellings developed a circular or oval pattern with bamboo thatch, heavy eave and horse-shoe sun-window that profoundly influenced the style of architecture developed in India in the later centuries. The Vedic fire-altars were also of hemispherical shape, though other forms of altars are referred to in Vedic texts such as those of the shape of falcon, chariot, man with uplifted arms,—all typifying the swift movement of the early colonists across the plains of the Punjab. In Europe as the first iron-users spread out between 300 and 400 B.C. they occupied hill forts ringed round with deep ditches, massive wooden palisades and pathways round the defences on the top of the ramparts. Even now the circular grass-grown ramparts of hill forts or Roman camps are discernible in various parts of Europe. As civilisation progressed it was the same circle that underlay the tribal dance and camp gathering or the lay-out of primitive settlements, dolmens, rock-tombs and altars that gave birth to the form of the dome in Assyrian, Roman, Saracenic and Christian architecture. Thus does the social monument express in different idioms man's mastery of the universe, at first in the physical sense in the ground plan of villages, tombs and fields, and later on as an aspiring spiritual vision in mounds, stupas, and domed mosques, temples and churches.

In early Indian architecture the hemispherical stupa, reminiscent of the ancient memorial mound, enshrining the relics of a holy personage, evolved into the elegant and stately architecture of Sanchi and the Buddhist rock-cut caves with their majestic gateways and facades. The circle, the bowl (inverted), the umbrella or the wheel were adopted as religious symbols and shaped the lay-out of thousands of stupas and their procession-paths for the faithful, "turning the wheel of the Law". Side by side we had the rectangular chaitya-hall that later evolved into an assembly-hall or college dormitory for the Buddhist monks, and the square or octagonal Brahminical temple, the Brahminical notion being that the universe was a symmetrical square with the firmament resting on four elephants in four directions giving it stability. Often one square cubicle, the abode of the deity, is piled up one upon another, gradually diminishing in size

with the height until we obtain the geometrical pattern of the pyramid (vimana) that is also recurrent in temple architecture in India and Indonesia. It appears that the pyramidal vimana is the direct offspring of the chaitya in pre-Buddhist India, dedicated to the Yakshas, Gandharvas, Pisachas, Nagas, tree-spirits etc. Thus the pyramidal design of Siva's shrine may have been derived from the association of Siva with the cremation grove full of evil spirits, formerly sheltered by Hinduism in the chaityas.

As significant and widespread as the circular square or octagonal form is the triangle that expresses with the greatest clarity human concepts and values of permanence or poise in rest just as the circle is expressive of poise in movement. The stability of the triangle has received its perfect architectural expression in the pyramids of Egypt, with a base sometimes extending to about 800 ft. and a height of about 500 ft. with neither doorways nor pillars nor decorations anywhere. The pyramid presents four bald, naked and exact triangles, formerly shining with polished limestone coating against the circular horizon and visible from long distances, and its geometrical proportions are such as to elicit a profound spiritual poise, a deep sense of unity with the heart of the universe. The pyramid is a basic and universal geometrical pattern intuitively discovered and consolidated, bespeaking man's realisation of the cosmic principle of the immortality of life and death. The overwhelming nakedness and exactness of the exterior are paralleled by the mystery and solemnity of the narrow steeply inclined passages in the interior that lead up to the burial chamber in the heart of the pyramid. Here and there hollow spaces and blind alleys add to the sense of mystery of eternal life and flesh that still enjoy the flowers and fruits, the furnishings and decorations, the songs of dancing girls and the pleasure trips on the river within the small stone-built chamber. Similarly, the Egyptian temples with their huge forbidding sloping walls, over-shadowed by concave cornices, their immense fore-courts and spacious halls, engender an atmosphere of majesty and solemnity that is heightened most as one reaches through a succession of small or large chambers and halls, corridors and galleries into the narrow, low and gloomy *sanctus sanctorum*. The obelisks, sphinxes, rams or colossal statues, often arranged in rows in vast collonnades or placed against the stark walls, all add to the effects of the simple, large and basic geometrical patterns echoing in human hearts the elemental rhythm or order of the universe in which life and death, enjoyment and withdrawal are but different aspects of an eternal and continuing process. Egyptian architecture is a profoundly authentic expression of life and death eternal.

Contrast in the Architectural Composition of the Greek, Egyptian and Indian Temple

Greek architecture was permeated much less by the feeling of the mystery of life and death than Egyptian, Buddhist and Hindu architecture but sought

through a meticulous simplicity, harmony and slenderness of proportion and unity of effect to express the sureness and immediacy of sensuous life. Nicety of construction, and proportion and delicacy and refinement of ornamental treatment constitute the unsurpassed glory of Greek architecture that is at once the outcome of the clear, limpid atmosphere of Hellas, the rocky nature of its landscape and the absence of forests, which all developed a profound appreciation of precise and exact forms and appearances and of sense-bound superficial life. The Greeks lived mostly an outdoor life and their administration of justice, representation of dramas and public ceremonies took place in the open air. It was thus that Greek architecture did not develop much variety, most of their buildings being temples in which rites were carried out with little of mystery but with full public participation. That there was no exclusive class or coterie of priests in ancient Greece, and that the ordinary citizens could officiate in the religious ceremonies account for· the strong contrast between the large Greek temple with its single uniform colonnade surrounding the naos, and the arrangement of courts, halls and chambers often decreasing in size from the gate pyramids, pylons or gopurams in both typical Egyptian and Hindu temples.

Like the Egyptian temples, Indian temples show successive additions of enclosures, chambers and apartments attached to or grouped around the original shrine. It is the mystery of god's presence and of the cults and ,observances of worship that have governed the arrangement of the *sanctus sanctorum* or shrine cell within the actual temple containing the images of the God or his symbol. The considerable height of the pyramidal roof of the shrine cell and its small floor space contribute to envelop the God and the pilgrim alike with the mystery, darkness and silence that are stressed by the incense smoke and the flickering lamps with their trembling shadows. Indian temple architecture has not freed itself from the earlier rock-cut methods in the treatment of the interior that is kept dim or intensely dark for shutting out distractions for the contemplative mind and maintaining an atmosphere of religious solemnity and expectancy. The porch or mandapa always covers and precedes the door leading to the shrine cell. This is lighted, spacious and full of pilgrim visitors. Here there are always both noise and anxious expectancy. Then the space shrinks, the corridor leading to the inner courts is narrow, cramped and dark, permitting the mind to concentrate towards the God, as huge throngs of pilgrims march reaching successively in a few minutes in tremulous expectation the nave, vestibule and transept connected with the innermost sanctuary. Mere closing of space and light and the distribution of shadows are here not enough for the Indian architect; for often he makes the pilgrim suddenly climb up or descend by steep stairs to the enclosed space in front of the sanctum. Both the body and mind are thus pitched up to an intense thrill of excitement in the vestibule or transept leading to the cell. Thus far can the uninitiated proceed. As one tarries here and looks

up and around, he comes across a most intricate and mysterious architecture, a bewildering assemblage of pillars, often strange and unreal in their design, and some of the most magnificent and majestic images of gods and goddesses ever sculptured by man, who suddenly leap from walls and pillars to life, and secretly beckon to him as fluttering lights and shadows assemble and scatter in rapid bioscopic succession. Such is the profusion of sculpture and ornamentation in the extravagance of spiritual emotions at the sacred doorway or railing in front of the god unvisited. The psychological effect of the half shadow and half darkness in the day and the fitful illumination of lamps and torches in the night in this dim pulsating gallery of the gods is profound. Hardly has artistic ingenuity been of such aid to religious imagination! In front of the assembly hall or mandapa, again, there are the even more spacious pillared halls where there is a vast assemblage of pilgrims reading, discussing, worshipping, bathing, cooking meals and so forth. In some temple plans there are also halls of dance, halls of religious discourse, and halls of offerings. Finally, the entrance is represented by the great pyramids or gopurams that are the principal features in the quadrangular enclosures which always surround the actual temples. In both Egypt and India the worshipper after crossing the massive entrances proceeds from one apartment to another, each successively diminishing in size until he reaches the shrine cell itself which is most narrow, cramped and dark. Such an arrangement first arouses the sense of awe and majesty in the mind of the worshipper in the colossal entrance towers that may be described as temple skyscrapers with a height sometimes of 200 ft., then presents before his vision a vast series of paintings and statues of gods and goddesses in the long corridors sometimes extending to 700 ft. as in Rameswaram, such horizontal expansion allowing contemplating space to the mind; and finally, leads him from one chamber to another, each smaller and dimmer than the one just passed, until he finds himself in the presence of God in the smallest and the dimmest shrine of shrines. Architecture is here entirely governed by a profound religious psychology that has planned the structural composition according to the needs of the worshipper's mind and heart. Nowhere has the logic of mystical contemplation determined architectural unity as in Egypt and India. In Egypt the unity was the result of the conscious plan of single Pharaohs and their priests. In India such unity was often unconsciously achieved as the result of gradual accretion of parts added through the successive centuries by pious rulers, guilds of craftsmen and religious brotherhoods. In Egypt religious rites were kept secret and carefully shrouded from the vision of the common people, who were awed into submission by the figures and spells of the magician-priests. The psychology of fear and domination of the people by kings, who were regarded in Egypt as actual divinities and who commanded priestly service for keeping the subject population in awesome bondage of ignorance and superstition, is reproduced in the

Egyptian temple architecture in which open and covered courts, chambers, chapel-like apartments and columned halls, connected by corridors and galleries, are strangely intermingled sometimes in the bewildering intricacy of a labyrinth, as in Karnak. In India each person brings his homage and offerings to God, but he must come cleansed in his body and mind to the holy of holies where the priest mediates to render his offerings acceptable to God. But if he be spiritually worthy at the end of his pilgrimage inspired by the vision of a thousand forms and images of God in the halls, naves and corridors, he will find that there are neither priests, nor images, nor gods but the universal formless spirit in the *sunctus sanctorum*. There it is a formless deity who receives his offerings, who is he himself—as in the temple of Chidambaram where the image of god is a formless circle with a dot in the centre. But there are few advanced souls like him. To thousands of pilgrims, even hundreds of thousands, the Indian temple offers spacious pools, wells or bathing places, granaries, large kitchens and regular markets catering to the physical requirements of life. In the numerous gay stalls are to be found the specialities of arts and crafts of the temple city that pilgrims must carry to their distant homes as presents and souvenirs. The entire city assembles in the temple on a festival day, wakes up the deity from his night's rest with music, bathes and feeds him and takes him with priests, temple servants and dancing girls in procession out to the city proper. The city is the temple and the temple is the city in Southern India. The plan of the temple is repro-duced in the city and *vice versa*. Within the enclosure of a great temple there are many subsidiary shrines and halls that are symmetrically grouped around the central shrine; while such an arrangement applies also to the congregation of temples within and around the sacred city, itself an architectural whole. It is thus that different religious concepts and social organisations leave their indeli-ble impress upon the architectural composition of the temple and the city.

Influence of Religious and Metaphysical Concepts on Temple Architecture

In another and yet more significant way cave and temple architecture in India, and in all countries within the ambit of Indian artistic hegemony, has been influenced by the Indian conception of oneness of the self, universe and deity. Buddhism led almost a whole people to the forests and mountains, where the monks followed the example of Buddha in utilising caves and grottoes for medi-tation, shelter and teaching, especially in the monsoon months when travelling and ministration were not undertaken. A large number of viharas or monaste-ries that served solely as residential quarters of the monks and chaitya-halls that enshrined as objects of worship a chaitya or stupa were hollowed out of the hills, scooped out and divided into rows of cells for meditation. Spacious naves and side aisles gave ample room for liturgy and collective rites. The nave was used not only for the meetings of the congregation (sangha), but also for the Buddhist

services consisting of reading and chanting from the Buddhist texts under the guidance of the abbot who sat on a raised seat near the stupa. Over the congregation looked down benignantly the Buddhas and Bodhisattvas from the gorgeous frescoes on the walls. On either side of the central court the long aisles extended, whence the lay community could see the shrine or stupa and walk round it without disturbing the service. The aisles were also used for daily perambulation for physical exercise by the monks and for the procession of the Bodhisattvas. The central court led out into the cells for solitary meditation, their number increasing as the vihara became important. The chapel containing the images of Buddha or Bodhisattva, the dormitory, the common room, the refectory and the kitchen were in course of time added; magnificent facades with large windows through which light was admitted were constructed, and walls, columns and ceilings were lavishly adorned with sculptures and frescoes. The subordination of painting and sculpture to architecture and of all three to the silent and contemplative spirit of man was established as the norm of the entire Asiatic art tradition under the influence of the Indian Buddhist monkhood. Karli, Kanheri, Ajanta, Bagh, Ellora and Aurangabad had their cave temples and monasteries magnificently adapted to the needs of both solitary meditation and corporate life, devotional gatherings and rites of Buddhist, Brahmanical and Jaina monks in distant secluded hills and forests. It was in these forest retreats that pilgrim beggars gave to Indian art the vision of the unity of all sentient life, the long train of the causes and effects of Karma that bind together animals, men, spirits and gods through a succession of births and rebirths. Thus Buddha or Bodhisattva is not one single person or deity; his images become as numerous as all men, all animals, all sentient creatures, "even as the sands on the banks of the Ganges." Has not the Master shown himself as the hero of sublime patience, charity and sacrifice through numerous episodes in his previous lives as inferior creatures that must also be portrayed as examples for the monks and the masses? Again, has not He in the miracle at Sravasti embodied himself in a thousand forms before the awe-struck multitude? The principle of multiplicity in Buddhist lyrical sculpture translates not only the exuberance of religious expression of the emotional masses but also the profound metaphysical belief of the One in the Many and of the Many in the One.

Thousands of faithful Indian craftsmen and artists for generations would work in converting hills and rocks into images of the same deity, either standing or seated with the various mudras, or indelibly impress upon each single stone or brick of walls and towers the same image thus expressing by a thousand hands the Indian conception of the unity of all life. Sometimes it is the image of Buddha or Bodhisattva. Sometimes the image of Siva or Krishna is thus reproduced in inexhaustible abundance in the caves, in the temple walls and pillars, on each single stone in the enclosing walls of the temple cities. The same deity thus

appears in every stone, springing from the same heart of the universe and the heart of each single craftsman. In the temples of Borobodur in Java, and Angkor Vat in Cambodia, we find the principle of decoration dominated by the same Indian spiritual concept of the eternal unity of all forms and appearances as manifestations of the universal spirit. Thus architectural ornament establishes the universal communion in the repetition of the image of Buddha as the primordial essence or of the dancing apsara as the underlying rhythm and joy of the universe. Much in the same manner the artists and builders of the Gothic cathedrals in France have filled the walls, pillars, railings and windows with a thousand images revealing with certitude the Christian belief of the unity of God-in-Man and of Man-in-God. Throughout the world's architectural history an exuberant lyrical note has always found its characteristic expression under the influence of religions that abolish the barriers between the real and the transcendental: Buddhism through its conception of the oneness of all sentient life and the worship of the infinitely varied Buddhas, the heroes of infinite compassion, charity and self-sacrifice; Hinduism through its dominant conception of the oneness of the cosmic spirit in all forms and manifestations, in life and death, creation and destruction; and medieval Christianity through its belief in the oneness of deity and devoted, suffering humanity in the worship of Mary and the Man of Sorrows. No doubt it has been left for Indian and Indonesian art to perfect the lyrical note in architecture under the influence of the humane philosophies of Mahayana Buddhism and Saivism that look towards human tribulations and sufferings with a compassionate and yet unruffled sympathy unparalleled in the history of human thought. Thus do we find a universal intermingling and communion of all forms of sentient life, all passions and moods of the human soul, of the foundations, lights and shadows common to both sculpture and architecture in India and Indonesia.

Effects of Religion and Society upon Islamic Architecture

A sharp contrast to these features is presented by the architecture of Islam whose uncompromising monotheism, severity and Puritanical condemnation of devotional images, born of the desert environment, completely banished lyricism from architecture. The mosque in Mohammedan architecture is interpreted as having emerged from the tribal majlis *i.e.*, the council tent, the cental point of social life for the individualist Arabs, with its sacred precinct and its far greater inviolability than the ordinary tent. The constant movement of the wandering Bedouins across the deserts and steppes, where no rich foliage nor undulation of the ground offers a resting spot to the vision but the limitless circular horizon ever recedes further and further, has led them to establish the laws of the circular form in architecture. Graceful domes, cupolas and vaults cover the sacred ground of the faithful. Higher than these rise to the burning sun the minarets

of the mosques, whence an old follower of the creed summons with his stentorian voice the faithful from the open spaces for assembling in congregational prayer at stated times of the day. Domes of various forms, pointed, oval and bulbous, become higher, more spacious and elaborately ornamented with coloured arabesque in the interior, in keeping with the wealth and magnificence of their builders, while minarets increase in height and elaboration of design and ornamental detail and also in number from one to even six, making a very effective sky-line in contrast with the flat roofs or domes of the mosque. As the faithful congregate for their prayers they must have their ablutions for refreshing themselves against the fierce heat of the sun. Thus the naves of mosques are preceded by courts with fountains for ablutions. Sheltering aisles, arcades or colonnades, small doorways and windows and also wide-spreading roof eaves evolve in the architecture so as to keep out the rays of the blazing sun. The rigorous simplicity of living of desert-dwellers and of desert-rulers, who go about on their conquests with only a bag of barley, a bag of dates, a water-skin and a wooden platter and are also known to tear down the palaces of luxurious brethern with relentless zeal, is responsible for the use of light and even flimsy materials for construction. And yet the Saracenic eye has sought to compensate for this in architecture in two ways. Saracenic architecture is characterised by a wild profusion of precious colours in surface ornament, making up for the dullness of the steppe landscape and of the white woollen garment, which can hardly be distinguished from the surrounding sands from a distance. As the faithful reach the mosque there is luxurious, green verdure in the surrounding maidan or garden, while jets of water from the gorgeous fountains that refresh and cool their limbs sparkle on coloured tiles. Colours also run riot on the floors, columns, roofs and walls, feeding the imagination of colour-starved and colour-blind people. Jaspar, porphyry, blood-stone, agate, variegated tile, marble and glass as well as illumination from innumerable hanging lamps offer to the desert-dwellers the much coveted feast of colours by day and by night. The democratic character of Islam is revealed in mosque architecture by the characteristic sitting accommodation for vast crowds of Mohammedans who sit on the same polished marble or mosaic floor, irrespective of rank and status. In the hall of the congregational prayer the faithful squat on the floor just as they do inside their tents, and only want an indication of the geographical position of Mecca, supplied by a niche in the wall, so that they can prostrate themselves in that direction during their prayers; the precedence belongs only to the Imam who reads passages from Koran from the elaborately decorated mimbar or elevated pulpit. Islamic architecture, grounded on the philosophy of social equality that both desert and religion impose upon the desert-dwellers, requires not only large enclosures with pools and fountains and shady aisles and arcades so necessary in hot and dusty cities, but also imposing halls where their entire populations can sit down together in

prayer. The assemblage, as it hears the Koran recital elucidating the formlessness and infinitude of God, looks at the walls, pillars and arches where their eyes meet the same passages from the Koran or the letters of the Arabic running hand or, again, forms of plants and animals, all treated in marvellous geometric or repetitive patterns. Forms intermingle with and pursue forms in an endless ever-receding flight to the accompaniment also of gorgeous colours giving neither the eye nor the mind any pause or rest. The environment of the steppe, where nothing intervenes in the horizon to titillate or fix man's gaze, encourages the architect's restless fancy to perfect the arabesque, an ornamental design in which there is neither beginning nor end. And how appropriately is this system of ornamentation, that obeys no severe laws of form, consonant with the Islamic metaphysical doctrine of the Supreme Deity who has neither a beginning nor an end, thus delighting the physical vision as well as satisfying the great hunger of the steppe-dweller's soul feeding itself on the emptiness of the universe and the fullness and unity of God. Finally, the arabesque is a symbol not merely of the severe mysticism of the Arabian mind but also of the utter lack of harmony between the fury of passions and appetites of the children of the desert and the demands of family allegiance and tribal solidarity, between the splitting up and disunion of tribes and folks that scatter like the sands and the rigorous unity of the faithful enjoined by Islam and its prophet. Steppe-dwellers have sought in the endless permutation and combination of geometrical device and arabesque those severe, abstract transcendental values that give them the peace and poise that they cannot wrest from their environment.

The Lyricism of Gothic and Buddhist Temple Architecture

A striking contrast with the regularity and repetition of geometrical forms and patterns in the interior of the Mohammedan mosques and the severe simplicity with which their outside was also generally treated is offered by the exuberant lyricism of the Gothic architecture of medieval Europe. It marvellously reflected the combination of a new individualism and freedom in economic and social organization, a new sense of the values of human life and of beauty in nature, largely the outcome of the Franciscan movement, and the profound religious imagination and enthusiasm of the common people that transcended the quarrels of Popes and Emperors. A strong wave of idealism was then sweeping across Northern and Western Europe. This became manifest in the form of the institution of chivalry, on the social side, Mariolatry on the religious side, the poetry of minstrels and troubadours composed in the vernaculars of the people, on the literary side, and the co-operation of corporations and guilds for the building of cathedrals in the newly enriched towns vying with their neighbours in piety and pomp, on the economic side. A new-born initiative and liberty that encouraged master-masons and sculptors to follow their whims and

caprices to the extent even of changing one tower for another as in Chartres and Rouen, and a deep sense of religious mystery transmuting the entire gamut of human loves and passions into spiritual delights that overcame the stark realism, misery and oppression of the age, supplied the keynote to Gothic architecture. The soaring instead of the rounded arches that direct the eye upwards, the lofty towers and spires embroidered with delicate tracery beckoning men heavenward from long distances, the high-ribbed vaults and wooden roofs decorated delicately so as to produce a sense of airiness, and the equilibrium of the entire structure held by the combination of oblique and perpendicular forces, the delicate adjustment of thrust and counter-thrust,—all these typify the medieval Christian ecstasy and longing to reach the Kingdom of God above. The spiritual abandon and exaltation, the mystical enchantment and transcending of the senses that completely free themselves from the ordinary laws of perception are expressed in the treatment of stone as if it were a thing of lightness and mobility, rising to meet a burden regarded as of no account, as if it were an uprush of sea-wave breaking into thin, multiform, delightful spray. This has been aptly stressed by Wilhelm Worringer: "Greek architecture wins to expression with stone and by means of stone, Gothic expresses in spite of stone. In the Gothic Cathedral there is a movement to the vertical in which all the laws of weight seem abrogated. Vainly do we seek what our natural feeling demands—some suggestion of the relation between burden and strength to bear. One would say that no burden any longer existed, only freely acting forces that with a mighty impulse are striving upwards. It is clear that stone has here given up entirely its natural character, and in a word has become de-materialised." For hundreds and thousands of pilgrims who periodically visited these cathedrals and participated in the increasingly ornate rituals and observances as the medieval towns rapidly increased in population, the shrines were a haven of refuge from the surrounding turmoil, bloodshed, disease and squalor. The hands of violence and oppression were stayed in the sanctuary, the brooding shadows in the vault ceilings and the wooden roofs and the mysterious interplay of crimson, gold and azure on the walls and on the floors stilled the senses. From everywhere the elongated sculptured figures of gods, angels and saints looked down enchantingly upon the crowd. The total effect was dramatic and exalting. The repetition of Christian gods, saints and Bible incidents in the Gothic Cathedrals corresponds to a similar repetition of Buddhas, Bodhisattvas, Sivas and Jataka and Purana incidents in the architecture of India, China and Indonesia,—an outcome of similar exuberant devotional expression surging from the heart of the multitude. Like the Buddhist sangha in Asia, the Cistercian monkhood in Europe contributed to the artistic expression order, unity and thoughtfulness. Nor should we forget the prevailing intellectual zeal of the scholastics in the newly founded Universities of the age that also influenced the logical consistency and

mathematical rigour with which the details of building of the Gothic Cathedrals were conceived and executed. But more attractive than the qualities of logical unity and formalism were the spirit of humanism, natural grace and tenderness in Gothic decoration in which sculpture and stained glass were so eloquent with sweet, human emotional appeals of god, angel and saint, and so impressive with the natural beauty of animal, flower and foliage. Architecture at Chartres, Amiens, Rheims and Paris like that at Ajanta, Ellora, Borobodur and at the Cave of a Thousand Buddhas is tenderly lyric. It speaks, therefore, in terms of multiplicity and ornamentation rather than simplicity and severity, and in those of symbolism and suggestion rather than realism and completion. Similar aspirations and patterns of living, similar faiths in the immanence of God articulate and consolidate themselves in similar tendencies in architecture.

Social Confusion and Modern Architecture

The unity of faith, life and action that received such noble expression in Europe in the great Gothic cathedrals which superseded the castles and basilicas of the feudal regime, and for which bishops, lords and commonfolk, all equally poured out lavishly and anonymously what they could give, land, treasure, religious knowledge and workmanship, was disrupted by the secularisation of philosophy and stress of individualism in Europe. Thus previous to the Industrial Revolution country houses and villas were built throughout Europe, embodiments of individualistic enjoyment that obtained their models from the mansions of imperial France, usually ornamental and luxurious beyond all proportion, but sometimes achieving elegance by refinement of proportion and detail and by adaptation of the surrounding landscape to architectural rules. The European country houses not merely reflected the materialistic outlook and social cleavage of the age but also the rediscovery of the individual artist and builder who expressed himself in his work. As the Industrial Revolution progressed the disunity of social aims and purposes became more evident in the contemporary architecture. The Industrial Revolution brought with it new technical materials, *viz.*, iron, steel and concrete, and new social needs of the people as represented by the construction of factories, power houses, banks, railway stations, bridges, theatres, departmental stores and educational institutions. But nothing has more vividly shown the chaos of values than the anachronisms in 19th century and modern buildings that bolster up Greek, Roman, Gothic, Renaissance, Post-renaissance, or other reminiscent styles without adequate regard to the adaptation of architectural forms to the modern materials and technical methods of covering space. Sometimes, again, these exhibit whim and idiosyncracy irrespective of the requirements of use-function. There is no doubt that steel and reinforced concrete have now released the art of architecture from some of its old limitations. The tyranny of walls over floors, it is aptly observed, is now ended. The

framework of steel and reinforced concrete enables the weight of a roof to be supported on a few widely spaced verticals, the solidity of the walls having disappeared. Thus walls can be used for their proper purpose of insulation, to be made transparent or to be left out altogether. Windows cease to be holes hollowed out of the solid supporting walls but become continuous horizontal casements, subdivided by their steel mullions admitting plenty of air and sunshine. Glass becomes structurally more important and adds a note of gaiety to the modern home. The typical modern building, structurally speaking, is a frame or a skeleton, the spaces between being filled in, or glazed, or left open as desired. The hard-and-fast division between room and room has gone; so has the rigid continuity of floor levels; so—aided by the cantilever—has the separation between indoors and out; parts of buildings can be open to the air or parts of gardens can be included under the roof. There is continuous uninterrupted floor-space, about which non-weight-bearing partitions can be disposed at will; and, finally, there is the possibility of exploiting the third dimension freely, which has always been the ambition of architecture.[1] Unfortunately the above theories of modern architects are not yet usually put into practice. The division between the social classes, the ostentatious display of wealth of the capitalist aristocracy and the poverty of the mass of the people in an industrial civilization—all contribute to maintain the distinction between the rich man's district and the poor man's district in all cities and towns, between the rich man's Florentine palace or Tudor type of mansion and the poor man's slums and tenements. The new typical building of the metropolis has now become the sky-scraper that in its design has not adequately capitalised height but has often broken the logical verticals by repeated horizontal lines, courses, colonnades, entablatures and cornices. Thus, as Sheldon Cheney well remarks, the sky-scraper looks like what it is not—a low reposeful Greekish structure, "like several poor academic buildings piled on each other," instead of the sky being pierced, scores of storeys built up, thousands of windows, perfected steel articulation that permits the building to tower. The sky-scraper in fact displays more the power, iciness and tyranny of the directive classes than the collective courage and enterprise of a whole people bound together by common interests and aspirations to tower. With its new offices, restaurants, dance-halls, and shops, it engenders new patterns of office routine, eating, dancing and shopping far different from those of the multitude. Its beauty and inaccessibility are rooted in the disorder, congestion and feverish tempo of action on the ground below. On the other hand, the sky-scraper itself creates and aggravates the intensity, instability and confusion. It is not related organically to the structure of society as a whole: it suggests a social structure that the twentieth century has outgrown.

1 J. M. Richards: *Modern Architecture;* see also Le Corbusier: *Towards Architecture,* and Gropius: *The New Architecture and the Bauhaus.*

The Social Background of Sky-scrapers and Shrines

Metropolitan society's sharp division of classes and strata with differentiated standards of living, manners and recreations has thus created the sky-scrapers of modern industrial civilisation whether in Europe, America or Asia. These typify concentration of wealth, industrial and mechanical power in the hands of the small directive financial class and their social segregation and distance, and thrive on the misery and intense unremitting drudgery of the rest of mankind. The sky-scrapers and the great commercial and industrial buildings are both a cause and consequence of congested streets, highland values, excessive "over-head" costs and over-burdened utilities and services that rise higher and higher and lead to lower and lower standards of housing, labour, morals and art for larger and larger sections of modern urban dwellers. Such overpowering buildings house highly specialised functions of industrial and commercial direction and management, involving extreme development of production and exchange and extreme concentration of wealth and power and control over the instruments and methods of production and distribution that is symptomatic of a profound unbalance of the industrial and social structure. The unity, symmetry and grim exactness of the sky-scraper hide the injustice, irrationality and chaos of the industrial structure and the urban aggregation that have held the masses in their grip driving them into a mad whirl of activity with the underlying canker of insecurity, unemployment and maladjustment. The modern sky-scraper, unlike the Greek temple, is built entirely out of the common man's economic reach and moral stature laying upon him at its base an inhuman driving pressure and urgency that all the more signalise the frustration of his goals and satisfactions. Like the Egyptian pyramid of old, the sky-scraper overwhelms, demoralises and conquers his personality by engendering fear and awe through exploiting the economic and political power implicit in the social organisation as the pyramid exploited the despotic and priestly power in Egyptian society. Both the Gothic cathedral and the Indian temple are also sky-scrapers. The former was a sanctuary of retreat of the common folk from the misery, brutality and turbulence of the medieval community. It also soared far beyond the scale of extremely narrow and limited life-goals and values that the common people of medieval Europe cherished and found within their reach. The Indian temple is not built out of reach of the values and aspirations of the common folk who find themselves at home with the heroes, angels and gods inside the temple, while the stalls, markets and assembly halls, range in its quadrangle, are always thronged with crowds whose aims are not exclusively spiritual.

In thousands of village shrines of Northern India the temple rises skyward like the thatched conical hut of the Indian peasant, but since the temple is the abode of God it is capped by the inverted petals or fruit (amalaka) of the lotus flower or the inverted water-jar (containing the nectar of spiritual

wisdom)—religious decorative motifs that have been adapted to the familiar water-pot placed over the ends of the bamboo supports on the roof of the Indian thatched cottage for catching the rain water. But the bigger and loftier temple, with its shoulder-like pinnacles spread out, looks like God himself wearing on his head a gorgeous head-dress (mukuta) or like the sacred mountain of India, Meru, Mandara or Kailash, the abode of the God in miniature grandeur or, again like a colossal lingam, chariot or other symbol of the God. No doubt this architectural form symbolises one of India's profound spiritual convictions. In the Indian mind nothing is truer in the search for the deity than the discipline of gradual affirmation and negation of all forms and expression (neti, neti) until the mind can reach the Beyond, which is like empty space. The Indian temple architecture incarnates this dialectic of the human spirit by its stress of verticals with the alternate sequence of light and shade in the arrangement of conical towers that gradually shrink and taper off into the spire and then into the trident or disc. The trident is the symbol of Siva's power as the disc is that of Vishnu, and like the cross in the European churches calls people from a distance to prayer. The design of the spire is the distinctive excellence of Indian temple architecture, and is perhaps seen at its best in the Khajuraho group of temples in Central India. Here the refinement and beauty are derived from the repetition of miniature replicas of turrets rhythmically rising tier upon tier on the sides of the principal temple, breaking up the mass and accelerating the tempo of the mounting verticals and producing an illusion of higher ascent. In the Orissan temples the verticals are more pronounced, rising almost parallel to one another, but soon incline inwards to produce a magnificent and massive shoulder, on which rests the ponderous and grave coping stone (amalaka-sila) that is supported by sedent gryphons and crowned by the water-jar and trident. The fluency of the volume and mass is heightened here also by a vertical distribution of miniature turrets filling in the angles of the recesses. The entire architectural composition of towers that rise by the side of towers, gradually increasing in height and dimension leads the Indian mind to the emptiness and wholeness of sky symbolised by Vishnu's blue lotus as the cap through the gradual abrogation of all forms. From a distance the temple looks like a gorgeous tiara on the head of Vishnu or like the legendary pillar, Mount Mandara, used as a stick by the gods for the churning of the ocean or like the holy Mount Sumeru, that supports the sky, and it is noteworthy that the image of Vishnu who is God immanent in the Universe stands absolutely erect and immutable as a pillar within the shrine. On the other hand, the temple of Siva who is God immanent in the self is often built like a pyramidal tower with the solitary cell of Yogic meditation, rising tier upon tier until the last is crowned by a stupa dome or cupola, representing the sky or the umbrella of sovereignty of the universe. Inside the shrine the God is seated in his

profound meditation or there is his form-less symbol, the lingam. Vishnu is God representing the mind in activity that upholds the universe; Siva is God representing the mind in rest that withdraws itself from, or destroys, the universe. A profound metaphysical conception of the principles of cosmic evolution and involution has gone into the differentiation of images, symbols and temples in India though in respect of architecture there has been a juxtaposition of types of design. Yet the temples of Vishnu and Siva have often different kinds of roofs, and congregating together within the same enclosure make an excellent sky-line.

The Indian temple, due to the age-long Brahmanical and Buddhist social emphasis of integration of human and spiritual values, was built in scale with the people in it, and even sought to integrate all their activities and interests by holding in its bosom shops, markets, assembly halls, colleges and kitchens along with gods, angels and kings. Indeed, it became symbolical of the integrative tendencies of human life and experience. In contrast the Western sky-scraper houses not the whole man but the fractionalised man, and the extremely specialised activities undertaken by fluid regimented masses, not the integrated activities of persons at peace with themselves and with the social world. With increase of urbanism, specialisation and segregation of functions and concentration of wealth and power, the sky-scraper in modern industrial civilisation is getting more and more out of scale with the human persons and less and less integral with their lives.

Architecture and Social Planning

Urban industrial civilisation is also giving birth to a second type of human dwellings *viz.*, portable houses with their portable furniture and appurtenances that keep pace with the abnormal mobility and tempo of industrialised communities. The trailer house and the roller coaster are architectural symbols of excessive velocity and instability of life with their profound effects upon the uprooting of homes, the disruption of attachments in family, neighbourhood and occupational groups and man's preference of the empty space of noise, anonymity and thrill to the enclosed space of rest, poise and affection. Obviously, unless we have a new social and economic structure with a balanced property system, a redistribution of population masses and industries and a reorientation of social and economic relations between city and village, region and region, a new architecture cannot assert itself. It is noteworthy that the influence of ideas of such modern architects as Walter Gropius and Le Corbusier is most visible in Sweden and Switzerland among the countries of Europe. These are countries that have the most stable, social and economic structure, and have escaped the social disorder and malady of excessive urbanism. In Soviet Russia also modern architecture has desisted from the construction of either sky-scraper tenements or villas and cottages. Everywhere architecture is brought into intimate relation

with the entire street, neighbourhood and city, and there is the most rational allocation of factories, residences, parks and gardens and public buildings. Secondly, Soviet architecture equips houses and city blocks with special premises for clubs, laundries, factory-kitchens, reading rooms, kindergartens, athletic fields and play-grounds according to the social needs and ideals of communism. The city blocks do not comprise monotonous blocks and lines as in many European countries, but acquire the more expressive forms of architectural ensembles with definite compositional centres. Each city develops its own independent cultural, social and administrative centre, planned integrally in subordination to the common urban centre. Central squares and thorough-fares are thus established, parks and gardens laid out, and the landscape planned. Thus the city becomes a unit of a single architectural whole. Soviet architecture is seeking new forms of artistic expression of the collective idealism and buoyancy of the people in the working class quarters, public buildings, clubs and "palaces of culture" of the cities as well as in the residential and public buildings of the villages of the U.S.S.R. Such forms are also in close correspondence with the climate and topography of different regions of Russia and reflect the traditions of folk-art.[1]

It is regional and civic planning, the break-up of concentrations involved in the giant modern cities and industries, the placement of factories, small industries and workshops in rural-urban habitations, aided by the spread of electricity, the internal combustion motor and the mass production of power tools for use in production and service, that may bring forth the new architectural style in which modern industrial civilisation may speak in an authentic language of its own. Clustered houses in small groups built to the scale of a normal human family or to small communities and habitations of people, adequately spaced and bounded, will demand the new style. On the other hand, architecture because of its muscular and kinæsthetic implications may be a powerful influence in creating new habits and patterns of life and action. Architecture can reunite families in real homes as it now sunders them in one-room tenements, childless apartments, clubs, restaurants and trailers. It can encourage child-raising and rearing under natural and human conditions as it now sterilises whole populations. It can bind together economic groups and classes in friendly social intercourse, activities and amusements as it now segregates and antagonises them.

Finally, architecture now depersonalises the individual by dissociating home work, home education, home crafts and home delights from the house and focussing his interests and activities towards factories, offices, restaurants and cinema houses where life cannot take root. But it may help towards the integration of the personality by redesigning his routine of activity and repose from day to day in tune with the normal rhythmic activity of mother, daughter, wife and children

1 The work of the Armenian architect, Tamanyan, for instance.

in rooms and terraces, courts and gardens, where they may "strew with fresh flowers the narrow way of life". Its motifs of ornamentation and adornment of pictures and furniture may debase æsthetic taste and moral susceptibility. as these may stimulate personal and social idealism and humanitarianism. Thus can architecture recreate man and society through its new forms and relationships, giving new designs and new significances to man's long and strenuous patterns of coming and going, climbing and descending, exerting and resting in everyday life.

The Human Meanings and Values of Architecture

A people's or an epoch's architecture depends upon its collective patterns of living, its social institutions, faiths and ideals. Architecture is the unerring and most enduring witness to social history. Victor Hugo once observed: "During the past six thousand years of the world architecture was the great handwriting of the human race. Not only every religious symbol, but every human thought has its pages and monuments in this immense book." Noble architectural forms are associated with the unity of social purposes and individual goals and integration of the human personality. A stratified community and a disintegrated personality with fractionalised compartmental activities and life-goals dissociated from those of the community would speak in a Babel of architectural styles. It is the present chaos in the social order and values that is, to be sure, reflected in the vogue of a great variety of architectural forms, classical, Romanesque, Gothic or Byzantine, or the adoption of the Gothic for churches, schools and universities and of the Classical or Neo-grec for government offices, courts or banks, all empty symbols of bygone cultures, contradicting the principles and processes of the present society. If in the future social and economic order man's engineering skill and technique is guided by collective inspiration and purpose, new architectural forms will arise, first in the coherently planned cities, villages and regions with their civic parks and playgrounds, colleges, clubs and working men's residential quarters, spaciously laid out among gardens, orchards and cultivated fields. The planning of towns and regions and community architecture will go together superseding through its sense of economic justice, idealism and order the present deep-rooted individual assertiveness and social anarchy, ugliness and waste. Such community planning and architecture will arouse and hold community loyalty and participation and subtle and deep joys of neighbourhood living, just as the medieval Gothic cathedral and the Indian temple stimulated piety and spiritual ecstasy, and will, therefore, constitute some of the most significant creative social enterprises of the time. Domestic architecture will not only integrate the lives of persons within a house by departing from the present formal assignment of the major family activities between the different rooms taking advantage of the new flexibility of partition and continuity of floor space,

but also by the proper use of terraces, courts and large windows will abolish the division between indoors and out-of-doors so that the contrast between life in intimate touch with earth and nature and a de-natured, housed life will be mitigated. The structure of steel, concrete and glass would contribute to refashion the structure of modern industrial society.

Regarding its visual qualities, the new architecture would be characterised by flexibility, exactness and airiness of form superseding the massiveness and solidity as well as ornateness of the past, by harmonious use of colours and textures on different surfaces, both inside and out, instead of dullness and monotony, and by subtlety, refinement and economy of use and adaptation of materials and methods to functional needs as determined by the non-individualistic planning of regions, communities and cities that would be more and more true of the future. Instead of the hampering ornamental curves and wavy lines of the old architectural styles pure geometrical patterns that are conditioned by the economic placement of supports, weights and openings and that are now met with in modern Cubist and Constructivist movements in painting and sculpture would import the supersensible and the limitless into the grossly material task of definition of space by enclosure. The relation of wall to window, solid to void, volume to space, block to block in steel and iron, stone and glass would throw the gates open to the mind for the immeasurable Beyond. And, indeed, architecture would recover its old sovereignty among the visual arts. Architecture would rule while painting and sculpture would serve.

The new architecture would usher in the society of tomorrow quicker by integrating the behaviour and ideals of men, at the same time revealing significant eternal geometrical forms of things and the universe, of human life and destiny that outlive man and outreach his mind. As art architecture prophesies and blesses new ideals of human conduct and makes these articulate, manifest. It defines and interprets the structure of society and of human life, and expresses and integrates man's destiny. As philosophy architecture brings into the concrete realm of touch and vision the mysterious unity of structure or pattern in all forms and appearances, transcending man's natural experience and his ideological division between spirit and matter, inner and outer, subject and object. The structure and integrity of personality and society, of life and the universe are best brought home to man through brick and mortar speaking straight to his body.

CHAPTER XV

THE SOCIAL SIGNIFICANCE OF MUSIC AND DANCE

Music and the Abstract Values

Music is the culmination of the arts. Representing as it does the temporal and not the spatial version of rhythm, and depending for its symbols on sounds that are indirectly related to natural sounds, it embodies more abstract and impalpable æsthetic values than either painting or sculpture. In the ancient Indian treatise on painting and image-making, the Vishnudharmottara, we find an interesting basic principle laid down. "Without a knowledge of the art of dancing the rules of Chitra (sculpture in the round, relief and painting) are difficult to be understood. Without music dancing cannot exist, nor music without singing. He who knows the rules of singing knows everything properly." [1]

The artist moves us powerfully by his words, colours, sounds and forms as these echo some more ultimate harmonies in the depths of his soul. The appeal of poetry, music, dance, sculpture and painting lies, in the first place, in this that the imagery, arrangement of words, colours, sounds and shapes and rhythm recall for us the deep harmonies in the ocean of Being with which all men find themselves intimately in tune. Thus they awaken themselves with joy, wonder and awe as they hear the great overtones of an unlimited existence. Secondly, as they apprehend and appreciate such harmonies, concords and unitary patterns they themselves achieve a new orientation of the spiritual states, a new ordering of their souls. The latter aspect has been well stressed by Plato : "God devised the gift of sight for us so that we might observe the movements which have been described by reason in the heavens, and apply them to the motions of our own mind which are akin to them, so far as what is troubled can claim kinship with what is serene. For so we might learn a lesson and by entering into the ideal nature of that design and imitating the imperfect pattern set by God might adjust thereto our own random motions. And the same holds good of voice and hearing ; the gods bestowed them on us for the same end and purpose. For that is the end of speech, which it serves more than any other faculty. And so far as vocal music goes it is given us to be heard for the sake of melody. And melody, since its movements are related to the changes o our own souls, is to be valued, if a man use his mind in art, not for irrational pleasure, as is the fashion now ; rather it is given us to help us in ordering and assimilating to it the discordant motions of our souls. And rhythm again was given us from the same source and

1 Stella Kramrisch (Ed.): *The Vishnudharmottara*, pp. 31-32.

for the same purpose, to help us in dealing with what is measured and chaotic in the minds of most of us."

Music and the Emotions

It was thus that the Greek philosopher recognised that music, though often used for arousing sensual delights and pleasures, should subserve the function of bringing poise and order to the soul. Through the medium of sound, music is the food of love and indulgence of the pleasures of the senses as it also stirs the soldier to heroic battle and sacrifice, the shaman or the saint to mystical ecstasy, and the common man to strenuous and monotonous toil. Sound itself reports an abrupt and sudden stress or strain, change or movement, and hence directly and intensely excites emotions. Thus music and poetry, with sound as their medium, are most favourable for the expression of the dramatic episodes in nature and human life, tensions, crises and struggles with their corresponding rise, maturation and crescendo of emotions such as love, fear, sorrow, pity, exaltation and wonder.

There is hardly any human passion and desire that has not been celebrated and fostered by music in the history of civilization. In primitive culture music encourages the savage in wars or hunting expeditions, enlivens his fasts and festivities, conveys the feelings and meanings of his rituals and sets the pace for his dances in connection with sowing, harvesting, love-making and other familiar activities. It stimulates zest in monotonous toil and drudgery, and devotion in prayer and worship. It assuages sorrow and misfortune and fosters elation and excitement in victory and prosperity. On the other hand, out of the strong emotions aroused by the feast, hunt, battle, magical observance or ritual arise the many-voiced chorus and the harmony or concord of several accompanying musical instruments that intensify the group feeling and solidarity. Music has played an important rôle in social cohesion and integration through the ages in close association with feasts, dances, games and rituals. The basic connection between music and the ethos of a people is illustrated by Plato's fear that a change from the Doric to the Lydian mode of music in Athens would be the sure precursor of civic degeneration. If music is put to a variety of uses by society in the crises of battle, disease and love, in economic operations and religious rituals or in man's triumphs and disasters that all require unity of action, and serves among all communities, savage or advanced, as a powerful affective social binder, music also facilitates the journey of the alone to the Alone. Man's isolation is rendered poignant or exalted by song. His withdrawal from the world is magnified by the music of hymns and psalms. Most religions utilise music for eliciting moods of detachment from the life of the senses; while some seek to bring about mass spiritual ecstasy through prolonged, repetitive song and dance in the group or congregation.

Music is itself depressing, stimulating, pitiful, grim, fierce and sublime for the multitude, who in a choir, band or concert entirely forego the customary controls and inhibitions and behave like beasts or for the solitary individual, who soars with the flights of ethereal music far above the ordinary mortal's range of consciousness. While Havelock Ellis found that musical performances are resorted to by some persons for obtaining sexual orgasms, Beethoven's experience was that music is a higher revelation than all wisdom and philosophy, the one incorporeal entrance into the higher world which comprehends mankind but which mankind cannot apprehend. The latter consummation is reached by that type of music that is dissociated from human speech, and hence from the commonplace associations of human objects and phenomena. Thus Dewey observes : "Through the use of instruments, sound is freed from the definiteness it has acquired through association with speech." It thus reverts to its primitive passional quality. It achieves generality, detachment from particular objects and events. At the same time, the organisation of sound effected through the multitude of means at the command of the artists—a wider range technically, perhaps, than of any other art save architecture—deprives sound of its usual immediate tendency to stimulate a particular overt action. Responses become internal and implicit, thus enriching the content of perception instead of being dispersed in overt discharge. "It is we ourselves who are tortured by the strings" as Schopenhauer says.[1] It is this long-continued fusion of the incipient responses and integration of incompatible attitudes that open to the mind vistas of experience of the super-sensible that are generally inaccessible to the ordinary consciousness.

Music as the Goal of the Other Arts

Music is a more accurate and intimate mirror of the travails and victories of the lone human soul than any other fine art. It brooks no enduring partnership or association with things of human or earthly origin. Its communication is more unshackled than that of other arts because of its more complete freedom from the operation of intellectual symbols and technical procedures, its extreme abstraction. It relies on pure combination of sounds or on rhythm that gives delight often because it is unfamiliar or incredible. Man's subtlest emotions and moods embodied in a momentary glance from the eye, a quick drooping of eye-lids, a quiver of the lips, a delicate nuance of the lovers' approach or separation, a soft murmur of parting kisses, an overwhelming grief too deep for tears, a secret terror of the soul or a supreme spiritual exaltation and beatitude can be articulated by music in a manner that neither sculpture, nor painting nor even lyric poetry can.

1 Dewey : *Art as Experience*, p. 239.

Music is in fact far different from sculpture that expresses and suggests clearly defined and stable moods and emotions, not the subtle, fluctuating, vague and elusive ones that go exceedingly well with the medium of former. But equally like sculpture it reveals the universal and the enduring, even more so as, due to its abstraction, it soars high above the limitations and contingencies of human life and existence. It suggests the impalpable and the transcendental that underlies the, world's existance—'the form in all forms and of all souls the soul.' Even the magnificent poise and sublimity of the seated meditative image of Siva in Hindu sculpture cannot breath the serenity with which the morning melody of Bhairon Raga in Hindu classical music inundates the human soul. Certain magnificent paintings such as the Ajanta and the Horyuji Boddhisattvas, the Primavera of Botticelli or Joie de Vivre of Henri Matisse with their flowing curves and swift rhythmic patterns recapture the floating arabesques of music. Similarly many Chinese landscapes and the pictures of Watteau, Corot, Turner and Whistler, among others, are dream-like, outpouring man's longing and wistfulness and the peace and harmonies of the soul. Mist and haze and colour and atmospheric effects over infinite distances produce the impression of fine, thin notes of music wafted by the breeze from afar. All this clearly shows that music can reveal human moods and emotions in a very special and profound manner not accessible to either painting or sculpture. This is why Walter Pater has observed that all arts have in some sense their goal in music.

The Enchantment of Music

The reason why music can express and suggest the deepest, subtlest and unutterable human feelings and moods is not far to seek. Though its changes of pitch, pace and volume, its accelerations and retardations, relaxations and on-rushes, diminuendos and crescendos, music gives the consciousness control over the flux of time itself and makes it transcend the temporal world. Mind as it arrests, halts and speeds up time seizes temporality itself. It is transported to the supersensible realm and enjoys acosmic experiences. The apprehension of pure time is the essence of music as is the apprehension of pure space that of architecture, when the builder's appropriation of a limited fraction of space by a dome, a spire, a colonnade gives the glimpse of unfathomable space. Through pure time whose throb unites the past, the present and the future into a mysterious flux that knows no beginning nor end, through pure space whose sweep encompasses and overreaches all directions, the mind enters into the tranquillity of Being in the heart of nature and human life. It is music alone than can render articulate the majestic rhythms of nature, in her ebb and flow, dawn and night, the alternation of the seasons, or the sequence of birth, maturity and renewal as the counterpoise or antiphony of man's own sleep and awaking, death and life, withdrawal and renewal. For music is both the incomparable universalised

rhythm and the emotion itself. Nurtured in nature's rocking cradle, music can transcribe in unalloyed purity the original rhythms of the soft advent of the dawn, the sequence of morning, noon, twilight and night and the recurrence of summer, autumn, winter or spring with all their magic oscillations of the moods of alarm, suspense, hope, contentment, sadness and despair. Music enchants because it alone can express through its complete spontaneity and freedom from the limitations and contingencies of its earthly origin the inexpressible, supersensible, primary rhythms in which all existence partakes. As the lesser rhythms of song stir and agitate man's lower passions and desires by reproducing the vibrations of his body, its greater rhythms echo through the universe and bring to the soul the wild tumultuousness and speed as well as the order and silence of the interstellar spaces. The recitation of the sacred syllable 'Om' and of certain Vedic hymns and mantrams, the Indian Ragas or the music of Beethoven, Brahms and Bach give us the apprehension of strange elemental forces, light, fire, water and wind in their tumultuous commotion as well as in their all-pervasive tranquillity on a grandiose scale that does not belong to the earth. It is a paradox that the highest music embodies sounds that never were on sea and land, expresses movements and happenings that never were on this earth. Because of its supreme linking together of the known and the unknown, the sensible and the supersensible, the earthly and the heavenly, music enables us to taste sweetness in sadness, serenity in activity, order in confusion. Mankind experiences incredibly varied, strange, abstract and transcendental moods and sentiments through harmony and melody of tone that mingle the reverberations of the natural world with the disembodied murmurs, tremors, cries and concords from unknown worlds. Music removes man farthest from the tenor of his life and the world, from the tensions and limitations whence arise the other fine arts. Music is sentiment, pure and extremely abstract, freed from the limitations of its human origin. It thus expresses at once the inexpressible aspirations and the triumph of the spirit of man that he seeks but cannot achieve on this earth. Music is the only adequate, final and impeccable utterance of mortal man's emotion of Being, of his unutterable ecstasy of concord of Being and Becoming.

Nature and the Origin of Dance

The dance is the visible communication of music but now reinforced by the more intense appeals to emotions and sentiments associated with the rhythmical movement and gesture of a living person. The appeal of a rhythm that it is at once visible, audible and familiar is further strengthened in dance by the mimicry of nature and muscular sympathy or kinæsthesis. Slow or animated movements of animals and other objects in nature, recapitulated or reintegrated in dance, arouse in the on-lookers feelings and attitudes associated with similar muscular sensations in their own experiences. Herein lies the contagion of

emotions aroused in the social group by the musical arts, especially when these repeat the simplest movements and cater to the primary and generic emotions. Music begins with the participation of voice in the rhythm of bodily movements. Choral music, vocal and instrumental, the clapping of hands, the stamping of feet and the rhythm of movements of the body and of familiar or remarkable happenings in nature aid one another in crystallising and enhancing the emotions of the dance group. Mind and body at rest and in animation differentiate between the solemn and sustained and the excited and frenzied music and dance according to social and psychological needs and situations. Man's arduous toil in association is, for instance, much relieved by uniform and rhythmical movements of the body, especially where rhythm and melody correspond to the latter. Not merely song and ballad but even speech and ideation may have originated in the considerable heightening of emotions in choral music and dance. Thus the routine of man's life punctuated by the sequence of the seasons and the specific moods and emotions aroused by nature and by the intervals of strenuous common labour, leisure and excitement is strung together by an adaptive variety of dance, music and song.

It is not the genius of individuals nor deliberate social purpose but the collectively experienced emotion and mood in particular social situations and their specific expression in rhythmic or mimetic movements that originally discovered the rhyme, the ballad, the song or the dance. Not reason but the emotions, not the deliberate activity of individuals but irrational rhythm in mass movements are more significant formative factors in the evolution of culture. Man carries from animal life into dancing the primary rhythms of rest and activity, and the corresponding feelings of tranquillity and excitement that govern the rhythmic and melodic motives and the main forms of music (such as songs for work, for war or for ritual) and poetry (such as the epic, the ballad or the lyric).

It is noteworthy that while animals cannot see and appreciate beauty through vision, they hear and appreciate music and perform elaborate dances spontaneously. The difference between human and animal experience is thus explained by Pijoan: "The higher animals have eyes placed in such positions on the head that it seems unlikely they see things as we do. They make no attempt at adornment to make themselves more beautiful. The apes which live almost like savages do not make garlands of flowers or necklaces of leaves as do the primitive savages of the human race. No, beauty is a human experience." Not however, rhythm. The songs of birds flowing out of their high spirits and inexhaustible vitality show a profound sense of rhythm. Several species, as for instance, the skylark, the nightingale or the Indian cuckoo vary their combinations of notes, link, oppose, repeat and improvise them, achieving great musical art. A famous French ornithologist, Jacques Delamain, aptly observes: "A bird enjoys the note modulated by his own throat. But if he attains art it is because,

endowed with a sense of the beautiful, he is able to choose among his notes the clearest, the purest and the fullest, to link one to another, to find the rhythm, compose the phrase, transpose the tones, thus achieve pure music and make a song gush out from a cry. And it is in his search for beauty that the art of the bird touches us. We comprehend and interpret his æsthetic effort. The Lark's song becomes for us the expression of courageous and serene cheer: in the stanzas of the Nightingale we find an accent of fervour."[1] Birds express life not only by music but also by gay frolicsome dances. Such birds as lapwings, rupicola and scissor tail perform, according to the observations of Hudson, elaborate dances both on the earth and in the air, involving group activity and regular figurations. Dances are also to common to plovers, stilts, peacocks, pheasants, ostriches and penguins. Julian Huxley refers to the "flying sports" or dances of ravens, rooks, crows, herons, curlews, swifts and snipe characterised by controlled performance and excitement in rapidity of motion. Certain species of insects, fish and small herbivorous mammals also dance. Such exuberant manifestations are marked in periods of particular gaiety among the animals, while in the mating season under the added excitement of sexual impulses these reach a higher degree of vigour and perfection of execution.[2] These have indeed played an important rôle not only in courtship and sexual selection but also in general adaptation among various species of animals.

Man has continuous sex life and interest, and not only spring time but all occasions and activities that arouse intense emotions are celebrated with dancing. His supple and vigorous body gains flexibility in his life in the forest through the chase and other adventures, and this contributes towards the skill and success of the art of the dance. More than in the case of any other animal, man's face, feet and hands can be used successfully for mimetic expression and gesture, while their repetitive movements can give him genuine pleasure through an indefinite production and variation of rhythm. Thus man's powerful play-impulse from the beginning fashions dancing into playful forms, utilising his capacity for infinite variations of postures, movements and mimetic expressions. "Dancing originated," observes Giddings, "in an overflow of energies as spontaneous as the frolics of animals, but unlike animal frolics, this human diversion is soon reduced to conventionalised forms. Imitation works the transformation. The crude and savage dances are imitations of animals and of familiar occurrences." Men spontaneously sing and dance due to natural vivacity and high spirits or under the stimulus of food, sex and intoxicant and also for overcoming emotional stresses and strains. Dances to influence the behaviour of the game and enemies by imitation, or to produce war fever, religious mania and orgiastic fury, according to the imperative needs and conventions of the community, came

1 *Why Birds Sing*, pp. 58-59.
2 Martin: Article on Dance in the *Encyclopaedia of the Social Sciences.*

later in social development. More often dances, whether among savage or among advanced peoples, are performed for the sake of the effects upon other persons. Man is profoundly affected by the steady and poised, or rapid and fluttering movements of birds and animals, or by the rhythms of the march of clouds, the play of lightning, the shower of rainfall or the rush of waves. Through catching these rhythms in his dances he seeks to reproduce and consolidate his emotions and experiences for the group, or control or manipulate the occurrences of nature to its advantage. Play and natural abundance of high spirits, emotional crisis, natural or induced imitation and magic, all enter into the origins of dancing that serves a variety of social ends, and is hence institutionalised into formal artistic designs and patterns, incorporating the movements of animals and of natural happenings but investing them with new human meanings and purposes. The intensity of emotions and sentiments and the accrual of rational social aims and values transform and perfect dancing.

Dance and Social Integration

There are no movements in nature, the swoop of the waterfall, the placid flow of the stream, the hurricane, the streak of lightning, the conflagration of fire, the earthquake, or again, the flight of the eagle, the gait of the wolf, bear, serpent, flamingo or swan that cannot be expressed by man through the medium of his swaying arms, hands and feet with coloured draperies flowing in unison. Man also epitomises and records in his dancing his primordial passions and intense and profound experiences that stir him to his depths. Thus do the rhythmical movements of dance also reveal the happenings of the inner world, the interplay of the entire gamut of human desires and sentiments from the varied nuances of love and outbursts of jealousy, anger, grief and power to spiritual ecstasy, exaltation and repose. Organised and intellectualised into conventional forms, these serve to discipline and integrate emotions and experience for the community and the individual. In the history of social development music and dance co-operated in clarifying and enlarging man's feeling and experience and in fostering and consolidating his sentiments of aggression and combat, love and abasement, hunger and economic toil so as to bring about unity of action, and thus contributed in varied manner towards the adjustment of individuals and societies. Magical, erotic and martial dances, worked off or stimulated rebellious and dangerous emotions and tided over psychological crises of the people, helping them to secure timely rain and abundant harvest, defeat their enemies in war or capture animals in the chase. Such dances and particularly those celebrating birth, puberty, marriage and death tended to establish and reaffirm the unity and solidity of the group by directing into socially approved channels the fluctuating emotional life of the individual. Savage dancing is violent and mimetic. But as the primitive controls nature through magic and ritual, so his dance bears the

impress of his power and purpose. By his dance he makes the crops ripen into maturity, his animals to reproduce or be captured and slain, and the passions of his own heart find their true social goals; while he even makes the revolving sun obey his movements and gestures that become organised into formal designs— not mere naturalistic mimicking of animals and happenings in nature. The community in its dance draws both nature and the feeling and experience of man closest into its heart.

As the family and kinship group participate in choral songs and vigorous simultaneous movements and gestures for a common purpose, the attitudes and norms of the community are clarified and reinforced. The reciprocal excitation of hunger, aggression and sexual desires that are canalised into legitimate social channels by the collective dance and ritual and the intensification of group feelings and experiences are equally important in individual and social adjustment. Among many primitive peoples collective dances at the ritual of initiation are of pantomimic nature, intended to teach the youths of the community to abstain from homosexual practices and resort to normal sexual intercourse that is often inculcated by lewd gestures and movements. With others puberty rituals and dances are periodic occasions for sex licence when emotional release is achieved, and the mind of the primitive people becomes free for other serious pursuits. No doubt, group dancing by boys and girls as a preliminary to pairing off and marriage, that we come across in most primitives, has been a means of facilitating courtship and sexual selection, the young men who can handle the spear and other weapons and dance best deserving the fairest. Among the primitives of Chota Nagpur the courtship dances take place on full moon nights, the young men and women decking themselves with attractive flowers and feather and singing and dancing to the tune of musical instrument. Boys and girls do not actually mix during the dancing, but dance in separate rows linked in pairs, arm in arm. It is only after dancing that they meet and court. Both the aims and features of courtship dances have survived in the smooth and ceremonious dances of modern times. The food quest is an important concern for all primitive peoples. Thus hunting communities have their dances that represent the habits of the animals and their movements when attacked. The wolf, the bear, the deer, the emu and the kangaroo are all counterfeited. If such dances are designed as preparations for a successful hunt or chase, many savage groups also dance their totem animals in order to enter into communion with them or share their mystic potency. Agricultural peoples have their sowing and harvesting dances that anticipate the appropriate agricultural operations at definite seasons of the year and comprise a vital discipline and practice for prolonged and strenuous team work in the fields. Finally, among all primitive peoples the procession of the seasons and changes in the landscape, such as the blossoming of sala and mahua flowers, the beginning of rains and snowfall or the phases of the moon are

occasions for tribal dances and rituals carried out with unrestrained enthusiasm, relieving the monotony of daily life and providing opportunities for both emotional release and expression. That rituals and dances would intermingle is entirely logical. For, as John Martin observes, "even the most natural movements when backed by intense feelings assume larger dimensions and stronger stresses and, as the outgrowth of a particular purpose instead of merely generic excitement, slip naturally into rhythm and form." Secondly, at the mental level of the primitive peoples ideas remain vague and implicit while the feelings dominate, and are stimulated by mutual participation an excitement in the routine of overt gestures, rituals and observances in which they pin their faith. Man at this stage 'dances out his magic and religion rather than thinks them out.' It is in this manner that dance epitomises, crystallises and consolidates the dominant ideas of the primitive peoples, supernatural, economic or social. As a matter of fact the blending of these vague and incipient, yet socially invaluable, ideas has its counterpart in the primal cohesion of the dance group, the cultural core of the community.

Dance as the School of Culture

In all dancing man seeks the perfection of rhythm from all exquisite moving things in nature, and at the same time super-imposes upon rhythm and form the moving drama of his own passions and desires through accent, repetition or contrast of movements. Thus music and dance epitomise and celebrate in various stages of civilisation the meaning of movement in both the outer and inner life: the orgastic fury of the Australian aborigines, the more sober courtship dance of most primitive peoples in spring, the ritualistic whirl of the Dervishes and Bauls, the war-time parade of the Maoris, North American Indians and Kaffirs, the agricultural dance of rural folks throughout the world and the grave hesitant ball-room two-step of civilised social intercourse. At each level of civilisation the social function of dance is the communication of æsthetic images, the excitation of collective feelings, whether sex ardour, courage or religious emotions, the dispelling of the fear of disease, blight, infertility or death and the promotion of *rapport* between the individual and the group. In primitive culture, the dance represents the ideal set of activities and movements, whether hunt, war, agriculture, fishing or love-making and imports into these latter their full meaning and purpose. Through its ease, rhythm and totality of movements the dance becomes the school of culture, the nucleus not only of music, painting, sculpture and poetry but also of religion and science that all arise and differentiate from it. It is the regularity and symmetry of man's movements in the dance and their accompanying kinæsthetic sensations and experiences that foster rhythm and plastic values in his painting and sculpture, while the ritual objectives of the dance early call for decoration and adornment of body, masks, tools

and objects. From initiation ritual dances have emerged forms of sculpture saturated with sex motifs among many primitive peoples; while the masks used in their dances also exhibit rhythmical patterns. From masks to totem poles, pottery, textiles and sculptured figures, the dance in fact spreads its rhythm everywhere as it originates music and poetry. The ritual ends of the dance have even a more far-reaching influence. The primitives in their adjustments to life and the world lean more on the automatic efficacy of their ritual dances and performances, with their gross but forcible symbolism and their full burden of meanings and values, than on any metaphysical thinking of their own. The dance, taking the rhythm and form of a familiar episode or movement, creates the unity of feeling and understanding of the totality of life from which emerges the discipline for primitive man's fresh exploration of facts in the fields of magic and science. That same *rapport* of feeling, understanding and movement also becomes the creative stimulus for achieving fresh relationships with the universe, that represent the essence of all artistic expression, stirred as it is by the quickening of emotions. Using in the oft-repeated dances the bow and the arrow, the spear, the sickle, the paddle or any other tool or implement, and wearing the head, head-dress or mask of the animal guardian, or the garment showing the marks of small-pox, primitive man enters into an active mystical intercourse with the forces of his natural or supernatural environment, and defines and clarifies these for his welfare, security and competence. On such inward assurance and power that dance achieves rests the whole fabric of early man's culture. The dance in early times thus crystallised and enriched the entire range of man's experiences in the realms of both practical and imaginative life which it revealed in unsurpassed intensity. It held in solution the seeds of the varied sciences and arts of life as it incited the group consciousness to higher co-operation in society and to greater mastery over the environment.

On the whole, the history of civilisation is also a history of the decline of dance that is such a stirring and wholesome social art among the less advanced peoples. Dance, which is the most direct and elementary record of the perception of life and movement, cannot but decline in its significance with the evolution of intellectual and sophisticated media of expression and of physical exercises, drill, and games superseding dancing as a vital practice related to both the inner and outer life. In all countries the division of economic classes with the stress of courtliness and 'genteel' manners of the upper social strata has been responsible for the artificiality and superficiality of dancing, largely shorn of its vital meanings and expressions. Modern social development also largely eschews public display of emotions, while sex and courtship are relegated to private life. Thus the gulf between folk music or dance and the theatrical form has increased although movements have been afoot to introduce the cardinal principles of primitive and folk music and dancing into the modern arts, thereby restoring

their former social significance. The rural folks everywhere sing and dance, celebrating in essentially the same manner the occasions that supplied the inspiration for primitive peoples. Thus folk music and dance everywhere retain their sincerity and vitality. But urban civilisation at the same time dissociates dancing from intimate and genuine individual and social experiences and qualities.

Stylisation of Dance, Pure and Pantomimic

Dance differs from sculpture in this that the body cannot be dissociated from its association with its familiar emotions and experiences and their specific expressions that constitute the universal vocabulary of dance. The human body cannot be fashioned or transformed into an abstraction of lines, and shapes. Such effort would result in abnormal, incongruous or fantastic forms and movements that may be sensational or bizarre, but cannot stir the mind to a deeper or fuller appreciation of life and the environment. On the other hand, all movements are not expressive. Thus in great dance there is a mingling of spontaneous and calculated movements; there are selection, distortion and emphasis, all obeying the rule of number and of rhythm and of measure and of order, of the controlling influence of form, of the subordination of the parts to the whole.[1] Regarding the limitation of naturalism in dance it has been aptly observed : "Not representation but interpretation in the dancer's task, his duty to nature itself; the abstracting into essences of those deep-rooted experiences of human living which appearances, surface truths and naturalism cover and deny." The aim of dance is not merely to communicate emotional experiences and attitudes but to lead through these to a profounder, wider and more intense revelation of life and the environment, to an appreciation of unuttered truths and values in respect of human life and destiny. Its distinctive characteristic lies in this that the eternal verities and spiritual values are presented in the context of a finite individual's subjective emotions and sentiments and their unique expressions in the contours and movements of the human body as the vehicle of such expressions.

True dance avoids the dangers of cold and insipid abstraction on the one hand and the interplay of specific subjective moods and expressions, on the other. Thus it becomes highly stylised, using in some measure the technique of architecture in evolving a rhythm and a balance out of motion and repose, fall and recovery, tension and release, all full of meaning for human desires and aspirations. The choreographic technique in dealing with relations between the human body and space and gravity unfolds abstract values as architecture does, but unlike the latter these attain to much greater complexity due to the possibilities of variation of the rate of the bodily movement, and the "tonalisation of the movement in terms of music". Dance rises to yet higher achievement as it becomes representational i.e., pantomimic, widening its subject-matter so as to

1 Havelock Ellis: *The Dance of Life*, p. XI.

include other individuals and types and the reciprocal interplay and development of contrasted or opposed feelings and attitudes in both their static and dynamic aspects. In fact pantomimic dance with the help of costume and stage setting can more effectively reveal the dramatic movements in emotional life and experience than pure dance, and represents much higher complexity and unity of the art of the dance. Isadora Duncan has remarked: "A great art should no longer be kept for the delight of the few cultured people. It should be given free to the masses as air and bread are the spiritual wine of humanity." It is pantomimic dance with a large number of individuals symbolising distinct moods, emotions and ideals that are opposed to one another in the moving drama of society that throws open to the masses a new moral and social vision. In fact this phase of development of dance, with the appropriate costume, decoration and scenery revealing social conflicts and aspirations in dramatic form is already distinctive of the modern theatre and ballet in several countries. Soviet ballets, under Asafiev and Semyonova and Indian ballets, under Uday Shankar, Simkie and Amala, are saturated with the elements of social satire and inspiration.

The respective achievements of pure and pantomimic dance with reference to the expression of the religious emotions are pointed out by Havelock Ellis thus: "These religious dances, it may be observed, are sometimes ecstatic, sometimes pantomimic. It is natural that this should be so. By each road it is possible to penetrate towards the divine mystery of the world. The auto-intoxication of rapturous movement brings the devotees, for a while at least, into that self-forgetful union with the not-self which the mystic ever seeks. The ecstatic Hindu dance in honour of the pre-Aryan hill god, afterwards Siva, became in time a great symbol, 'the clearest image of the activity of God' it has been called, which any art or religion can boast of. Pantomimic dances, on the other hand, with their effort to heighten natural expression and to imitate natural process, bring the dancers into the divine sphere of creation and enable them to assist vicariously in the energy of the gods. The dance thus becomes the presentation of a divine drama, the vital re-enactment of a sacred history, in which the worshipper is enabled to play a real part. In this way ritual arises". Classical Indian dance is in fact both a divine art and a sacred worship. In India the classical dance in its higher forms sought to present the eternal sport (lila) of the generation and destruction of the Universe, so far as the outer life was concerned, and the eternal drama of human moods and experiences as pulsations of the soul's rhythm of Being and Becoming. The gods were actors and dancers, and men personated as gods as they danced before temples. The male dances *tandava*, vigorous and exuberant; the female dances *lasya*, elegant and seductive. There developed an entire systematic science of gestures, defining the positions and movements of the head, neck, eyes, hands and fingers as echoing specific moods and sentiments (rasas). Recently classical dance has been resuscitated

in India by Uday Shankar who has translated ancient plastic figures into dynamic dance-forms and assimilated into his compositions various elements of folk art from Northern and Southern India. Indian art in this particular sphere concentrated itself on the revelation of profound truths in regard to man's life, activity and destiny in the context of familiar myths, legends and episodes from the epics and the Puranas in which different types of personality and their contrasted generic emotions and moods act and react upon one another resulting in disasters and triumphs for the human soul. As in other fields of artistic expression, the aim of the Hindu art of dance has been frankly spiritual, enabling the onlooker to comprehend the mutability of life and attain mental poise and spiritual bliss. "By clearly expressing the generic mood (rasa), and enabling men to taste thereof, the art of the dance gives them the wisdom of Brahman whereby they may understand how every business is unstable; from which indifferences to such business and therefrom arise the highest virtues of peace and patience, and thence again may be won the bliss of Brahma". More specifically the aim of the art of the dance is adumbrated in the Abhinaya Darpana (Mirror of Gesture) in a fine context. The Titans came to see a drama being presented by the gods and remonstrated with the latter since it depicted their defeat. Then Brahma explains: "This play is not merely for your pleasure or the pleasure of the Gods, but exhibits mood (bhava) for all the three worlds. I made this play as following the movement of the world whether in work or play, profit, peace, laughter, battle, lust or slaughter; yielding the fruit of righteousness to those who follow the moral law, pleasure to those who follow lust, a restraint for the unruly, a discipline for followers of a rule, creating vigour in the impotent, zeal in warriors, wisdom in the ignorant, learning in scholars, affording sport to kings, endurance to the sorrow-stricken, profit to those who seek advantage, courage to the broken-willed: replete with the diverse moods, informed with the varying passions of the soul, linked to the deeds of all mankind, the best, the middling and the low, affording excellent counsel, pastime, weal and all else." The a-moral, impersonal and universal aims of the art of dance have seldom been elucidated so clearly and pointedly in a classical text.

With such an aim even at the start of classical tradition, it is no wonder that dancing has been a constant source of inspiration to Indian sculpture and painting, and that the dance motif is utilised in Indian music, literature and philosophy for the expression of the supreme metaphysical rhythm that underlies the world process. In Indian iconography the entire cosmic pageant of rhythmic creation and destruction, manifestation and withdrawal is epitomised by the divine dance images that translate eternal movement in the universe, whether represented by the larger more pervasive rhythms of the phenomena of nature or the lesser pulsations of human moods and sentiments. The palpitating patterns of human figures thus incarnate in unsurpassed fashion the physical, biological and metaphysical rhythms with their profound spiritual meanings and values for

man. The dance is very certainly the quintessence of the eternal and universal meaning of motion and rest in the universe.

In no culture or religion has the conception of the necessary and complementary character of the soul as Being and Becoming in its alternating accents of rest and motion, silence and sound, creation and destruction which it shares with the recurrent alterations and symmetries of the universe brought out more significantly than in the myths and art forms of Hinduism. In the Upanishads we have the emphasis of music of the sacred monosyllable 'OM', divided into its three elements (matras) as underlying the alternation of the states of Being and Becoming. The Mandukya Upanishad in particular indicates the steps of the realisation of the ego from the state of waking through the state of dream to the state of beatitude symbolised by the respective sounds of A, U and M in sequence. The ego first controls and fulfils all its desires and identifies itself with this sensible world. This is the condition of the ego as represented by the sound of 'A'. Then the ego finds the manifested universe as the product of its own knowledge which is inseparable from himself. This is the stage of the ego symbolised by the sound 'U'. Thirdly, the ego finds itself identical with the unconditioned and unmanifested, the first cause at the same time becoming the final cause. Indian meditation conceived of the dialectical alternation of the soul from the conditioned to the absolute and back in terms of the rhythm and harmony of the pre-eminent syllable OM which symbolises both the withdrawal and unfoldment of manifestation. Hardly has ever the rhythm of sounds as expressing the essence of the opposites, Being and Becoming, been fashioned into a metaphysical system as in the Upanishads which laid the foundations of Indian meditation through the centuries. Different religious schools of India have adopted meditation on the harmonies and concords of mystic syllables and formulas. Such concentration on the music enables the mind to discover the primary and original pulse of the soul in its oscillating phases of Being and Becoming, and thus come in tune with the outer rhythms and pulsations in the life of the universe. Thus the microcosmic rhythms of silence and sound, sleep and waking become identical with the balanced rhythms of the macrocosms.

The Cosmic Dance Images in Indian Art

Indian civilisation represents in stone and bronze the physical and metaphysical laws of rhythmic recurrence in the Universe in cosmic dance images which are some of the most majestic conceived by human intuition. Such dance images, with their numerous variations in the complex and vast Indian iconography, are founded on the alternating rhythm of Being and Becoming, of motion and repose, creation and withdrawal, and on a dominant fundamental Indian metaphysical conception. Indian metaphysics and religion conceive the cosmic process as a succession of vast cycles of Being and Becoming, manifestation and non-manifestation, creation and withdrawal, and the phenomenal world at all times as one of perpetual change, involving perpetual creation and destruction,

Being and Becoming. The human soul at rest or withdrawal (Being or Siva) represents the non-manifestation or dissolution (pralaya) of the universe; in activity or manifestation (Becoming) it represents the creation (srishti) of the universe. The urge of the absolute that is Alone to multiplication or manifestation in the world process first expresses itself in the form of cosmic rhythm or dance. Through ever-recurrent cycles of non-manifestation and manifestation the world-process moves on in unison with the eternal dance of Nataraja, the Lord of the Dance or rather the world process is Siva or the Dance itself. In the symbol of Nataraja, siva or being is imaged as the soul of everything and everybody, the essence of all manifestation in nature. Siva's dance is the source of all perpetual pulsations from the movement of the planets to the alternation of attitudes in the soul and represents all his five acts, viz., the world processes of creation (or evolution); preservation; destruction (or involution); the embodiment of souls; and their release from the cycle. The purpose of the dance is the withdrawal of the soul to Being, and its final release from the cosmic process. In the majestic icon, Siva, the supreme actor and dancer among the gods, "whose gesture is the world process, whose speech is the sum of all languages and whose ornaments are the moon and stars" dances the *tandava* dance, energetic and virile. He wraps about him as a garment the skin of a tiger, the tiger symbolising the fury of human passion; He wears as a necklace the serpant that symbolises the guile and malice of mankind, and beneath His feet is forever crushed the hideous malignant dwarf, the embodiment of evil. "His drum, shaped like an hour-glass and held in the upper right hand beats the cosmic rhythm-sound representing the primary creative force and the intervals of the beat of the time-process." The flame held in the corresponding left hand represents the primary destructive force, the cosmic fire that swallows up everything that is to produced by the gesture of his right hand. In some images Siva has twelve or eighteen arms which make circles round his head as he dances. Indian art expresses the symmetry and rhythm of cosmic movement by the repetition of the arms of the dancing God in circles.

The Image of Nataraja

Siva, the Lord of Dancers, dances eternally not in the temple but within the cosmos and in every individual human soul. In the temple at Chidambaram one hundred and eight different poses (karanas) are represented interpreting the variegated pulsations of the universe. For each of these 108 sculpture-poses the appropriate description from the Natya Sastra is inscribed in the frame-work above it. These illustrate the exquisite dance technique and discipline of Bharata and his school of dancing[1]. The poses (karanas) varying from two to four units, comprise the matrika. Several of these matrika units combine into the angahara or garland of bodily movements. In India the poses are stylised and must follow the accepted language of gestures from head to foot of the body.

1 Naidu and Pantulu: *Tandava Lakshmanam*, p. 9.

There is thus no room for the amateur here. Yet new poses are continually invented. It is noteworthy that it is in Southern India, and especially Kerala, that the best classical traditions of dance are still preserved, there being elaborate and skilful gestures of the hands (mudra) accompanying the facial expression and attendant movements of the body and the eyes, as formulated in the Natya Sastras. "Each dance (nritya or karana) may be said to symbolise," Havell observes, "some kinetic attributes of the Godhead; a separate series of time beats of the cosmic rhythm like the musical ragas or variations of the cosmic mathematical law." Among the geometrical movements are those of svastika, spiral and circle (cartwheel), while the serpent, the scorpion, the bee, the elephant, the garuda, the peacock, the deer, the lion and the bull and various creatures of the air are also imitated. The emotions and attitudes expressed include sympathy, terror, merriment, wonder, intoxication, perplexity, passion or jealousy, sense of superiority and abasement, sorrow, meditation and spiritual joy. Regarding the sublimity of this image of Nataraja in His diverse poses Coomaraswamy wrote as follows:[1] "It may not be out of place to call attention to the grandeur of this conception itself as a synthesis of science, religion and art. How amazing the range of thought and sympathy of these *Risi* artists who first conceived such a type as this, affording an image of reality, a key to the complete issue of life, a theory of nature, not merely satisfactory to a single clique or race, not acceptable to the thinkers of one century only but universal in its appeal to the philosopher, the lover, and the artist of all ages and all centuries. How supremely great in power and grace this dancing image must appear to all those who have striven in plastic forms to give expression to their intuition of life! No artist of today, however great, could more exactly and more wisely create an image of that energy which science must postulate behind all phenomena. It is not strange that the figure of Nataraja has commanded the adoration of so many generations past; familiar with all scepticism, expert in tracing all beliefs to primitive superstitions, explorers of the infinitely small, we are worshippers of Nataraja still."

In a later 18th century presentation of the dance in a gorgeous painting belonging to the school of Kangra, we find all the gods, angels, ascetics, vidyadharas, apsaras, and heavenly musicians assembled to witness the divine dance. Some of the gods and goddesses play on the musical instruments, while others stand in mute wonder and adoration. But yonder sits on her lotus throne Siva's consort, dark red in hue, oblivious of the dance but looking intently at her own image in a mirror presented by one of her attendants. For is not her relation to Siva the same as that of the energy of heat and combustion to fire, is she not herself the primordial spirit behind the same cycle of creation and destruction, manifestation and withdrawal, life and death, that Siva's dance represents? It

1 A. K. Coomaraswamy : *The Dance of Siva*, pp. 56-66 ; also article on Indian Dance in the *Encyclopædia Britannica* (14th Edition).

is in the mirror of her own image that she intuitively sees the panorama of the cosmic processes that are from another angle of vision symbolised for the denizens of the universe by Siva's dance rhythm. Thus the vision in the mirror is the same as the outward scene before the vast assembly in which every type of being dwelling in the three worlds is represented. Seldom has metaphysics found such elegant and vivid pictorial treatment in the history of art. Contrasted with this scene is that presented in another companion picture of the same school (second half, 18th century) representing Sakti as the Power of Death or Destruction. Here the goddess, jet black, in skin and bone, fierce and grinning, devours the flesh of a king whom she has slain in the lonesome night and whose crown, sword and garments are lying on the rock-bound river bank. At a distance is the white, shining temple of Siva with the crescent moon overlooking it. The swift current of the river as it flows down the rocks symbolises Time (Kala) that swallows up prince and peasant alike. The peace and serenity of Siva (enshrined in the form of the white marble lingam) is in profound contrast with the swirl of the river and the fervid destructive fury of Kali that represents the obverse of the mighty cosmic rhythm of creation.

Cognate to the cosmic dance of Siva is that of Kali or Chamunda and Ganesh representing in Indian sculpture with equal symmetry and sublimity the elemental force through which the universe is created, maintained and ultimately destroyed, corresponding to the primary and original pulse of activity and renunciation of the human soul.[1] One of the celebrated songs of the Sakta mystic, Ramaprasad of Bengal, addresses Kali thus: "Oh, Thou Dark one, haunter of the cremation ground, I have made my heart like a cremation ground in order that thou might dance here eternally". In these majestic dance-images mankind has risen to some of its greatest heights of plastic creation embodying the metaphysical development of the human soul and its final silence in the cosmic setting of oscillating evolution and involution of the forces of life in nature. The entire realm of existence and not merely the moods of the human soul participate in the majestic rhythms of dance of Siva, Kali or Ganesh which the Indian artist has discovered in the depths of his own self.

The opposite metaphysical entities of Being and Becoming are represented in Vaishnava mythology and art not in intellectual and austere aspects as in the dyad, Siva-Sakti, but rather in poetic and devotional aspects as Krishna-Radha. Thus the flute-playing Krishna's dance with Radha, surrounded by the Gopis who represent the yearning human souls, has a similar cosmic artistic import, although such single dances of Krishna as the pot-dance after his victory over Banasur and the dance on the head of the subjugated dragon, Kaliya, in the poisonous lake are familiar themes in Indian art. In no Indian art work has the cosmic significance of the interplay of Radha and Krishna been more picturesquely

1 The familiar dance images in Mahayana Buddhism are those of Hevajra and Heruka.

and profoundly expressed than in the Jaipur painting of the *Rasa-mandala* or the universal circular dance of passion of Krishna in the moon-lit night. The scene of "sixteen thousand damsels", each in the prime of her youth, each decked in a distinctive form of toilette and exhibiting a particular gesture of love, is seen from a height. They turn round and round in this typical folk dance of Northern India, (the Jhumar of Rajputana), interlaced with one another, making three revolving circles with Krishna and Radha in the centre, whirling round with feet together and leaning apart with hands clasped at full arm's length. Thus do the divine lovers, symbolising the deity and the human soul in the ecstasy of communion, guide the circular dance that symbolises the world process into a single rhythm of collective love and bliss. The gesture and movement of every single damsel interlink with those of her associate; the collective dance of a vast multitude pulsates in one rhythm set by the ecstasy of the Divine Dancing Pair in the middle. The gods, who witness the dance, offer their homage to this purely human assembly by showering flowers from heaven. It is thus that a Rajasthani painter interprets the profound mystery of Being and Becoming in terms of the rhythm of the human-divine love dance. As in painting, so in pantomimic dance describing the adventures of Krishna with the milk-maids, the same circular grouping and movement even today inspire the Jhumar dance of Rajputana and Garbha dance of Gujarat, characterised by soft swift measures and saturated with a rich symbolism that the common man understands.

The Opposition of Certain Universal Principles in Art as Symbolising the Antithesis between Being and Becoming

Such is the poise and serenity achieved by the self as it merges into the silence of Being that as it turns outwards and manifests itself in the world process it suffers a tremendous agony. The alternation of the self from silence to sound, from rest to motion, from sleep to waking is accordingly defined and apprehended by the artist as discord, arhythm and asymmetry. What is in reality a recurrent rhythm and alternation of Being and Becoming is now regarded as an essential and original antithesis and opposition. The principle of duality now supersedes the principle of unity as governing all motion, form and structure. Thus the essence of all significant forms in art becomes the interplay and intuited reconciliation of the basic antithetic concepts of light and darkness, motion and rest, space and substance. In painting, the effects of blending of light and shade, colour and whiteness, mass and line express the ultimate harmonies in the all-encompassing void, illumination or darkness which once symbolised the silence of the soul. In sculpture the contrasts of light and shade, mass and emptiness of space, and of dimension render significant the harmonies of the soul. In architecture, formal uniform design blends with the asymmetrical in the variegated contrasts of the force of stability and the force of gravitation along with those of light and shadow, volume and space. In music we find a similar blending and

reconciliation of the principles of dissonance and resonance, novelty and repetition of sounds. Indeed, the artist uses that which is usually found ugly to get æsthetic effect; colours that clash, sounds that are discordant, cacophonies in poetry, seemingly dark and obscure placcs or even sheer blanks in painting, dissimilarities of design in architecture. "It is the way the thing is related that counts". Distortion of shapes, disharmony of colours or dissonance of sounds serve the purpose of creation of new rhythms and discovery of new æsthetic qualities in commonplace associations and ordinary experiences where these are missed. "The equations of mathematicians," observes Dewey, "are evidence that variation is desired in the midst of maximum repetition, since they express equivalences, not exact identities."[1] Man expresses the pain of his separation from Being and his ceaseless struggle for unification by recapitulating in all his arts the essential opposition of certain universal principles, which obtained their synthesis and reconciliation in Being; it is through this antithesis that he communicates in moving terms the ultimate harmony which he has lost. All great art, therefore, has its elements of surprise and tension in blending the unpredictable with the predictable, the immediate or recurrent chaos with the order of the cosmos. It is a paradox that æsthetic delight becomes the deeper and more intense through an encroachment of the anarchic, the arhythmic and the asymmetrical, symbolising the dual character of the universe since man has lost identity with it.

The Reconciliation of Being and Becoming in Myth and Literature

It is not, however, in the visual arts but in myth, legend and literature that we find the simplest and most direct representation of man as inhabiting two alien worlds, earth and his dream-land or heaven. In the myths of all nations humanity has in its perilous journey on the earth recurrently picture and grieved for the lost Garden of Eden. The entire group of legends dwelling on the transmigration or metamorphosis of human beings through a sequence of births in vegetable and animal levels is reminiscent of a state of bliss and enlightenment man has lost. If man cannot reach Heaven in his present existence, his religion and art give him a promise of a thousand births and re-births through which he acquires merit enough to reach Heaven in the distant feature. Such is the belief of Buddhism, and with what fervour and devotion has the sculptor represented the series of births of man as the elephant, the deer, monkey and so on before he attained enlightenment or Buddhahood. The vast hierarchy of living beings, angels, archangels, demons, goblins, yakshas, kinnaras, fauns, centaurs, mermaids, gorgons, ghosts and spirits, whom we meet with in the scriptures, myths, legendes and fairy tales of all countries, is a vivid reminiscence of the loss of man's glorious estate and of his pitiful attempt at compounding hybrid or blended orders of beings, who may cross the gulf between the real and the unreal, the visible and the invisible that he cannot do in the concrete world of reality

1 *Art As Experience*, pp. 169-173.

since his supposed descent from Heaven. To some of these beings he definitely assigns a superior order of existence. These help him in his journey to Heaven. Others are inferior and dangerous creatures which lead him away from his own order unawares to Hell. The supernatural aloofness and supremacy of the lion and the hawk in Egyptian, and of the Bull (Nandi) and the tiger (Sardula) in Indian sculpture, represent established art traditions. The Egyptian sphinx and the colossal Indian bull agree in their portentous solemnity and detachment. Or, again, the discipline and restraint of the animal break out into superhuman vigorous action as the lion vehicle (vahana) of Durga in the fight against the titan Mahisasura, or as the lion-divinity, Narasimha, tearing the wicked Hiranyakasipu in a moment to pieces. It is in this manner that religion and art assimilate the essence of animality into the perfection of man and the conception of God.

Good and evil, the angel and the titan, heaven and hell become no longer rigid moral or spiritual concepts, but art takes upon itself the paradoxical task of creating transitions and identifications of good and evil, of angelhood and devilry, of heavenly and hellish existence, which overstep the barriers created by religion and morality, and make an extraordinary appeal to humanity. No longer these are treated as alien and diverse, but there are shades, gradations and compromises through which mankind gropes its way to the ideal in the concrete world of everyday experience. For man likes best to see his own transformation or Becoming, and literature is its best account, man's most effective bridge between the real and the ideal, between the sensible and the super-sensible. All imagery or metaphor, which is the natural tongue of literature, seeks to bring together different kinds or levels of reality, and as it does so it arrests man's attention. In awe and wonder as he passes in imagery some ordinarily untraversable gulf, he listens to the overtones of existence. Man also depicts himself in canvas and stone, and that portraiture appeals to him most where he remains strange and mysterious, a denizen of another world. And similarly those gods and angels, carved in stone or painted on canvas, ravish his emotions through the centuries, which though infinitely remote are incredibly near to him. Thus the abyss between the seen and the unseen, the sensible and the super-sensible no longer yawns. It is thus that art expresses the primary and original rhythms and harmonies within the self and the universe by the interplay of opposed categories. What literature does through imagery, painting does through the contrasts of light and shade, colour and emptiness, sculpture and architecture through the contrasts of mass and space, light and darkness, and music through the recurrence as well as variation in tempo, key and pitch of sounds. The eternal and recurrent rhyrhms of Being and the cosmos thus are, paradoxically enough, made manifest through the translation in every medium of expression of the opposition of principles and categories that symbolises in the human heart man's ceaseless struggle since the fall from his high estate. Yet he can restore himself to his estate only through expression in terms of this simulated opposition.

GUIDE TO ILLUSTRATIONS

GREEK ART revealed man's perfect physical beauty and dignity, and the grand Attic ideas of harmony and proportion in all activities and phenomena have dominated European art through the epochs. It was a sense-born art praising the beauty of the sensible world, and fitted well into the upsurge of energies and vitalities of the Renaissance and the French Revolutionary epoch. But Greek homo-sexual love, child exposure and slavery did not permit art to develop enduring patterns and symbols of biological wisdom and social insight; and no deep religious emotions inspired it. Greek art that hardly touched the fringe of the supersensible continued to furnish the idealised human type for Europe until the 13th century when the Continent suddenly achieved spiritual expressiveness in Gothic art. In the Renaissance, art again devoted itself to the celebration of sensual joy, and mystic overtones became rare. If medieval art in Europe occasionally celebrated the chase, the hunt and the pilgrimage along with religious episodes and feelings that were dominant, Renaissance art more often escaped from religious imagery to racing, jousting, pageant and triumph as well as to allegorical and legendary episodes. More and more the greater artists devoted themselves to the sensuous and even sensual aspects of life. Christianity, no doubt, for about twenty centuries set the Virgin Mary, depicted by so many sculptors and painters, as the type and symbol of motherhood. But the Virgin was imaged simply as a noble and beautiful woman, while the Man of Sorrows was also an idealised elegant person. The majestic humanism, half-pagan and half-Christian, of Michael Angelo's Pieta and Raphael's Sistine Madonna set the norm of Western religious artists, except of a very few such as Fra Angelico, Greco and Roerich. The human beauty and elegance of the Madonna and Christ far outshone the emotional significance of the universal maternity of the Virgin and the glory of Christ's sorrow and sacrifice. For the last four centuries of the new era since art took to the celebration of pleasure and the sensuous loveliness of woman for the delight of the upper classes in Venice and other rich and flourishing cities of Europe this conception of painting still remains popular in the West. From Giorgione, Titian and Rubens to Manet, Renoir and Rodin, woman has become the symbol of erotic play that has overpowered the imagination of Europe. Yet for once in the middle ages (in the 12th and 13th centuries), the era of the culmination of chivalry and Mariolatry, woman came to her own in Europe, and her virginal austerity and radiant motherhood and tenderness as recorded in Gothic sculptures recaptured the kinship between human and spiritual affections that is the main-spring of Oriental inspiration in religion and the fine arts. Even in the Madonnas and angels of the Gothic cathedrals of

Europe (e.g. the Virgin of the Portal at Amiens) the dignity and elevated expression of serenity are sacrificed to a tender lyricism and dreamy elegance. The treatment of woman in art reveals clearly the basic social attitudes and values of a particular culture.

Contrast the sexual vitality and opulence of the women of Titian and Rubens with the brooding tenderness and other-worldliness of the Buddhist Tara and Prajnaparamita, and the Hindu Chandi and Parvati. Not that Oriental art did not picture the courtesan and danseuse. In the soft-limbed Nayikas and Surasundaris of Indian art we find a three-fold inflexion of the figure, an exaggerated emphasis of the breasts and hips and a sinuous flow of garlands and garments strongly suggestive of the allurement and exuberance of sex. But sex is treated in abstraction, as a part, type or symbol of the cosmic energy setting it far above the plane of sense-enjoyment. Often Beauty is depicted as completely self-sufficient, in profound detachment from the world or looking hypnotised upon her own reflection in the mirror as the undefiled image of divinity. Here metaphysics helps Oriental art. All metaphysics derives unity and order in the universe or world-process through the dialectical method in a synthesis, the reconciliation of certain primary opposites or antithetical principles. In India the world-process is conceived in terms of the reciprocity of the masculine (Being) and feminine (Becoming) categories that cover the universal rhythms of silence and activity, renunciation and enjoyment in the universe as well as in the inner life of the individual. This dualism that supplies the fundamental key to life, mind and the world-process has been greatly conducive to abstract symbolism and subtle expression in the fine arts. The dichotomy of supramundane archetypal masculine and feminine forces (Purusha and Prakriti, Being and Becoming, Unity and Duality) helps towards typification of ideas, feelings and sentiments and abstract rendering and emotional concentration so favourable for art. Further, art is invested thereby with a courage and tolerance to include within its ken both spiritual ecstasies and glories of life as well as sensual joys and experiences.

In Indian art there are discernible neither puritanical prudishness nor affected disguise nor provocative camouflage of sex and sensuality as in the West. Indian art, dominated by a feeling of the unity and totality of life and aspiration, is equally successful in creating divinities and angels as well as monsters and goblins, in recording man's glorious triumphs and beatitudes as well as his frightful degradations and apparitions. Art finds, indeed, inexhaustible materials from the vast panorama and moving levels of life and mind and sheds eccentricity and violence of styles and techniques. It achieves sobriety, depth and impersonalism equal to the treatment of metaphysical notions and transcendental moods as of the delights of the senses. If sculpture in the East records the soft, melting love of the goddess and the supreme loveliness of the angels

and messengers of gods, it harmoniously blends rapture with restraint through a combination of roughness of surface and smoothness of modelling of the figures and play of sunshine, darkness and tremulous atmosphere of the rocks, caves and temple interiors in the background. This is far different from the exaggerated smoothness and pliancy of the drawing-room statues of modern masters like Rodin, Malliol and Kolbe. It is the greater glory of art that the sculptor, while remaining true to the supersensible moods, captures unobstrusively the melodic loveliness and grace of the human figure; and in fact many Indian and Indonesian nudes have achieved a sensuous charm. expressed by fluent and caressing rhythms, hardly met with elsewhere in sculpture in stone. Sculpture is equally at home in the treatment of the desires and passions of life in the larger background of human destiny as of the suprahuman moods. The grand supramundane passions of righteous indignation and wrath have nowhere been celebrated with such strength and vigour. Instances of the terrible in Oriental art are the figures of Siva and Durga destroying the demon, Narasimha, the lion-form of the god of retribution, and Kali, Chamunda, Yama and Mahakala in Eastern Indian and Tibetan plastic art. The colossal Siva-Bhairava, engaged in grim fight against the demons, and accompanied by both her consorts—the gaunt, terrific Kali as well as the charming Parvati—in the temple of Ellora is one of the wonders of the world in sculpture. The transcendental fury of destruction of wickedness which is the same thing as the beneficent spread of god's compassion and love is suggested by the sweeping diagonal posture supported by the movements of the various hands and the heavy diagonal thrust of the trident piercing a demon. The entire plastic composition of the group of figures forms a synthesis conveying a sense of suprapersonal anger, majesty and dramatic vigour that can only be discerned within the cave temple itself. The Bhairava at Ellora is comparable only with another image—the majestic Javanese bronze image of Trailokyavijaya trampling Siva and Parvati under his feet. The few Western instances of the terrible represented by Michael Angelo's painting of the Prince of Hell, Goya's Saturn Devouring His Children and Rodin's well-known sculpture, The Gate of Hell, pale into insignificance in contrast.

On the one hand, the massiveness and monumentality of the individual figures that reveal enduring personal and social values and aspirations—the social universals—cement the alliance between sculpture and architecture. On the other hand, a profound sense of the universality of Energy and the compositeness and inter-connection of Life abolishes the distinction between painting and sculpture. Sculpture is subordinated to architecture, and crowds figures of gods, angels, men, animals and trees on all sides in palpitating, melodic rhythms that thrill rocks, walls, railings, pillars, roofs and towers. The sculptures of Amarvati, Mahabalipuram, Ellora, Elephanta and Khajuraho and the frescoes of Ajanta and Bagh equally exemplify the characteristic and Indian passion for

dense massing of figures in vital and inexhaustible communion born of a profound sense of the compositeness of life. At the same time the lush patterning of swarming figures and their sinuous movements are often subordinated to the calm, detached, majestic figure of a divinity lending a poise and serenity to the whole scene.

In the rock-cut temples and caves of India there is a clever utilisation of improvement of light or deepening of shadows, a flat background or a narrow sharp and receding corner for psychological effects in sculpture hardly met with anywhere in the world. This applies equally to an individual figure and to an ensemble of figures with contrasted generic attitudes and emotions that are all unfolded as in a momentous human myth or drama by the skilful sculptor, playing with the entire gamut of human values with the help of roughness of stone surface or smoothness of modelling and the manipulation of the gradients of light, depth and darkness in the rocks and caves. Light, darkness and vibrating atmosphere not only form the stage or background of the human moods and values but become integral parts of the conception and composition of the sculptured forms themselves. How often do we find in caves and temples devoted pilgrims easily establishing a rapport with rows of stone gods, praying angels, lamp-maidens or effigies of pious persons in the shimmering darkness that becomes pregnant with tense spiritual emotion! The throng of worshippers, the living mass of rocks or stones and the extending, reverberating abyss in the cave or temple interior become all fused into one collective thrill of spiritual ecstasy. India's passion for retirement into mountains has led to the achievement of new dimensions and rhythms for the plastic art, of new vistas of exaltation and experience for the life of the spirit.

As art takes into its fold the entire province of Life and the manifold variety of the passions and desires, joys and sorrows of Man it creates and multiplies symbols of his social feelings and aspirations that have played no small part in spreading discipline, joy and serenity in the Orient. Because of the stress of the integrative, universal character of moods and experiences, art and religion slip into each other and combine their resources in exploring and expressing the entire meaning of Life. The East in a way does not distinguish between art and religion. Both create generic symbols and images, but it is of course art that makes these emotionally potent for the individual and society. In the West the social failure of Christianity accompanies a complete lapse and disintegration of the images and symbols of the spiritual life. A few great artists like Blake, Ryder and Redon created new spiritual images and symbols, but the field is occupied by the surrealists and subjectivists who too often represent in symbols the working of repressed complexes and disintegrated personalities. Art in the Orient never stresses the lesser themes of personal moods and emotions and the sensible world, but seeks to import the universal and the immortal into the daily episodes and

experiences of life. Marriage is a familiar theme in Indian sculpture and paint-
ing which treat it against a metaphysical background. Art adds a new world of
rhythm and loveliness to the realm of religion and metaphysics. There is no
grander representation of marriage in world art than the sculpture at Elephanta
celebrating the betrothal of Siva and Parvati. The sacred silence of the whole scene,
the profound poise and reciprocal devotion of the couple and the flight of the
numerous gods (more suggestive because undefined), hovering in suspense in the
shimmering darkness above, bear witness to a favoured moment that unfolds the
secret of cosmic creation. Here again the peculiar advantage of modelling in
the fluctuating light, depth and darkness of the cave has magnificently aided the
presentation of a cosmical event. An incarnation of the God-man a profound
social myth or legend, a primordial divine-human or devilish type or a generic
social value and aspiration, are all carved out of the living rocks in India, the
imagination and plastic skill of the cave throwing open untold possibilities of
the harmony of formal values with psychological clarifications and characteri-
sations. Oriental art is full of images and symbols of the social virtues—
conjugal devotion, motherly tenderness, neighbourliness, charity, love and com-
passion—often depicted from the Jatakas, the epics and other tales. These in-
culcate noble social ideals and have nurtured through the epochs the social good-
will behind asylums, Dharmasalas, guilds and other protective institutions in
the East.

 Cliffs and caves in India and China are full of images of the contemplative
man, Buddha, Bodhisattva, Maitreya, Mahavira, Siva or Vishnu. The norm of
human perfection in the East is the passionless meditative person, "still as a flame
in a windless place". The image of the yogi seated in the fixity of ecstatic medi-
tation is one of the greatest motifs contributed to the world history of art by
India. Everywhere the regular triangular or pyramidal pattern of the seated
god or the stern verticality of his standing posture or that of his emblem (mace or
trident), aspiring straight up, bring into relief the austerity and poise of religious
contemplation. Or again the god sleeps in the cosmic waters before creation—
the image of breathless cosmic silence (Seshasayi Narayana or Buddha's Parinir-
vana). There are also a hundred images in Oriental art of the Divine Dance
(Tandavas of Siva, Ganesa, Devi and Krishna), symbolising the alternations
of creation and destruction, life and death, silence and activity. The structural
basis of the figure composition here, with the swaying movements of hands, tools
and garments, is the perfect circle revealing equipoise in movement and deeply
satisfying both the artistic and spiritual emotions. As significant as the simple
geometrical rhythms of lines, planes and volumes in the figure composition,
adroitly reinforced hy elusive light and darkness effects in the rock-cut caves and
temples, is the blend of impersonality and illumination in facial expression. In
the cradle land of India, the meditative faces—and every image is one of

meditation and assists meditation so that the beholder cultivates and reveres in and through it the mood that is a bridge to the divine—are on the whole characterised by greater abstraction, detachment and unearthliness. This is perhaps due to the emphasis of the impersonal and negative aspects of reality throughout in Buddhist and Brahmanical religion and metaphysics. Thus Indian sculpture on the whole stood more for massiveness, solidity and formalism than for warmly human, vibrant modelling. But in China, Java, Cambodia and Japan religious art combines profound serenity and majesty with poignant humanness and emotional fervour. This is the result as much of a more realistic view of life and mundane temper of the peoples as of the idealisation and ethereality of attributes and conceptions associated with the religion coming from an unfamiliar holy land. Thus the gentle smiling Buddhas and Bodhisattvas of the Chinese caves and Cambodian temples are on the whole in sharp contrast with their other-worldly, serene Indian proto-types. But here and there in Bagh or Elephanta, in Chandela Central Indian or Pala-Sena East Indian sculptures and paintings we encounter the Eastern Asiatic warmly human mellowness and tenderness and melodious, graceful modelling and interplay of masses and planes confined consumately within the rigours of abstract harmony. It may have been the result of Mahayana, Tantrayana, Vaishnava or any other transcendantal idealism and mysticism, of the impact of folk or popular feeling or of the sub-tropical fecundity of soil and nature, singly or collectively modifying the purely formal plastic conventions and making sculpture more transparent, tender and engaging. It is the notions of human personality and the social attitudes and aspirations of a people that mould forms, motifs and styles in art.

In the West it is the variegated interplay of moods and emotions of the individual personality which forms the main theme of art through the epochs. In the Orient neither art nor religion is satisfied unless it derives the essential values of the human personality from the collective transcendental. Pregnancy, birth, marriage and death are all features of the divine cycle of creation, preservation and destruction in which all sentient existence participates. Family and social events accordingly obtain their due place and significance in divine happenings. Myth and legend, art and poetry transform the man-woman, the child-mother or the father-daughter relationship or the relationship between friends, neighbours, masters and servants into a universal symbol or vehicle of the transcendental.—This bridging of the gulf between the worldly and the other-worldly keeps alive the tremendous social propulsion of art constantly renewing art motifs through the symbolical treatment, concentration and transfiguration of the ordinary emotions and experiences in the East.

The spread of Tantrik metaphysics and ritual in the Middle ages, that profoundly modified Buddhist and Hindu religion and art, intensified and carried forward that tendency of blending the sensible with the supersensible, the human

with the transcendental. Medieval sculpture in Central and Eastern India with its images of divine couples, Siva-Uma and Krishna-Radha, and its numerous maids, messengers and ministers of grace, celestial beauties, the lovely women of the gods, achieves a rare combination of abstraction and warmth of feeling. Here sculpture with its monumentality and abstract rhythm and smoothness of modelling has developed a psychological suggestiveness that merges it with painting. There is *pari passu* a strange transformation of the image. The image is no longer the deity of worship, but as Uma, Radha, Yogini, the celestial beauty, the apsara or the saint is the poignant lyrical mood of the human creature touched and transmuted by divine grace. Sculpture, like poetry and painting, abandons itself to the intensity of religious rapture, and the tremulous aspiring human creature, along with the praying angel and muse, becomes himself an object of worship—the permanent embodiment and exponent of Bhakti. Medieval sculpture, like medieval poetry and mysticism, which were inspired by the popular religious movements led through the centuries by the Saiva saints of the South, Ramanuja, Ramananda, Kavir, Chaitanya, Nam Dev, Tukaram and Mira Bai, became the apotheosis of the divine-human creatureliness. No wonder that medieval temple-buildng and sculpture in India became dramatic and lyrical, eloquent with sweet human emotional appeals of god, angel and saint from walls, railings, roofs and towers, nay from each stone or brick on which were sometimes multiplied the images of God by thousands. For God now lived, strove and suffered with the comman man. The exuberant expression of Bhakti surging from the heart of the multitude not only created in India the idols of the devotee within the sanctum sanctorum and of the celestial angels, saktis and apsaras in the temple walls and pillars by hundreds, but also lavished architectural ornamentation on a scale of profusion and meticulous devotion and delicacy unparalleled in world art.

Medieval painting in India, which was a vernacular folk art inspired by Hindi Bhakti poetry and music as well as by the spirit of mystical pantheism in medieval sculpture, also painted with a bewitching and serene loveliness the joys and yearnings of man and woman in an ideal setting. Siva and Krishna represent two contrasted eternal archetypes of human approach to the Beyond, of austerity and of action. Poets and painters abundantly interpreted the subtle elusive moods and gestures of the human soul in the background of the penance of Siva and Parvati in the rugged and snow-clad Himalayas, and the love-play of Radha and Krishna on the flower-decked banks and meadows of the Jamuna. Thus the immanence of the devine—the grand theme of medieval art—reached the common man in India and directed the education of the ordinary moods, feelings and experiences of life. It was also in the middle ages that the musical modes (Ragas and Raginis) were treated in painting, again based on the motifs of human and spiritual love in its various nuances either in union or separation.

Poetry, music and painting all collaborate here in revealing and consolidating generic æsthetic moods turned to nature in the procession of the seasons and of day and night in a manner not met with anywhere else in human culture. The all-pervasive sympathy with the life of animals, birds, trees and flowers, which we find in the Ajanta frescoes, is fully recovered in Rajput and Pahari painting. But here are both greater emotional concentration and logic of design. Man, animal, tree and flower are parts of the same idea, life and aspiration in dramatic interplay. Landscape painting in India is largely symbolical and dramatic; in China it is poetic and philosophical, and in the West it is realistic, incidental and anecdotal. Nature in India is a full and ardant participant in human lives, delights and sorrows treated abstractly and in an impersonal, transcendental background. In China she absorbs and swallows up the finite moods of man in her infinite emptiness, silence or movement. In the West man decks and fashions Nature with the variegated and resplendent hues and colours spilled from his agitated breast. Like the treatment of woman, the treatment of Nature in art also illustrates vividly the collective visions and experiences of particular cultures and epochs. Through self-transcendence art reaches everywhere the supreme self-consciousness which is the same as the supreme, poised individual and collective awareness of life and the world.

ILLUSTRATIONS
OF SCULPTURE

Religion has led almost a whole people in India to the mountains and forests, where caves and grottoes are utilized for meditation, shelter and teaching for monks and laymen alike. Over them all look down benignantly from the hillsides and corners sculptured Gods, Buddhas, Bodhisattvas and Tirthankaras. Sculpture is subordinated to architecture, and both to the contemplative spirit of man. Often these images are multiplied, translating into stone the conception of 'the One in the Many and of the Many in the One.' While in the West, sculpture removes the stone and imprisons it in the image, in the Orient figures are carved in or scooped out of the living rock, and their poise, movement and direction are compositionally related to the walls, surfaces, and inclines of the mountains in their pristine mass, or refashioned according to the needs of architectonic treatment.

(pp. 234-240)

One of the loveliest temples of India with its entrance porches, assembly hall, sanctus sanctorum and steeple as well as subsidiary shrines and enclosures exquisitely correlated with one another — a religious lyric in stone, a cut diamond of artistry of horizontal, vertical and circular lines, planes and volumes scintillating into the form of a curvilinear pyramid. Refinement is added by the narrow flat bands, extending from the base to the summit of the temple, and the serried succession of miniature replicas of the main tower, rising tier upon tier on all sides of the principal shrine, creating an illusion of quicker and higher ascent. From a distance the temple looks like Siva himself wearing his gorgeous head-dress. The logical coherence and rigour of the temple plan are combined with an incredible profusion of sculpture and ornamentation on the surface and on railings, pillars, walls and roofs.

(pp. 240-248)

1. ROCK-CUT IMAGES AT KHANDAR HILL, CHANDERI, GWALIOR

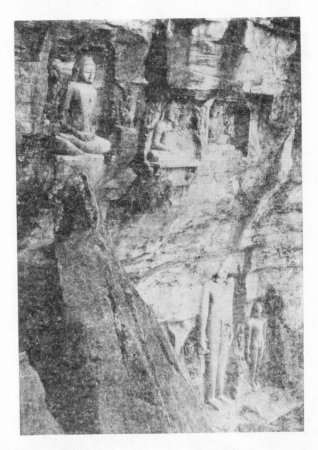

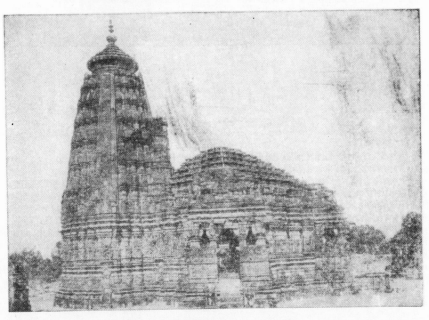

2. THE UDAYESVARA TEMPLE, UDAYAPUR, GWALIOR

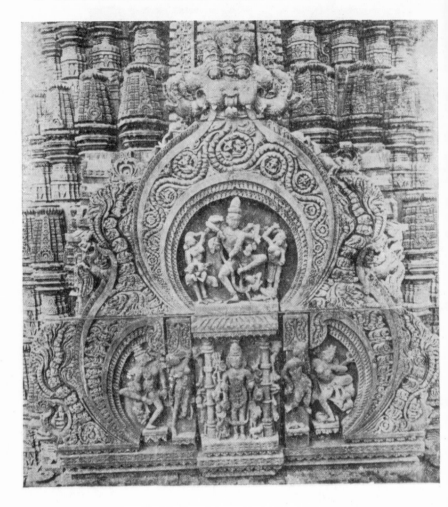

Indian temple architecture is often tenderly lyrical, characterized by lavish adornment with sculptured figures and decorations on walls, pillars, railings and roofs. The striking image of the cosmical Dance of Siva at the centre of the medallion in the main spire of the temple is supported by the dancing images of the Goddess and flying angels on each side, and by the entire spiral dance-move-ment of the decorations capped by the gorgon motif. The horizontals of the many miniature temples above the medallion accelerate by contrast the spread-ing dance-movement. The principle of multiplicity and ornamentation (rather than severity and simplicity) in architectural treatment records the exuberant devotional expression of the emotional masses that throng in the temple day in and day out.

(pp. 240-244)

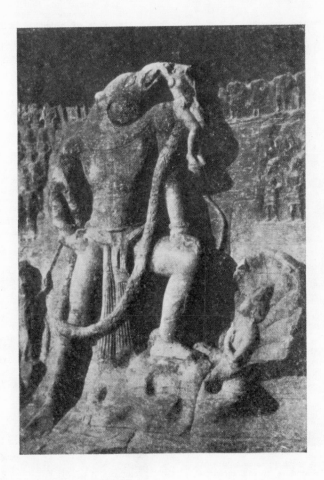

One of the grandest representations of a cosmical event—the Creation of Earth which is rescued from the waters by the Boar-God. The colossal rock-cut relief, simple, massive and monumental, overreaches the size of the wall thronged with gods, men saints and demons. The surrounding lotus decorative motifs, the flowing garland as well as the loin cloth, with its three folds hanging down vertically, serve to balance the composition as Vishnu by the sheer weight of His ponderous body lifts up the Earth that resigns herself to this fateful movement and, as she rises, delicately places her feet on a lotus bud. On the plane of history this magnificent image records Emperor Samudra Gupta's rescue of India from chaos and confusion as the nearby images of Ganga-Jamuna in the same cave indicate his conquest of Middle India. There may be even a more direct reference to Chandra Gupta rescuing Dhruva Devi, later on his consort, who was cowardly offered by her imbecile husband to the Saka invader in exchange of peace in the realm. (p. 105)

5. SARNATH BUDDHA. V CENT.

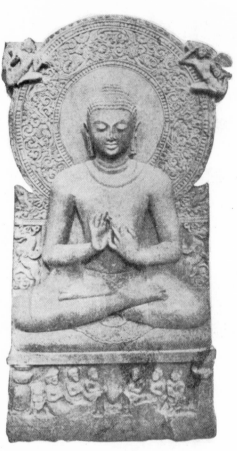

The image of Buddha commemoratin the deliverance of his first sermon the Park of Antelopes in Benares. Th Master is shown in the attitude of discour ing. The Wheel of the Law as well as th five earliest disciples (together with the wo man donor of the image with her child) a appropriately carved on the pedestal. Th composition is most delightful, breathir poise, profundity and sweetness that a stressed by horizontals, triangles and circle The stable, triangular pattern is overhung the elaborately decorated, circular nimbu The hovering angels deftly integrated in the nimbus produce an atmosphere of eth reality. Nicety and simplicity of compos tion blend with a serene linear rhythm en bodying the complete cessation of desire a perfect clarity. Thus did Gupta art for t first time in human culture invest the huma figure with the highest moral value.

(pp. 17-19; 111

Gupta sculpture in Northern India (A. 320 to 600) represents the classical phase Indian Art, efflorescent in both poise a charm, vigour and fineness, and characteris

of a most favoured epoch in human culture. Its motifs and techniques spread throughout Eastern Asia. The lofty Mathura figure of Buddha is one of the world's most significant symbols of Man's moral and intellectual glory. The massiveness and simplicity of design are heightened by the skilful treatment of the monk's diaphanous robe producing an impression of ethereality and heavenliness; while the severe verticalism of Buddha's standing posture that stresses his austerity and serenity is softened by the rounded folds of the robe, by the immense richly ornamented nimbus, and above all by the delicate and refined expression of the highly sensitive hand and fingers, eloquent of the message from the super-sensible world. Behind the half-closed eye-lids is hid profound knowledge of the mystery of the world-process, while the benignant comprehending smile (not discernible in the more celebrated Sarnath image) reconciles the impersonality of Nirvana with the Master's profound pity for the world. The image, 't should be remembered, is contemporaneous with the birth of. Mahayana idealism in Ayodhya and is, in our view, its purest embodiment.

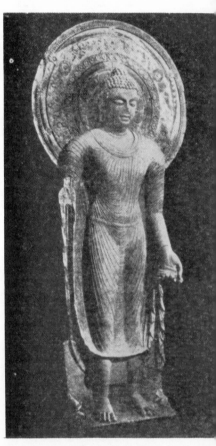

6. COLOSSAL STANDING BUDDHA MATHURA MUSEUM. V CENT.

7. COPPER IMAGE OF BUDDHA. SULTANGANJ, BHAGALPUR. EARLY V CENT.

A colossal copper image of Buddha resembling the well-known Mathura Stone image of the same century in the treatment of the diaphanous garment and the gesture of the hands. The left hand holds a palm-leaf manuscript, and the right shows the attitude of benediction. Unlike the stone image, the copper image combines animation with serenity, due to the massiveness and rigour of surface and outline in stone receding in favour of pychological modelling. The face, more clearly defined, is less stern and other-worldly, and the humanism is brought into relief by the curls set in regular rows. The arms and hands are also less heavy and embody great vitality, full of both spiritual and physical import. Yet the absence of the nimbus (as seen in the image of Mathura and Sarnath) does not detract from the presentation of the Nirvanic state of existence in which Buddha ever dwells.

(p. 17-18.)

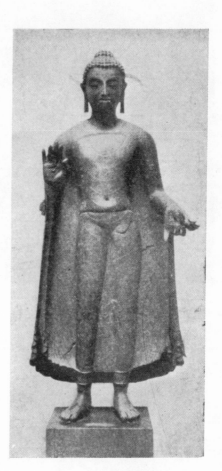

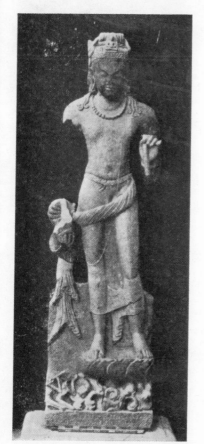

Here is one of the earliest Buddhist Mahayanic images from the Park of the Antelopes itself. There is no aloofness from the world. An infathomable profundity is combined with youthful charm and elegance, brought into relief by the lotus and foliage at the feet, the coiffure, the necklace and the girdle and by the embellishments of the garment. The radiance of the figure and the decorative pattern, not too elaborate, incarnate the Mahayanic metaphysical conception that bridges the life of contemplation and the life of the senses.

(pp. 17-18; 112)

8. BODHISATTVA PADMAPANI. SARNATH MUSEUM. V CENT.

9. VISHNU AT UDAYAGIRI. GWALIOR. V CENT.

The representation of another cosmical event—the silence before creation or withdrawal of the soul into meditation. The fixity of meditation is stressed by the severe horizontality of the reclining image, the flattening of physiognomy and the repetition of the serpent's coils.

(p. 115)

10. LOKANATHA

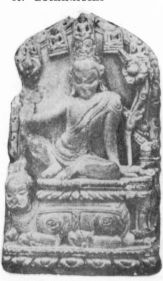

A Mahayanic prince of wisdom and compassion—a rare and happy combination of abstraction with warmth of feeling, of formalism with luxuriance, and of impersonalism with delicacy and charm in plastic treatment. The broad shoulders, the sleek, arched waist and the sensuous flow of ornaments and garlands stress a bodily charm that is born of the illumination of the spirit; while the serene yet compassionate face blends omniscience with sympathy for world-misery. The coherence of drapery, jewellery and body as parts of the compositional rhythm underlies the tender limning of the delicate and heavenly body.

(pp. 111-113)

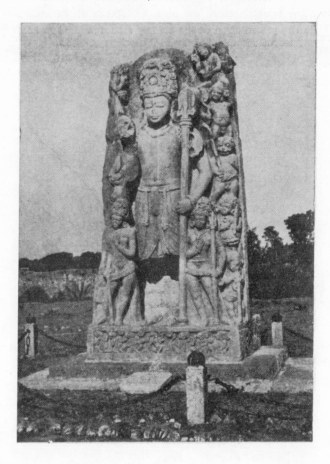

A colossal image of Siva that rules by its stern verticality and subordination of detail and easily leads the mind to concentration. Note also the stillness and poise of the meditative face, the power added by the volume of the chest and the contrasted animation of the ganas and goblins around.

In India many temples record not only the legends of the gods and heroes but also scenes of love, sport and war, assemblage and procession of men, animals, flowers and foliage—the entire panorama of life. The total effect is dramatic and exalting; while the presentation of the worldly scenes is quite in keeping with a religion that stresses the immanence and incarnation of God.

(p. 248)

Here sculpture has adopted the methods of painting, lending a lightness and buoyancy to the sky-flight of the Gandharva couple. The wife's thin scarf, contrasted with her heavy coiffure as it trails in long undulations in the sky has received a singularly melodic treatment, forming a series of swinging vaults which keep alive the illusion of soaring in stone. Gandharva in Sanskrit literature of course typifies illusion. But rarely does sculpture produce such illusion.

(p. 102)

12. PART OF RELIEF SCULPTURE IN A MEDIEVAL SAIVA TEMPLE,
PADHAVALI, GWALIOR

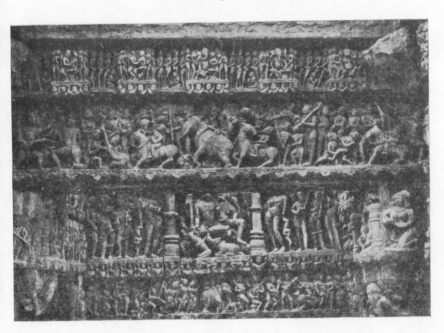

13. GANDHARVAS : GUPTA SCULPTURE AT SONDANI, GWALIOR. VI CENT.

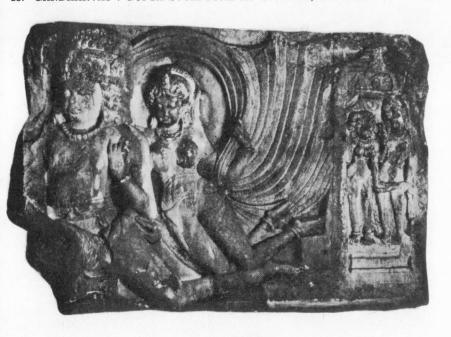

14. NARA-NARAYANA AS THE SUPREME SELF, ONE IN TWO.
DEOGARH TEMPLE; VI CENT.

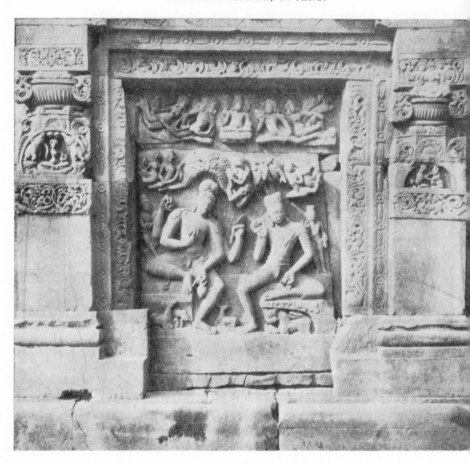

There is a profound contrast established between the serenity of the dyad Nara-Narayana and the movement of the hovering angels and gods above. According to the Mahabharata, Nara and Narayana are mind-born grandsons of the Progenitor. They performed severe austerities in the Badari forest of the Himalayas for ages. Indra sought in vain to disturb the meditation of the two brothers. From Narayana's thigh Urvasi emerged as his gift in a spriit of irony to Indra. Urvasi is sculptured as rising to heaven with her hands folded in worship of Narayana to the left. The Badarikasrama, with its luxuriant vegetation growth, its wild animals living in concord and its ascetics, is also depicted. The two pedestals on which Nara and Narayana are seated represent their separate pithas as mentioned in the epic. Above, Brahma as well as Vishnu and Siva with their consorts are happy at man's siddhi and Indra's d.scomfiture. The myth that in a sense represents a Brahminical rejoinder to the myth of Buddha's victory over Mara is worthily represented in a Vaishnava shrine which also shows Vishnu as the compassionate deity, akin to the Bodhisattva, in the Gajendramoksna legend. The Brahminical myth is more significant metaphysically. Nara and Narayana are also Arjuna and Krishna, the Deity's incarnations for the Battle of Bharatas. By yogamaya, Nara-Narayana creates his own double or multiple. Seldom does art so eloquently represent a metaphysical truth—the reconciliation of the notions of transcendence and immanence, of the One in Two. It is rare that in sculpture intervening empty spaces (as between the two Selves and between their large limbs) as well as parallels and horizontals are so effectively utilized for an emphasis of poise and fu filment. The two ascetic figures carved with melt.ng softness and largeness, suitable for the luxuriant modelling or nudes, appear as ever-lasting exponents of the mood of perfect self-absorption and help each other both aritstical y and psychologically in the consolidation of that mood. They both breathe **prajnanam** (wisdom) and **santam** (tranquility) recorded by a combination of restraint and amplitude in modelling and the large expansive rhythm of the ensemble.

15. THE COLOSSAL SEPTENNANTE LINGARAJ AT
PAREL, BOMBAY; ABOUT VII CENT.

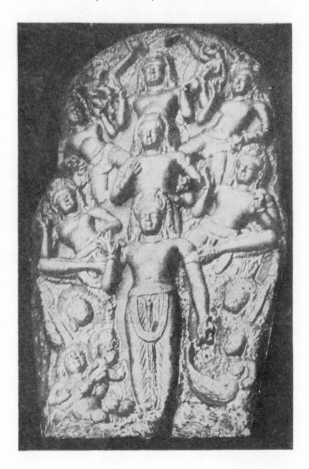

Cosmic energy and solidity are symbolized by the Lingam (phallus) in India. The three central figures of Siva, standing fixed in meditation, comprise the firm vertical axis of the Lingam; while the four other dancing Sivas establish its compositional unity and continuity. The mind whether in serene contemplation of itself (as represented by the three central Sivas) or in activity (as represented by the four remaining dancing figures) is Siva, who is externally worshipped in the colossal Lingam-pillar that symbolizes the universe as well as its source. This is the meaning of the multiplicity of Siva as underlying the generation and destruction of the universe—the mind at rest (Being) and in movement (Becoming). The devoted ganas play to the everlasting music of alternation of Being and Becoming.

(pp. 121 and 263)

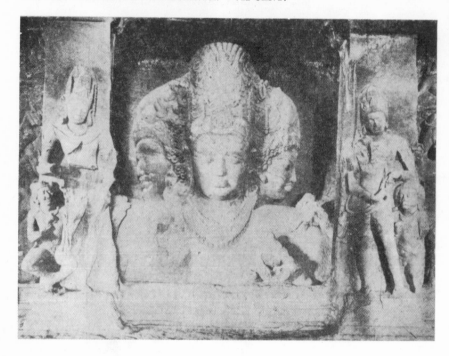

The Cosmic Spirit, Mahesha, Three in One—one of the most sublime creations of plastic art in the world. The three contrasted gigantic countenances, magnificently reconciled in the same bust through the integration of three tiaras into a single royal mukuta or head-dress of wrought gold (resembling that worn by the Avalokitesvara at Ajanta), reveal a master notion in Hindu metaphysics and religion, the idea of diverse accents or variations of the single, supreme Self —the alternate, ever-recurrent rhythms of activity, withdrawal and repose that underlie both the inner life of man and the world-process. Such a metaphysical image of the Supreme Siva or Self was once common in the Indian Brahmanic temples—Mahadeva (Tatpurusha or Absolute), Bhairava (Aghora or Terrible) and Uma (Vamadeva or Blissful), embodying the three-fold aspects or pulsations of Man and Nature. Hiuen-Tsang, awe-struck, obviously described such a colossal image of Siva at Benarese "full of grandeur and majesty" that has since disappeared and given its place to the present Visvesvara lingam. In Gwalior there is a variant of this composite image. Mahadeva as the serene yogi is in the middle with Mahakala, the Destroyer, licking blood from a plate, and Mahamaya, the Enchantress, looking at her own beauty in a mirror, on his two sides. For a full description see pp. 119, 120.

17. MARRIAGE OF SIVA-PARVATI. ELEPHANTA; VII CENT.

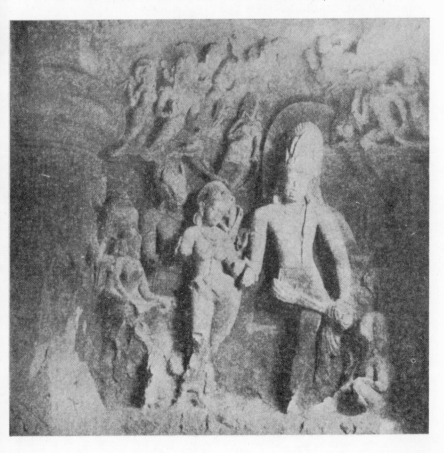

The sanctity and solemnity of the Divine nupitals are emphasized by the verticals of the image of Siva, Parvati and her father on the right, Himalaya. In striking contrast with their poise and serenity at the sacred moment are the joy and animation of the gods and angels floating in the horizon above. Dramatic character is added to the plastic treatment by the incompleteness of several images and utilization to the fullest extent of the effects of light and darkness in the recesses of the cave. In the colossal tableaus at Ellora and Elephanta we encounter a new type of relief composition where atmsophere, light and shade are deftly utilized to intensify the dramatic emotionalism of man that obtains its true meaning as part and parcel of cosmic tension and poise.

(pp. 115; 173-74)

18. SCENE FROM THE RAMAYANA—TWO TERRACOTTA PLAQUES FROM NANOOR, DT. BIRBHUM. XVII CENT. FOLK-ART.

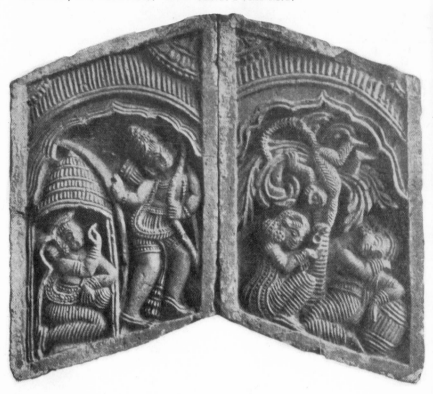

(1) Sita reprimanding Lakshmana for his delay in succouring Rama in his hunt for the deer (Mayamriga). The noble warrior recoils against Sita's warmth and reluctantly leaves her in fateful isolation.

(2) Hanuman delivering Rama's signet ring to Sita in the Asoka garden of Lanka. The monkey's camouflage, Sita's eageress and the woman-guard's negligence are all feelingly presented.

19. NATARAJA AT UJJAIN. VIII—IX CENT.

The image of the cosmical Dance of God represents the everlasting alteration of silence and activity, destruction and creation in the universe and in the inner life of the soul. The slenderness of the torso, the swirl of the many hands and weapons and the supple poise and playfulness of the dance movement, in which the gana and the bull participate, show an affinity with a South Indian bronze rather than with stone.

(pp. 117; 268)

20. SIVA SLAYING THE DEMON GAJASURA, BADOLI, GWALIOR. VIII—IX CENT.

Righteous wrath and destruction of evil. The concentration of heroic vigour of the soul is stressed by the diagonal posture and the stiffened summary handling of the mass. The generalization of body and limbs of Siva and the elaboration of his tiara, necklace and other ornaments are in sharp antithesis. The garland of skulls seems to move as Siva is in action and is utilized to the utmost in the composition, (p. 151)

21. THE BIRTH OF KRISHNA. BADOLI, GWALIOR; VIII—IX CENT.

The glorification of motherhood. The serene happiness of the mother is stressed by the heavy horizontals of the reclining figure and its summary treatment as well as by the reiterated verticalism of the stiff-limbed maidens standing in vigil with their chouries. Here is the representation of the generic archetype of motherhood into which cosmic rather than individual emotions and attitudes have been introduced. The soft melting benignity in the countenance of the Indian Madonna is supported by the look of expectancy and eager ministration in the faces of the group of attendants.

22. BODHISATTVA PADMAPANI. BHANDARHATI, DT. HOOGLY, ABOUT X CENT.

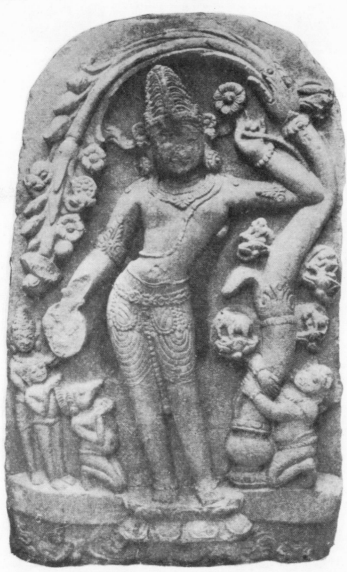

The graceful three-fold flexion (tribhanga) of the elegant, well-decked body is echoed by the lotus plant with its swaying leaves, buds and flowers forming a delicate framework that is eloquent of the Bodhisattva's mood of tenderness and pity for world misery. Picturesqueness is added to the mellifluous treatment by the gestures of the worshipful figures below. The warm current of lyrical or romantic idealism in Mahayana Buddhism here in some measure subordinates sculpture to the pattern of painting.

(See pp. xviii, 24)

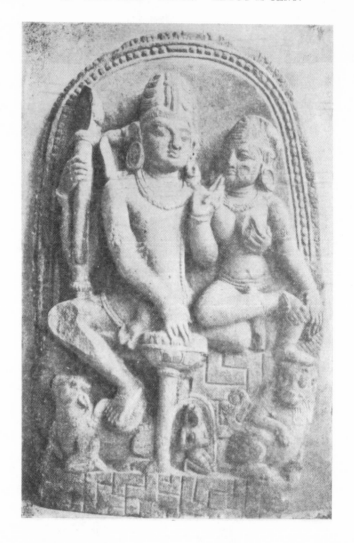

A magnificent image of the embrace of the Divine couple, Uma and Siva, revealing the metaphysical truth, unity in duality. Under the influence of Tantrika idealism it superbly combines austere and serene poise (as stressed by the verticality of Siva's posture, of the trident and of the lotus stem) with soft, melting love as discernible in the sinuous, nervous modelling of Uma's limbs. Here is no sensual spirituality nor erotic mysticism but a profound awareness of life in its full comprehensiveness, grandeur and force that Tantrika meditation imports into man's daily experience. This is an oft-repeated motif—especially in Bengal, Bihar, Orissa, Central India and Rajputana,—of the period of Tantrika dominance (X to XII Century), but here the rigorous simplicity of treatment and detachment of the figures are brought to perfection. (See pp. 115; 173-74). In the later images of Siva-Uma in Bengal, Orissa, Khajuraho, Gwalior and Rajputana, we come across smoother modelling with angularity of poses, faces and limbs and sinuous flow of garments, chains and jewellery, revealing less severity and serenity and more warm human passion and tenderness.

24. SARASVATI, THE GODDESS OF LEARNING
SUNDARBANS, BENGAL; ABOUT X CENT.

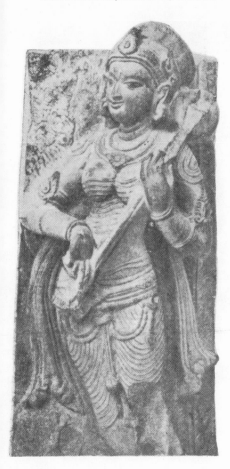

The image of the Goddess of Wisdom superbly combines poise and charm, serenity and springiness through the characterist.c threefold flexion of the body that seems to be brought about by a surge from below raising the swelling breasts as well as the lyre upwards. Springiness is also enhanced by the three-quarter profile and the linear rhythms of the beautifully composed drapery and ornaments that mould themselves to the underlying soft body.

(pp. 146-47; 173)

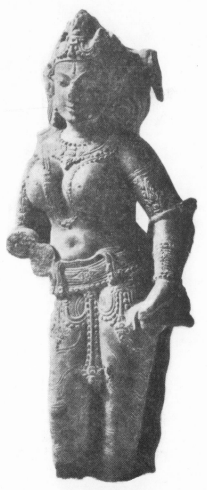

In this image of the Goddess of Fortune we find a rare combination of nubile charm with poise, competence and majesty. The solidity of the body, expressive of the majesty and power of Wealth, harmonises with the exquisitely easy and graceful Indian feminine pose and profusion of ornaments symbolizing the embellishment of life that Lakshmi stands for. The column-like building of the legs, stressed by the parallel folds of the drapery and the fall of the bejewelled pendant of the belt, produces a sense of absolute stability that blends in harmony with the soft plasticity of the hands, loins and rotund breasts.

(146-47;173)

25. LAKSHMI

26. THE CELESTIAL BEAUTY. MEDIEVAL INDIAN SCULPTURE. SUHANIA, GWALIOR. ABOUT XII CENT.

In the Indian temples are imaged not only Goddesses but also angels, ministers and messengers of grace. Radiant with a sensuous charm such lovely Women of the Gods are depicted in seductive attitudes, not derived from any human models, as well as in self-transcendence and aloofness from the world in the contemplation of their own beauty (reflected in mirrors in their hands) as the sport and delight of Maha-Maya. It is also striking that inwardness is often emphasized in these beauties by a complete omission of the eye-balls. They are multiplied on the temples, in the pillars and all round the walls. Such repetition itself indicates joy and exuberance of the feeling of immanence of Sakti. For what are the Celestial Women interwoven rhythmically in belts and storeys from wall to wall and from corner to corner except the undefined human spirit akin in its essence and movement to the Divine?

(p. 147)

This is a rare example of happy plastic synthesis and stylistic perspicacity
worthy of the moderns. The abstract rigour of the poised, triangular composition
is enhanced by the heaviness of the lute held diagonally, by the baldness of the
nimbus, and by the severe verticalism of the round bald pillars on each side, set-
ing the main figure in a plain rectangular compartment. The entire design is
quite in keeping with the theme of representation of Pure Consciousness.

(pp. 147; 150)

28. BODHISATTVA

A brass image of self-absorption and self-transcendence. The latter is symbolized by the aureole of illumination around the image. A typical triangular composition in sculpture associated with poise and silence. This illustrates how in India the nature of the material, whether stone or bronze, counts little in the sculptural pattern.
(p. 151)

Copper image—a rare combination of profound poise with brooding motherlines, of dignity and aristocracy with litheness and grace. The easy posture (lalitasana), together with the eloquent gestures of the hands, which we have encountered so many times from the Gupta period onward, are here employed to stress the association of Compassion (Karuna) with Illumination (Prajna) in terms of which consciousness and reality were interpreted by the Vajra and Sahaja phases of Buddhism.

29. BUDDHIST TARA—GODDESS OF ENLIGHTENMENT

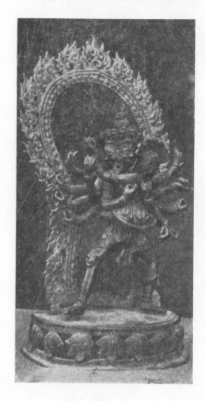

An example of the conjunction (Ada-vaya, Yugandhha) of the Divine pas-sive, masculine and dynamic, feminine principles of Void and Compassion in Buddhist Tantrika art and worship. The burning frame behind represents the matrix of the universe, the seat of Primordial Energy of the cosmic pro-cess. For several centuries the Vajra and Sahaja used and practised the metaphor of sexuality as regards the unitive state, reached through the experience of the basic complemen-tary principles of Void and Com-passiin corresponding to Siva and Sakti in Hindu Tantrikism. Such a metaphor governed religion, ritual and iconography.

(pp. 118-119)

Woman, mysterious and terrible.
(pp. 146; 150)

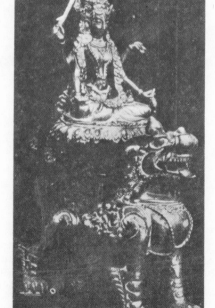

31. TIBETIAN IMAGE OF TARA

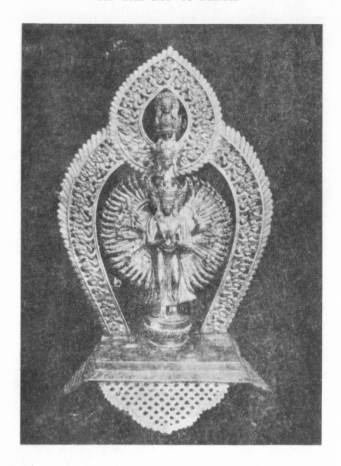

A Tibetan image of the myriad-handed deity within the Tantrika Yantra. Both the geometrical pattern of the Yantra and the image are instruments of the mind's fixation on the idea, mood and gesture of the deity by means of which the devotee seeks communion with the infinite. For facility of meditation the image and the Yantra are integrated in the plastic composition. The stern verticality of Death's standing posture is brought into relief by the animation of his many limbs both in the image and the decorative treatment in the Yantra that express Death's omniscience. (pp. 9; 151)

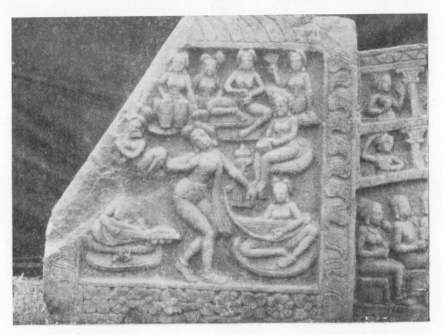

Various kinds of musical implements are being played by the female figures as they are all brought together by the dance whose languid, self-absorbed character saturates every limb and gesture. In the Indian temples dance is both a divine art and a sacred ritual, and is abundantly represented in sculpture and bas relief. (p. 264)

34. NATARAJA OR THE LORD OF THE DANCE.
A SOUTH INDIAN BRONZE.

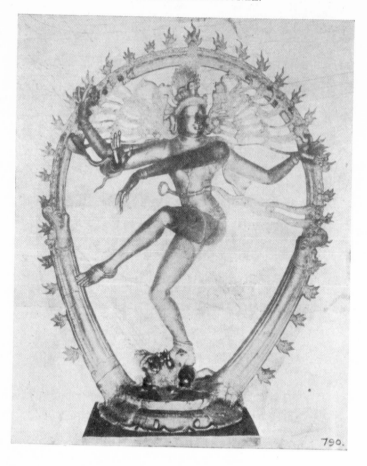

A most profound motif embodying a basic conception of Hindu metaphysics and science, a key to the entire Hindu theory of nature, life and mind. The image of the cosmic dance of Siva Nataraja, the Lord of the Dance, incarnates the perpetual pulsation in the life of the mind and of the universe, rest and activity, manifestation and destruction. It magnificently records both supreme aesthetic comprehension and spiritual ecstasy. The formal pattern is perfect circular movement, composed by the swirl of four to eighteen hands with their tools and implements and the sweeping curves of the legs, flowing locks and garments and of the aureole around. It grandly expresses eternal equipoise in eternal movement that has to be realised in the world-process, in every phenomenon of nature and in every mood of the human soul. For full details of the symbolism, (see pp. 47; 117-118; 267-268).

35. NATARAJA

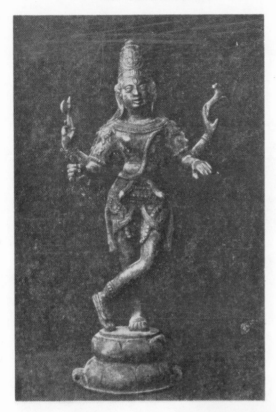

Another pose of Siva's Dance. This is the evening tandava dance of Nataraja as contrasted with his perennial dance, figured in 35.

The decorative treatment of the matted locks and beards is noteworthy. The symmetry of the meditative postures stresses the brotherhood in the spirit.

36. BAULS ('MAD ASCETICS')
OF BENGAL (TERRAVOTA). FOLK-ART.

The image of the ascetic is that of Siva, Dharma or Jogi that merge in one another in the folk-cult of Bengal. Since the Buddhist Siddhacharyas and Saiva Natha Jogis achieved a strange fusion of Vajra, Sahaja and Siva in the middle ages, folk culture has shown an exceptional vitality in Bengal springing from rural mysticism and humanism. Crude cottage-made tools and appliances used in making ploughs and carts have here carved out a figure of g.eat spiritual vigour and serenity, reflecting the defiant rejection of Brahmanical cult and priest-hood from which the whole strength of the folk-art is derived.

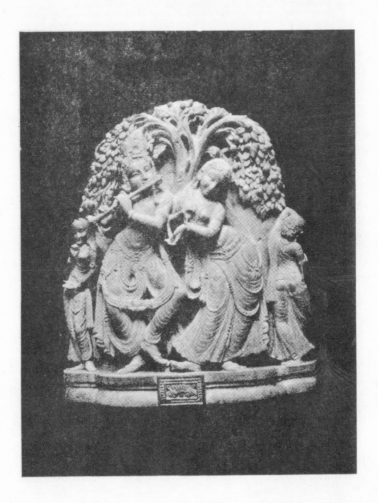

Belonging to a family of hereditary image-makers of
Puri, Orissa, the artist blends a living family tradition of
craftsmanship with a modicum of modernity.

ILLUSTRATIONS OF PAINTING

1. **AVALOKITESVARA PADMAPANI OR THE COMPASSIONATE BODHISATTVA OF THE BLUE LOTUS FROM THE AJANTA CAVES.**
(Classical Gupta Painting, 6th to 7th Century A.D.)

The Ajanta frescoes represent perhaps the greatest artistic marvel of Asia. Here is superbly expressed and consolidated the Buddhist metaphysical myth of the unity and solidarity of all life that governed the thought of Asia for a whole millennium. Mahayana absolute idealism, in spite of being rooted in the conception of void or Nirvana, stresses the inexhaustible charity and compassion of the new gods, Padmapani, Avalokitesvara, Maitreya and Manjusri. Man is bound to every sentient creature of the earth through the cosmic chain of the action and interaction of karma in a million births. The Deliverer from these is the Bodhisattva who has taken the vow that he would not enter into Nirvana before the creatures of the world, "as numerous as the sands on the banks of the Ganges", are all liberated. Suddenly the Buddhist world is inundated with a surging wave of piety and delight. It is the magic apparition of Padmapani that transforms the spiritual landscape.

Padmapani, the symbol of human perfection in India, represented by the Mahayana blending of the self-absorbed yogi and the self-giving Bodhisattva, has, since the sixth century, aroused veneration and engendered universal charity throughout the Buddhist world.

2. THE APSARAS FROM THE AJANTA CAVES.

(Classical Gupta Painting, 5th Century A.D.)

The Ajanta frescoes are characterised by a marvellous blending of the worldly and the spiritual, the sensuous and the mystical. For these are the creations of the Buddhist Mahayana idealism that bridged the gulf between Life and the Beyond, *Samsara* and *Nirvana.* Thus we find here not merely Buddhas and Bodhisattvas, but also celestial dancers or Apsaras. The qualities of earthiness and the sensuousness of alaka (heaven) in the classical poetry of Asvaghosha and Kalidasa have mixed here exquisitely with the asceticism and mystical wonder of the *Lalitavistara,* the *Buddhacharita* and the *Jatakamala.* Indian classical painting also created here its distinctive formal values that have inspired the art of middle, south and east Asia for subsequent centuries: vigorous and decisive but subtle and delicate line-drawing; a plastic sense in figuration; a simple but consummate colour scheme; and a smooth dynamic rhythm of composition unrestricted by any rigid demarcation of frames.

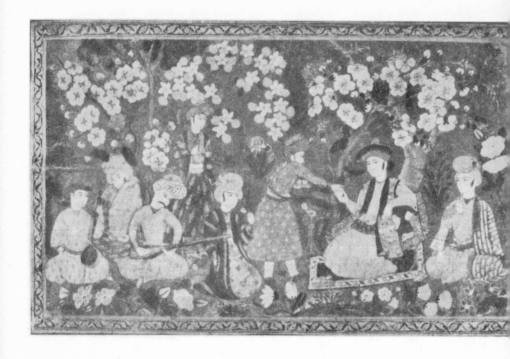

3. PERSIAN PAINTING
(17th Century)

The serenity and trimness of the garden are stressed by the logic of design. Note how the flowers and leaves of the tree and plants on the ground are transformed into elegant decorative designs. The garden symbolises in Iran man's freedom and serenity that are sought under the golden plane and cypress trees far away from the heat and dust of cities. The communion of the musical soirée is emphasised by the expectant attitudes of the men and the tenseness and severity of the whole atmosphere relieved by the movements of the two cup-bearers. The economy and loveliness of line, flowing yet stilled, and the exquisite distribution of space are also noteworthy. The contrast of colours in flowers and plants, in carpets and rich attires, reflects the contrast between the chromatic monotone of the desert and the tender green of a garden-oasis in Iran.

4. THE ASCETIC CONGREGATION
(*Moghul Painting, 17th Century*)

This original painting of a group of Hindu and Muslim saints was drawn by a court-painter of Shah Jahan. The age saw a remarkable fusion of the mystical ideas and practices of Hindu Yoga and Islamic Sufism that is symbolised by this meeting round the fire and under the sacred banyan tree of Hindu sadhus and Muslim fakirs, who can, however, be easily distinguished.

A striking effect of serenity and austerity is produced by the verticality of the trunk and shoots of the huge banyan and of the postures of the saints that is brought to sharp relief by the elliptic composition. The treatment, with the spaces in between the figures, is extremely poised and tranquil. The everlasting bata tree, which, with its ever-spreading roots and branches, symbolises in India the life eternal, solemnly participates in the austere discipline of man who seeks its shelter.

5. SPARROWS *(Moghul School, 17th Century)*

The Moghul Emperor Jehangir was a notable lover of nature and art, and in his reign flourished many distinguished painters, including Mansur who painted this picture. Here the phantastic cloud-shaped rocks, the waterfall, trees and flowers give rise to a symphony in colour, delicately articulating the emotional rapport between the pair of birds. Moghul painting, associated with the courts of the Moghul Emperors, is neither inspired nor aided by any religious enthusiasm. It shows a meticulous observation of nature and a passionate drawing representing a trend that is foreign to truly Oriental art, and that is due to the influence of European painting, reaching India through Iran, via the Moghul court. On the other hand, it is not generally known that the Dutch merchants took to Amsterdam many Indian paintings and that the great European master Rembrandt could get hold of and copy several of these.

6. THE EXPECTANT DAMSEL
(Rajasthani Painting, 18th Century)

The human soul is portrayed in medieval Hindi literature and mysticism as the Bride of God. In the springtide of love she is full of happiness. But often she is depicted as in utter desolation due to separation from the Beloved or as braving the night and the forest during rain and storm to unite with him. Here the Bride stands, early in the morning, "on the tiptoe of expectation, still as a painted picture framed by the door-sill". Her night has been spent in profound agony.

7. THE BRIDE
(Rajasthani Painting, 18th Century)

The Maiden, inexperienced in the lore of love, has forsaken her home and is led by her confidante to her Lover. From the doorstep the servant with the torch will take her to the Chamber of Love where deep darkness hovers. It is the affectionate embrace of her confidante that dispels her coyness and fear. The Bride is the human soul that must undertake its journey to the Dark Chamber in expectancy and trepidation. The radiance of the charmingly limned faces of the two girls is sharply contrasted with the lengthening shadow behind them and the darkness of the silent night above.

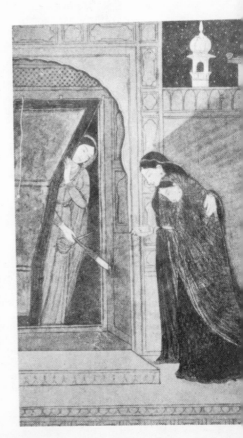

8. THE NIGHTLY VIGIL
(Himachala School, Early 19th Century)

All through the night the fawn-eyed Bride stands at the door gazing into the moonlit landscape. But the dark-blue Krishna, having promised to come, does not fulfil his promise. The maid has gone to sleep and the bed lies empty. The Bride is the heroine of the empty bed, Vasaka Sajya Nayika. The tranquillity of the night is in sharp contrast with the agitated mood of the human soul, just as the symmetry of the verticals and horizontals of the white marble building is in marked contrast with the tremulous gesture and movement of the Damsel that make her charm even more captivating.

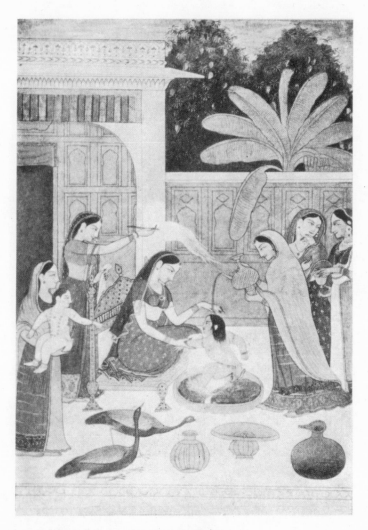

9. THE ABLUTION OF INFANT KRISHNA
(Himachala School, 18th Century)

There are many versions of this familiar episode of the recalcitrant Infant's daily ritual of ablution at the hands of his mother Jasoda. Profound and concentrated tenderness is consolidated by the similarity of countenance of the charmingly limned attendants. The latter is in sharp contrast with the distinctive dramatic movement of each contributing towards the appeasement of the Infant. A familiar scene in every Indian household is here transfigured in the Divine legendary setting. The plantain tree, with its overhanging broad leaves in the courtyard, as well as the pair of peacocks participate in the drama of the household. The glory of the Rajasthani and Himachala schools of pictorial art consists in its revelation of perennial beauty and goodness in all that is familiar and intimate in our daily life.

10. KAKUVA RAGINI OR MUSICAL MODE.
(Rajasthani School, 17th—18th Century)

A unique field of Indian painting is represented by the depiction of melodies. In Europe the compositions of Chopin, Bach, Schumann and others have only recently received visual interpretation. In India there are exquisite paintings of the musical modes (ragas and raginis) in which the various *nuances* of love, either in union or separation, are symbolised by typical Heroines of Love, singing the tunes most appropriate for the particular situation, season or hour of the day and night. The dominant sense of separation from the Beloved during the rainy season is poignantly expressed and stimulated by the tune of Mallara, which is personified in painting as a disconsolate woman singing as a big storm approaches. Kakuva Ragini is represented as a forlorn woman in the solitary woodland where she has been deserted by her lover. She holds a cluster of flowers, reminiscent of her past dalliance. Several pairs of birds come near to console her. At a distance the animals graze and browse, and the drama of life goes on untouched by her grief.

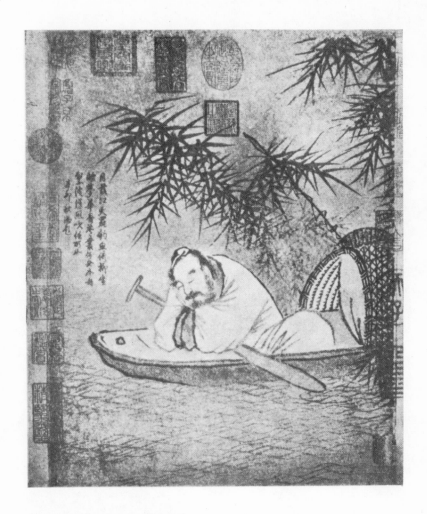

11. ANGLING ON THE RIVER
(Chinese Sung Painting)

Chinese painting reached its peak under the Sung Dynasty (960-1279), harmonising realistic detail with profound emotion stirred by the aerial vistas of the mountain-water landscape. Not the resplendent aspects of nature, but the vast spaces and serene horizons, mountain solitudes and river expanses, appealed to the Chinese artists, as to the Chinese poets and sages. "The finest landscapes", observes the Chinese painter Kuo Hsi, "are those in which one can wander, in which one can live."

In China Nature absorbs and swallows up the finite moods of man in her infinite emptiness, silence or movement. In India she is a full and ardent participant in human delights and sorrows treated abstractly, lyrically and dramatically. The wonder and solemnity of the universe in Sung landscape painting were the offspring of the mystical communion fostered by the Zen School of Buddhism that had been introduced from India.

12. BIRD ON THE BAMBOO TREE
(*Su Kuo, 1072-1123 A.D.*)

This painter was a distinguished autho on bamboo painting. The bamboo, due to similarity to the Chinese ideograph, was co dered as an ideal theme for Chinese ink-pa ing. Among the famous six canons of pain formulated by Hsieh Ho of the 6th Cent "the use of the brush to form anatom structure" is given the second place a "rhythmic vitality". The delicacy, sensit ness and refinement of Chinese painting largely due to the training in brush w given by Chinese calligraphy. Thus Chinese have always excelled in the st tural use of the brush.

13. ON THE TERRACE
(*Hokusai*)

The art of Japan combines the ancient Chinese tranquillity and profundity of mood felt in the presence of Nature with the freshness and boldness of a relatively young nation. Hokusai and Hiroshige flourished in Japan in the late 18th and early 19th centuries. Their colour prints of landscapes, temples, mountains, rivers, birds and flowers show a vigour, freshness and subtlety that have hardly been approached. No wonder the "people's art" of Japan provided a pattern which was adapted by Whistler, Ganguin, Van Gogh and Toulouse-Lautrec to suit their respective styles.

14. THE BOW MOON
(Hiroshige)

Hiroshige succeeded in capturing almost all the beautiful aspects of Japan, marvellously combining the majestic moods of nature with realism. Man in Japan sees a new glory added to the temples, mountains, lakes and rivers of his land because of his works.

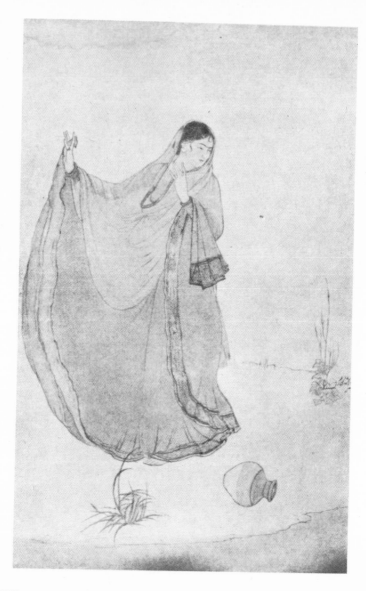

15. THE CALL OF THE FLUTE
(Abanindranath Tagore, Modern Indian School)

The Indian artistic renaissance was ushered in Bengal by three great masters, Abanindranath Tagore, Nandalal Bose and Asit Kumar Haldar. Of these, Abanindranath Tagore was the pioneer and guru, reaching in his works a synthesis of various Oriental traditions: the harmony and blend of colours of ancient Indian murals, the subtlety and delicacy of Chinese ink-drawing, and the elegance and finish of Persian miniatures. All this was expressed, as is the rule in Oriental art, in the depth and detachment of aesthetic and spiritual contemplation, altogether removed from contemporary European realism and representationalism. His themes also indicate the catholicism of the Indian revival, embracing at once the austerity of Siva's consort and the moral grandeur of the Buddha, the longing of Radha for Krishna and Shah Jahan's dream of the Taj Mahal.

16. SIVA DRINKING THE WORLD-POISON
(Nandalal Bose)

Nandalal Bose shows profound concentration blended with spiritual vigour, and is at his best in legendary and mythical themes in which he can reconcile classical grandeur with modern meaning. Recently he has evolved a decorative pattern of his own, integrating the ancient classical with the folk style. The episodes in the life of Siva and Parvati, Buddha, Krishna, the heroes of the epics and Chaitanya are brought home to us in his paintings in a somewhat familiar setting, revealing as these do, universal moods freed from the local context or tradition.

AT THE CROSS-ROADS
(Asit Kumar Haldar)

Asit Kumar Haldar is the poet-painter the Indian artistic renaissance. His ength is lyricism and romantic tender-s that make his illustrations of Omar ayyam, Kalidasa's *Meghaduta* and *usamhara* and Todd's *Rajasthan* ex-site gems of poetry. He combines the t linear grace of a Botticelli with the ritual fervour of a Rossetti, while re-ining true to the smooth dynamic rthm of Ajanta. Himself a Bengali t and composer, he indulges in unceasing, creative dialogue bet-en the imagery of songs and the har-ny and rhythm of delicate lines and tle colours.

This picture blends romantic longing h mystical expression, introducing us o a magic world in which we come and as phantom figures. It is lacquer-work wood, in which medium he often ates exquisite designs, following the ural grains of the wood.

18. SUMMER
(Asit Kumar Haldar)

In this illustration from Kalidasa's 'Six Seasons of the Year', which he has translated into Bengali verse, we find Haldar's dominant lyrical tenderness, the charm and delicacy of his figure-drawing and the harmony of his simple colour pattern that distinguish him as the colour-poet of India. The artless and impersonal adoration of the charms of femininity makes this painting far different from the self-conscious voluptuous nudes of Gascoigne and Rubens or the impassioned and seductive figures of Renoir.

19. OMNIFORM
(*Asit Kumar Haldar*)

Recently Haldar has been experimenting with forms of abstract art that delve into new reaches of aesthetic insight and spiritual experience, and are far removed from their modern Western equivalents. A series on how the birds, bees and reptiles see the world is illuminative.

20. DREAM-LAND
(*Gaganendranath Tagore*)

In the midst of revivalist doctrine and practice, G. Tagore deftly and courageously experimented with cubism and expressionism, exploring unknown levels of consciousness through his phantasies of surface and depth of appearances and juxtaposition of forms. He has much to teach the younger generation of radical artists.

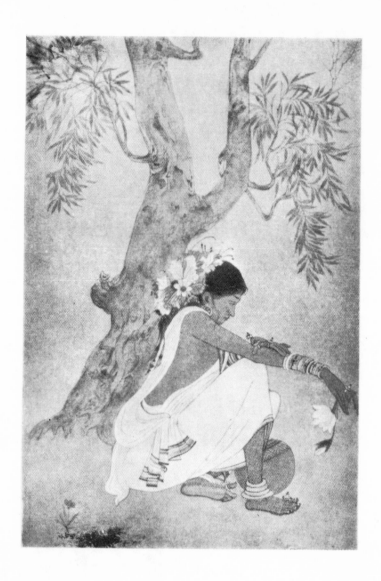

21. JAMUNA
(Kshitindranath Mazumdar)

Mazumdar's paintings are permeated by a deep and ardent Vaishnava tenderness and devotion that find expression in the refined delicacy of his lines and suavity of his colours. In this original painting his theme is the blue river Jamuna that holds in her bosom the love-play of Radha and Krishna, symbolised by the lotus-buds in her hand.

Index